AMERICA'S GREAT
RAILROAD
STATIONS

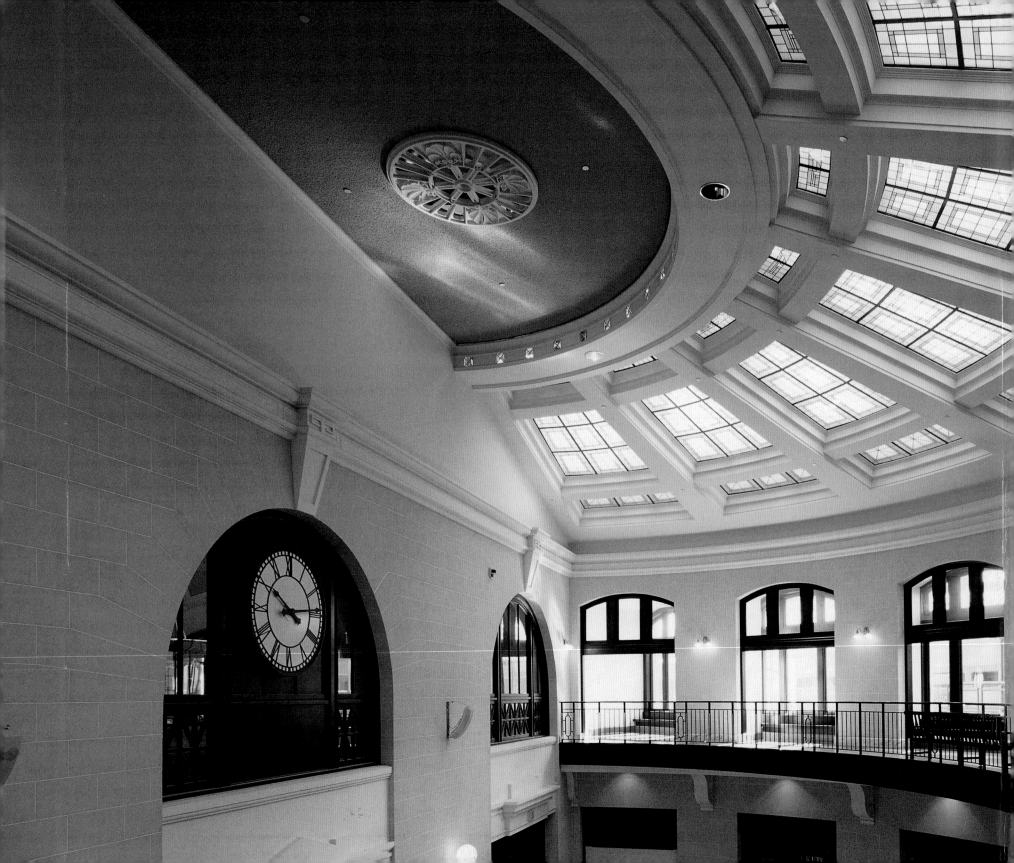

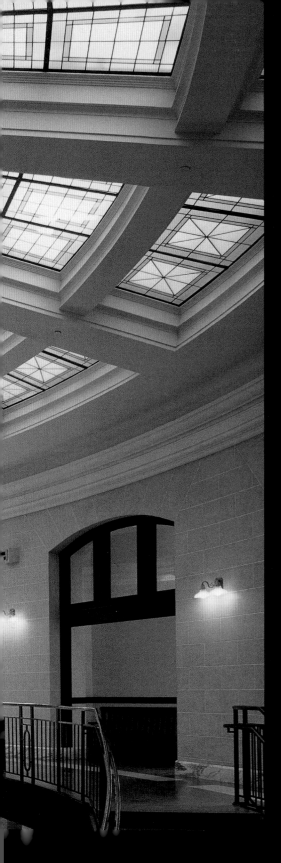

AMERICA'S GREAT RAILROAD STATIONS

ROGER STRAUS III

TEXT BY ED BRESLIN AND HUGH VAN DUSEN

VIKING **STUDIO**

VIKING STUDIO
Published by the Penguin Group
Penguin Group (USA) Inc., 375 Hudson Street, New York, New York 10014, U.S.A.
Penguin Group (Canada), 90 Eglinton Avenue East, Suite 700, Toronto, Ontario, Canada M4P 2Y3 (a division of Pearson Penguin Canada Inc.)
Penguin Books Ltd, 80 Strand, London WC2R 0RL, England
Penguin Ireland, 25 St. Stephen's Green, Dublin 2, Ireland (a division of Penguin Books Ltd)
Penguin Books Australia Ltd, 250 Camberwell Road, Camberwell, Victoria 3124, Australia(a division of Pearson Australia Group Pty Ltd)
Penguin Books India Pvt Ltd, 11 Community Centre, Panchsheel Park, New Delhi – 110 017, India
Penguin Group (NZ), 67 Apollo Drive, Rosedale, Auckland 0632, New Zealand (a division of Pearson New Zealand Ltd)
Penguin Books (South Africa) (Pty) Ltd, 24 Sturdee Avenue, Rosebank, Johannesburg 2196, South Africa

Penguin Books Ltd, Registered Offices: 80 Strand, London WC2R 0RL, England

First published in 2011 by Viking Studio,
a member of Penguin Group (USA) Inc.

1 3 5 7 9 10 8 6 4 2

LIBRARY OF CONGRESS CATALOGING-IN-PUBLICATION DATA
Straus, Roger, III.
America's great railroad stations / Roger Straus III ; text by Ed Breslin and Hugh Van Dusen.
p. cm.
Summary: "An evocative and stunning photographic tribute to America's railroad stations. For much of the nineteenth and early twentieth centuries, the railroad station or depot was the communal hub of every American town that could boast of train service. There, citizens gathered before they sent loved ones off to college, marriage, or war-and where they greeted them on their return. Most of these buildings were architectural gems, and while many are still in service, certain others now house museums, banks, restaurants, and more. In fact, in cities like Washington, D.C., and Philadelphia, renovated stations are destinations unto themselves even for those not boarding the train. And in other places, whole sections of towns have been remade around these structures, restoring their vitality in novel and interesting ways long after the last train has left the station. In America's Great Railroad Stations, award-winning photographer Roger Straus III, and two lifelong railroad buffs, Ed Breslin and Hugh Van Dusen, join forces to tell the astonishing story of these enduring structures and the important role they still play in the country's landscape. Journeying from the Pennsylvania Railroad to the Union Pacific to Michigan Central and more, readers will be dazzled by the Beaux Arts monuments of New York and the adobe buildings of the Southwest. Filled with both new and archival photographs and drawings, this volume is a glorious salute to the institution that transformed our nation." —Provided by publisher.
Includes bibliographical references and index.
ISBN 978-0-670-02311-0 (hardback)
1. Railroad stations--United States--Pictorial works. I. Breslin, Ed. II. Van Dusen, Hugh. III. Title.
TF302.U54S77 2011
385.3'140973—dc23 2011013901

Printed in Singapore
Set in Sabon LT Std
Designed by Renato Stanisic

To Connie, Lynne, and Wendy

CONTENTS

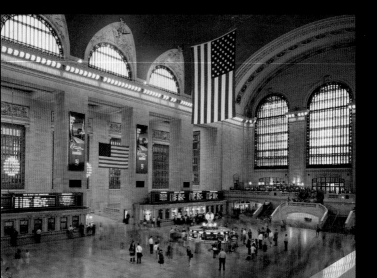

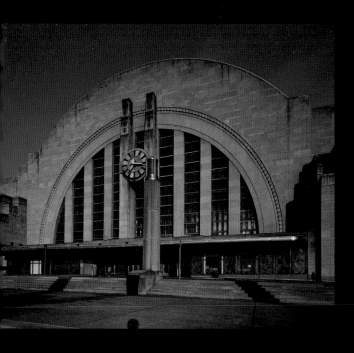

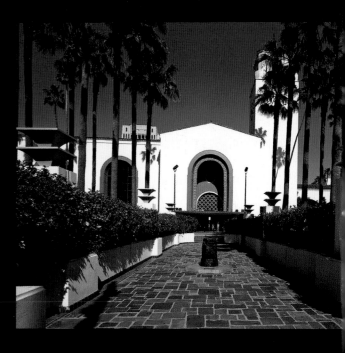

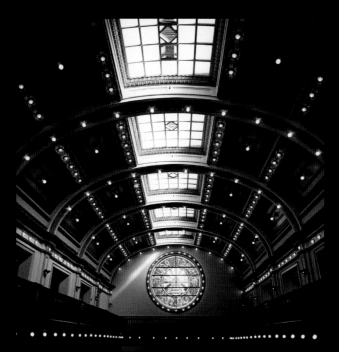

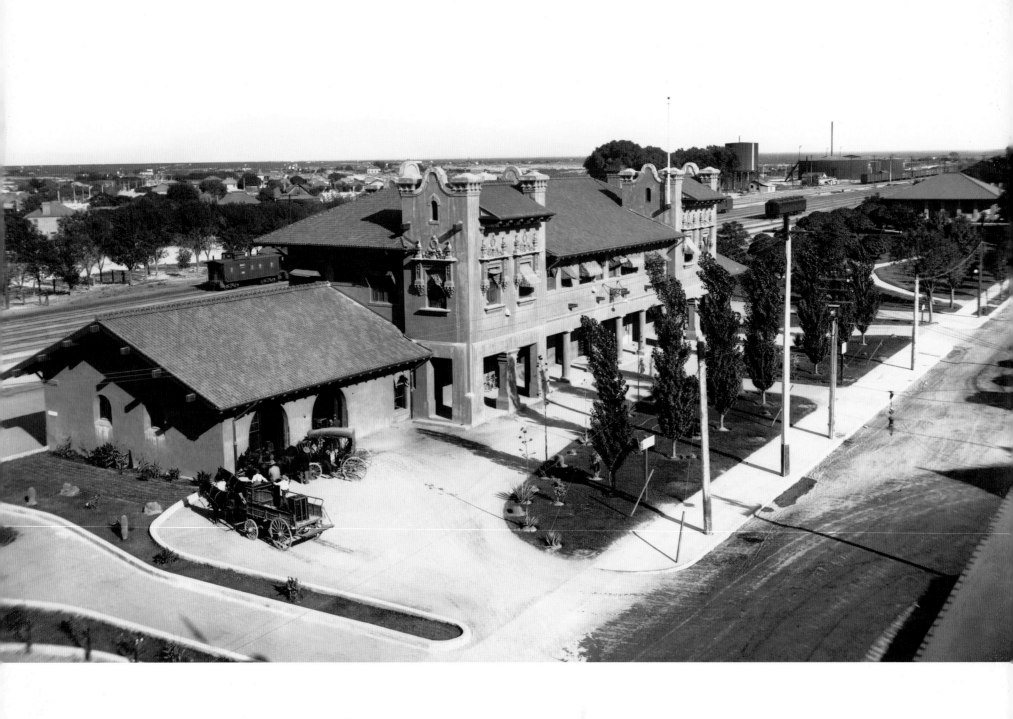

TRAVELING IN STYLE

We travel by plane, oftener than not, and yet the spirit of our country seems to have remained a country of railroads.

<div align="right">JOHN CHEEVER, BULLET PARK</div>

Transportation is civilization," Rudyard Kipling observed, and never was a statement more accurate or descriptive. From the invention of the wheel to the creation of sailing vessels, the speed of movement over land and sea has determined the nature of all civilizations, especially their ability to expand and grow. Up until the time of the invention of the first true railroad, at the beginning of the nineteenth century, the sailing ship pretty much determined the configuration, size, and nature of civilizations, and it especially governed the size and power of an empire from the end of the Middle Ages until the advent of the twentieth century, often called the American Century. Nothing made possible the American Century as did the power and speed brought to land travel by the steam locomotive in the middle years of the nineteenth century. Specifically, it made possible the continental configuration of the United States; by connecting the country from the Atlantic to the Pacific, the railroad made America the bridge between Asia and Europe and simultaneously freed both Asia and America from dependence on Europe: Europe was no longer the world's fulcrum, and the Mediterranean was no longer the defining and delimiting sea in the middle of the earth, as its name implies. Without the invention and proliferation of its railroads, America as the powerful nation it became is inconceivable.

Even though American railroads did not do so via a seaborne route, they nevertheless made possible the reality of the Northwest Passage, the route traveling west from Europe that Columbus, and countless explorers before him, had been seeking when he discovered the New World in 1492. The only difference is that this terrestrial Northwest Passage, this "Passage to India," as Walt Whitman described it, would involve portage across the continent of North America, a portage made practicable for travelers and freight only by the invention of the speedy and efficient steam locomotives. With only

prairie schooners available for transport, as had been the case before the railroads, the American West would not have been settled so expeditiously, and would never have become, so quickly, the populous industrial and commercial powerhouse it has been for a century and a half. The railroads actualized the America that Thomas Jefferson visualized when in 1804 he sent Meriwether Lewis and William Clark to map the territory west of the Mississippi. With its resultant continental reach because of the railroads, America became bicoastal, spurring the accession of its powerful merchant fleet and navy, thus enabling it to establish a formidable presence, both militarily and commercially, on the world's two largest oceans and to become, in very short order, the world's foremost trading partner, manufacturer, free market, and financial center, by virtue of possessing the world's largest economy.

This is why for over two hundred years America has had a serious romance with the railroad, and why the allure and aura of American railroading linger even now, in an era of travel dominated by cars and airplanes and in which outer space is explored on a daily basis. A visit to the great participatory railroad museums in Steamtown, Pennsylvania, in Roanoke, Virginia, in Danbury, Connecticut, and in Sacramento, California, is proof positive that America's romance with its railroading past is alive and well and thriving. In recompense for what the railroads enabled this country to become, American communities ranging in size from small towns to great metropolises built dazzling stations with civic fervor and aesthetic passion. Each station functioned as did the main gate on a medieval town: it was the welcoming portal to that community, and it was meant to impress, comfort, and reassure the visitor. Each station was a focal point

of collective pride, a civic monument large or small. All embodied America's love of, and genius for, commercial excellence. Whether built on the scale of a small chapel, a substantial church, or a monumental cathedral, all of these stations personified and reflected America's secular spirituality fueled by the belief that life could endlessly be enhanced by aesthetic beauty, industrial might, technological knowhow, and creature comforts while traveling in style with alacrity from one point on the compass to another.

These stations also played a large role in the social life of their town or city, often serving as a gathering place akin to the plaza in front of a medieval church or cathedral, where cafés and restaurants, shops and newsstands clustered around the plaza. In the case of the train stations, especially the larger ones built from the mid-Victorian years up through the 1930s, the station itself was an epicenter of town or metropolitan socializing, with the cafés and restaurants, the shops and newsstands located within the station. Station lobbies were often meeting places not just for travelers but for inhabitants intent on lunch or dinner, or on buying a book, newspaper, or magazine, or, perhaps, on getting a haircut, shoe shine, facial, or manicure, since the larger stations usually held barbershops and beauty salons. Socializing for the locals, of course, was casual; in the opposite instance, when family members and friends bid farewell or welcomed each other home, the stations hosted vivid moments, charged with emotion and treasured in memory forever.

This was especially true during wars; if verification is needed, simply read Bob Greene's uplifting bestseller *Once Upon a Town*, the story of how the townspeople of North Platte, Nebraska, way out there on the plains, converted their depot to a canteen during World War II and played host to

six million GIs passing through on troop trains. Staffed solely by volunteers and open from five in the morning until past midnight every day of the war, the North Platte canteen had only twelve thousand residents of the town to draw upon for volunteers at the time, yet managed to offer hospitality, home-cooked food, coffee, tea, magazines, and newspapers to these troops headed for combat in Europe or in the Pacific. Unfortunately, the North Platte depot has been torn down; instead, it should have been converted to a museum honoring the spirit of Americans.

Partings and reunions at railroad stations also fostered vivid memories rife with strong emotions when sons or daughters traveled long distances to attend college, to take up a career, or to marry and begin a family thousands of miles from their homes. Sadly, traveling to and from funerals often involved the train station as well, and often embedded painful memories. The stations also served as magnets for autograph hounds, celebrity watchers, and paparazzi because stage, movie and sports stars, presidents, world leaders, kings and queens, princes and princesses routinely passed through their portals. Train stations were at once gateways to and social centers for the towns and cities they served in ways airports never will be: train stations were central, airports peripheral; train stations were emblematic, lavish, and architecturally significant, whereas airports are banal, algid, and architecturally utilitarian, bland, and generic—except in very rare instances like William Delano's Marine Air Terminal at LaGuardia or Eero Saarinen's TWA terminal at JFK.

Make no little plans. They have no magic to stir men's blood, and probably will not themselves be realized.

DANIEL BURNHAM

So significant is the architecture of train stations in this country that one can trace large segments of America's history by visiting them, including America's architectural history. In the Georgian stations in Williamsburg, Virginia, and in Maysville, Kentucky, one sees tributes to America's colonial architecture. In Savannah, Georgia's station complex one sees exemplary federalist (a style often called as well early Victorian) buildings. In New London, Connecticut's masterful station one sees Richardsonian Romanesque, a middle-Victorian style, rendered to perfection. The stations in Durand, Kalamazoo, and Niles, all in Michigan, display, on a medium scale, the late-Victorian style to great effect. For an example of late Victorian on a larger scale, at the point where it transforms itself into the Beaux Arts style, there is the legendary station in St. Louis, with its vaulting clock tower, its turrets, its stained-glass windows, and its many other gothic elements. Then there are the Beaux Arts masterpieces like Grand Central Terminal in New York, Union Station in Washington, D.C., Union Station in Chicago, and Union Station in Kansas City.

Beyond question this native Beaux Arts style marked the high point in American railroad station design, and it was flexible enough to accommodate Southwestern themes in El Paso's entrancing Union Station and in Fort Worth's Santa Fe Station; moreover, it flexed enough yet again to transmute itself into art deco in Cincinnati's Union Terminal and in Fort Worth's Texas and Pacific Station, the latter also appropriating Southwestern accents. Finally, the American Beaux Arts style melded itself into the masterpiece that is Los Angeles's Union Station, paying homage to California's early mission architecture even as it incorporated the futuristic flair, streamlining, and high style of vintage 1930s art deco. For great mission revival style of an earlier and purer vintage,

Right: Danbury
Station circa 1920

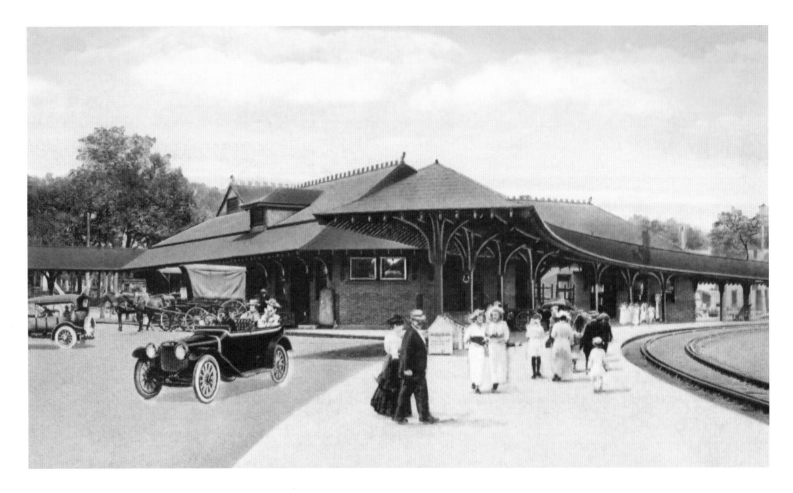

untouched by the Beaux Arts and art deco styles, there is the architectural wizardry of San Antonio's two bewitching stations: Mopac Station and Sunset Station.

All of these architecturally glorious stations are either second or third generation. First-generation stations were merely very large "barns," spare and functional, their purpose mainly to store, usually overnight, the idle engine, its tender, and the freight or passenger carriages it pulled. These earliest "stations" were usually built of wood and had no amenities for passengers, not even a platform, let alone a waiting room, shops, restaurants, and a newsstand. First-generation stations were built in the 1830s and '40s and were outmoded shortly after midcentury, when second-generation Victorian stations started to appear. Usually constructed using rough-hewn stone or bricks, second-generation stations typically had a few passenger amenities, and they often had architectural flourishes like turrets, gables, mansard roofs, and other Victorian characteristics and appurtenances, including, quite often, a soaring clock tower visible from a considerable distance.

Beginning in the last years of the nineteenth century and stretching through the first four decades of the twentieth, third-generation stations sprouted to accommodate the heyday of the railroads, when they were the principal means of long-distance travel for passengers and of long-haul shipping for freight. This trend of building extravagant third-generation stations started in the Gilded Age, and the opulent stations that resulted reflected America's new role as a wealthy world power, a manufacturing dynamo, and an economic juggernaut surging ever onward. These magnificent stations were almost all built in the Beaux Arts style studied and mastered by American students lucky enough to have matriculated at the famous École des Beaux-Arts in Paris in the latter half of the nineteenth century.

If the people of the Northwest actually knew what was good when they saw it, they would some day talk about Hunt and Richardson, La Farge and St. Gaudens, Burnham and McKim, and Stanford White when their politicians and millionaires were otherwise forgotten.

HENRY ADAMS, *THE EDUCATION OF HENRY ADAMS*

While attending the École des Beaux-Arts, these talented American students studied the classic architecture of Greece and Rome as well as European Renaissance buildings, mostly French and Italian, based on the same classical architecture of Greece and Rome but often embellished with emphatic decorative and ornamental flourishes never used by the ancients. Yet when these students returned home they managed to invest the buildings they designed with an American idiom that became known as the American Beaux Arts style. This style is less decorative, more linear, and exceptionally

foursquare and substantial, a carryover from H. H. Richardson's middle-Victorian Romanesque style. As a result, not only is the American Beaux Arts style distinct from its European forebears, its overall effect is somewhat plainer and more imposing. In Kurt C. Schlichting's estimable book *Grand Central Terminal: Railroads, Engineering, and Architecture in New York City*, he quotes Le Corbusier, the iconic French architect and avant-garde advocate for modern architecture, on the distinctness and strength of the American Beaux Arts style: "In New York then, I learn to appreciate the Italian Renaissance. It is so well done that you could believe it to be genuine. It even has a strange, new firmness which is not Italian, but American."

Had the talented Frenchman visited Virginia, he would have noticed this trend in American architecture begun much earlier by Thomas Jefferson, self-taught genius who learned his lessons by studying the books of Andrea Palladio, the seminal architect and principal theoretician who inspired much of the Italian Renaissance style and codified its tenets, all based on his study of classical models from Greece and Rome. Though Jefferson lived surrounded by structures built in the Georgian style imported from England that formed the basis of the American colonial style, when he designed and built his three masterpieces he relied on the aesthetic principles spelled out by Palladio: his home, Monticello; the Rotunda and Ranges of the University of Virginia; and the Virginia state capitol in Richmond are all based on the dicta underpinning classical architecture.

One of the chief moving forces in the vanguard of the American Beaux Arts style of architecture was Daniel Burnham of Chicago. Others were William Morris Hunt, Cass Gilbert, Stanford White, and Charles McKim. The galvanizing

event Burnham organized, and served as coordinating architect for, was the World's Columbian Exposition in Chicago in 1893, with its monumental buildings based on the classical examples of Greek and Roman architecture and its exemplary actualization of the theories espoused by the City Beautiful movement. Burnham was a principal theoretician of that movement, earning him his designation as the founder of city planning, though the French, especially Pierre L'Enfant and Baron Georges Eugène Haussmann, with total justification, might dissent vigorously to this designation in view of their respective work in Washington, D.C., and in Paris.

Henry Adams was so impressed by the World's Columbian Exposition that he visited it twice. It was there that he first saw, in addition to the superb architecture and ingenious city planning, the mighty dynamo and other technologic and engineering innovations that propelled what has been called America's "Age of Energy," the period from 1890 to 1930 that progressed simultaneously with the ascendancy of the American Beaux Arts style in architecture, each making the other possible. This remarkable epoch, often called the American Renaissance, produced such technological marvels as the Brooklyn Bridge, the Panama Canal, Sullivan's skyscrapers, New York's Penn Station and Grand Central Terminal, the transcontinental railroad, and the New York subway. In his classic autobiography, Adams wrote: "Chicago was the first expression of American thought as a unity; one must start there."

The urban planning and architecture Burnham exhibited in the World's Columbian Exposition, especially in his "White City," propelled the American Beaux Arts style of architecture to its apex. Almost all large railroad stations erected in America's major cities for the next half century employed the Beaux Arts style, and the architectural monuments this style left for posterity are national treasures. All of them should have been preserved and cherished for all time, but, unfortunately, they were not. The destruction in 1963 and 1964 of perhaps the most supremely beautiful of them, New York's Penn Station, marked the nadir of American architectural barbarism in the name of its eternal, but often misguided and benighted, headlong lunge at, and homage to, the demanding God of Progress. Not for nothing did one critic call the razing of Penn Station the greatest act of urban vandalism in American history. Yet the old saw that there is some good in everything obtains here. The cultural desecration of Penn Station spurred the national movement to preserve our architectural heritage and led to the foundation of the National Register of Historic Places, on which today one will find many train stations, all of them uplifting, many of them so aesthetically overwhelming that their impact is a species of architectural sorcery.

Certainly the sorcery of Penn Station worked its magic on many writers, artists, photographers, filmmakers, and songwriters. It is virtually a main character, so prominent is it, in the 1945 MGM film *The Clock*, a wartime romance starring Judy Garland and Robert Walker. Songwriters Harry Warren and Mark Gordon's lyrics to their smash hit "Chattanooga Choo Choo" featured it, and Glenn Miller and his orchestra made the song an enduring classic. No one who has ever seen the monumentally beautiful photographs of the station taken by Berenice Abbott, and published by her in outstanding books on New York City architecture, can ever erase them from memory. As William D. Middleton points out in his excellent book *Manhattan Gateway: New York's Pennsylvania Station*, William Faulkner wrote a memorable short story

about the station titled, appropriately enough, "Pennsylvania Station," and Thomas Wolfe in his novel *You Can't Go Home Again* evoked the building's fabled ability to cast a spell over all visitors: "The station, as he entered it, was murmurous with the immense and distant sound of time."

While viewing most of the stations displayed in this book, we too heard that immense and distant sound of time, even in the modest small-town stations: all of these vintage stations seem to whisper to you of America's inexhaustible energy and ever questing capacity for invention, enhancement, progress, and beauty.

Americans care about their past, but for short-term gain they ignore it and tear down everything that matters. Maybe . . . this is the time to take a stand, to reverse the tide, so that we won't all end up in a uniform world of steel and glass boxes.

JACKIE KENNEDY ONASSIS

Penn Station perished in the postwar rush of America in the fifties and early sixties to modernize everything and to customize every aspect of society around two new and onrushing modes of transportation: the automobile and the airplane. The train could not match the automobile for convenience and availability. The train had to stick to its timetable; the automobile adapted to whatever schedule its driver desired. The airplane, on the other hand, shortened the travel time for long-distance journeys by many multiples over even the fastest trains. Coast to coast in five hours was worlds quicker than coast to coast in three days. No matter that the airplane, like the train, also had a timetable to adhere to; for sheer expediency, there was simply no comparison between the two.

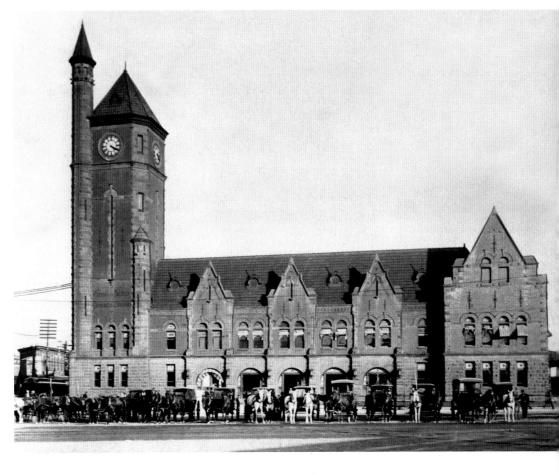

Above: Fort Worth Union Station circa 1900

There was, however, one area where the train had a definite and significant advantage: comfort, elegance, accoutrements, safety, and classiness. No automobile travel, even in a Rolls-Royce, could approximate the grace and comfort of the plush and legendary trains like New York Central's *Twentieth Century Limited* or the Pennsylvania Railroad's competitor to it, the *Broadway Limited*. Both streaked between Manhattan and Chicago in sixteen swift overnight hours during which the traveler could relax in comfort in a deluxe lounge car, dine in luxury in a gourmand's dream of a dining

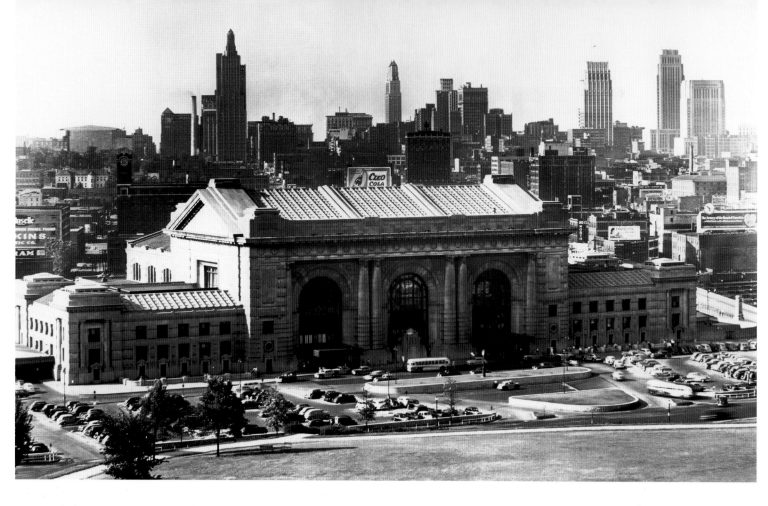

car, and sleep in a roomy and cozy Pullman's berth, thereby arriving next morning fresh and ready for a day's business or pleasure. There were many other great luxury trains, like the legendary *Super Chief* and the *California Zephyr,* to name only two, and they all had inspired and poetic, romantic and emblematic names, befitting the fabulous conveyances that propelled the age when traveling in style was still possible. Their cohorts in this mission, the great ocean liners, with names equally inspired, poetic, and romantic, unfortunately fell prey, just as the luxury trains did, to the speed and expedience of the airplane. The art of traveling in style, as Paul Fussell made clear in his splendid book *Abroad,* was the exclusive province of a vanished era. Today such elegant travel is little prized in the whirling rush of commercial dashes and tourist junkets.

When the automobile and the airplane cut the ridership for trains, the great railroad stations fell into the hands of short-sighted and often rapacious developers who viewed them as stodgy and useless relics of a bygone and obsolete age. At the same time the foundering railroad corporations, once omnipotent giants of commerce now fallen on hard economic times, saw the real estate these stations stood on as great assets to be maximized for their lucrative rental potential, usually as centrally located downtown office or hotel towers. In the instance of the great tragedy in Gotham, the Pennsylvania Railroad, once the mightiest corporation in America but lately

having ceded that lofty position to General Motors, sought to stay afloat by sacrificing Penn Station to the wrecker's ball so that Madison Square Garden and an adjoining office tower could be built and supply a revenue stream from rentals. The result was the ugly Penn Tower office building and the hideous bass-drum-turned-on-its-side horror that is "the world's most famous arena." The subterranean railroad station beneath these two eyesore structures is as insipid, uninviting, and bland as the average suburban bowling alley.

Other beautiful stations besides Penn Station were destroyed. Katy Station in San Antonio, built by the Missouri-Kansas-Texas Railroad, was ranked ahead of that city's two surviving stations, both exquisite: the Sunset and the Mopac. Pictures of the Katy capture its grandeur, grace, and beauty, and according to many persons it should have been preserved for the sublime tile work alone that mesmerized visitors to its opulent lobby. Yet it too fell to the wrecker's ball, and a nondescript chain hotel, as indistinct architecturally as a fire hydrant or a manhole cover, today occupies its former site. Schenectady, the "Electric City" and home to the General Electric headquarters for decades, had a glorious station that felt the fury of the wrecker's ball and is no more. Portland, Maine, had a fabulous station; it too was demolished. Philadelphia's Baltimore and Ohio Station, designed by Frank Furness, was obliterated, as was the Broad Street Station, another of his masterpieces. Atlanta's impressive Terminal Station disappeared in 1972.

The list is longer, but the point is made: they should have been preserved. The seventies were pretty much a wanton decade of wholesale demolition of architectural treasures, especially of significant railroad stations. At present we are in danger of losing Detroit's monumental Michigan Central Station. Like many of the stations in the pages that follow, Michigan Central should be saved and repurposed, as a museum or condominium, or as an Amtrak long-distance and light-rail station as well as a long-distance bus and local taxi transportation complex. The imaginative options open for repurposing this handsome building are legion. It would convert wonderfully well to dorms and classrooms for a college or for a community college; then again, as a self-contained art school it would be ideal. Yet it will probably perish.

As one travels around the country and views our legendary stations and witnesses their rehabilitation as transportation complexes or condos, as museums, banks, or hotels, one sees clearly the folly of annihilating them. Many of these refurbished and repurposed facilities display in their corridors or lobbies earlier pictures of the stations, showing them both in their heyday and in the horrible state of desuetude they suffered, especially in the seventies and eighties.

Such photos display these noble buildings with trees growing out of their roofs, with their sublime stained-glass windows stoned and shattered, with their copper piping and wiring torn out, with their plaster walls and ceilings chipped and fallen, with holes in their ceilings letting through destructive sunshine and deadly rain and snow, with their marble and travertine floors and staircases and wainscoting torn out, cracked, smashed, or otherwise neglected, and with graffiti defacing their sublime facades. Perhaps the saddest sight of all is a picture of a lobby as stunning as the grand hall in Kansas City's Union Station with rows of uncomfortable orange plastic waiting room seats in its center encased in a clear plastic heating bubble, the floor around the bubble laced with pools of dirty and stagnant water, everything else in the room—ceilings, walls, windows, and wainscoting—despoiled and wretched.

Then to look up today and witness what the great and enlightened citizens of Kansas City accomplished in rehabilitating this masterpiece is enough to induce tachycardia. To mistreat an outstanding cultural heritage is the ultimate crime of the philistine. Preservation is its own reward.

Ever since childhood, when I lived within earshot of the Boston and Maine, I have seldom heard a train go by and not wished I was on it. Those whistles sing bewitchment: railroads are irresistible bazaars, snaking along perfectly level no matter what the landscape, improving your mood with speed, and never upsetting your drink. The train can reassure you in awful places—a far cry from the anxious sweats of doom airplanes inspire, or the nauseating gas-sickness of the long-distance bus, or the paralysis that afflicts the car passenger.

PAUL THEROUX, *THE GREAT RAILWAY BAZAAR*

In both William D. Middleton's *Manhattan Gateway: New York's Pennsylvania Station* and Lorraine B. Diehl's *The Late, Great Pennsylvania Station* there is a foreboding and ominous photograph of a Transcontinental Air Transport's flagship Ford Trimotor sitting on display in the great station's main waiting room in July 1928. Amelia Earhart had the honor of christening this very plane that launched the first coast-to-coast air-rail service, a joint effort of the Pennsy and TAT, forerunner of TWA. This joint service meant that Los Angeles and San Francisco were now a mere forty-eight hours away from New York. In these and other books recording that era there are also shots of cars waiting in taxi queues outside the train stations, or on display within the lobbies and concourses of the stations. The cars are often perched on raised platforms for advertising and promotional purposes and to facilitate inspection by the hordes of potential buyers passing by them every day on their way to or from a train.

It is doubtful that either the railroad company executives or the passengers marveling at these two new modes of transportation had any idea of the negative impact they would eventually have on railroad travel and on the art of traveling in style. Yet, most assuredly, both the plane and the car spelled doom for the hegemony of rail travel. Even a cursory glance at Lucius Beebe and Charles Clegg's *The Trains We Rode* gives a full and panoramic impression of the luxury and opulence that characterized train travel in its supreme days in the last quarter of the nineteenth and the first half of the twentieth century. Comfort, serenity, safety, ambiance, and calm were of paramount importance. The china and silver, the linen napery, the food and the wines in the dining cars were all of the finest quality. Passengers were known to ride the legendary trains for short distances simply for the pleasures of their dining cars. The lounge cars were gracious and usually equipped with large windows and sometimes skylights for the pleasures of sightseeing. The sleepers were plush. The gracious and polished waiters and porters were knowledgeable and unfailingly helpful and polite. The trip itself was an adventure and often a joy. As Paul Theroux remarks in *The Great Railway Bazaar*, on a large and comfortable train one didn't even need a destination, only a good corner seat.

In the fifties American frenzy for Out With the Old, In With the New, trains and rail travel were viewed as passé. So the great railroad stations suffered and often even disappeared as train travel in our country morphed into a collective nightmare and a national disgrace. The Europeans, wiser and free of the twin noxious influences of Detroit's all-powerful automakers and our ever omnipotent Big Oil cartel,

did not abandon their national railroads. They also wisely retained electrified trolleys in their cities. Both of these moves are now seen as salubrious and environmentally enlightened. It would behoove America to follow their example. Amtrak has plans on the drawing board to initiate rapid train service in its busiest corridors and on its most popular routes; these planned supertrains are projected to travel at the two-hundred-mile-per-hour clip of France's TGV (*train à grande vitesse*) and Japan's bullet trains.

We can only hope these Amtrak plans come to fruition in the middle of the next decade, as planned. We can also only hope that more cities follow the example of Portland, Oregon, and unify their metropolitan transit system with integrated long-distance, light-rail, and suburban trains available from interlocking stations, as well as intercity and long-distance bus service equally available and interconnected, and with the entire system enhanced by environmentally advanced buses and taxis. By relying more on electrified rail and trolley service America could greatly reduce its outsized carbon footprint. A concerted effort to revive our railways is not only politically correct, it is not only environmentally beneficial, it is, more urgently, a sound strategy for self-preservation and for the enhancement of our quality of life.

We need to encourage a revival of rail travel in this country, to modernize it and make it work for us again, using clean energy to relieve congestion on our highways and in our big-city streets and to help clean up the air we breathe. We need to remember how early American railroads in the 1830s aroused fear in their passengers when their clothes caught fire from cinders and their eyes burned from smoke and when many of them dared the common wisdom that traveling as fast as thirty miles per hour would cause their blood to boil

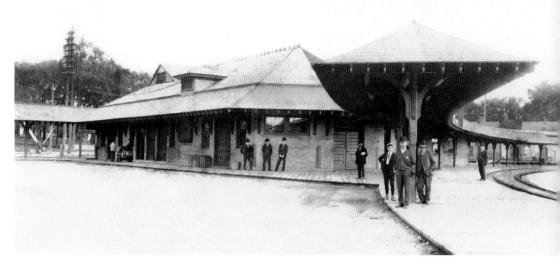

Above: Danbury Station circa 1905

or their hearts to burst. One railroad even hired Daniel Webster to counter the persistent rumor that rail travel would cause brain damage. From those primitive days with their voodoo fears, we've come a long way, but we've forgotten, in our headlong embrace of the auto and the airplane, the great promise modern rail travel now portends.

Most of all, we need to recall how safe, efficient, beneficial, and exciting rail travel became. We need to improve it once again to enhance our quality of life and to honor and embrace again the invention that enabled America to expand from a small congeries of colonies hugging the Eastern Seaboard to the large conglomeration of states forming a transcontinental nation stretching from coast to coast.

In starting over we should bear in mind the words of T. S. Eliot in *Little Gidding*:

> *What we call the beginning is often the end*
> *And to make an end is to make a beginning.*
> *The end is where we start from.*

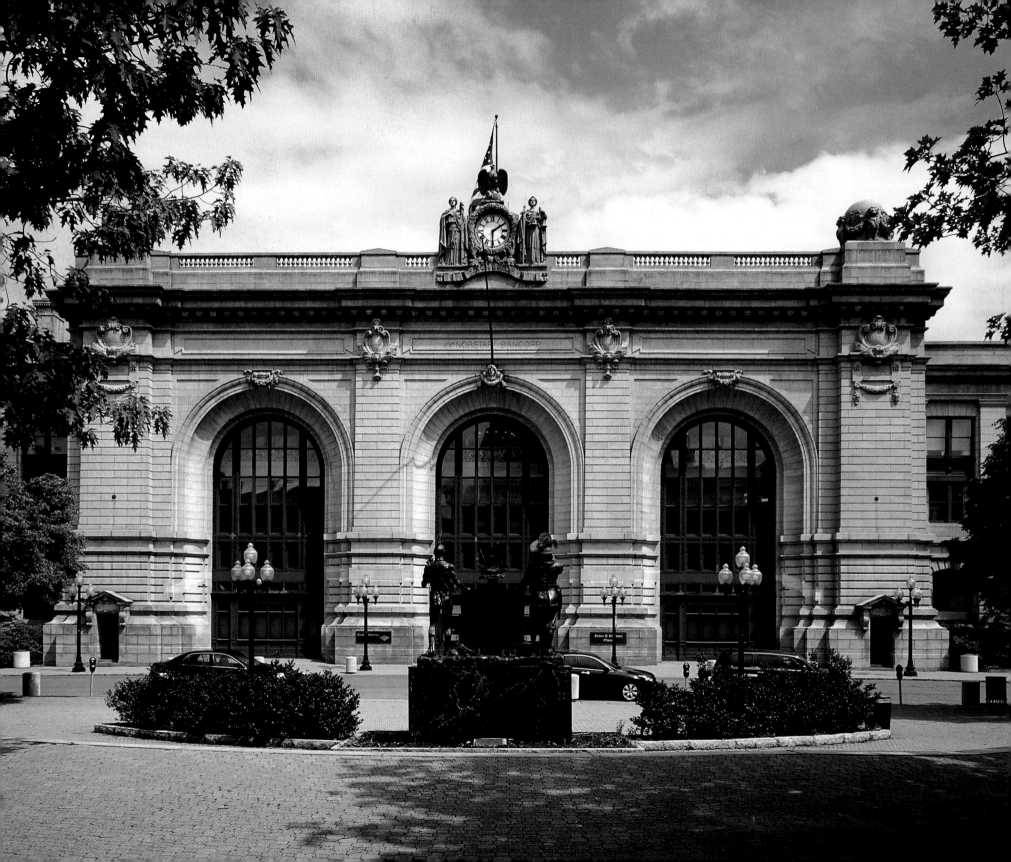

THE MID-ATLANTIC

*T*he Mid-Atlantic region offers outstanding examples of third-generation American stations large, small, and intermediate. In New York there is Grand Central Terminal, a supreme example of the American Beaux Arts style at its apex and considered by many the most beautiful railroad station in the world. Both Grand Central Terminal and the tragically razed Pennsylvania Station gave New York City two triumphs of the Age of Energy: Grand Central was the greatest excavation project in engineering of that era, except for the Panama Canal; and Pennsylvania Station pioneered the engineering feat of the subterranean riverine tunnel for trains, and eventually for cars. Two hundred miles south of New York City is another monumental Beaux Arts masterpiece: Washington's Union Station, generally acknowledged as Daniel Burnham's crowning achievement.

 Intermediate classics boasting the same Beaux Arts flair and fullness, if not the same grand scale, are Albany Union Station and Utica Union Station. Albany

Union Station reflects much of the solidity that typified the mid-Victorian American style of architecture known as Richardsonian Romanesque, but with added Renaissance Italianate flourishes, such as rusticated stonework, large arches, a classical colonnade, and decorative statuary on the exterior, and, on the interior, liberal use of marble columns and highly articulated plasterwork. All of these transplanted Renaissance elements are characteristic of the American Beaux Arts style. This distinctive combination of styles—the Richardsonian melding into the Beaux Arts—reflects the fact that Henry Hobson Richardson's successor Boston firm designed Albany Union Station.

On the other hand, architect Alfred T. Fellheimer, the man who designed many features of Grand Central Terminal, most notably its innovative encircling system of ramps, designed Utica Station. Fellheimer's next project following Grand Central Terminal, Utica Station is clearly designed in the Beaux Arts style and in much the same spirit as Grand Central Terminal, especially in its interior, yet Fellheimer cast this building in a slightly plainer idiom that would eventually morph into the highly streamlined, geometric, and rectilinear art deco style he later employed in Buffalo Union Station and in Cincinnati Union Station.

Conveniently enough, 30th Street Station in Philadelphia, opened in the mid thirties, also combines the Beaux Arts style with art deco elements, but in a more subdued and muted manner than that used by the flamboyant Fellheimer. The muted art deco elements and the subdued Beaux Arts style of 30th Street Station are in keeping with the classical tenets laid down by Daniel Burnham, who conceived this station's initial plans, though they were completed posthumously by his successor firm. Straight across the state in downtown Pittsburgh sits Pennsylvania Station, designed by Burnham at the beginning of the twentieth century. Its early skyscraper composition indicates the influence of Burnham's great Chicago rival, Louis Sullivan, the inventor of the skyscraper, yet another marvelous technological breakthrough of the Age of Energy.

Between New York City's Grand Central Terminal and Albany's Union Station lie three small river stations typical of the styles employed in the early years of the last century. Garrison Station embodies Edwardian solidity in gorgeous Vermont granite, with Arts and Crafts accoutrements that humanize and rusticate it, such as the hand-carved wooden brackets supporting the canopy and the deft use of stained glass in the windows. Hyde Park Station and Rhinecliff Station show to advantage the Spanish mission revival style popular in the 1910s and 1920s and used extensively by the architects for the New York Central Railroad.

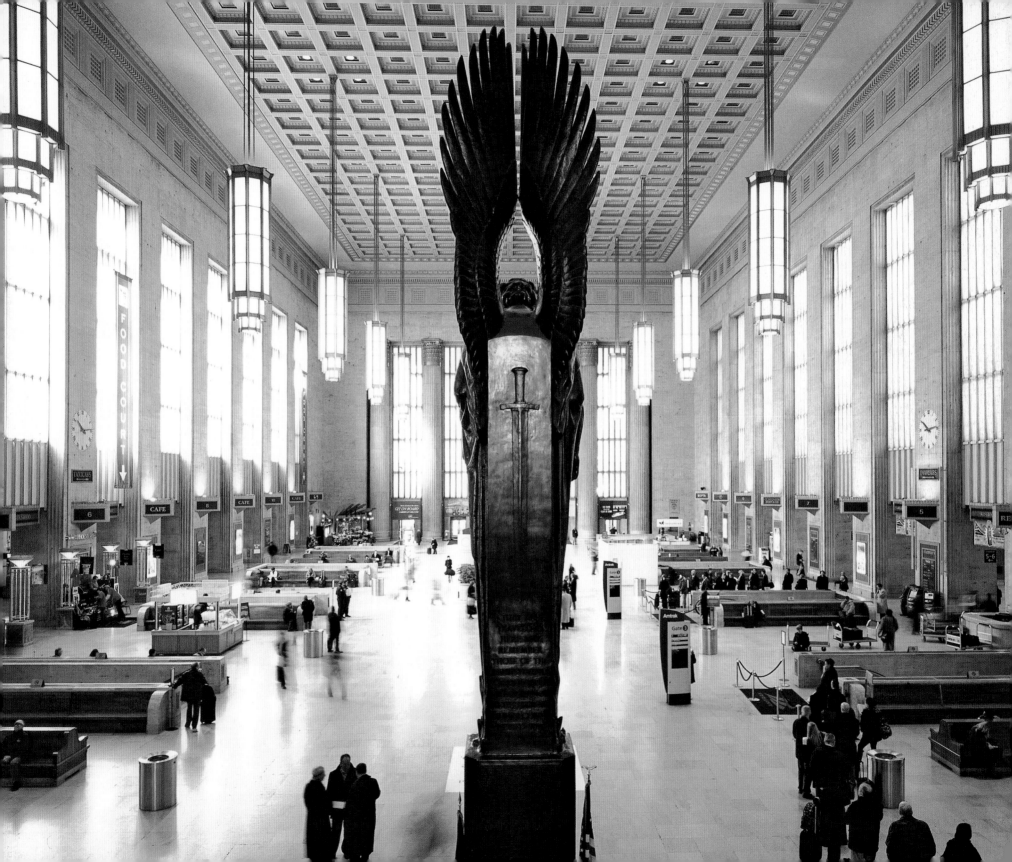

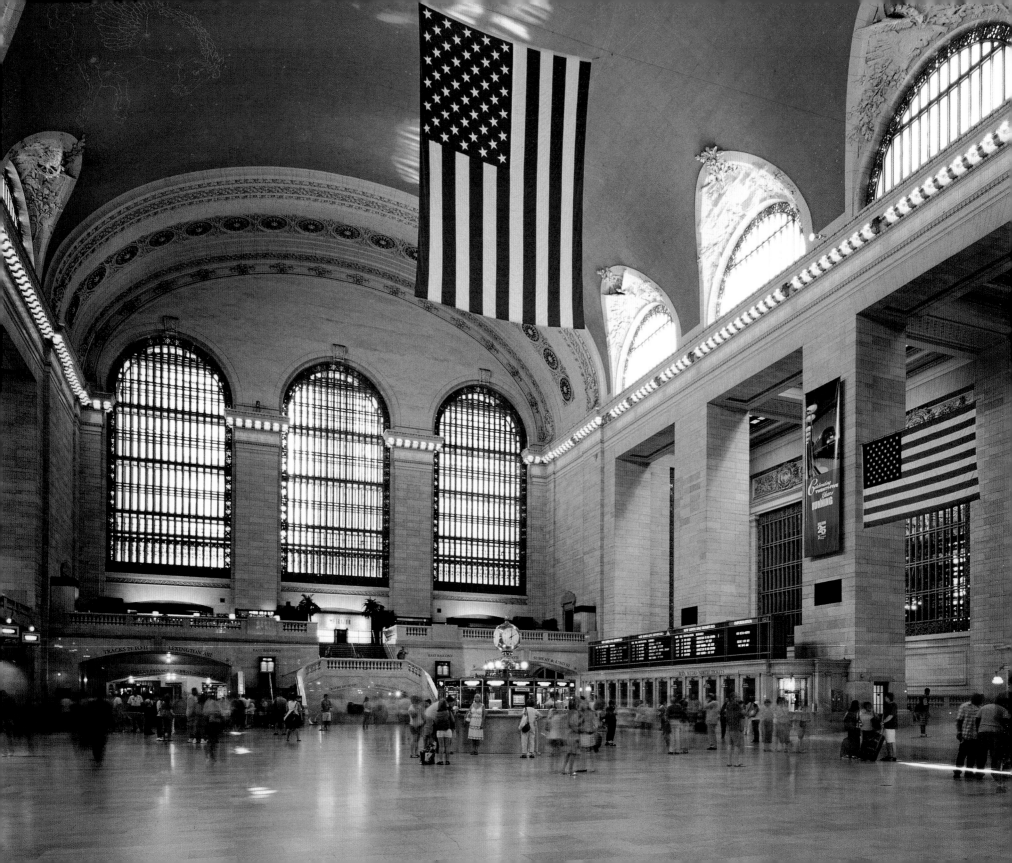

1

New York Grand Central Terminal

More than any other icon or symbol, Grand Central Terminal in Manhattan personifies American vision, energy, genius, and destiny at the dawn of the twentieth century. Opened in 1913, Grand Central, as it is commonly called, combined the practical inventiveness of American engineering with the innovative élan of American architecture, which was just then evolving at the apex of the American Beaux Arts

style into the soaring skyscraper style that would dominate the future worldwide. The proliferation of the skyscraper, ironically and unfortunately, would also leave Grand Central the most hedged-in civic monument in any major city, rendering a full appreciation of its many beautiful aspects a challenge.

Just as the sponginess of the marshy land on Chicago's lakefront led to the invention of the skyscraper—built with lighter materials like steel and glass instead of with heavy, rough-hewn stone or masonry, making increased verticality attainable—so the invention of electricity made possible the erection of an enormous station like Grand Central in the heart of midtown Manhattan, where the subterranean tracks would run for miles beneath wide swaths of the most

valuable real estate in the world, and where the problems of steam engine noise, pollution, dirt, grime, soot, right-of-way traffic disruption, and pedestrian danger were suddenly and permanently eliminated. The electric locomotive was a major technological breakthrough, nowhere better exploited than in New York City. As architect Louis Sullivan took his ingenious invention, the skyscraper, upward, the genius behind Grand Central, civil engineer William Wilgus, took his brainchild downward, burrowing into the dirt, shale, and granite of Manhattan Island to create an all-electric, bi-level underground rail yard and terminal, with a magnificent Beaux Arts station above, replete with an exquisite concourse that would become one of the world's most instantly recognizable interiors.

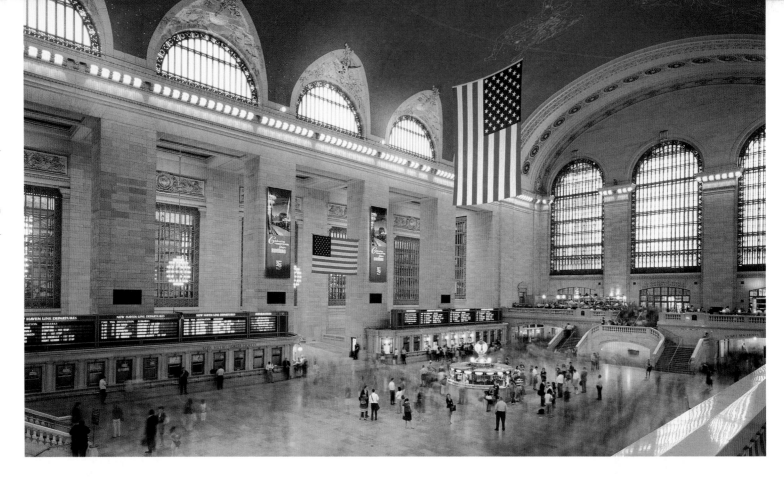

GRAND CENTRAL TERMINAL proved that necessity spurs invention. The history of railroading in New York City demanded an ingenious response to its challenges on the level at which William Wilgus responded. The Harlem Railroad, predecessor to the mighty New York Central of Cornelius Vanderbilt, ran a primitive train line on the east side of Manhattan as early as 1832. Eventually the Harlem Railroad built a utilitarian depot of the early "train barn" vintage at Forty-second Street near the site of today's Grand Central. In 1871 Grand Central Depot replaced the primitive train barn on the same site; the new installation was a large Second Empire station that served four lines: the New York Central, the Hudson River Railroad, the New York and Harlem Railroad, and the New York and New Haven Railroad. But by the turn

of the century, fewer than thirty years later, it too was inadequate. Thus was born the idea behind Grand Central Terminal. The key factor to bear in mind is that both predecessor stations had their rail yards and rail approaches entirely aboveground.

In crowded Manhattan, trains aboveground had been a problem since that inaugural train line in 1832. The trains were a hazard and an inconvenience. At first the city had dealt with this problem by restricting the track locations. When Fourteenth Street marked the border of population density, trains had to stop there, and indeed the first trains traveled no farther south than Fourteenth Street. That is how the two predecessor stations ended up on Forty-second Street; at the time they were built, Forty-second Street marked the

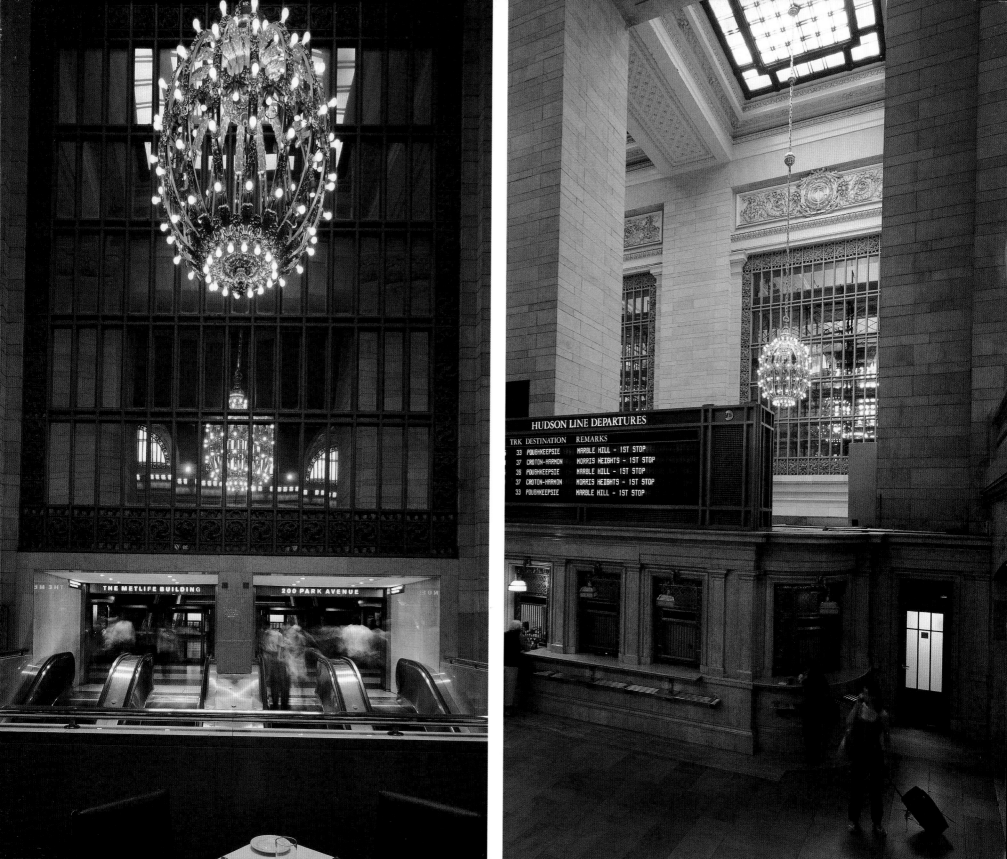

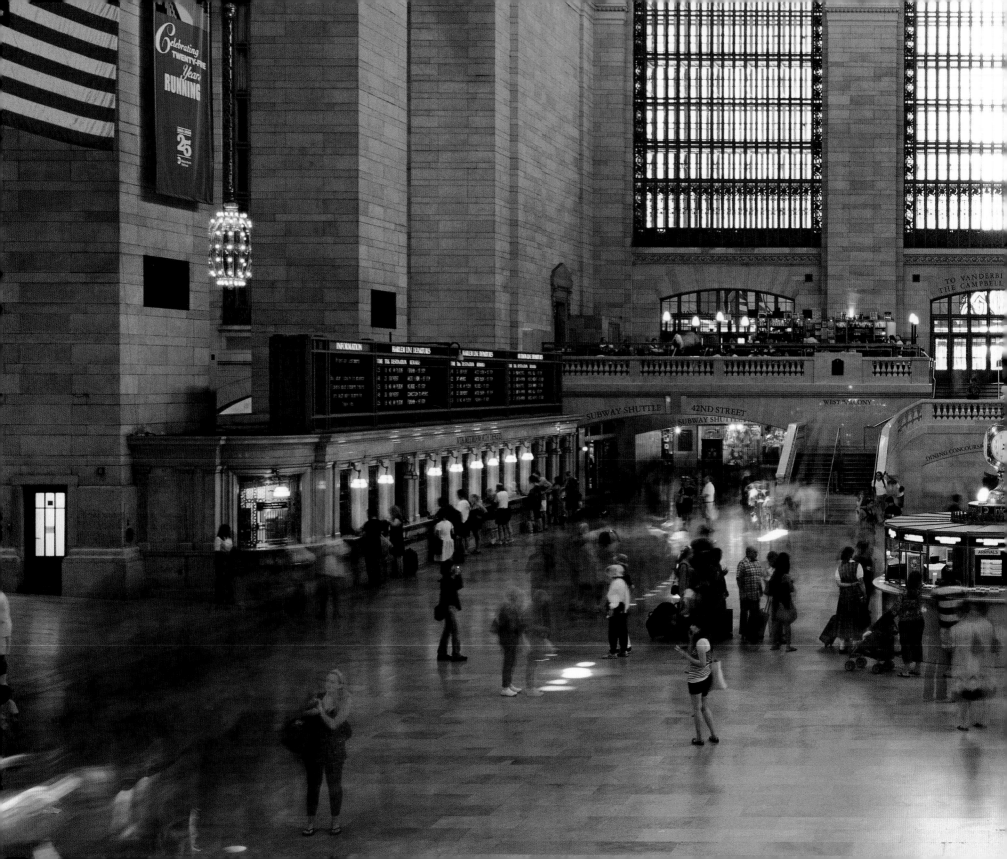

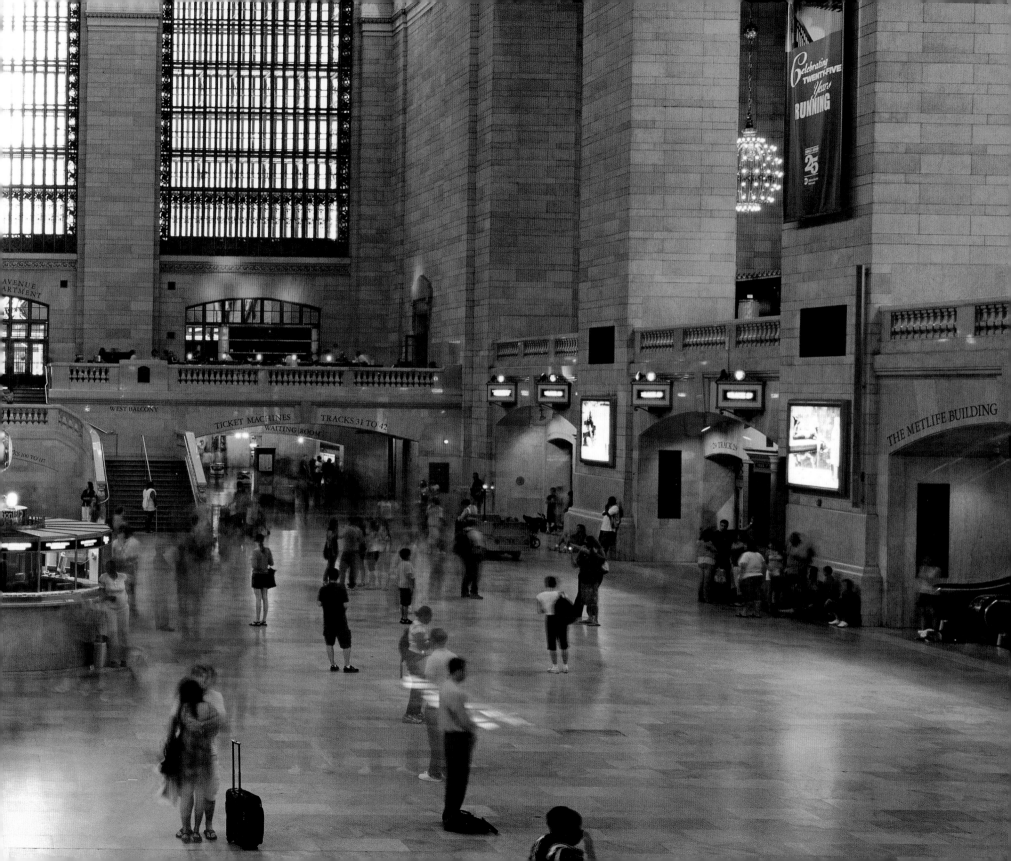

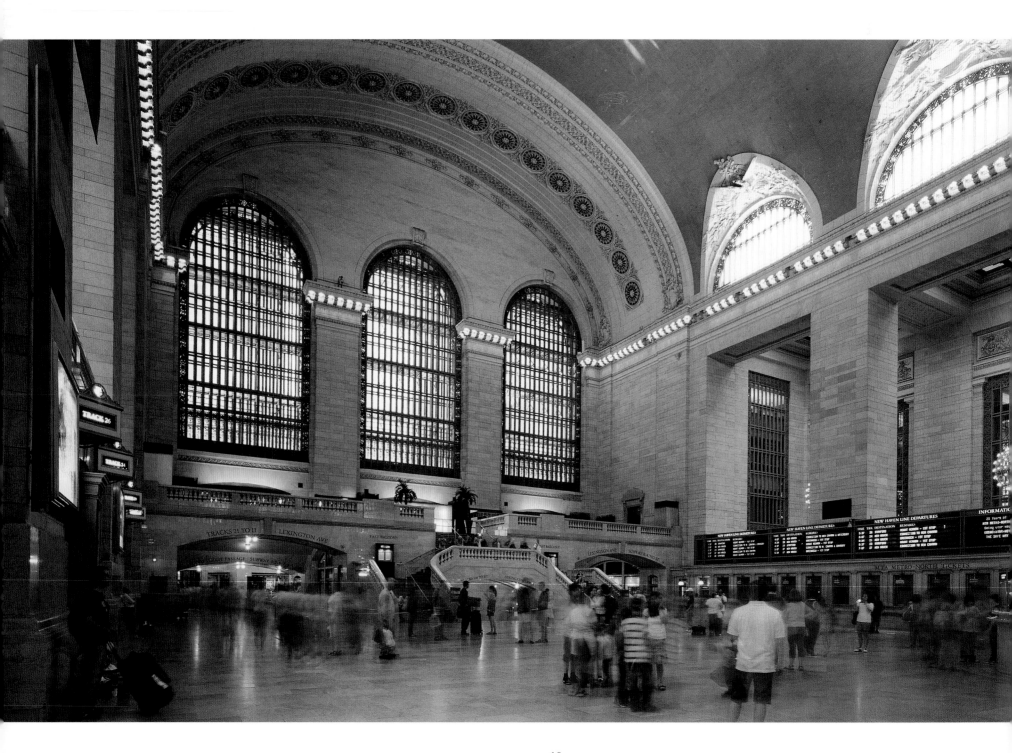

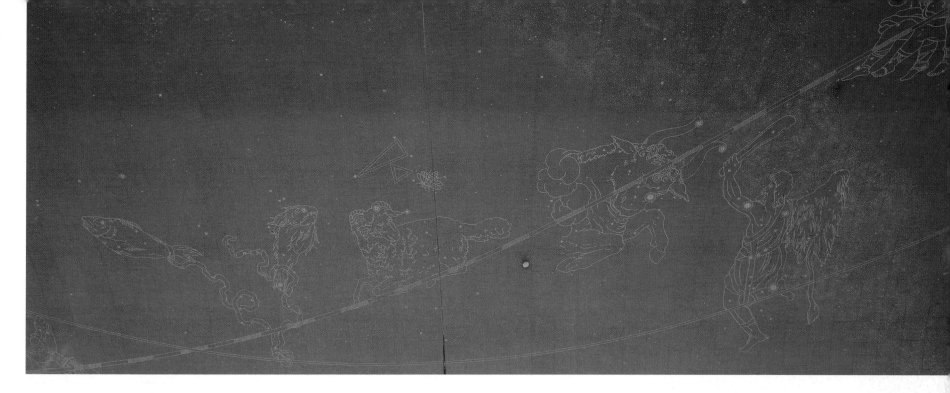

northern boundary of population density. By the turn of the century this was no longer the case. The wildly expanding city needed the real estate on which the rail yards and rail approaches stood. By this time Cornelius Vanderbilt's conglomerated giant, the New York Central, owned all the expensive real estate occupied by the rail yards and approaches. That's when Wilgus, chief engineer for the New York Central, decided to take his railroad underground. It was not easy: the excavation was second only to that required by the building of the Panama Canal, and there was a fiery crash in the tunnel and another on a curve in the suburbs that nearly derailed—literally—the plans to use electric locomotives. Yet, like the great engineer and true visionary he was, Wilgus stuck with the new technology whose future he believed in, and stepped-up engineering improvements proved him right.

The result was the largest railway station in the world by number of platforms—forty-four—servicing sixty-seven tracks.

All tracks are belowground, on two levels: the upper level holds forty-one, the lower twenty-six. If you count in the total number of tracks in the subterranean rail yards, there are more than one hundred. The terminal covers forty-eight acres, the equivalent of a good-sized farm. Note: there is no roundhouse, yet trains can turn around in three minutes. That's because Wilgus incorporated circular loops ringing the station belowground for this purpose. This was a good thing: in its busiest years, in the late 1940s, Grand Central accommodated 270 trains a day, just counting long-distance trains, not counting commuter trains. In 1947 Grand Central serviced more than sixty-five million passengers, or the equivalent then of 40 percent of the country's population. Every three to five minutes a long-distance train arrived. Yet another Wilgus innovation in Grand Central was the use of ramps throughout, prompting the *New York Times* to note that a person "on horseback could get almost anywhere." More important, ramps made the rapid movement of crowds

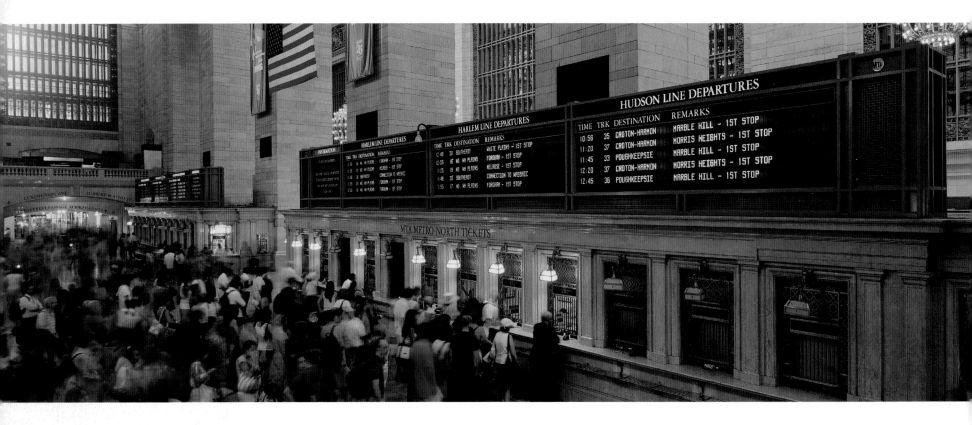

Above: The ticket counters at rush hour looking toward the southeastern corner of the Grand Concourse.

Opposite Page: The Grand Concourse looking west and showing in the middle ground the information kiosk topped by the four-faced opal clock valued at between 10 and 20 million dollars.

possible, whereas steps would have slowed their progress or impeded them entirely.

All things considered, Grand Central deserves its niche in the engineering pantheon.

ALL OF GRAND Central's brilliant engineering is crowned by one of the most beautiful Beaux Arts buildings in America. In 1903 the New York Central awarded the design of the terminal building to the St. Paul architectural firm of Reed and Stem, one of whose name partners, Charles A. Reed, was Wilgus's brother-in-law. When the New York architectural firm of Warren and Wetmore joined the effort—or muscled

their way in, depending on whose account is accurate—Charles Reed was appointed overall coordinator for the collaboration. Reed and Stem had responsibility for the overall design; Warren and Wetmore installed the architectural details and the Beaux Arts style.

Reed hired a young architect from Chicago, a graduate of the University of Illinois School of Architecture named Alfred T. Fellheimer, who took a Wilgus theme, the use of interior ramps, and extrapolated it to form an external "circumferential elevated driveway"—accessed and exited via ramps and a bridge across Forty-second Street—to route Park Avenue traffic around the station without splitting the avenue in two. This inspired architectural innovation, in combination with

Wilgus's ingenious depression of the rail yard and the rail lines, led to the rise of the integrated "city within a city" that came to be known as Terminal City, the area stretching slightly to the east and west of the station and to the north two and a half miles. Comprised of prestigious hotels, luxury apartment buildings, and office skyscrapers, Terminal City transformed midtown; moreover, because Terminal City was planned, uniform, and integrated stylistically, it embodied the concepts spelled out by Daniel Burnham in the City Beautiful movement. New York would wait another quarter century for a comparable development that combined so brilliantly the commercial and the aesthetic in architecture and city planning, when the uniformly built skyscrapers of Rockefeller Center soared above midtown in the late 1930s.

Whitney Warren of Warren and Wetmore oversaw the planning, development, and execution of Terminal City, which was fortuitous, so flawless was the result. He also commissioned the facade's prepossessing sculptural group, featuring Mercury flanked by Hercules and Minerva bracing an ornate clock. Towering above the colonnade, this five-story-high sculpture by Frenchman Jules Coulan dominates the facade and preserves the terminal's one remaining open vista from Park Avenue South. Warren's classical training at the École des Beaux-Arts in Paris, where Jules Coulan had been one of his teachers, came to the fore again on the spectacular interior, with equally triumphant results.

THE GRAND CONCOURSE is among the most beautiful interior public spaces in America. Flooded with sunlight from tall arched windows, boasting a cerulean blue ceiling decorated with starry constellations outlining astrological figures,

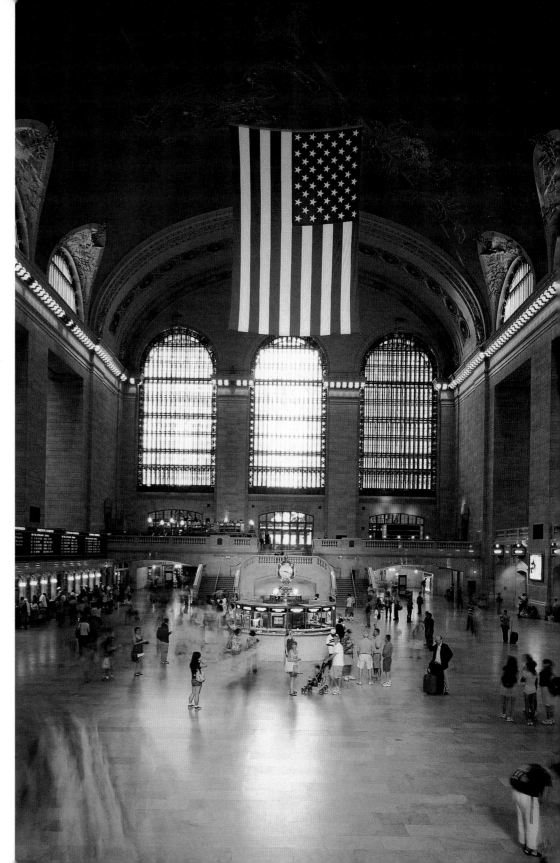

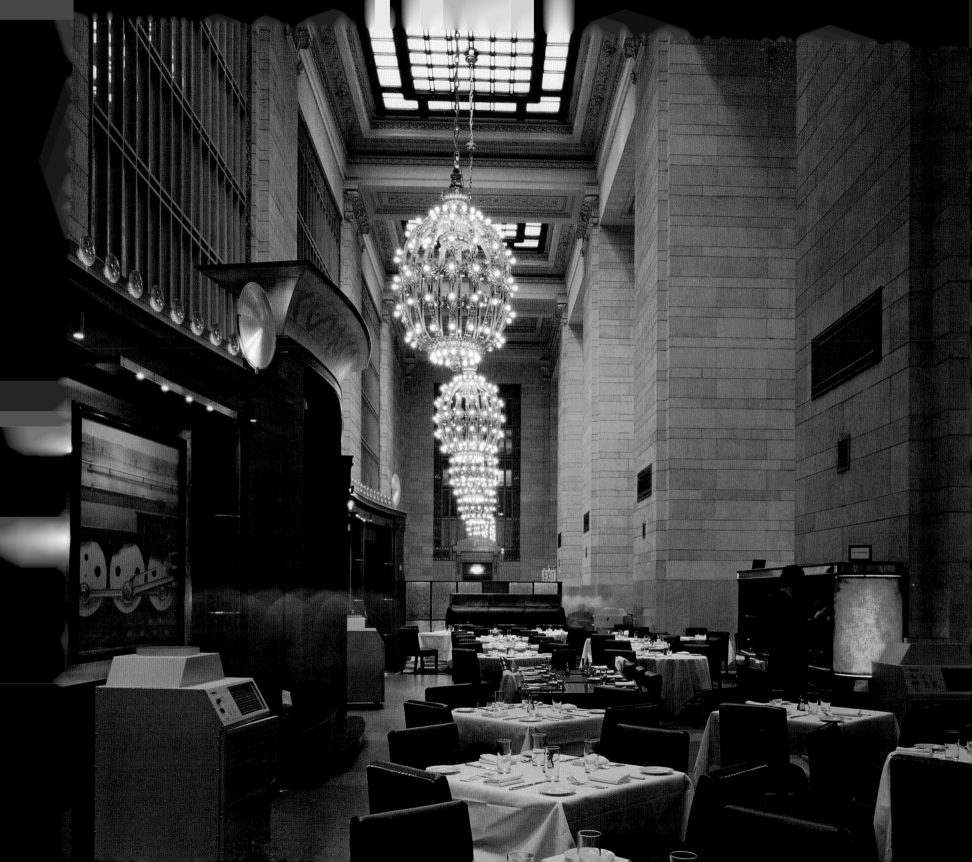

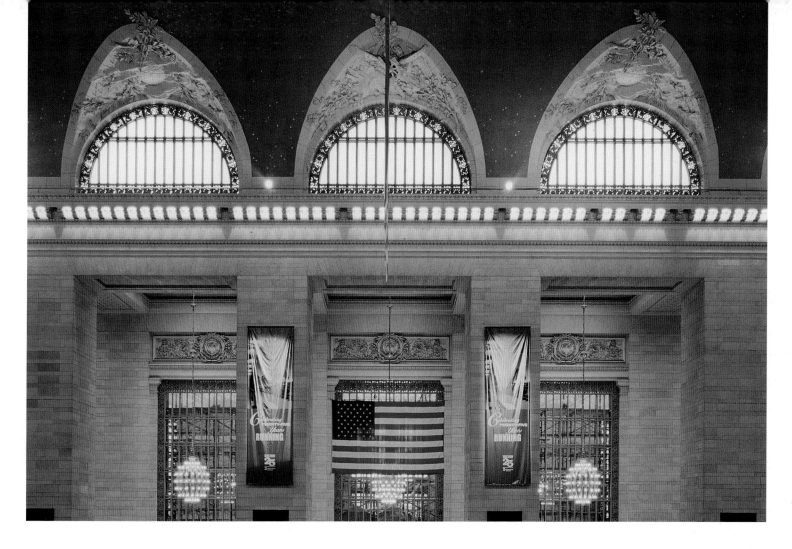

and bookended on two sides, east and west, by grand marble staircases—bifurcated and two-tiered, and based on those of the Paris Opéra—the grand concourse is impeccably serene and perfectly balanced. Designed to awe, reassure, and comfort any traveler, this magnificent room never fails to fulfill its mission. The approaches to the grand concourse are, in comparison, deliberately confined, so that upon reaching it one is overwhelmed immediately by its size and grandeur. The 125-foot-high ceiling arches over the sparkling floor of Tennessee marble while the light from the tall arched windows forms shafts that illuminate the towering columns of

the walls and highlight the beauty of the twin marble staircases. The gold-plated clock atop the information kiosk in the center of the room has opal facings on all four sides; Christie's and Sotheby's have appraised its worth between ten and twenty million dollars.

Every bit as much as a great gothic cathedral does, Grand Central Terminal emphasizes the spiritual quest and vaulting ambition of humankind. Among the most beautiful train stations in the world, it had no rival in America once McKim, Mead, and White's Pennsylvania Station, a fifteen-minute walk away, suffered the depredations of the wrecker's ball.

Opposite Page: The restaurant on the western balcony.

Above: The south wall and ceiling of the Grand Concourse showing the clerestory windows to full advantage above the middle passageway that leads to Vanderbilt Hall.

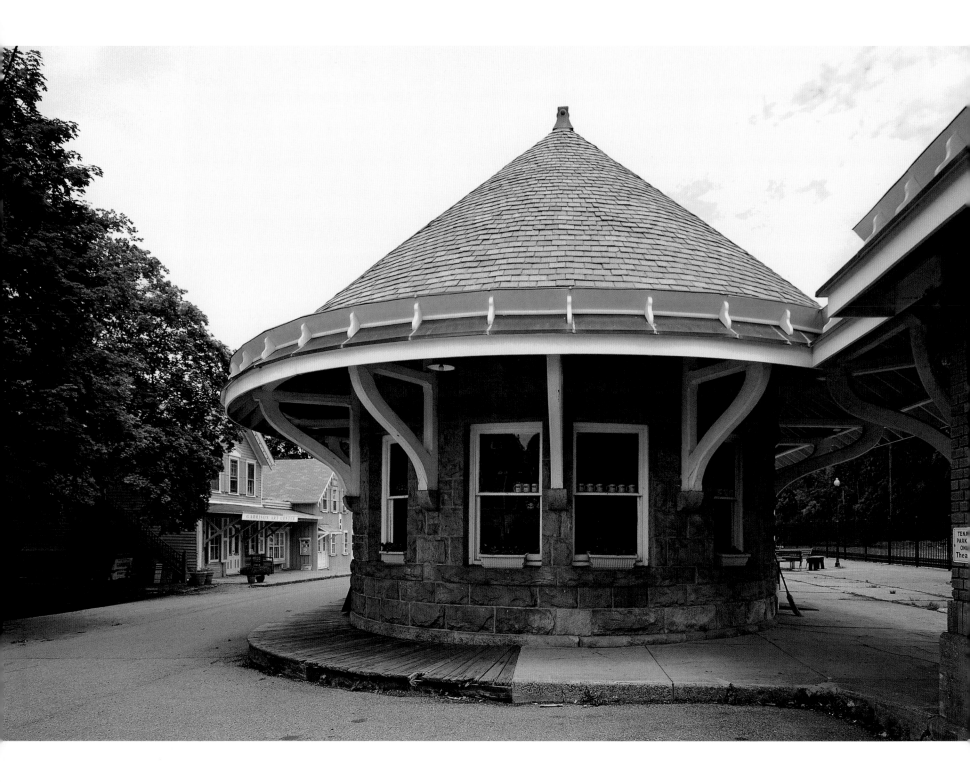

THE RIVER STATIONS

GARRISON STATION

T *he Garrison railroad station is deceptive, but offers several hidden opportunities. Built right after the turn of the twentieth century, it affords a glimpse into what a really small station was like along the crowded rail corridor between New York City and Albany in the great days of train travel in this country.*

A round-trip ticket to Garrison on the Metro North trains is inexpensive, and the trains run with wonderful frequency and clockwork efficiency. For the price of two movie tickets you can marvel at one of the most scenic routes in America for one hour up and one hour back. When you arrive at Garrison, there in front of you will be a classically charming station built in the very early years of the twentieth century, small, self-contained, and hewn from Barre, Vermont, granite, light gray and flawless.

The station's exterior is enhanced by solid touches in its construction such as scrolled and hand-hewn wooden brackets supporting the eaves and the canopy above the old and no longer used ground-level passenger platform. Windows and windowed doors are also plentiful and well placed. The architect thought of every method to light the

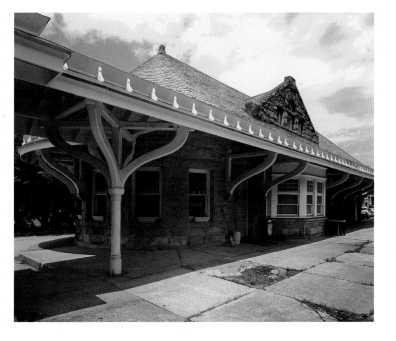

Opposite Page: The rounded southern end of Garrison Station showcasing its granite solidity and its Arts and Crafts lyricism.

Left: The trackside of the station with the three-directional bay window for the stationmaster's office beneath the trio of pedimented dormer windows.

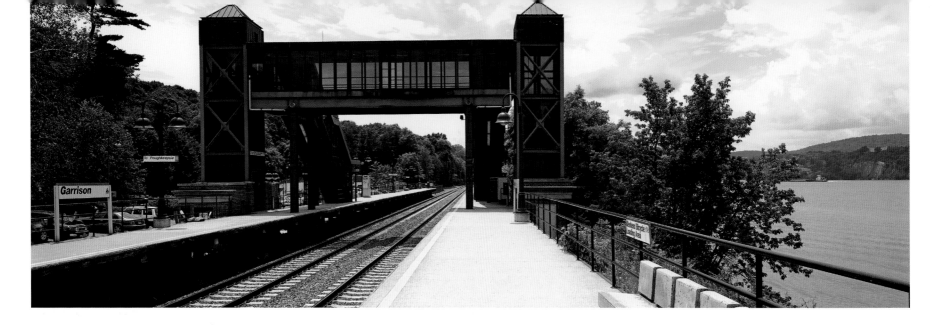

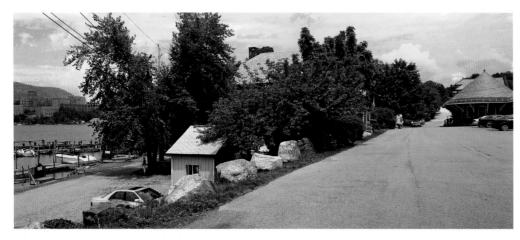

building well using natural light—always an important consideration in a stone building.

Unless you've purchased show tickets, you won't be able to visit the station's interior. As a big sign hanging from the eaves will inform you, the old station is now the home of the Philipstown Depot Theatre. On a nippy night it must be snug and delightful. In its quiet way Garrison Station represents substantial Americana brilliantly recycled as today's small and quaint repertory theater.

Top: The modern station with its raised platform and its elevated crossway, facing south, with the Hudson River in the background.

Above: The Garrison Yacht Club a hundred yards south of the old station with the buildings of West Point visible across the river looking north.

Right: The houses of the town lining the tracks leading north from the station.

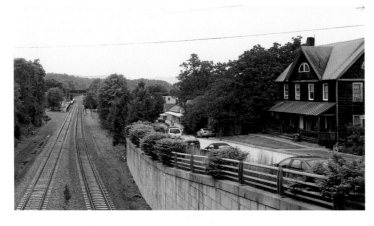

BEFORE LEAVING, WALK along the station's river side a hundred yards south to the front of the Garrison Yacht Club. Look across and slightly upriver. There loom the spires and crenellated walls of West Point, built on the most beautiful outcropping of land, on the most scenic bend, of the justly fabled Hudson. Imagine Ulysses S. Grant, Robert E. Lee, Douglas MacArthur, George S. Patton, Omar Bradley, and Dwight David Eisenhower gazing across the river at Garrison, and you'll realize just how luckily, and historically, this little town and its vintage station are sited.

HYDE PARK STATION

Small though it is, Hyde Park Station is redolent of history in every brick, board, stone, and tile. Merely one story tall with a pitched Mediterranean tile roof and covering only about fifteen hundred square feet in total, this Spanish mission revival building is significant and charming. This is true not simply because Presidents Franklin Roosevelt and Harry Truman, as well as other historical world figures, have passed through its waiting rooms.

Hyde Park Station's magic results principally from the loving care and preservation showered on it by the townspeople of Hyde Park and by the members of the Hudson Valley Railroad Society. Together they have managed to decorate the waiting room with authentic period furniture and other accoutrements, to replicate a vintage station manager's office in one corner of it, and to install in the old baggage room enlightening displays of text and photos about local and national railroad history. In addition, in the baggage room's loft, they have set up a model HO train display to cheer the heart of any railroad buff or fan, age eight to eighty-eight. The HO platform takes up the entire

Below: The north wall of the station showing the original marble drinking fountain above the original radiator and flanked by the original oak doors of the restrooms with their period lettering.

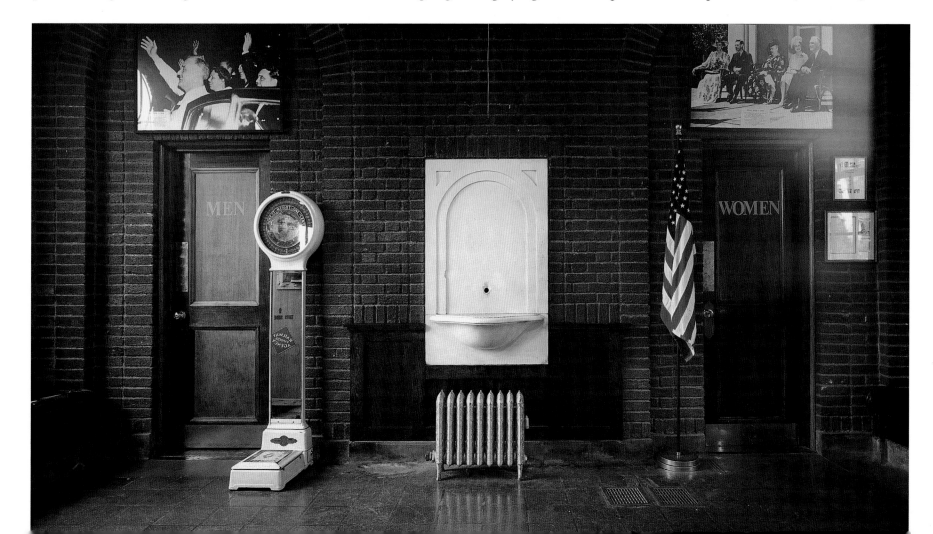

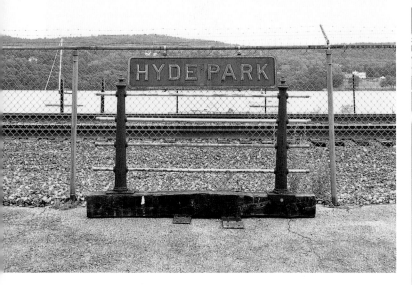

Top: Panoramic view of the station with the Hudson River in the background.

Above: The original station sign trackside behind the station.

Right: An authentic stationmaster's desk in the restored stationmaster's office.

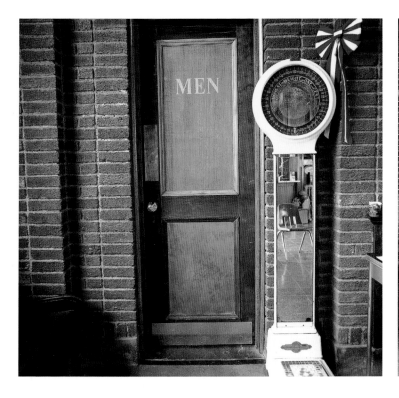

Far Left: A vintage porcelain and mirrored human scale manufactured by the Peerless Weighing Machine Company of Detroit.

Left: Period milk canisters and a baggage wagon outside the rear entrance to the baggage room.

loft, a considerable space of about three hundred square feet, and contains a comprehensive replica of the nearby town of Poughkeepsie from about 1940 or so. Downstairs in the baggage room itself, along with cases holding railroad tools and signals and lanterns, there is a scale-model nineteenth-century New York Central combination mail and passenger car, a model steam engine, and a few working miniature N-gauge train sets.

Today the station is purely a museum. Not a single train stops there. But from old schedules on display in the waiting room, it's clear how busy the station was in its prime, during the first forty years after it opened in 1914. In those days, before Amtrak passenger service and Metro North commuter service took over from the New York Central, the station was a busy stop for local trains between New York City and Albany.

Even before the New York Central was formed, Hyde Park had also been a stop on the earliest nineteenth-century train lines running between New York City and Albany. The 1914 station replaced a Victorian station that had opened circa 1851. That would have been the same year that rail service first reached Albany. From the fascinating displays of historical text and photos in the baggage room one learns that Matthew Vassar, the founder of the famous college in Poughkeepsie, started the first line to serve the Hudson Valley, the Hudson River Railroad. He began the line in New York City in 1847, and two years later it reached Poughkeepsie. Two years later still it reached Albany.

RHINECLIFF STATION

R hinecliff Station is emblematic of the architecturally distinguished stations built around the turn of the nineteenth century to service the small towns fronting the eastern bank of the Hudson River between New York City and Albany. Most of these stations were built at the instigation of the owners of the wealthy estates sited in or near the small river towns, often along the eastern bank of the river itself, with its spectacular views across the water of the

Palisades, the Hudson Highlands, and the Catskills, in ascending order on the western bank as one travels north.

The station opened in 1913 and was built by the New York Central Railroad. There were, in addition, two prominent residents of Rhinebeck instrumental in its construction. They were Levi P. Morton, who was the twenty-second vice president of the United States, under President Benjamin Harrison, and John Jacob Astor IV, who perished on the *Titanic* after displaying admirable character and courage.

Like the next station down the line at Hyde Park, Rhinecliff Station is an example of the Spanish mission revival style

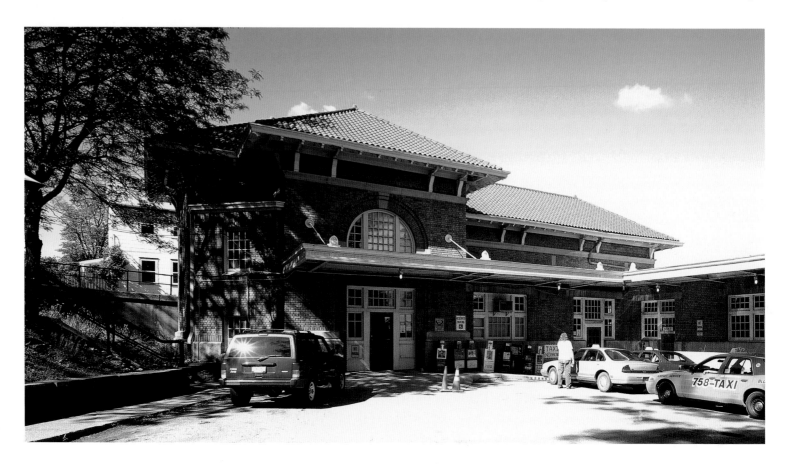

Right: The courtyard outside the main entrance to the station highlighting its Spanish mission revival features to great effect.

favored by the New York Central for its medium and small stations along the Hudson in that era. It is built into a hillside above the old docks where the ferry used to shuttle between Rhinecliff and Kingston, directly across the river. In the nineteenth century, Kingston was the busiest port between New York City and Albany. The hamlet of Rhinecliff lies a short distance down the embankment from the town of Rhinebeck proper. Like many of the buildings in Rhinecliff, including the elegant Morton Library, the station is a prominent component of the Hudson River Historic District.

For children and rail buffs, easily reachable nearby are the Trolley Museum of New York, the Empire State Railway Museum, and the Catskill Mountain Railroad.

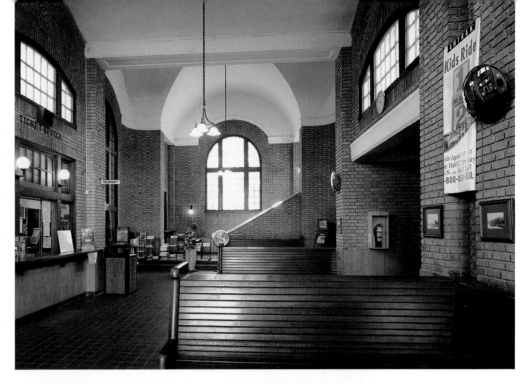

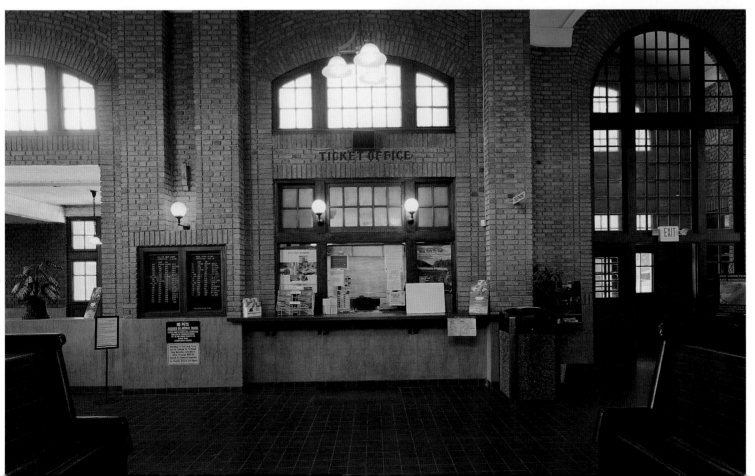

Above: The main waiting room showing the handsome oak settees and the arched alcove and staircase at the eastern end.

Left: The ticket office in the center flanked by the main entrance on the right and the corridor leading to the tracks on the left.

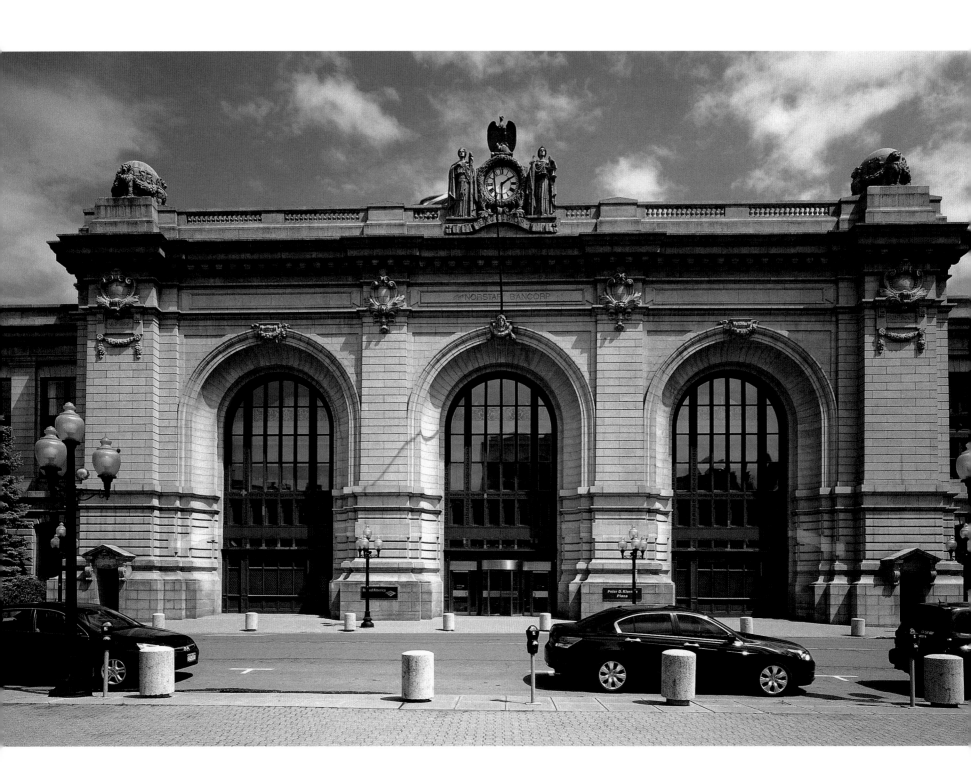

3

ALBANY UNION STATION

*A*lbany Union Station takes your breath away. From afar its peerless Beaux Arts exterior boldly declares *its monumentality, and the closer you draw to it, its scale, its symmetry, and its startling attention to detail reinforce that impression. The exterior of the building shows what the American Beaux Arts style could achieve when executed with restraint. None of the perfection of the Renaissance influence—itself predicated on*

classical Greek and Roman models—was sacrificed to an impulse to the baroque, let alone to the rococo. Decoration and statuary are used sparingly and therefore achieve the proper impact. The front and back facades are pleasingly balanced and forcefully plain, despite their decorative flourishes. Each is composed of rusticated granite with handsome quoins at either end, and they are identical except for the ornate clock and statuary on the front. The spectacular interior sustains the themes of tasteful balance and unstinting attention to detail.

It's not an accident that Albany Union Station is so superb. The architectural firm Shepley, Rutan, and Coolidge designed it. This Boston firm carried on the tradition of Henry Hobson Richardson, one of the earliest Americans to study at the École des Beaux-Arts in Paris. Richardson applied Beaux Arts

lessons to the sturdier traditions of classical Rome and evolved a highly individual style called Richardsonian Romanesque.

When you take into account that in the late seventies there were trees growing on the roof of Union Station and that scavengers had stripped the building of all its salvageable parts like copper tubing and roofing, you know the restoration had a hero, a prime mover.

In this instance it was the president of Norstar Bank, a local Albany boy and World War II veteran named Peter D. Kiernan. From 1986 to 1988 he spent $14.5 million of the bank's money to restore the station to its former glory so that it could serve as the corporate headquarters for Norstar Bancorp, at the time a member of the Fortune 500.

Upon completion of the renovation, the building won awards and certificates from many organizations, prominent

Opposite Page: The stately facade of Albany Union Station in copious summer sunlight with wispy clouds above.

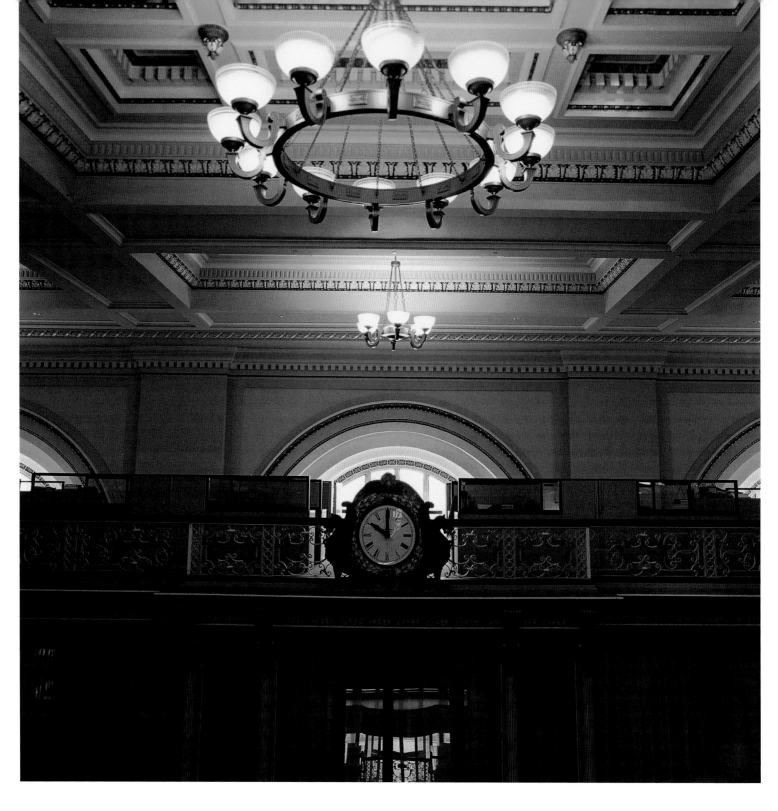

Right: The gallery above the main waiting room showing the filigreed clock, the recessed panels and coffers of the ceiling, and, in the background, the tops of the tall arched windows of the back facade.

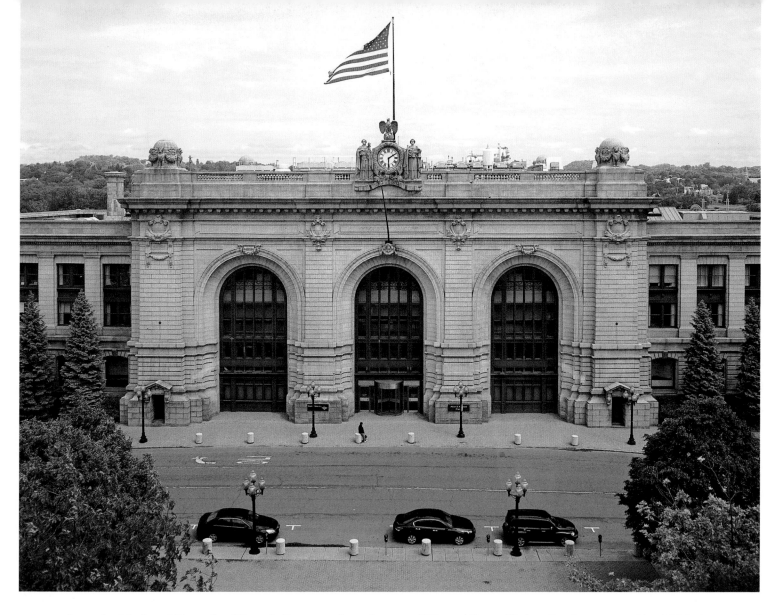

among them the National Trust for Historic Preservation, the American Consulting Engineers Council, and the New York State Association of Architects. The 1988 renovation led to the revival of the downtown area of Albany, which, in concert with Governor Nelson Rockefeller's erection of the famed South Mall, revitalized and transformed the entire city, as well as the nearby cities of Troy and Schenectady that compose the tri-city complex.

When Albany Union Station opened in 1900, it received 96 trains per day, and during World War II it accommodated 121 trains per day. Because trains going west from the station had to climb a steep hill, the fabled *Twentieth Century Limited*, due to its length, needed a boost from an auxiliary diesel.

Albany Union Station closed on December 29, 1968, when the last train pulled out.

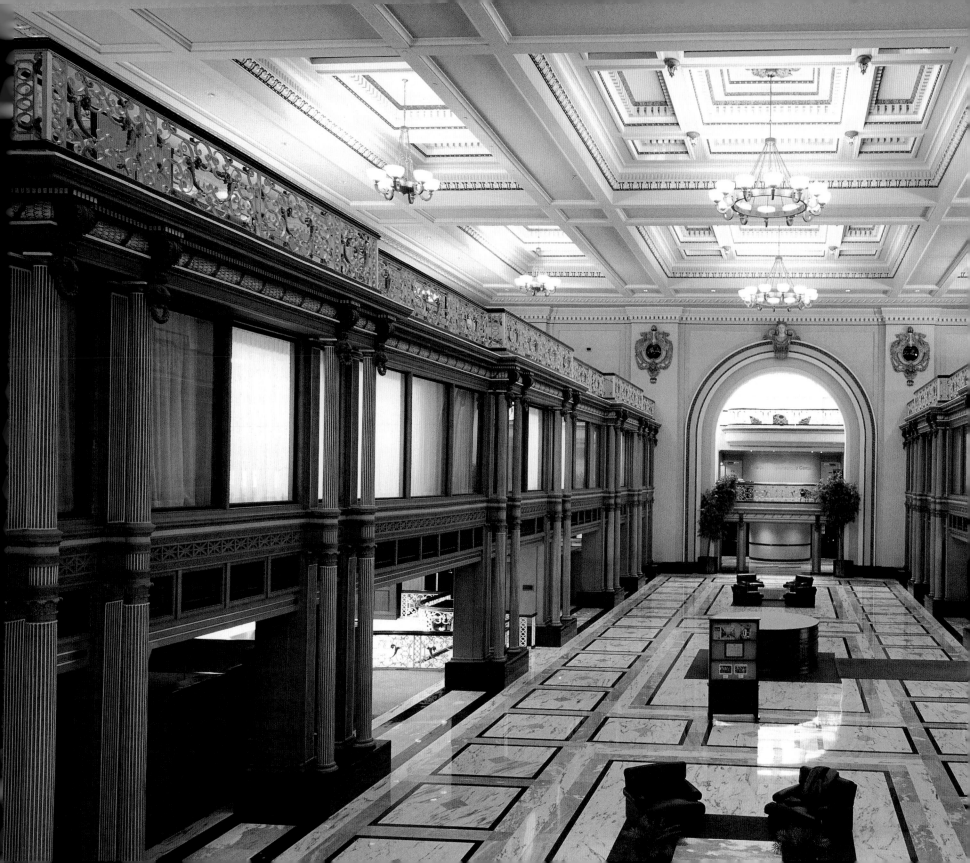

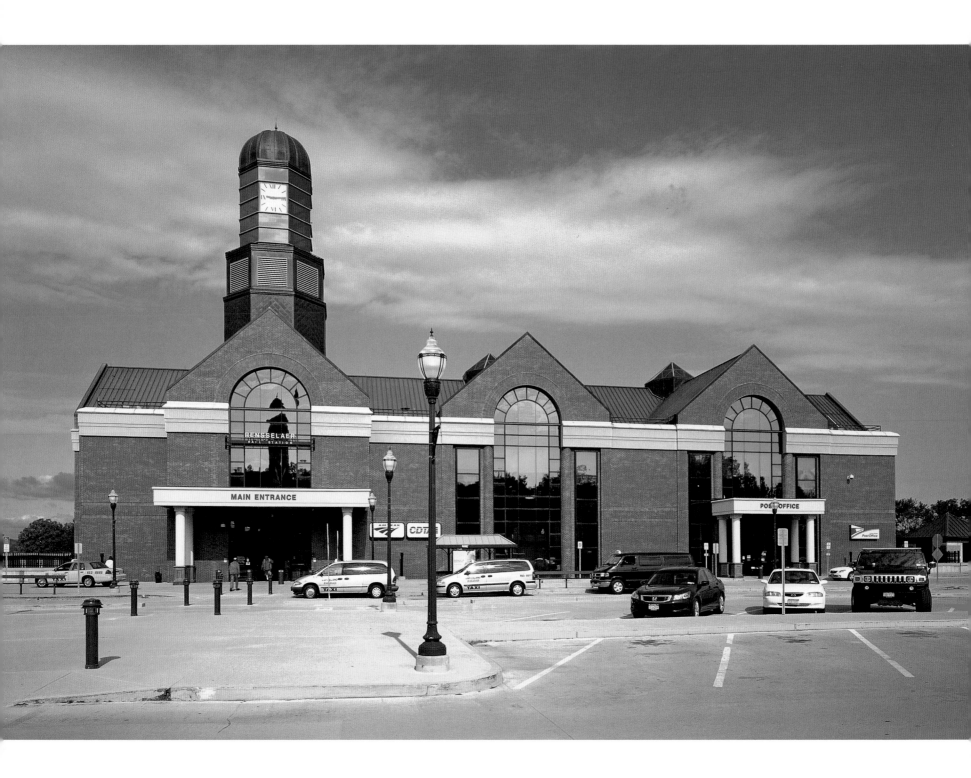

ALBANY-RENSSELAER STATION

The new Albany-Rensselaer Station is included in this book not because it is one of America's great railway stations but because it illustrates a measured response to the reduced circumstances railroads—and the municipal, state, and federal governments charged with subsidizing and running them—find themselves in today. Many people feel that the railroads were unmatched in the power and wealth they wielded in America

for about a hundred and ten years, roughly from 1835 to 1945. The stations built during that era, especially during its last seventy-five years, cannot, for economic reasons, be equaled today. That said, Albany-Rensselaer Station, though a workable solution to a mass transit need, is, as architecture, a soufflé that simply fails to rise.

When Albany Union Station closed at the end of 1968, passenger trains servicing Albany had to stop instead across the Hudson River in Rensselaer at a one-story rectangular pillbox that had no more distinction than a large gas station or the anchor store in a strip mall. It was bare-bones utilitarian but managed to serve Albany and the tri-city community for the next thirty-four years, until the present three-story Albany-Rensselaer Station opened adjacent to it on September 23, 2002. Amtrak now uses the old pillbox as offices.

Opposite Page: A sweeping view of the front facade of Albany-Rensselaer Station

Left: Looking southeast at the back of the station from the glass-enclosed passageway that leads down to the track platforms.

Though only about a mile and a half from old Union Station, the new station is light-years removed both in stature and grandeur.

One great benefit of the new station is that it eliminated the need for the trains to climb the steep hill that led out of downtown Albany. That hill necessitated the use of auxiliary diesels by westward-bound trains from the old Union Station. With typical urban planning foresight, Governor Rockefeller linked the location of the new station to his network of superhighways ringing the city. That means the new station is but five minutes by car from the old station and therefore super convenient to downtown Albany.

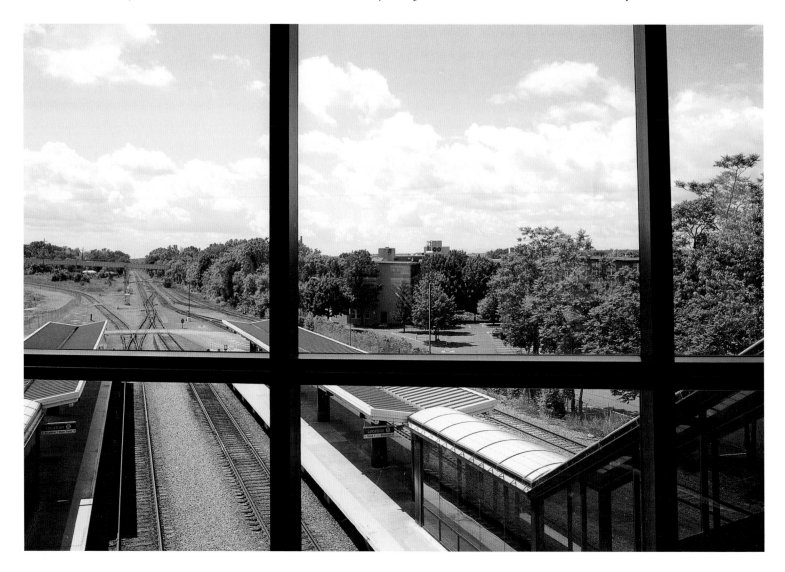

Right: A view of the tracks and the butterfly canopies on the platforms from the glass-enclosed passageway that leads down to the platforms via covered escalators.

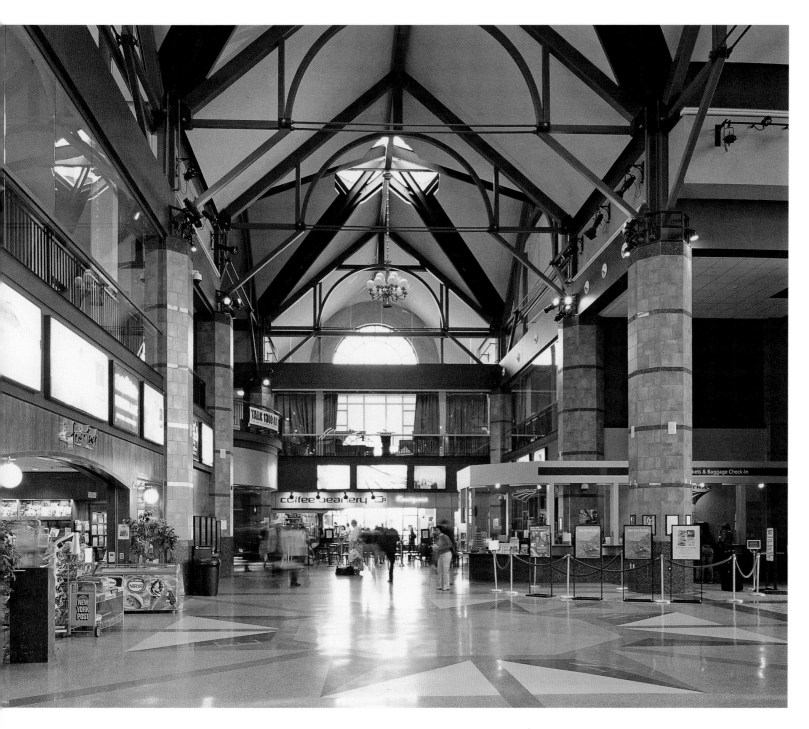

Left: The Main Waiting Room and lobby with its arched window and its trussed cathedral ceiling, terrazzo floor, and marble-clad columns.

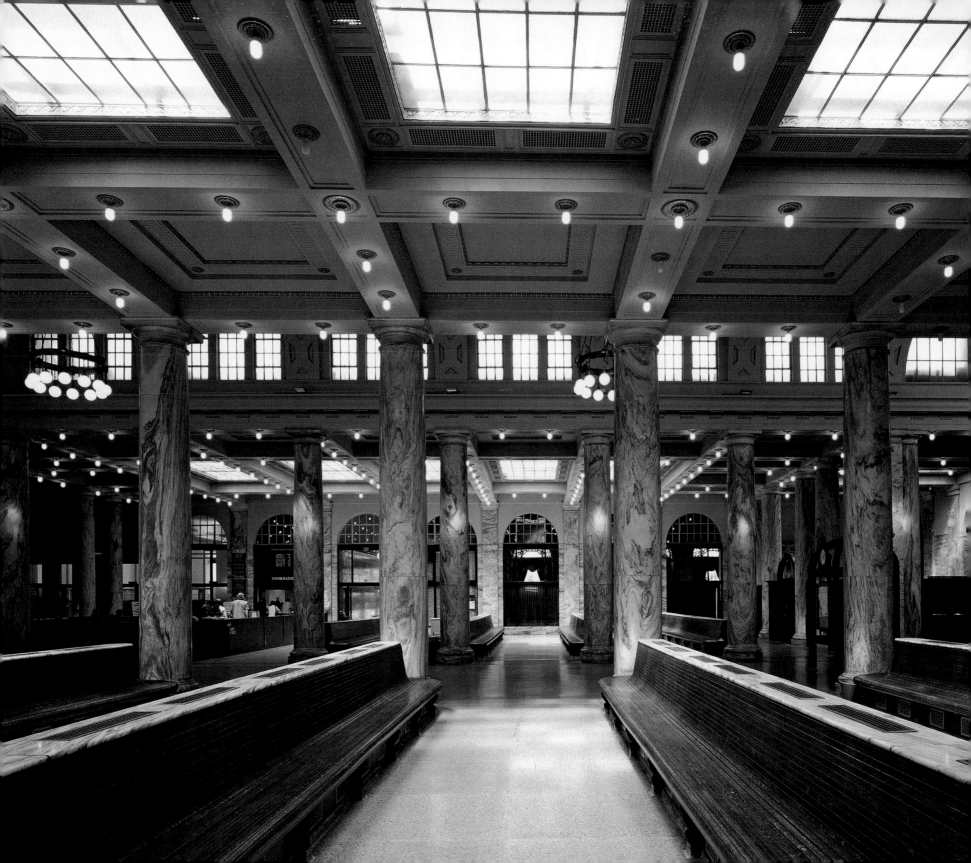

UTICA UNION STATION

Utica Union Station is a study in relaxed grandeur. Scaled down, it is a pocket version of Manhattan's flagship Grand Central Terminal, the jewel in the crown of the New York Central system in its heyday. That makes Utica Union Station its bijou. The moment you enter the station you are aware that you're in the presence of exquisite taste in the execution of a serviceable public building.

Situated a block south of the Mohawk River and a block north of the site of the colonial Fort Schuyler (built in 1760), Union Station from its opening in 1914 until the late 1950s was the city of Utica's front entrance. The two main arteries of the city, Genesee Street and Main Street, flow directly south from the station and lead to the revitalized downtown. The rest of the city spirals out from the station to the southeast and the southwest. From before the Revolutionary War, Utica was a major hub of transportation and the gateway to the Adirondacks, vital for stagecoach travel. In 1797 the state legislature appropriated money to build the Genesee Road starting in Utica, and three years later the legislature converted it to the Seneca Turnpike, a toll road. Prior to the building of Union Station, Utica had two previous rail stations, the first serving from 1836 to 1869 and the second from 1869 to 1912.

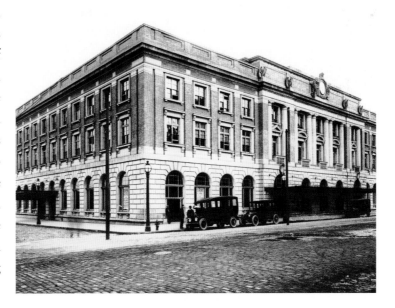

Opposite Page: The Main Waiting Room of Utica Union Station with its large oak settees, paneled and sky-lighted ceiling, marble-clad columns and walls, and terrazzo floor.

Left: Vintage photo of Utica Union Station shortly after it opened in 1914.

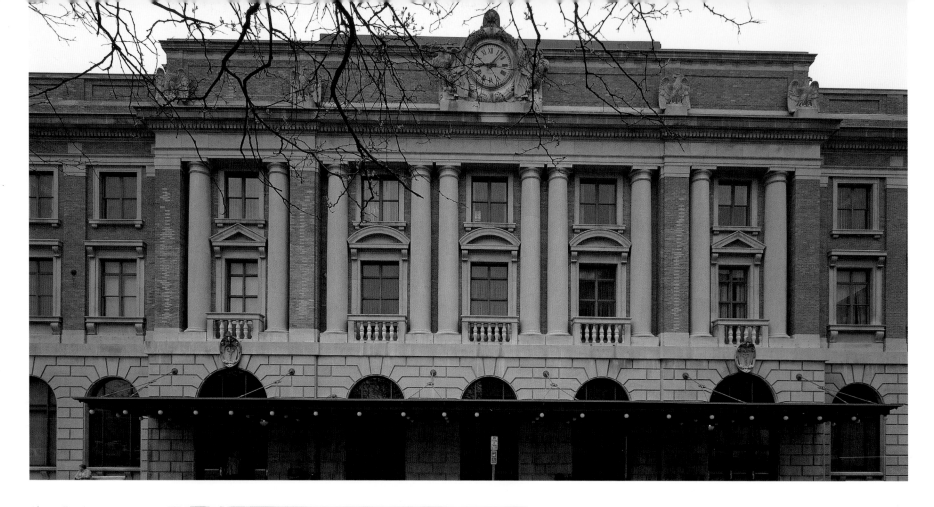

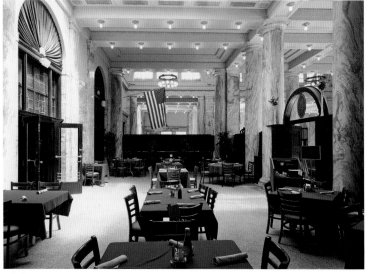

Above: The front facade showing the rusticated limestone footing, the beautifully spaced colonnade, and the wreathed clock and spread-winged limestone eagles of the parapet.

Right: The renovated restaurant adjacent to the lobby.

The building of Union Station was the focus of massive civic pride when it was undertaken in 1912. Construction lasted two years and the final price tag was a hefty one million 1914 dollars. The city spent sixty thousand dollars alone on the marble that renders the interior spectacular to the eye and comforting to the sensibility. As tasteful and robust as the exterior is, it does not prepare you for the interior; immediately upon entering the main waiting room, you'll pick up the theme of Renaissance splendor again. The two-story columns clad in light and dark gray marble above a white-and-green-speckled terrazzo floor catch the eye instantly. Light splashes in everywhere.

The massive renovation and restoration undertaken in 1978 reflected the reduced passenger traffic the station serves

today, and showed good civic planning to underwrite the cost of maintaining such a magnificent building by augmenting its usefulness. Besides locating local government offices within the bays lining the lobby, city planners also made the station a hub for local and long-distance buses, and the old diner was repurposed as a restaurant replete with event rooms.

Also in keeping with the city's role as a transportation hub, the corridor leading to the train tracks was modernized and an addition added, including a glass-enclosed pedestrian overpass to the refurbished and covered track platforms themselves. Reflecting Utica's reputation as a gateway to the Adirondacks, the Adirondack Scenic Railroad runs excursions from the station and maintains a ticket office in the lobby. This rail service is in addition to the Amtrak trains using the station several times a day. In a nice nod to history, the station displays a vintage nineteenth-century engine and coal tender on a siding next to the main tracks. There is also a children's museum adjacent to the station.

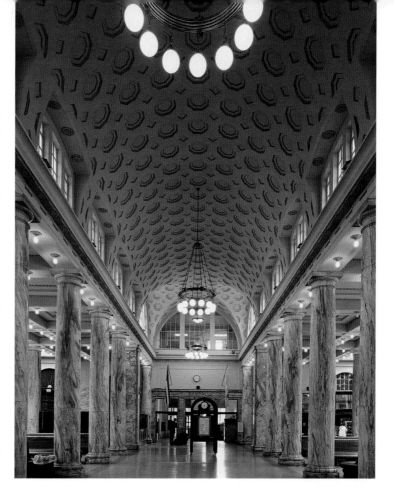

Left: The barrel-vaulted and coffered ceiling running down the center of the main waiting room with its beautiful clerestory windows adds welcome light and airiness to a spectacular interior.

Below: An antique steam engine and coal tender on a siding behind the station trackside.

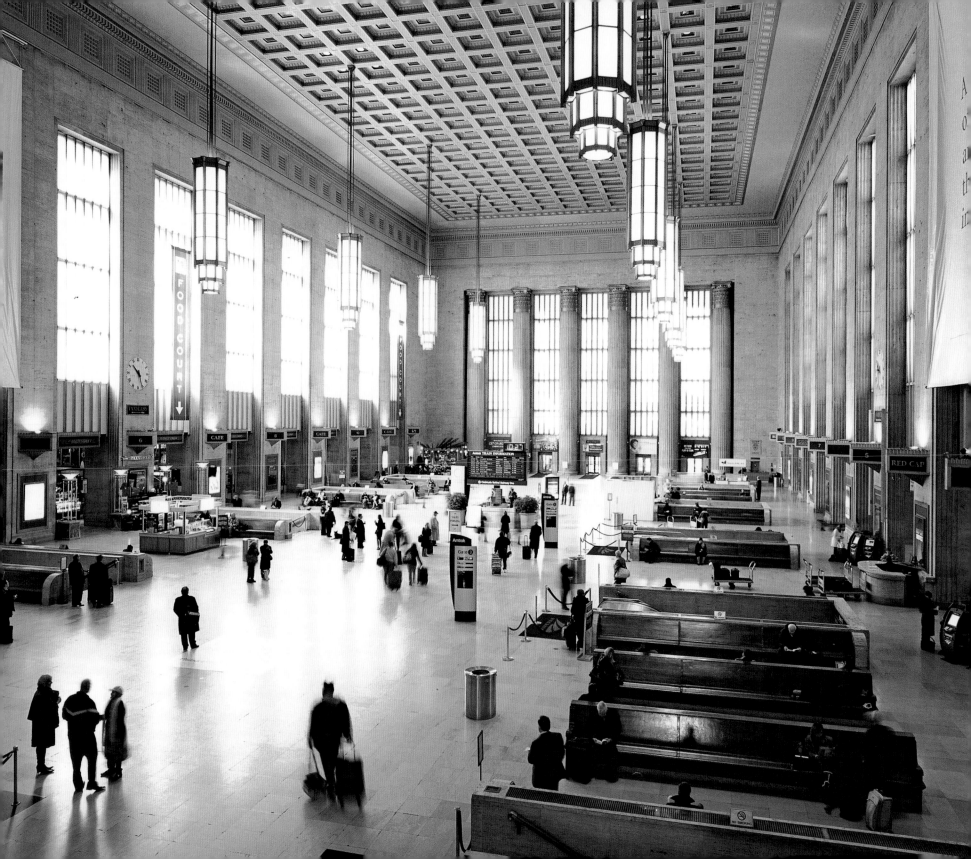

PHILADELPHIA 30TH STREET STATION

3 0th Street Station is the principal railroad station in Philadelphia. It opened in the depths of the Great Depression in 1933 and represents yet another architectural gem built by the Pennsylvania Railroad in its glory days. The Chicago firm of Graham, Anderson, Probst, and White designed the structure, a happy combination on the outside of the neoclassical and on the inside of art deco.

Two perfectly proportioned wings flank the taller central section that houses the main passenger reception hall. Large, high ceilinged, and flooded with light, the main hall features tall rectangular windows on three sides that perfectly echo the rectilinear vigor of the two rows of large golden art deco chandeliers arrayed down the length of the hall in two rows of five each. The white marble floor blends perfectly with the travertine walls, enhancing the sense of grandeur without being grandiose. The brightly painted coffered ceiling and the colorful frieze around the tops of the walls, featuring subtle plaster moldings, complement the white and beige tones of the interior.

The station marked a great advance in urban planning when it opened. It replaced the smaller and older Broad Street Station that had depended on a raised causeway housing several tracks that cut right through the heart of the city's downtown, making expansion of the business district impossible. Called the "Chinese Wall," this unsightly causeway was essential because Broad Street Station was a stub-end terminal from which through trains had to back in and out noisily, showering smoke and soot along the causeway's mile length. 30th Street Station was built above the main through tracks of the Northeast corridor right after electrification of the tracks made this subterranean arrangement possible. In earlier times steam engines would have exposed the passengers to soot and cinders. The new station also had other modern touches like a pneumatic tube system, an electronic intercom, and a reinforced roof with space to permit small aircraft to land. Remember, this was the age of streamlining.

Opposite Page: The main hall and waiting room of 30th Street Station showing the neoclassical Beaux Arts elements mixed with the art deco accessories like the chandeliers and the track marquees.

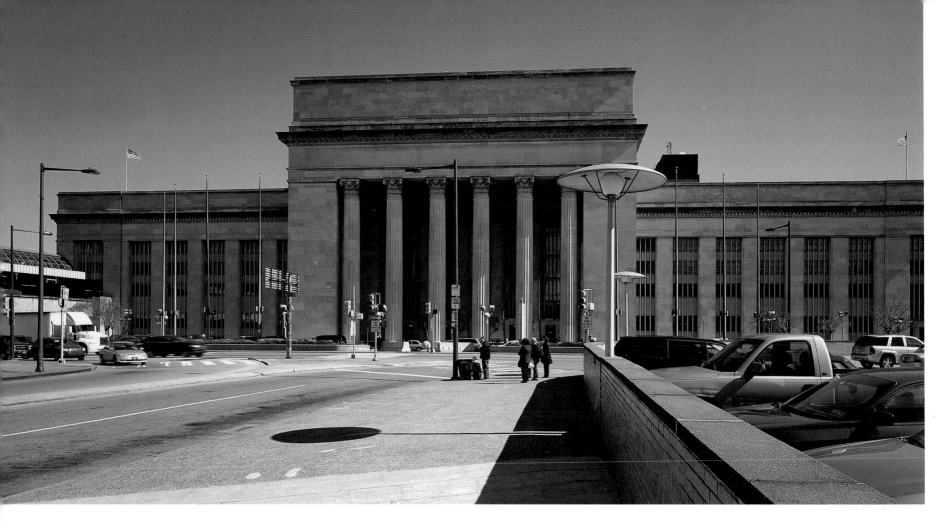

Above: The eastern facade showing the colonnaded portico and the symmetrical recessed wings.

The new station was also perfectly situated to service the downtown business district and the expanding academic community, now called University City, that houses the University of Pennsylvania and Drexel University. The main entrance to the west adjoins both campuses while the main entrance to the east faces Center City and provides access to it within minutes by taxi, bus, or subterranean trolley. Each entrance has a covered portico supported by two rows of six limestone Corinthian columns. 30th Street Station was also built to assume all the commuter rail responsibilities of the old Broad Street Station, and it features subterranean tracks. Just as the suburban commuter trains spiral out of the station, so too do all forms of local transportation, including bus and subway lines.

The southern wing of the station has been modernized with bookstores, coffee shops, car rental offices, a food court, and gift shops. The northern wing houses the ticket office, the Amtrak office, and the entrance to the suburban train platforms.

In one small lobby there is a bas-relief sculpture transported from the old Broad Street Station. Titled *The Spirit of Transportation*, this piece by Karl Bitter represents the triumphal procession of modes of transport from covered wagons to a child holding a model of an airplane, visionary for a work executed in 1895.

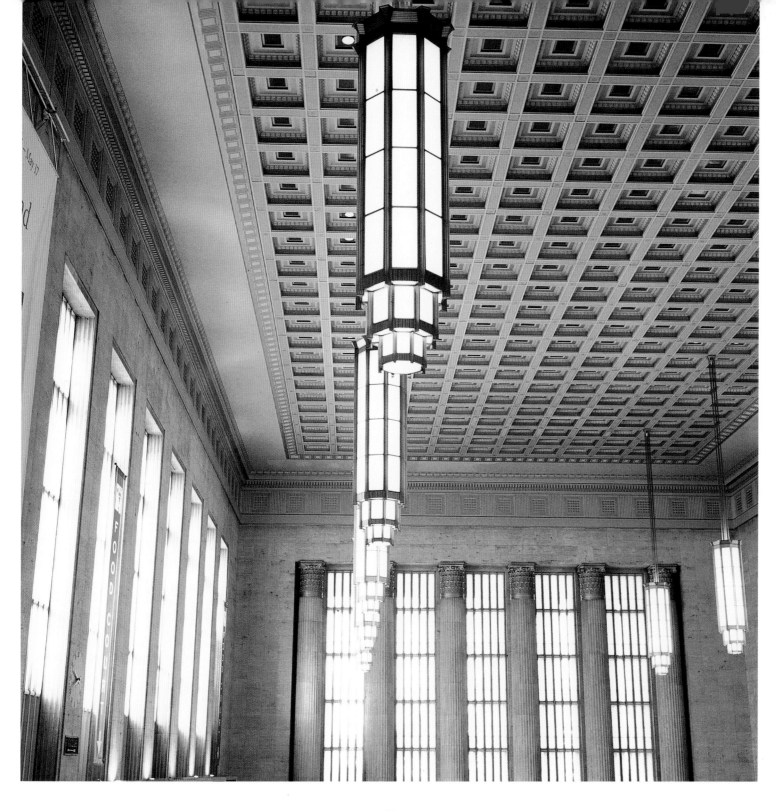

Left: The austerity of the Beaux Arts neoclassical cleanness of line complements the streamlined art deco chandeliers and the tall rectilinear windows.

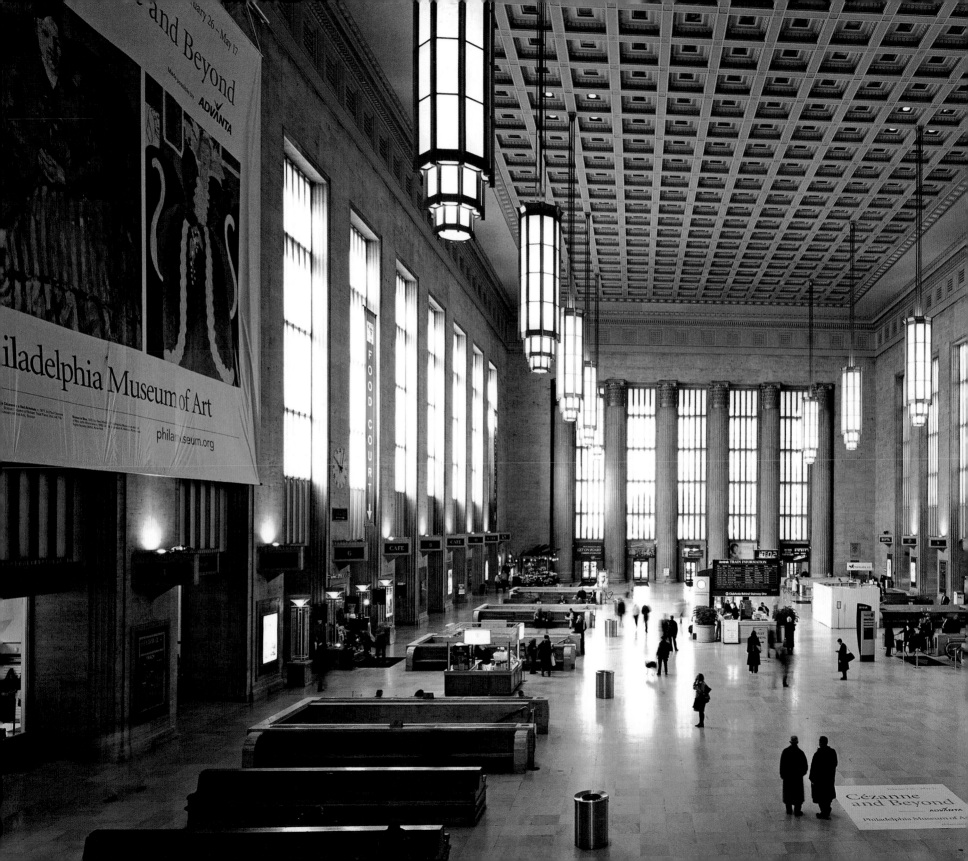

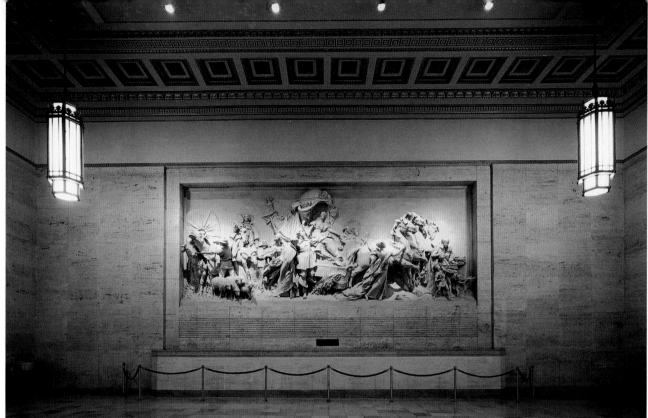

Far Left: The World War II memorial to employees of the Pennsylvania Railroad who died in the service of their country.

Above: The Spirit of Transportation sculpture by Karl Bitter that originally graced the old Broad Street Station, 30th Street Station's predecessor.

Left: One of the main doors under the colonnaded porticos showing its rectilinear limestone framing.

Opposite Page: This sweeping lengthwise view of the main hall and waiting room taken from the eastern balcony underscores the imposing scale and relentless spareness of this magnificent room.

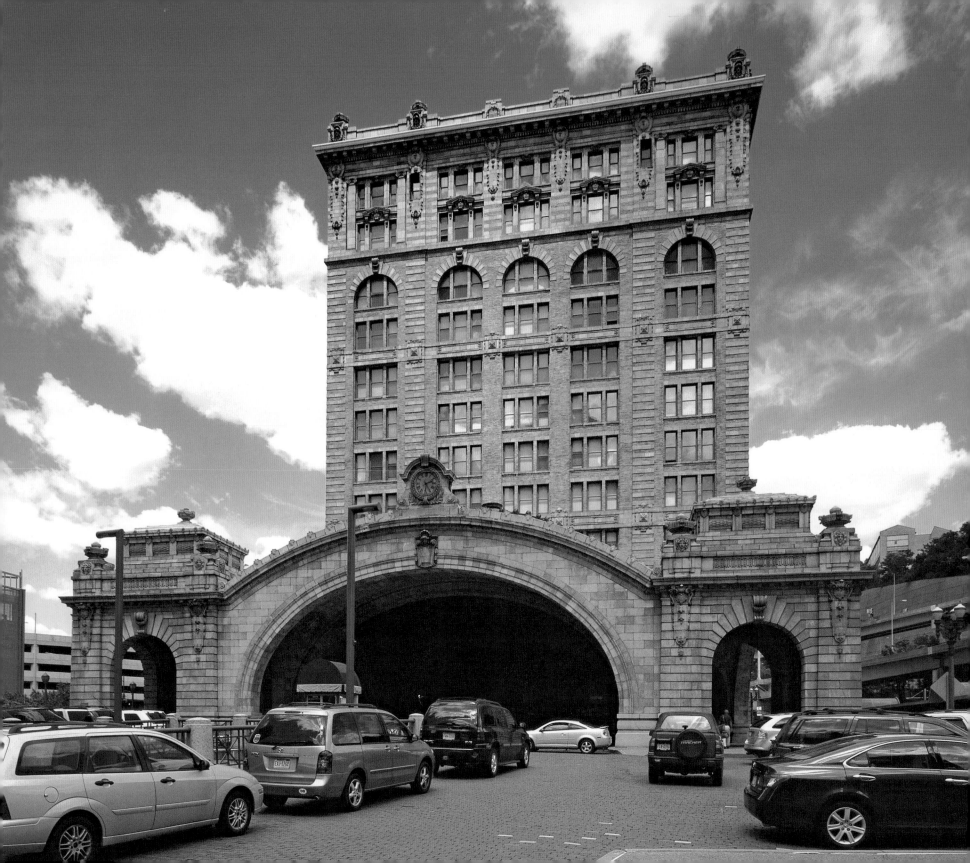

PITTSBURGH PENNSYLVANIA STATION

Pittsburgh has the most beautiful cabstand in the world. It is the terra-cotta rotunda that stands proudly in front of the twelve-story headhouse of its venerable Pennsylvania Station, opened in 1902 and still serving today as a beautifully converted office, apartment, and condominium complex in the very heart of the revived downtown area. The headhouse is an early forerunner of that most American of inventions, the skyscraper. Within the headhouse is a

magnificent vestibule featuring frescoed walls and a large hooded fireplace with a cozy inglenook. The vestibule leads into a lush Edwardian waiting room, featuring frescoed walls, a marbled floor patterned in black and white, and a coffered ceiling with a large skylight running down its center.

The rotunda, though, is clearly the station's outstanding attraction. It is so stunning that nothing can prepare you for actually walking up the long vehicular ramp to it and standing within its hallowed, shadowy, magical interior. Obviously influenced by the exposition architecture first displayed at the 1893 World's Columbian Exposition in Chicago and the Paris Exposition of 1900, the rotunda is a flight of inspired fancy by the great Chicago architect Daniel Burnham, whose signature style has aptly been called Burnham baroque. With its

shallow four-centered arches and its tightly recessed dome, the rotunda is clearly baroque, but when one takes into account its pronounced feminine themes and its festive female touches, the influence of art nouveau is also forcefully present, yet mercifully restrained from the eccentric excesses art nouveau too often succumbed to.

VIEW THE EXTERIOR from as many angles as possible. Start at the foot of the long vehicular ramp. Stop halfway up and shake off your awe. Such a sprightly rotunda bespeaks a jocular confidence America had not had in its architecture up until that point. In 1902, in the full flush of America's first imperial age, big-shouldered Pittsburgh was flexing its muscles as the

Opposite Page: A frontal view of Pittsburgh Pennsylvania Station showing the terracotta cabstand in the foreground and the early skyscraper headhouse in the background.

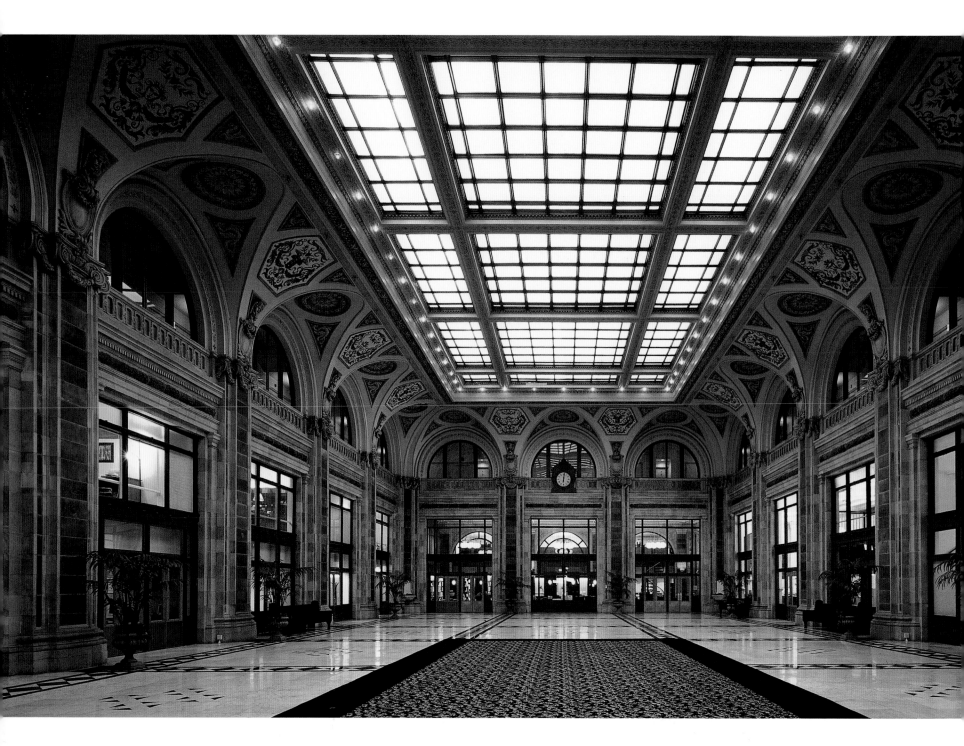

world's leading industrial city, the foundry for the steel with which America would build its towering cities and sturdy infrastructure. Money in Pittsburgh at the turn of the century was plentiful; the cost of this magnificent rotunda was not a problem.

To Step Onto the circular brick driveway within the rotunda is to experience the magic and beauty of a manmade grotto. You notice the sunspot on the driveway and look up at the oculus in the center of the dome. Like the "eye" in the center of Rome's incomparable Pantheon, this one lets in light too, but here the light is filtered through a beautiful round stained-glass skylight shielded by a detailed copper grille in a swirling Gallic filigree pattern. The interior ceiling of the dome is

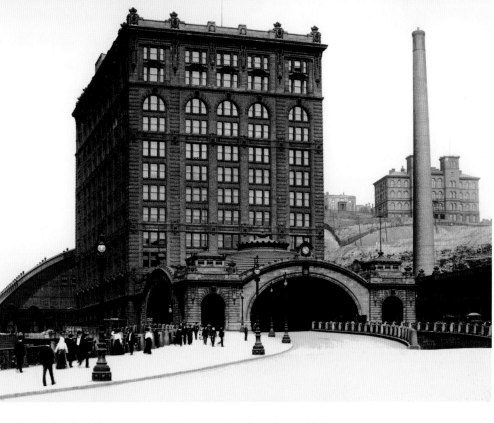

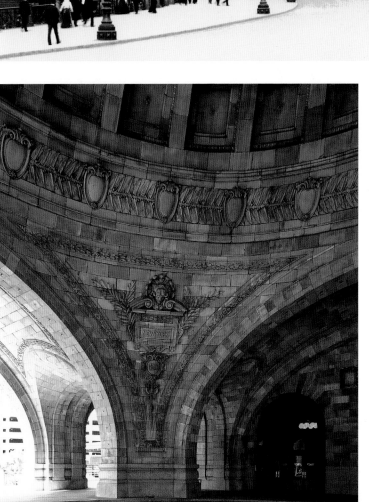

Opposite Page: The unimpeachably perfect Edwardian waiting room with its magnificent frescoed walls and ceiling, its two-toned marble floor, and its dramatic outsized skylight.

Above: Pittsburgh Pennsylvania Station shortly after it opened in 1902. Note the large train shed behind it, now torn down.

Far Left and Left: The gorgeous ocular skylight at the center of the cabstand rotunda with its whimsical art nouveau grille encircled by terracotta ceiling coffers.

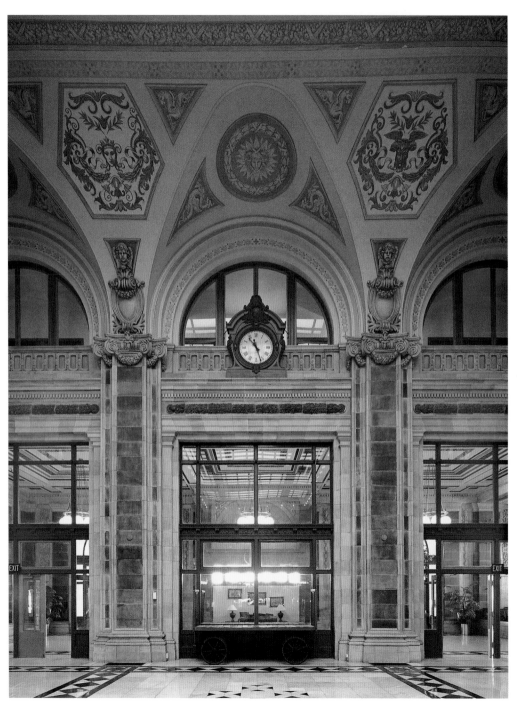

coffered terra-cotta and the gently sloping pendentives are tastefully highlighted with carved plaques beneath leaf-crowned female mascarons. The mascarons perch at the center of subtle pediments above the plaques. Each plaque spells out the name of the four chief stations served by the Pennsylvania Railroad: New York, Philadelphia, Pittsburgh, and Chicago. These were also the four principal stops on the Pennsy's fabled *Broadway Limited*. In an oval medallion below each plaque the date 1900 is boldly carved. Beneath each medallion are two small ascending cornucopias. Oddly enough, the word Pittsburgh in its plaque is spelled the archaic way, with the *h* left off.

You leave this fabulous pavilion recalling that, before St. Louis inherited the role, Pittsburgh was the gateway city to the beckoning and virginal American West. The rotunda is a grand tribute to that bygone civic distinction.

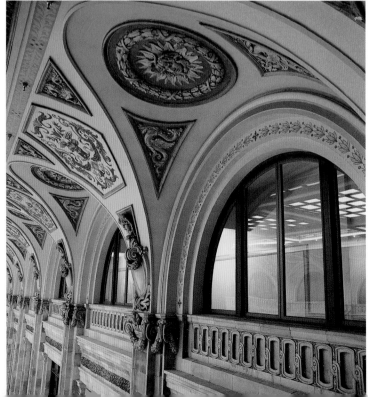

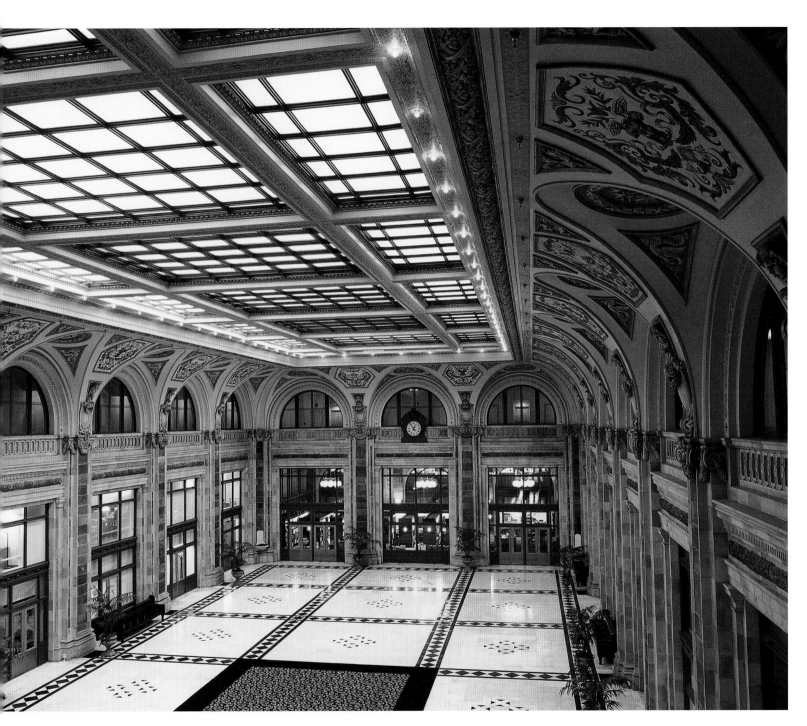

Opposite Page Left: The far end of the Edwardian waiting room showing the pilasters and their green marble insets, the encased clock, and the windows and arches on the upper floor. These doors formerly led to the train concourse and gates.

Opposite Page Right: This close-up view of the curvilinear ceiling highlights the splendid frescoes in and between the arches as well as the beautiful arched windows on the second floor.

Left: The gigantic skylight is ringed with lightbulbs and together they flood the room with abundant light that emphasizes the sheen and beauty of the patterned two-toned marble floor.

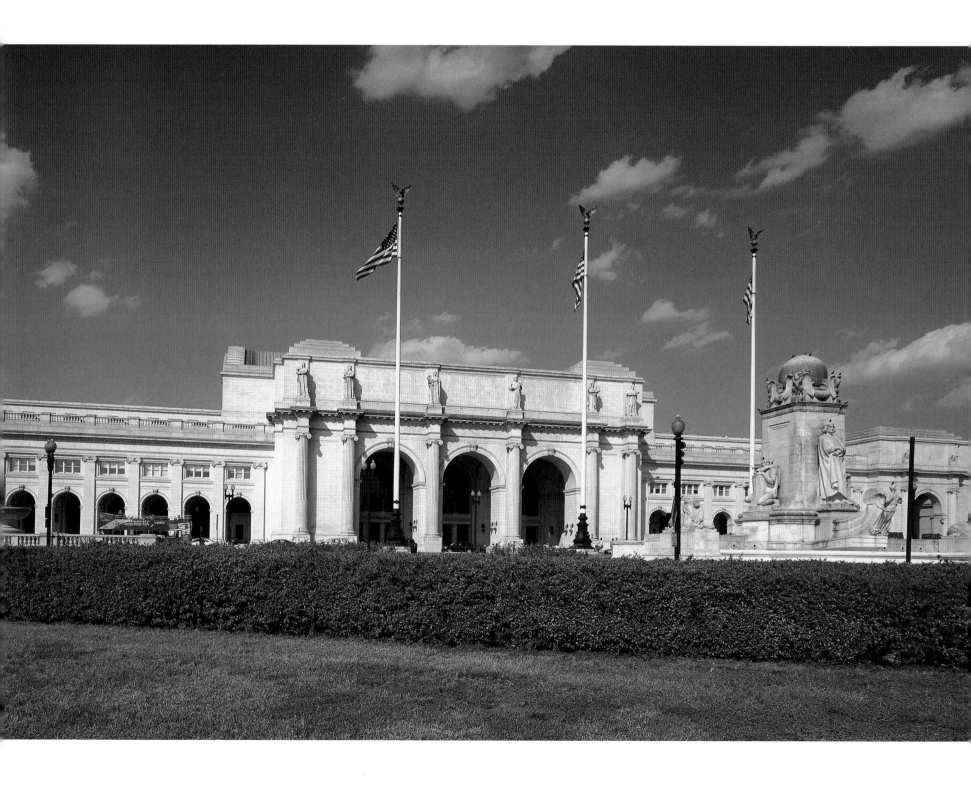

WASHINGTON, D.C., UNION STATION

Washington Union Station is the majestic portal to our nation's capital and is the great architect Daniel Burnham's masterpiece among the trio of glorious railroad stations he designed, the other two being Pittsburgh's Pennsylvania Station and his native Chicago's Union Station. Burnham was the chief architect for years for the Pennsylvania Railroad.

Washington Union Station opened in 1907 and marked a major step forward in making Washington, D.C., the distinguished and cosmopolitan world capital it is today. Burnham's masterpiece catalyzed the city's evolution from the rural, backward, swampy, and unkempt provincial eyesore it had been to the metropolis of tree-lined boulevards, beautiful parks, classical buildings, imposing monuments, and the triumphant mall that now define it. As the father of city planning, Burnham added a classy accent to the city designed a century earlier by the Frenchman Pierre L'Enfant, considered by many a Paraclete for the profession of city planner. This profession Burnham concretized at the World's Columbian Exposition of 1893 in Chicago, with his paradigmatic White City as its centerpiece, a model for his City Beautiful movement. Burnham's City Beautiful movement harmonized with L'Enfant's original conception of Washington and spurred its achievement.

JUST AS L'ENFANT had carefully planned the whole city, so Burnham painstakingly planned its crowning railroad depot. As an instance of American Beaux Arts architecture at its zenith, Washington Union Station appropriates examples of classical architecture Burnham studied on a government-sponsored tour of Europe before he undertook the station's design. The most influential examples proved to be the Baths of Diocletian and the Arch of Constantine in Rome and the Place de la Concorde in Paris. The latter served as a model on

Opposite Page: A panoramic view of Washington Union Station showing Columbus Plaza in the foreground and the quintessential Beaux Arts facade in the background.

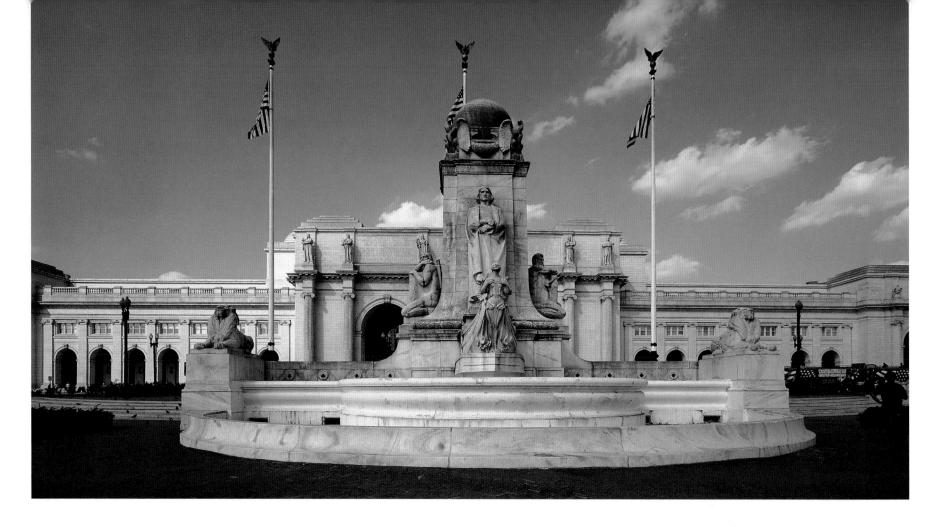

which Burnham hoped to base a colonnaded grand plaza in front of the station, much like the colonnaded piazza in the forecourt of St. Peter's Basilica in Rome. Congress, however, nixed this scheme as too costly and grandiose. Still, the station, so splendidly completed even without the plaza, provided a sturdy cornerstone on which to build the imperial city of marble, granite, and limestone.

In Designing the station's grand entrance, Burnham followed the example seventy years earlier of using a triumphal arch, as had been done at London's Euston Station in 1837.

He used the Arch of Constantine for his model and placed six large statues above the main cornice in the Attic block to represent *The Progress of Railroading*, much as the statues of the Dacian prisoners occupy the same position on the Arch of Constantine. Designed by the celebrated sculptor Louis St. Gaudens, Burnham's allegorical statues memorialize Prometheus for fire, Thales for electricity, Themis for freedom and justice, Apollo for imagination and inspiration, Ceres for agriculture, and Archimedes for engineering.

To either side of the grand entrance, the facade stretches six hundred feet across, and the two end pavilions are connected by a large loggia with handsome lighting fixtures. Across from

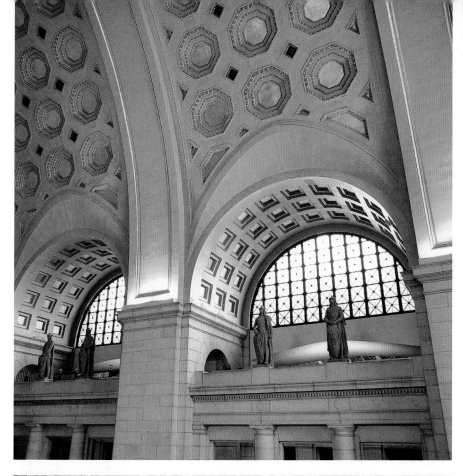

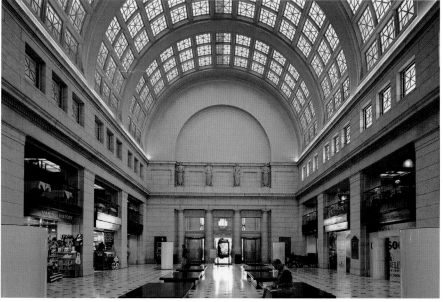

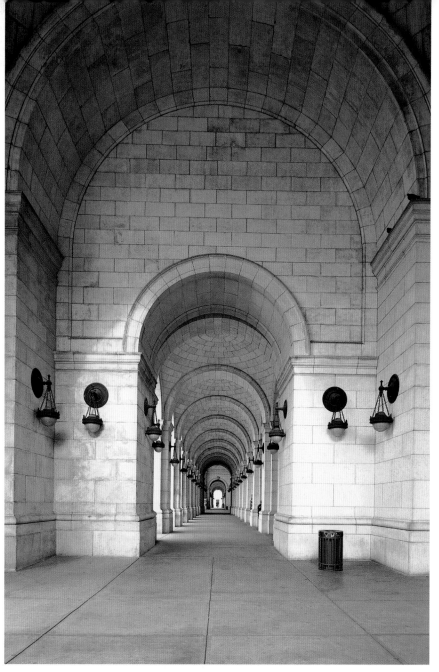

Above: The receding series of arches that form the loggia that runs the length of the facade on either side of the main entrance.

Top Left The statues of the centurions designed by the sculptor St. Gaudens that ring the balcony of the great hall.

Left: The barrel-vaulted and skylighted west wing that leads off the great hall and contains in its bays shops and newsstands.

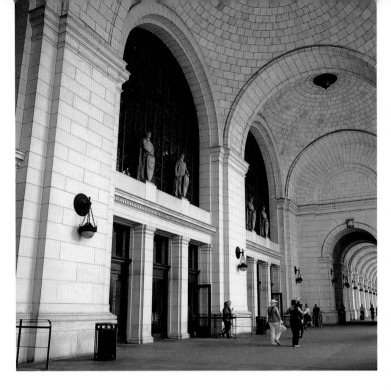

the grand entrance sits Columbus Plaza, with its large white marble and limestone fountain paying homage to Christopher Columbus as the man who linked the Old and New Worlds.

THE INTERIOR BURNHAM based on the Baths of Diocletian. It consists of the magnificent great hall and, behind it, a vast concourse that originally led to the gates and platforms. The concourse today has been reduced as a boarding area for the arriving and departing trains and converted to a pleasant triplex combining a food court and a shopping mall with the surviving gates and platforms. When the station opened in 1907, the concourse was the largest indoor room in the world.

In the great hall Burnham again called upon the sculptor St. Gaudens to design the statues of the centurions that ring the balcony and serve a utilitarian as well as a decorative purpose: they hide the floodlights that illuminate the vast room at night. The great hall's barreled and coffered ceiling in white

and gold, its large arched windows, its vaulting height, and its extensive use of marble evoke Burnham's memorable Hall of Heroes at the World's Columbian Exposition of 1893.

DURING WORLD WAR II the station accommodated two hundred thousand passengers a day, and throughout the heyday of railroading it was the principal through station connecting trains from the Northeast to the South. On January 15, 1953, the station made significant headlines when the Pennsylvania Railroad's *Federal Express* lost its brakes twenty-five miles from the station and had to make a crash landing into it. The new electric locomotive, weighing almost 224,000 tons, smashed into the bumper, jumped onto the platform, demolished the stationmaster's office, and flattened a newsstand before coming to a stop in the concourse just shy of ramming through the wall into the great hall. There it broke through the floor and crashed into the basement. Luckily, because the train's engineer had radioed ahead, people had been evacuated and no one was killed. This accident provided the ending for the hit 1976 movie *The Silver Streak*.

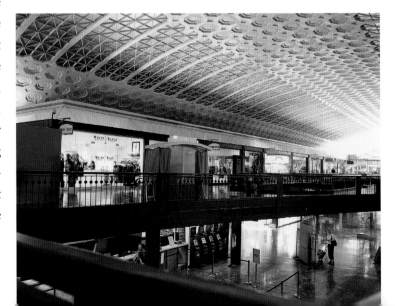

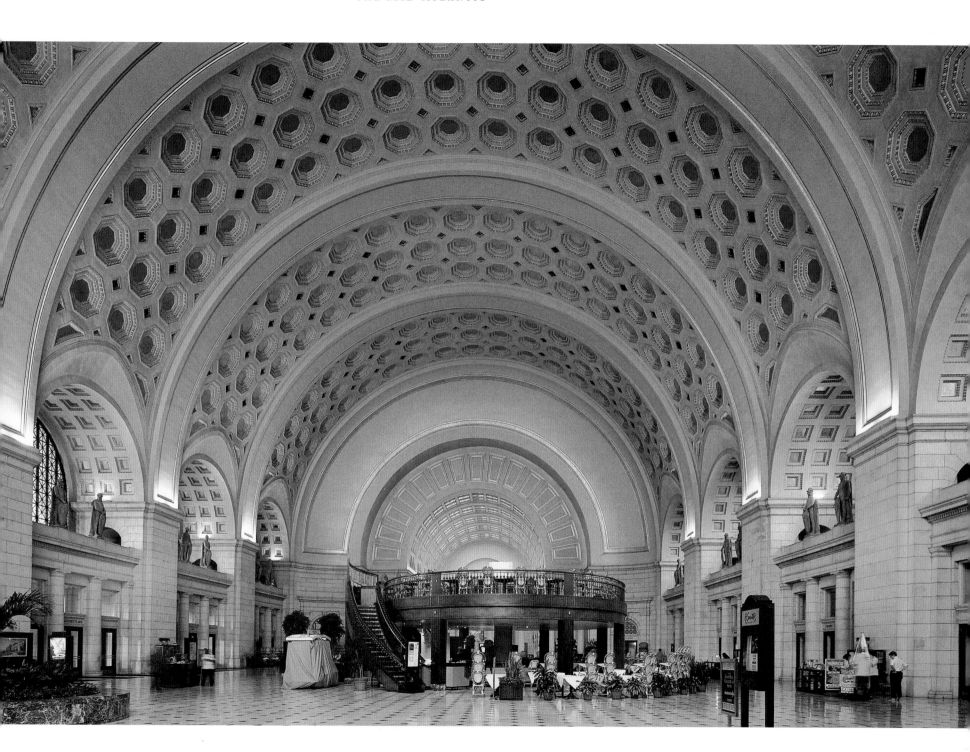

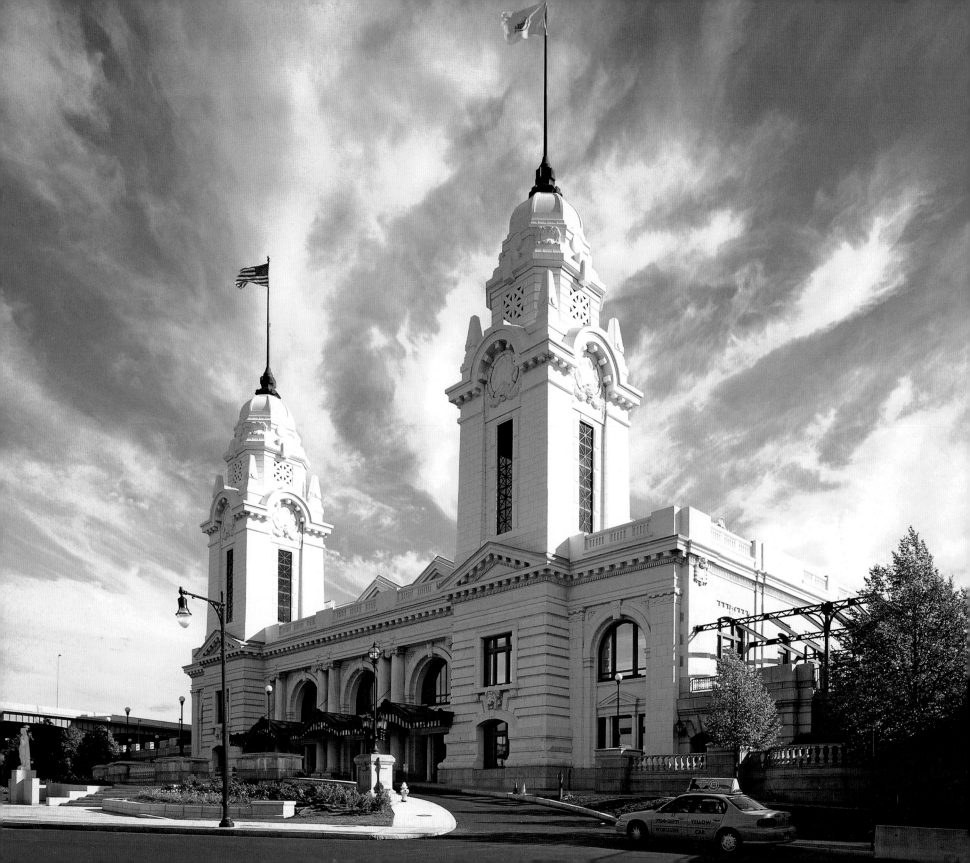

NEW ENGLAND

Like New England itself, its stations are quirky, classical, and sometimes quaint. They range from the whimsical Russian charm of North Conway through the art nouveau wonders of Worcester to the exquisite perfection of New Haven's Italian Renaissance palazzo and New London's Richardsonian Romanesque masterpiece. There is also the semidesecrated pink granite monumentality of Boston's South Station, whose style combines the substantiality of the Richardsonian Romanesque with the decorative and classical élan of American Beaux Arts at the precise point where the latter is about to take precedence. Danbury offers early twentieth-century American substance and plainness on a small scale enhanced with Arts and Crafts accessories, as well as a museum and terminal filled with authentic equipment tracing the evolution of railroading in America. North Bennington's mid-Victorian quaintness and tranquility amid the verdant Berkshires will have you imagining a quieter and gentler time punctuated with the rhythmic clopping of horse-drawn carriages and filled with soothing vistas.

North Bennington, North Conway, and New London offer a triumvirate of quintessentially great second-generation stations.

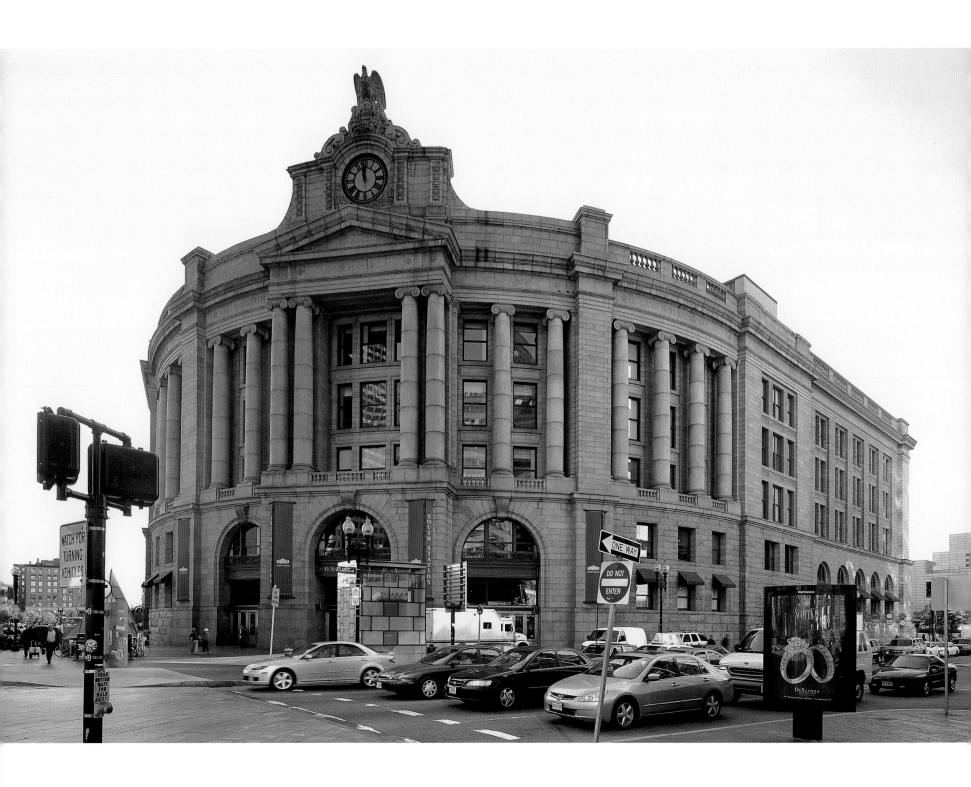

BOSTON SOUTH STATION

The instant you step off a train and into South Station you're reminded of the great Victorian stations of London: Paddington, Charing Cross, and, especially, Victoria. After you walk down the length of a covered train platform and enter the main waiting room, you immediately absorb its open-shed feel, the same feel you get in London Victoria. Above you loom openwork steel girders and trusses beneath a plain

concrete-block ceiling. Today the whole station has a pronounced aura of metropolitan functionality to it, without many flourishes.

Part of this functionality derives from the original design, but much of it also springs from the way the city leaders of Boston have seen fit to rehabilitate the station. Sadly, South Station nearly earned the sobriquet of Catastrophe II, to follow hard on the tragic fate of New York City's Pennsylvania Station, the original and ultimate Catastrophe for America's great railway stations by way of its total demolition.

South Station was not merely threatened by the wrecking ball. Its Atlantic Avenue wing actually felt its wrath. It was partly destroyed, until architectural sanity reasserted itself and the crane swinging the desecrating ball was stilled and the wing rebuilt, albeit without the flair, style, and classiness of its

counterpart, the still intact and original Summer Street wing. Heartache for the lost glory of the desecrated wing is inevitable the minute you inspect the Summer Street wing, especially when you look up and take in its gloriously paneled, recessed, and multicolored ceiling. Its walls are also original and decorative, both inside and out. On the outside they are made of the original granite blocks and on the inside they feature highly decorative plasterwork to complement the magnificent ceiling. In this restored original wing you'll also encounter a glorious archway topped by a handsome inset clock, and you'll experience inside the Summer Street entrance a stairway and vestibule that are regal and decorative, yet forthright.

By contrast the demolished and now ersatz Atlantic Avenue wing has been rebuilt using pressed brick instead of rusticated granite on the outside, and, on the inside, with plain

Previous Pages: Facade of Worcester Union Station.

Opposite Page: The facade and main entrance of pink granite South Station showing the symmetrical colonnades and the parapet shaped like a shield that evokes the masthead looming above the prow of a great ship, thereby saluting Boston's nautical heritage.

plaster and ordinary stonework. The ceiling in this ravaged wing is also plain, and features only make-do pseudo–art deco lighting fixtures, vulgar and unappealing. Whereas the intact wing houses the gracious ticket offices and the handsomely appointed Acela Club lounge, the ersatz wing plays host to fast-food eateries in large booths below a mezzanine devoted to cafeteria-style seating, all modern, aggressively utilitarian, and ugly. The fast-food theme plays on in the large main hall, which has been converted to a giant food court.

THE FACADE IS this station's premier aspect. It is another forceful example of how formidable and aesthetically pleasing the Richardsonian Romanesque style of American Beaux Arts architecture can be, just as Albany Union Station is. Richardson's firm, Shepley, Rutan, and Coolidge, designed South Station a few years before it took on the design of the Albany station.

Notice the facade's perfect balance and symmetry in its three colonnades above the center doorways and in the two colonnades marking the beginnings of each of the curved wings. Also note how sparingly and effectively Richardson employed parapets, entablatures, and balustrades. He brilliantly crowned this bold facade with a tall parapet rising above the station's six floors. Shaped like a shield, it holds a large clock in its center and has a dramatic stone eagle perched at its apex. Viewed from the far side of Dewey Square, the pediment brings to mind the masthead looming above the prow of a great ship and wonderfully evokes Boston's nautical past.

Yet there is from this view a countervailing drawback. Looking to the right along the Atlantic Avenue wing, you fully realize how symmetry and integration have been hurt by the partial demolition. The station today is like a stately lady whose outfit is only half accessorized.

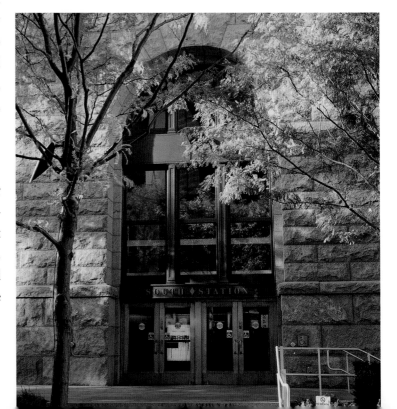

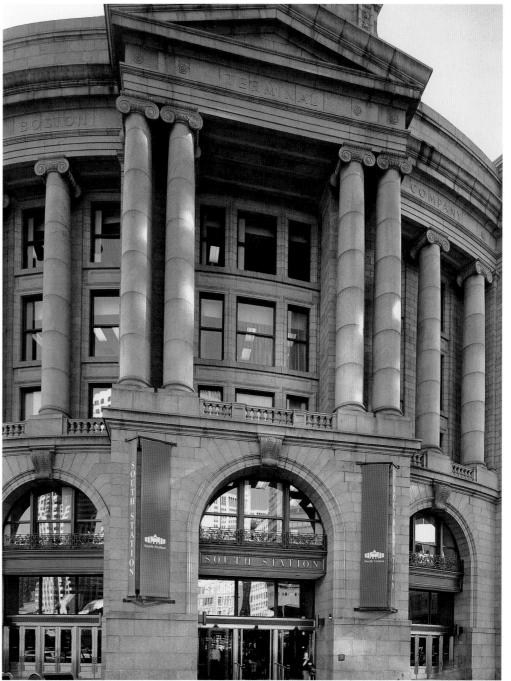

IN THE FIRST decade of the twentieth century, soon after South Station opened officially on January 1, 1899, heavy commuter ridership made it the busiest railway station in the world. The initial cost of building the station was $3.6 million in 1899 dollars. The five railroad companies that combined forces to build the station, beginning in 1897, were: the Boston and Albany Railroad Company; the New England Railroad Company; the Boston and Providence Railroad Corporation; the Old Colony Railroad Company, which serviced Cape Cod; and the New York, New Haven, and Hartford Railroad Company.

When completed, South Station boasted one of the largest train sheds in the world. But the shed had to be taken down in 1930 during a renovation. Salt air blowing across the bay from the ocean had corroded its steelwork.

During World War II, South Station serviced 125,000 passengers each day.

NORTH CONWAY DEPOT

*D*esigned by a knowledgeable Boston architect and built in 1874 by a talented local contractor, North Conway Depot reflects not only a full understanding of the nineteenth-century Russian provincial style but of outstanding carpentry skills as well. In such details as the curved brackets supporting the large canopy encircling the entire building, as well as in the tempered and deft use of gingerbread trim on this canopy, the

carpenters showed themselves clearly to be masters of their trade. Their mastery is also evident in the deft placement of oval and circular windows in the sides of the building and in its two front piers. These piers support the twin rectangular towers anchoring either longitudinal end of the building. Though lost in the seventies renovation, twin oval windows also originally adorned these two rectangular towers.

THE FUN OFFERED by North Conway Depot resides with the trains it runs. Several excursions are offered, of varying lengths, from one short hour to a modest ride nearly twice as long to, finally, a full run of five and a half hours up into the White Mountains to see their renowned Presidential

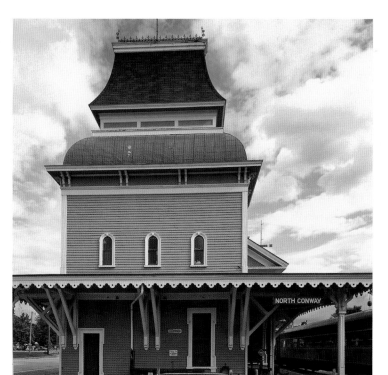

Opposite Page: The striking carved oak staircase curving off the lobby at the North Conway Depot, emblematic of the expert carpentry this station embodies.

Left: The south pier of the depot accentuating its Russian design roots and its lack of adornment except for the gingerbread trim on the canopy.

Range, capped by a view of Mount Washington, the highest peak in New England.

The Conway Scenic Railroad has restored many passenger cars ranging in age from the late nineteenth through the middle of the twentieth century. There is an authentic Pullman parlor observation car with wicker chairs positioned in front of the windows on either side of the aisle to afford passengers full views of the passing landscape. Two other cars have domed observation terraces. Yet another car offers a full dining experience, realistic in every detail.

If you can afford the time, the long excursion will take you over trestles spanning steep gorges and show you rills, rivers, streams, sheer bluffs, and deep ravines. It will show you pastures filled with horses and cows and such natural rock formations as White Horse Ledge and Cathedral Ledge, as well as the famous gorgeous mountain formation known as Crawford's Notch.

INSIDE THE STATION the lobby still has its sturdy ticket booth with handsome Victorian woodwork. But the old waiting room space has been decked out with display cases and photo

kiosks. These hold some of the most fascinating pieces of train equipment and memorabilia about New England's railroading past that you are likely ever to come across. There are such things as old brochures for the Boston and Maine ski trains, fancy chinaware and cutlery from various train lines, a collection of lanterns, and even large model trains, much like architect's renderings, built by manufacturers like

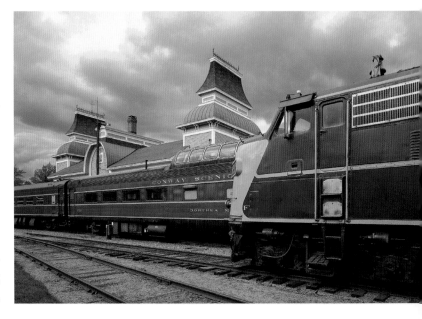

Baldwin Locomotive and American Locomotive Works to show their client railways what they were ordering. One case holds Lionel standard-gauge electric toy trains circa 1920; these prove how long ago young boys were entranced by the romance of the railroads. The walls, in addition to the kiosks, are lined with piquant photos.

A quick glance into the ticket booth in the center of the lobby reveals that it has a three-paneled bay window out back facing the tracks, the usual accommodation for the stationmaster to view approaching or departing trains in both directions. The interior, from its plank wooden floors to its handsome woodwork on the ticket booth, the windows, the doors, and the handsome curved wooden staircase, is almost exactly as it would have been nearly a century and a half ago.

Below: A frontal view of the station showing its polychromatic plainness and balance with the functional clock and elliptical pediment centered between the flanking and identical piers.

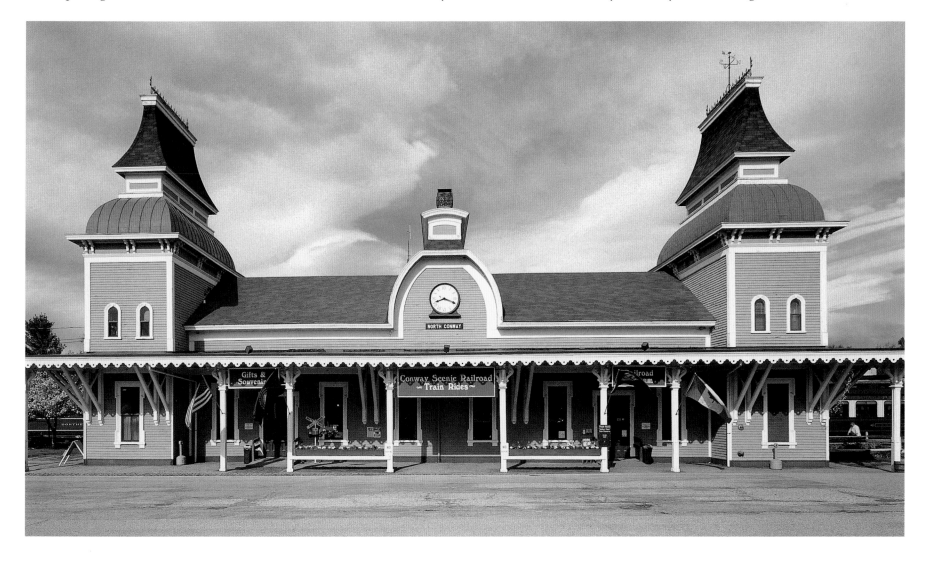

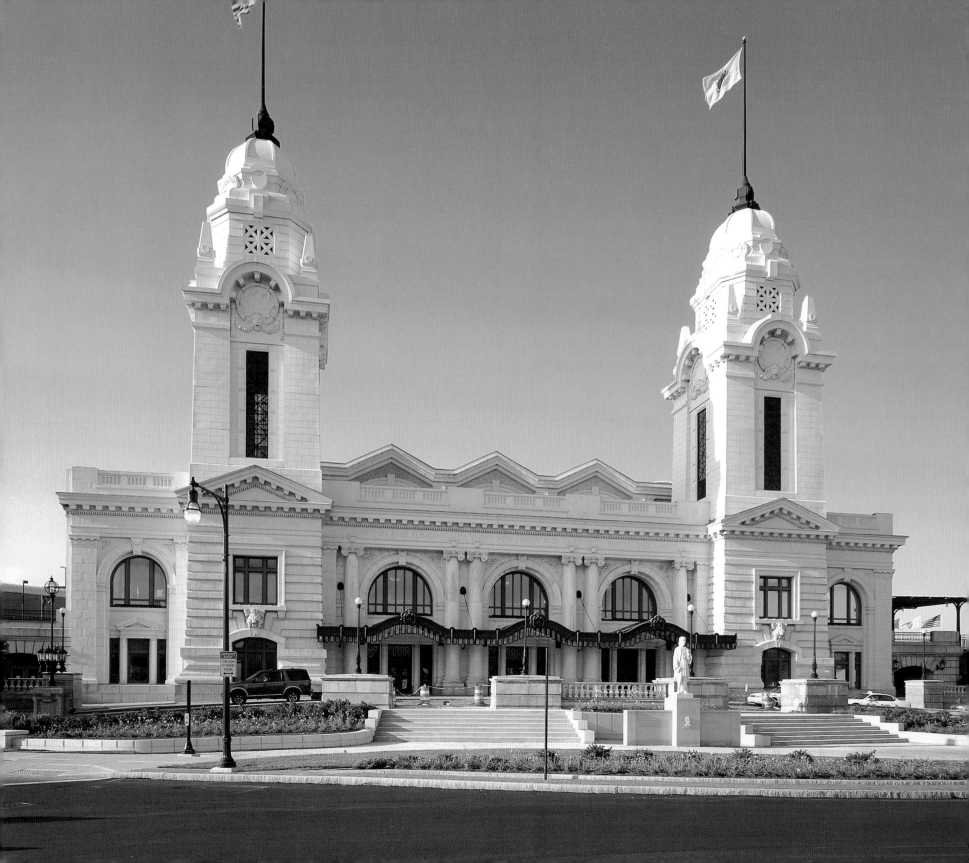

WORCESTER UNION STATION

The twin towers of Worcester Union Station jut into the sky like the gothic spires of a medieval cathedral and dominate the townscape every bit as completely. Built in 1911 in the French Renaissance style, this station has a pronounced art nouveau, as opposed to classical or Beaux Arts, aura to it. Quite easily it might have graced the townscape of Nice or Toulon, or even a Central or South American capital, instead of this

bustling nineteenth-century New England commercial center of manufacturing and transportation.

When the Boston to Worcester railroad opened on July 4, 1835, it cut the seven-and-a-half-hour trip down to three hours, and soon twenty-four trains arrived and departed Worcester's original Victorian station built shortly after train service began, rendering the city a major transportation hub. Nineteenth-century immigration propelled Worcester's population to grow by 40 percent from 1820 to 1830, then by an additional 30 percent over the next ten years. With its easy access to transportation and its growing manufacturing base, Worcester became a center of intellectual ferment and social reform, including campaigns for women's rights, temperance legislation, workers' rights, and, especially, the antislavery movement.

Opposite Page: A full frontal view of the facade of Worcester Union Station displaying boldly its French Renaissance style élan.

Left: The statue of Christopher Columbus stands out prominently at the center of a small plaza in front of the station.

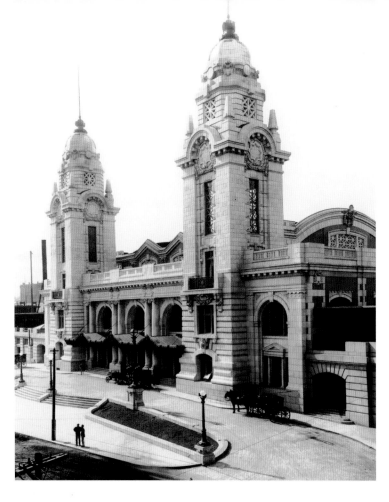

can take in all the details and appreciate all the subtlety instilled in the facade by the Philadelphia architect Samuel Huckel, Jr., when the building opened in 1911. Grand in conception and perfect in execution, the facade was meant to signal to visitors that Boston was not the only great and vital city in the Commonwealth of Massachusetts in the earliest years of the twentieth century.

THE STATION'S INTERIOR is every bit as enthralling as its exterior. From the front you pass through an exquisite marble and terrazzo vestibule and immediately enter the dazzling grand hall. Casting glorious tinted light onto its white terrazzo floor are three large elliptical stained-glass windows in

Not insignificantly, the renovation of the current station initiated by former mayor Raymond Mariano in the late 1990s pulled Worcester out of the urban decay that blighted so many American cities in the sixties, seventies, and eighties. Abandoned in 1975, the station was neglected and vandalized for over two decades. When it reopened in July 2000, following its $37.2 million makeover, it forged a downtown revitalization.

THE STATION'S FACADE is a white-on-white wonder only heightened in intensity when flooded with bright sunshine. Situated on Washington Square, in the heart of the city, the station has a little patch of green in front of it. From there you

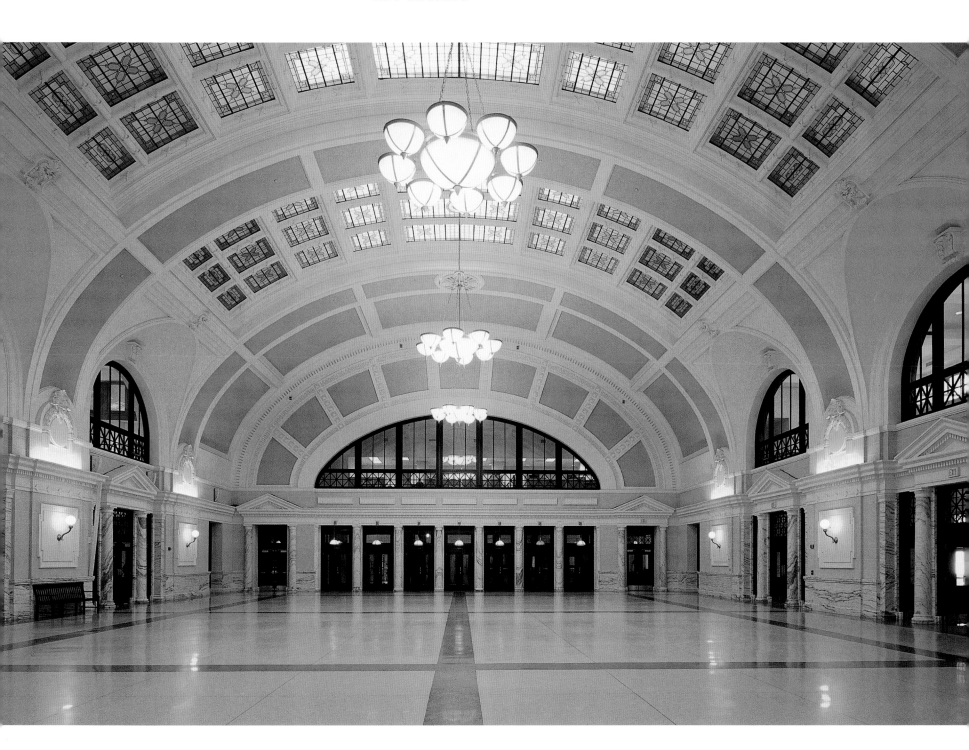

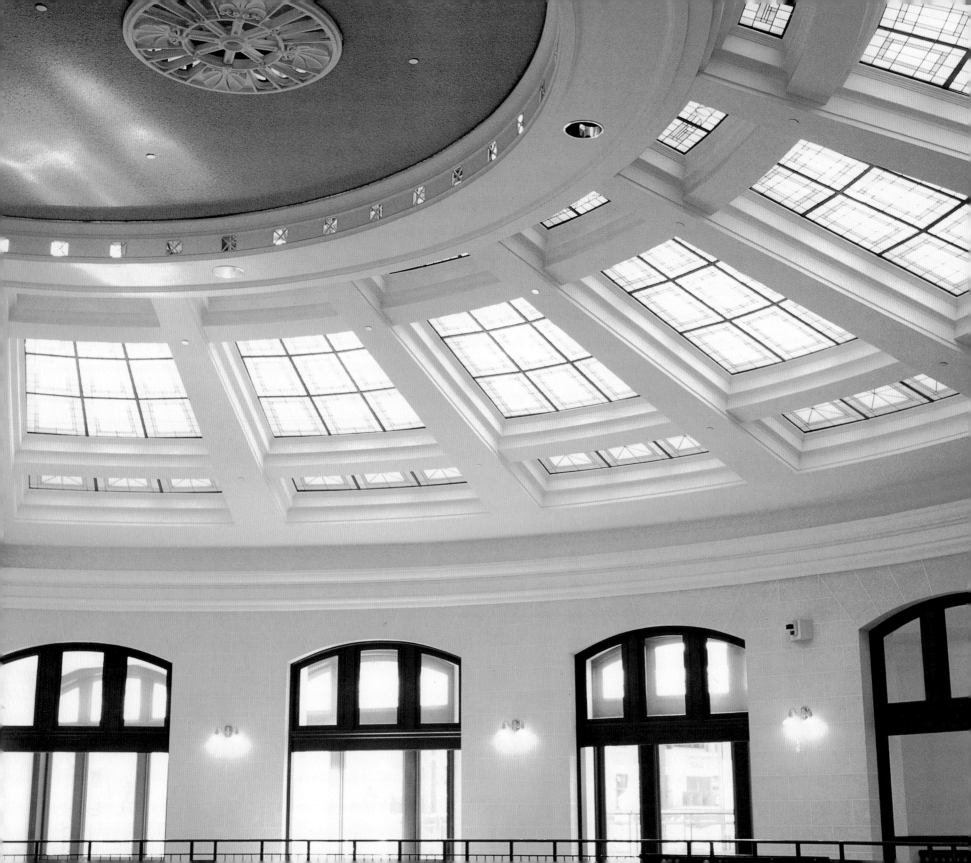

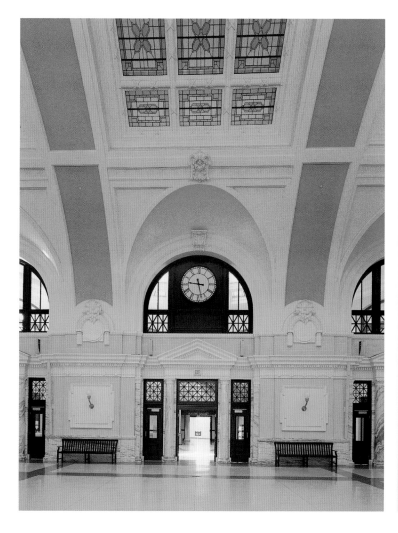

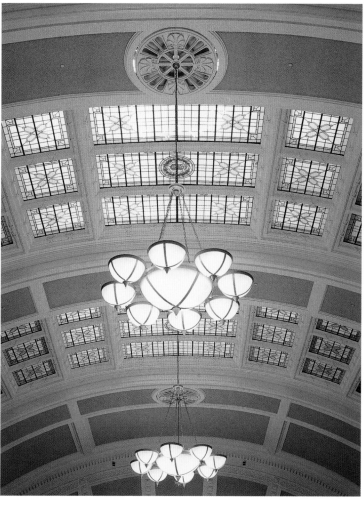

the barrel-vaulted ceiling. Brilliantly colored and patterned, the windows are worthy of any art nouveau conservatory.

Beyond the grand hall is a half rotunda with a ceiling that matches the excellence of the three curvilinear bands of stained glass you've left behind. Looking up, you're amazed all over again by tiers of stained-glass skylights ranked in descending panels from the top of the half rotunda to its base.

Architect Samuel Huckel, Jr., employed stained glass here as ingeniously as did that great icon of American architecture of the same period in his prairie houses out west, Frank Lloyd Wright. In keeping with the spirit of "organic" architecture espoused by art nouveau and amplified by Wright, every detail of this building is meant to envelop visitors and unify their visual and sensual experience of it.

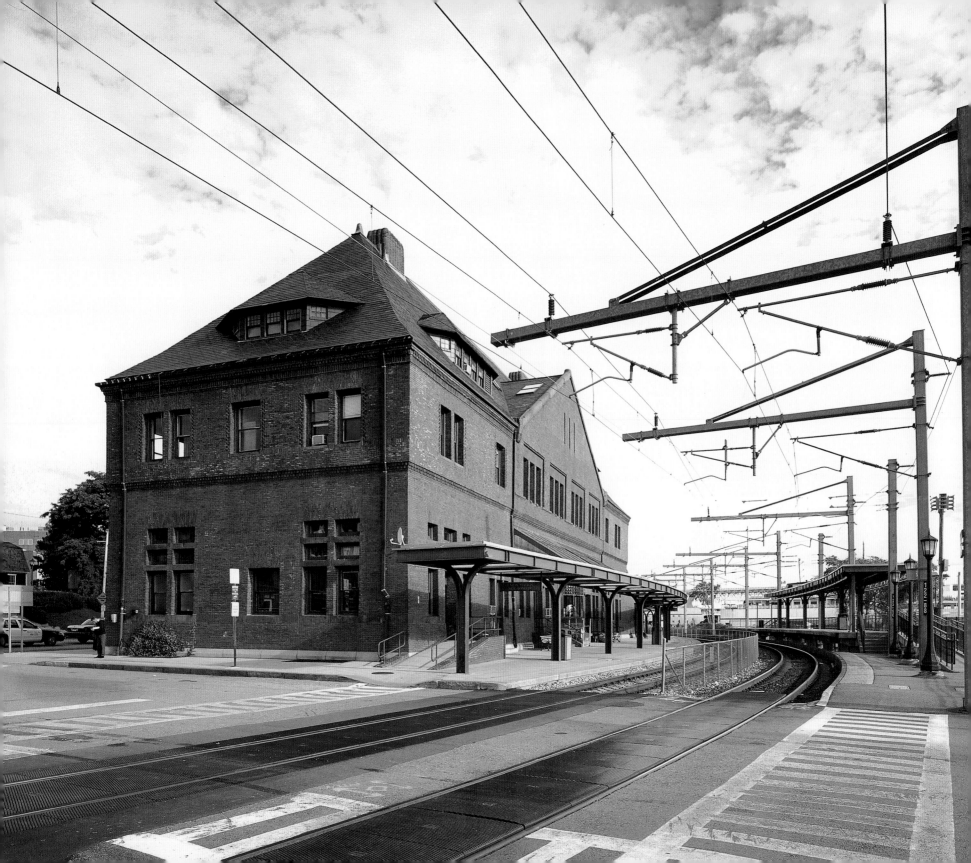

New London Union Station

New London Union Station is proof that poetry in architecture can be achieved using plain red bricks arranged artistically and topped with an angular slate roof, pitched steeply and punctuated with well-placed eyebrow dormers. The overall impression of this forceful building is one of medieval French elegance and protectiveness. This stately masterpiece is every bit as formidable as a castle keep. Designed in 1885 by Henry

Hobson Richardson, it is the last railroad station he built before his untimely death two years later from Bright's disease, when he was only in his forties.

On a small scale New London Union Station represents the apex of what became this seminal architect's legacy style, Richardsonian Romanesque, just as the Allegheny County Courthouse and Jail in Pittsburgh represent its apex on a large scale. Officially opened in 1888, New London Union Station would have been demolished over three decades ago had it not been for the intervention of the Union

Opposite Page: A view of New London Union Station from its southwest corner showing the magical arrangement of windows and bricks complemented by the shingled, dormered, and pedimented roof.

Right: The spacious waiting room with its beamed ceiling and its symphonic interplay of doors and windows offset everywhere by mass and solidity.

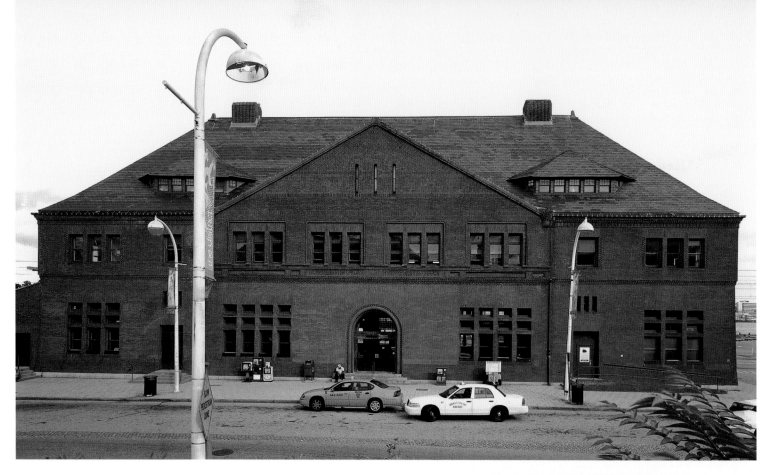

Station Railroad Trust in 1976, when the association obtained National Historic Landmark status for this oh-so-worthy structure.

CLEARLY UNION STATION shows the influence Richardson absorbed when he was marooned in Europe for six years during the American Civil War. The great-grandson of Joseph Priestley, the discoverer of oxygen, Richardson was born on a plantation in Louisiana to a New Orleans cotton merchant. Following graduation from Harvard he traveled to Paris and studied at the École des Beaux-Arts to further his ambition to become a skilled architect. While he was a student there, the Civil War broke out and, except for one

brief visit to Boston, he spent six years in Europe, mostly in France. He traveled throughout the continent and studied its architecture, especially the medieval architecture of southern France.

This influence, plus that of Robert Morris and John Ruskin, accounts for his break with the dominant style of the École des Beaux-Arts. He supplanted many of its neoclassical and baroque tenets with an emphasis on medieval elements such as rounded arches, the massing and texturing of stone to bring out its expressiveness, and the use of small windows, narrow windows, eyebrow dormers, and, in some cases, Loire dormers—those with the small scrolled and spired pediments above the window frames, like the ones that decorate the famous châteaux in the Loire Valley.

The little structural symphony played by this station's windows is given a snappy coda by the two eyebrow dormers peeking forth on the slate roof on either side of the triangular pediment. An additional horizontal divider takes form as a narrow frieze of raised brickwork between the first and second floors; it lends a decorative, but muted, touch, the same way the raised brickwork frieze under the eaves and at the top of the triangular pediment does. The whole facade, and every element composing it, plays completely on key, including the two tall chimney stacks at either end of the center roofline, right before it descends to form the perpendicular sloping roofs covering either wing. The result is pure spatial harmony.

THE REAR FACADE has its own balance and symmetry but is not as arresting as the front facade for lack of the central arched doorway and the more varied spatial placement and shape of the windows. More straightforward and less

Left: Note the fancy brickwork embroidering the arch of the large portal that serves as this station's main entrance.

decorative, this trackside facade has its vista broken sharply by the placement of a weatherproofing glass canopy over the main rear door. The canopy connects to the covered platform running more than the length of the building, affording passengers protection from the weather even when the platform is crowded.

Still, despite being plainer and less well showcased than the front, this rear facade does have the same subtle decorative raised-brick friezes between the first and second floors and under the eaves, it does have the same type of sharp triangle for a pediment, and it does feature the same pleasing arrangement of windows on the upper floor. The first floor holds an auxiliary double oak doorway on the eastern

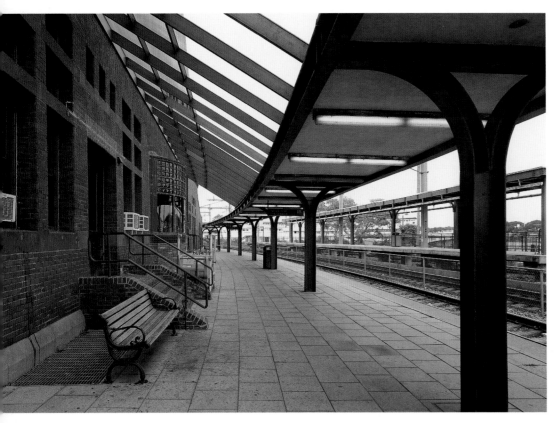

Above: A closer view of the track platform behind the station, with the old stationmaster's bowed bay window in the middle ground.

deft as that in both facades, though much simpler, and its sloping and shorter slate roof boasts a single eyebrow dormer that horizontally accents it emphatically. On the eastern side there is a lower ancillary building that is today used as a bus station. It effectively blights the integrity and the symmetry of that wall.

TO VISUALIZE THE interior in its glory, you need to call upon your imagination. By entering either from the front or the back, you step into one large room the size of a medieval refectory. During the station's period of neglect, the interior obviously suffered considerable damage. Today the floor is that horrid all-weather carpeting, spiky yet spongy, wall to wall, gray and dismal. No doubt the original floors were hardwood and sturdy. The seating is also modern garish.

Ignore these two drawbacks and notice the handsome oak wainscoting and the brilliant way the light is distributed throughout the room by the well-placed windows so smartly arranged to do just this. Also notice the way Richardson placed a bowed window in the center of the rear wall directly opposite the arched front entrance.

All things considered, this station is a medium-sized masterpiece, proving that less is more, even when you're dealing with mass. It's like a sustained tone poem offering proof that unadorned mass intelligently deployed can result in a pleasing and lyrical solidity.

side that leads from the large waiting room directly onto the covered platform. And, again like the front facade, the rear facade has the classy touch of the two eyebrow dormers winking at either side of the triangular pediment, as well as the two prominent chimney stacks marking the ends of the central ridgeline of the roof.

As you move from the front to the rear facade, go around the western side of the building, walk across the street, and look back. Richardson blended the shorter sides with the longer facades masterfully, including banding the whole building with the two raised-brickwork friezes. The western sidewall displays an arrangement of windows every bit as

OUT ON THE track platform, take in the view of the Thames estuary to the east where it joins Long Island Sound. The large ferries docked there shuttle from New London to either

Block Island or to Long Island. The Fishers Island shuttle is to the right. Often the Coast Guard Academy training vessel, the barque *Eagle*, is anchored majestically a hundred yards out in the sound, sails furled. Across the mouth of the Thames on the far eastern shore are the large assembly housings for the General Dynamics dry docks on which the Trident submarines were built.

Union Station anchors New London's Historic Waterfront District. Walk half a block up the hill away from the station and stroll down Bank Street taking in the fancy Victorian scrollwork on the cornices of the buildings. Mystic Seaport is nearby, only a short trip by car. It is especially appealing to old sea salts and sailing enthusiasts and also has many lively attractions and amusements for children. New London is a busy station and handles some forty trains a day, mostly Amtrak service in the bustling Northeast corridor, but a few commuter trains from Shore Line East connect the Connecticut seacoast towns.

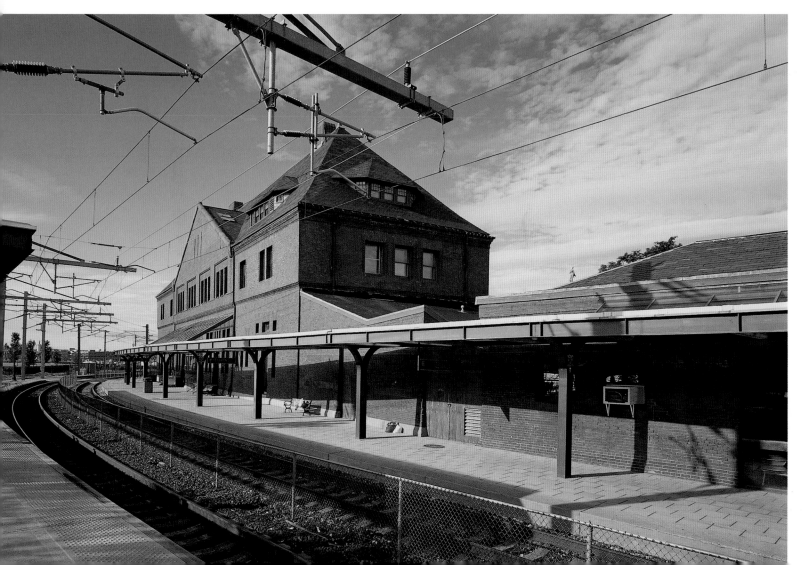

Left: A view of the station from its southeast corner showing in the foreground the old freight and baggage buildings and the station's eastern side and its rear facade in the background.

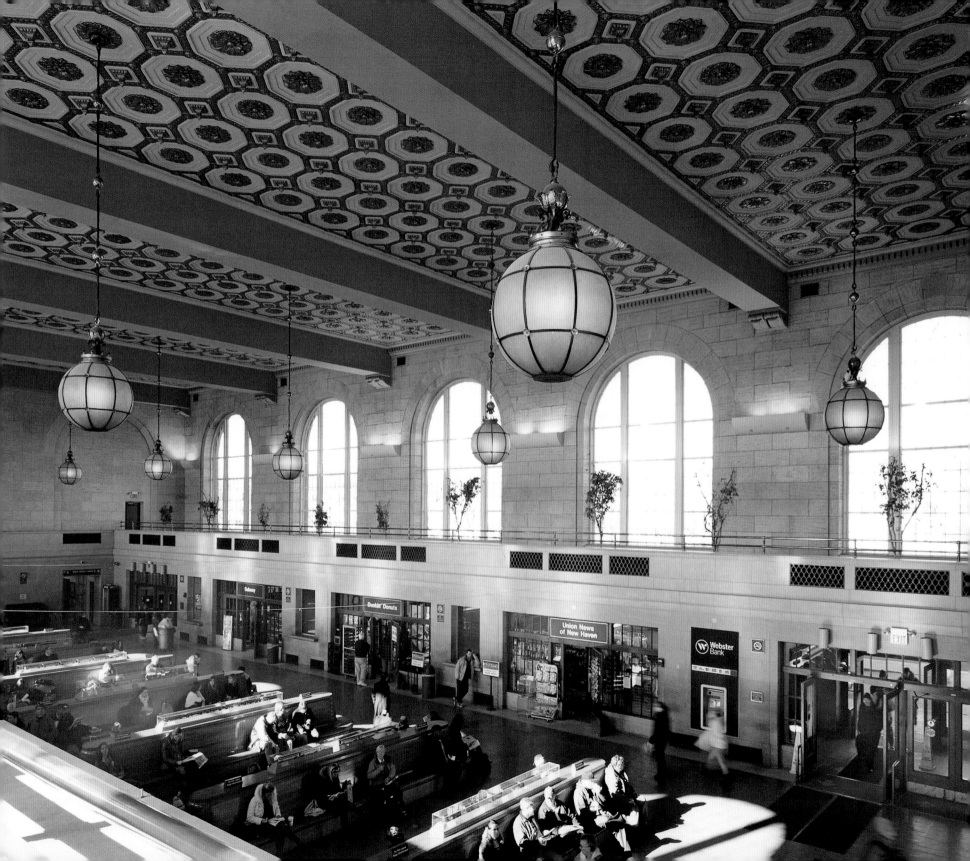

New Haven Union Station

*J*oy *is to visit New Haven via train after having not been there since the 1985 renovation of Union Station. During the thirteen-year hiatus between the station's closing in 1972 and its reopening in 1985, conditions for passengers arriving or departing New Haven by train were miserable. The magnificent redbrick Beaux Arts masterpiece by noted architect Cass Gilbert is startlingly beautiful and fun to visit, bright, shiny,*

and serene within, and solid, simple, and striking without. Although this building is categorized as Beaux Arts, it is markedly toned down and plain, with only a few hints of the baroque in it, most notably in the ceilings of the main lobby and the two smaller lobbies, including the one you just emerged from on the eastern side and the opposite one on the western side that leads to the car rental facility and the interstate bus service office.

THE INTERIOR IS a study in the power of unadorned elegance. The main lobby has plain limestone walls that radiate warmth in the abundant sunlight vented on them by the five large arched windows in the front and back facades. These ten magnificent windows are the building's most salient, attractive, and effective

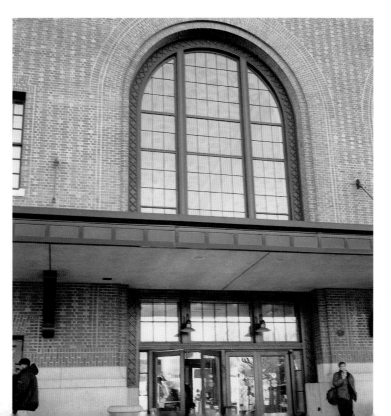

Opposite Page: The main lobby and waiting room of New Haven Union Station viewed from the rear balcony. The main entrance is in the foreground in the lower right corner.

Left: Exterior view of the main entrance with its tall arched window trimmed in decorative brickwork and bisected by the front canopy.

feature. The light from them cascades onto seven large oak settees, double sided and highly varnished, that run down the length of the room perpendicular to the facades. Though not original, these benches do not clash with the period feel of the room: they are, instead, intelligent replications of the originals.

The coffered ceilings in all three lobbies constitute the single unequivocal baroque element in this building. The ceiling in the main lobby features white octagons holding gold-leaf clusters at their centers against an overall gold background. In the two smaller lobbies the coffered ceilings are similar but feature gold rosettes instead of the larger

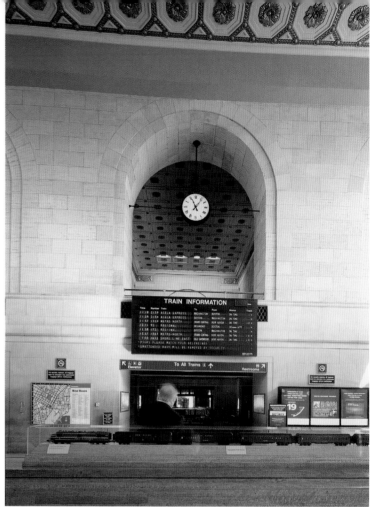

palm clusters. In designing these three rooms, architect Gilbert achieved exactly the emphatic and contrasting effect he wanted: the bold and plain slightly leavened by the unabashedly decorative.

THE EXTERIOR IS every bit as winningly plain as the interior. From this triumphantly plain and formidable exterior, reminiscent as it is of so many buildings in Renaissance Italy, it's clear why Cass Gilbert referred to this station, when it opened in April of 1920, as his "Beaux-Arts palace." Gilbert knew exactly what he had achieved in designing it.

Right: The front facade facing west and showing the Italian Renaissance influence in the large arched windows, the marble footing, the plain but striking brickwork, and the subdued cornice.

Far Right: The eastern archway of the main lobby leading to the small lobby holding the escalators that descend to the subterranean passage servicing the train platforms.

Opposite Page: A lengthwise view of the main lobby and waiting room showing the original marble ticket counters on the left, the replicated oak settees in the middle, and the bays for the newsstands and the fast food outlets on the right.

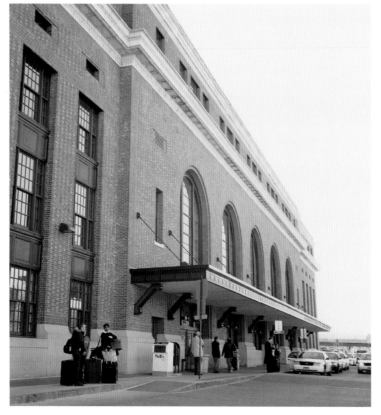

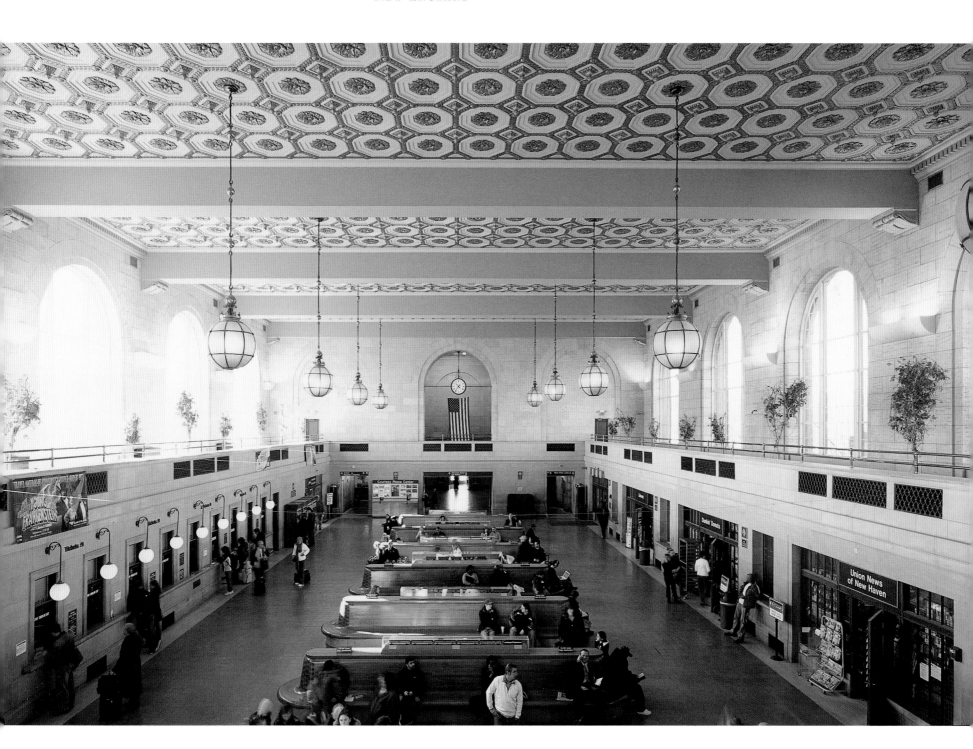

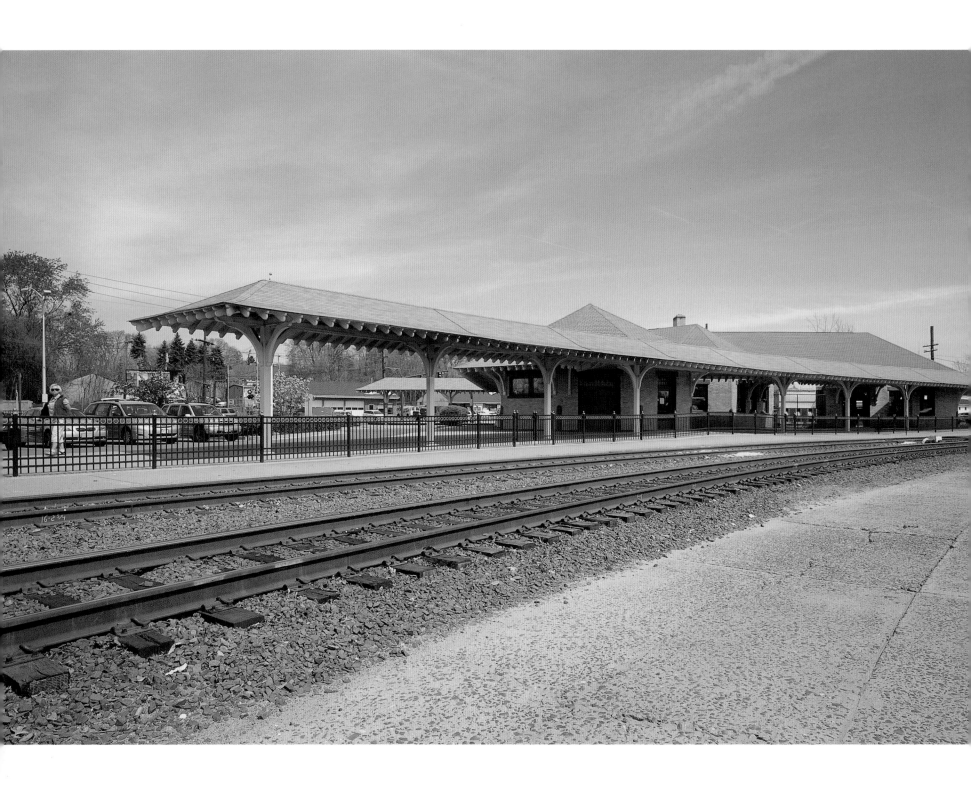

DANBURY STATION

If you arrive by train at Danbury expecting to slide up alongside the small picturesque station Alfred Hitchcock photographed so memorably in Strangers on a Train, *you'll be disappointed to disembark and find yourself face-to-face with an overgrown redbrick pillbox half the size of an average filling station. Relax. You'll be standing on the raised concrete platform all modern trains require, and which the classic old station*

could not accommodate. More importantly, you'll be only one city block and a half from that beguiling Edwardian structure Hitchcock seized the photogenic potential of when he made his offbeat melodrama in 1951. (Incidentally, it was screenwriting wizard Raymond Chandler who, along with fellow scenarist Czenzi Ormonde, ably converted the Patricia Highsmith mystery novel on which Hitchcock based the whole suspenseful enterprise.)

But make no mistake: the film buff lore of this station plays second fiddle to its appeal for railroad devotees. Today the old station contains a museum chock-full of interesting objects and souvenirs from railroading's gilded era, as well as a collection of model train sets, all operable, certain to delight aficionados and fans of that hobby, young and old. On a

typical weekday the museum is alive with happy parents treating their children to a rip-roaring good time, joined by nannies eager to divert and delight their young charges. Serious railroad enthusiasts join them, many having traveled considerable distances to be there.

Out back is another big reason for this enthusiastic turnout, especially among the older set of railroad enthusiasts. On several acres the once busy Danbury rail yard has been converted to a living museum featuring hallowed steam engines, diesels, boxcars, flatcars, a genuine 1910 U.S. Post Office car, and cabooses of all kinds. The vintage equipment on display ranges from Victorian times through the last-hurrah years of American train travel in the 1960s. There are guides available in the museum who will lead

Opposite Page: A view of the old Danbury Station from the southwest showing the tracks and the canopied platform as well as the rear of the station itself.

Right: A view of the front of the station surmounted by the dormer and showing its plain beige brickwork, the wooden brackets supporting the canopy, and the shingled, hipped roof.

Opposite Page Top: A large parking lot stands in front of the station today to accommodate the many visitors to its museum and its historical rail yard, featuring a working turntable and roundhouse.

Opposite Page Bottom: A Sperry Rail Defect Detection Car: using a sonar beam it detects flaws in the rails beneath it. One of many pieces of authentic equipment on display out back in the old station's rail yard, including a mail carriage, switchers, cabooses, and a V-12 turbo diesel, the "engine of the future."

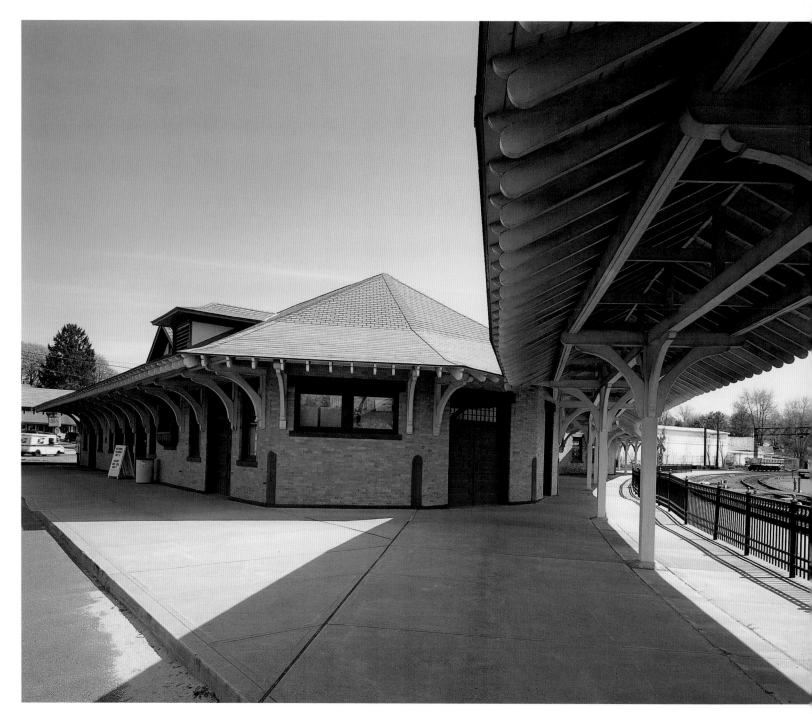

visitors through the yard, explaining the physics and mystique of railroading, including arresting facts about how the steam engines and diesels actually worked. Mechanical buffs will love it, so crisp and substantial are the engineering explanations.

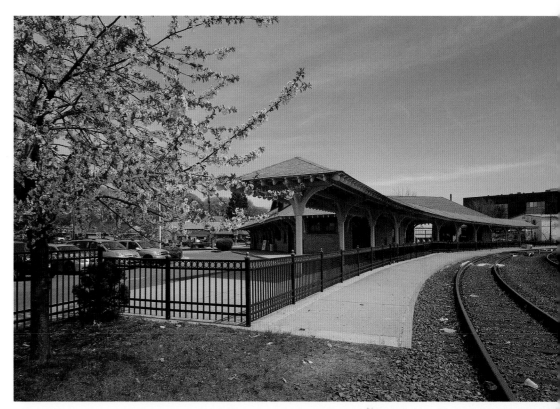

OUTSIDE, THE SIMPLE design of the old station is immediately apparent. Made of plain beige bricks with waist-high cast-iron corner moldings, this handsome one-story station sits beneath a pitched roof of simple light gray asphalt shingles. The main entrance on the north side leads straight into the building's main section, running east to west, off which the arm of the L runs north and south along the east side. The east-side tracks used to serve the long-defunct Maybrook line that ran trains to and from Poughkeepsie. The west-side tracks, guarded by a black wrought-iron railing, today serve the Metro North line that connects to Norwalk, and from there to New York City and south, or to New Haven and north. This set of tracks was the only line when service was initiated between Norwalk and Danbury in 1852 by the old Danbury and Norwalk Railroad, the D&N as it was called. The D&N was eventually replaced by the New York, New Haven, and Hartford, which in turn gave way to Amtrak and to today's Metro North line.

In its prime as the gateway to New England, Danbury Station serviced trains heading in all four directions, and when in 1907 it connected its northern line to Pittsfield, Massachusetts, it set in motion the exodus from New York City that made the Berkshires so desirable as a resort, especially in summer.

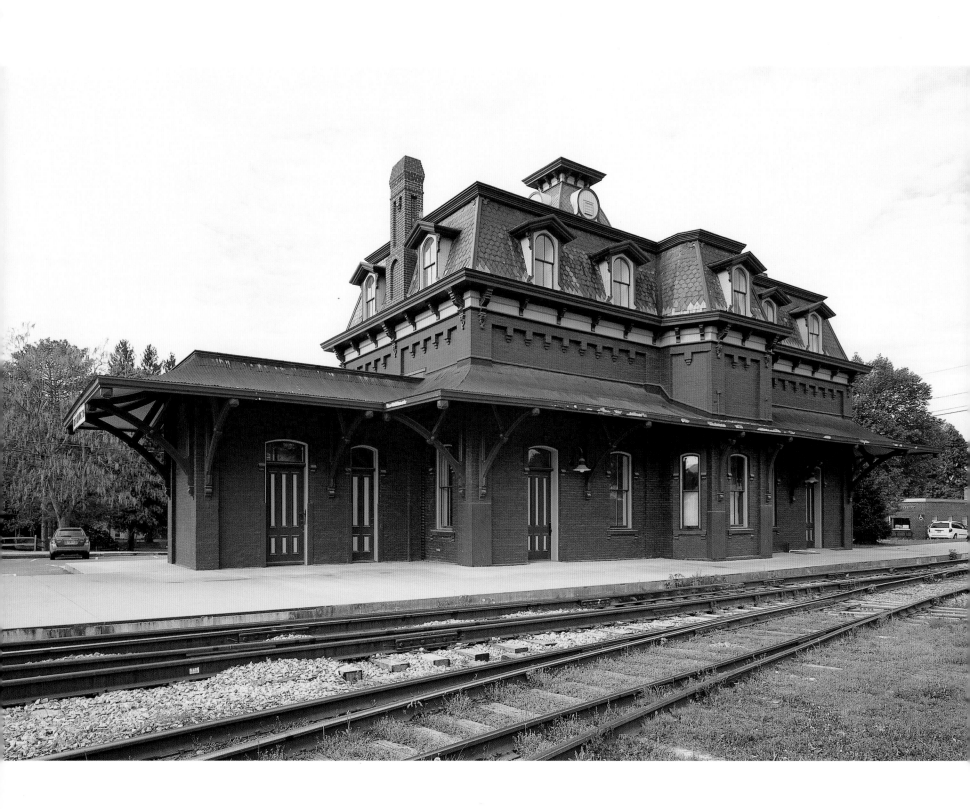

NORTH BENNINGTON STATION

*S*et *against the glorious backdrop of Vermont's rolling Green Mountains, North Bennington Station, built in 1880, is a nearly perfect textbook example of an American station built in mid-Victorian times according to the tenets of the French Second Empire style. Two and a half stories tall with a central tower climbing skyward another story and a half, this station pleases the eye no matter where it falls. The alternating light and*

dark gray hexagonal shingles of the mansard roof give way to brightly painted redbrick walls highlighted by doors and windows painted in light and dark green and decorated with dark green wrought-iron frames and moldings, including small keystones in the lintels of the doors and windows. The overall effect is decorative without being cluttered, pleasing without being solicitous, beautiful without being boastful, self-assured without being overbearing, a lot like the state of Vermont and its inhabitants in general.

Initially the station's tower will fascinate you and focus your attention. Crowned with a low-slung cupola, it has clocks right below the cupola on two sides, on the front and on the west, as you enter from Main Street. Beneath the clocks the tower has a sloping shingled roof descending for a story and a half until it meets the similarly shingled

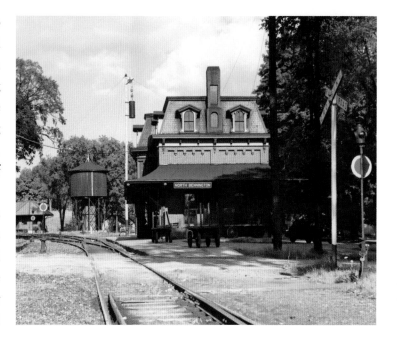

Opposite Page: A view of the rear facade of North Bennington Station from the northeast showing its French Second Empire stateliness and its mansard roofs to full effect.

Left: A vintage photo of the station in 1898 showing its western side.

mansard roof covering the entire upper story. This upper story holds two handsome dormer windows on either side of the central tower. In the middle of the tower, level with the dormers, is a centered double window that originally featured an ornate hood. Unfortunately, when this building was restored, the hood, probably for understandable economic reasons, was not replicated. That's a shame, because old pictures of the station show just how enriching this subdued ornamental flourish was. As things stand today, the centered double window still balances the dormers on either side of it and punctuates the tower forcefully without being showy about it.

Below the mansard roof is a decorative wooden cornice underpinned with handsomely carved and curved consoles. Right under the cornice the architect inserted a low-relief fretwork frieze of slightly raised brickwork. A few feet lower

still, the entire building is wrapped by a sturdy, sweeping canopy that extends outward a good five feet and weatherproofs anyone waiting under it. This is especially welcome in the rear, where it covers the platform next to the double tracks of the Vermont Railway.

In order for the Vermont Railway to pick up the freight loads from Whitman's Feed Store, the twin diesels it uses for this purpose must switch onto the track spur behind the station. If you want to time-travel back a hundred years and more, and if you're lucky, while you visit this lovely station one of these twin diesels will chug up alongside and the conductor will hop down, manually operate the track switch, jump back on board, and give the high sign to the engineer. This simple operation will enable the engineer to steer the diesels onto the spur and access the loads.

If you want to visit Bennington College's beautiful campus, it is a five-minute car ride back down Main Street and then south on Route 67A. You'll see the signs. The campus is nestled among the hills and offers fantastic vistas of the surrounding Green Mountains.

Below Left: The station today photographed showing the same western side in the earlier historical photograph. Whitman's Feed Store is in the left background.

Below Right: A view of the front facade from the east showing the central tower in the middle background.

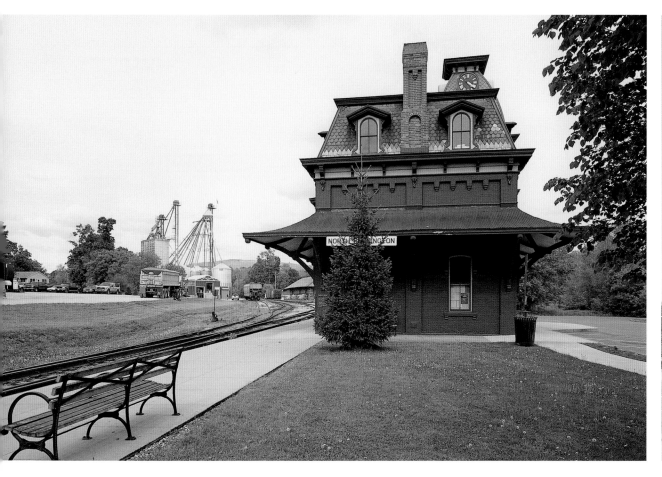

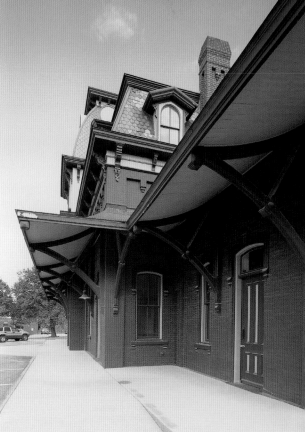

THE SOUTH

*R*ichmond displays two significant stations within a space of a few miles: the Palladian excellence of Broad Street Station and the Second Empire decorative fullness of Main Street Station. Both reflect on a large scale the sophisticated intellect and flawless taste of aristocratic Virginia. On a smaller scale those same two attractive assets are on display in the neocolonial restraint and precision of Williamsburg, which style migrated westward well and found itself once again flawlessly executed in the neoclassical balance and beauty of the Maysville, Kentucky, station.

The Beaux Arts style also found itself well incorporated into the southern landscape with a superb rendition in Chattanooga, where the massive main arch dominating the front facade is equaled within by the awe-inspiring grandeur of the towering rotunda dominating the lobby.

In comely Savannah, probably the most beautiful city in North America, the federalist headhouse of the old Georgia Central Station offers a peerless glimpse of a second-generation American station of intermediate size built with the practical and the aesthetic in perfect harmony.

RICHMOND BROAD
STREET STATION

Broad Street Station in Richmond has Thomas Jefferson's fingerprints all over it, like many beautiful buildings in Virginia, most prominently Monticello and the Rotunda at the University of Virginia. This is not surprising since the great New York City architect John Russell Pope designed this station, the only commercial building he ever designed. He also designed the Jefferson Memorial, the National Gallery of Art,

and the National Archives in Washington, D.C., all three of which, like Broad Street Station and like Jefferson's two masterpieces, are near perfect realizations of the best the neoclassical revival style has to offer.

Construction started on the station in 1917, and it opened to train traffic on January 6, 1919. Fifty-six years later, on November 15, 1975, the last Amtrak train departed. The station was subsequently converted for use as the Science Museum of Virginia.

Since two railroads combined forces to build the station—the Richmond, Fredericksburg, and Potomac Railroad and the Atlantic Coast Line Railroad—the building's official title is Union Station of Richmond, which is still prominently incised in the limestone frieze of the entablature above the

Previous Pages: The refurbished bar and fireside lounge in Chattanooga Terminal Station.

Opposite Page: The perfectly balanced and symmetrical facade of Broad Street Station in all its Palladian glory.

Left: The cast iron buttresses supporting the arched window frames on the ascending walls beneath the rotunda.

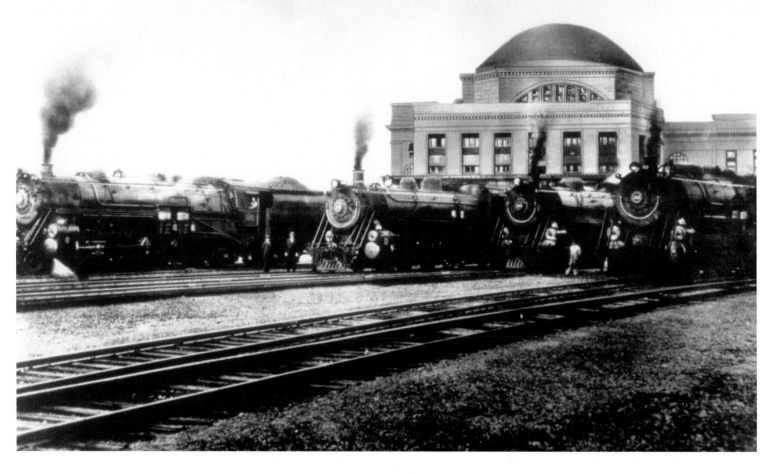

portico forming the main entrance. The portico itself is supported by six limestone Doric columns three stories high. Off the portico to either side are symmetrical wings, housing offices. A copper-clad dome 105 feet high towers above all and forms, on the building's interior, a dramatic rotunda that defines the marble and limestone lobby. Beyond the lobby lies the old waiting room and concourse, from which descends a series of ramps leading to the train platforms below. Their striking butterfly canopies, supported by cast-iron Ionic columns, distinguish these platforms. Today, as part of the museum, a vintage 2-4-4 Chesapeake and Ohio steam engine and coal tender sit on a siding out back, and nearby

are deep-sea submersibles used for scientific exploration in the 1960s and '70s.

During and after the Civil War, Richmond was a key railroad terminus for, and gateway to, the South. For that reason, a short car ride across town is well justified to take in the French Second Empire splendors of the Main Street Station, which today handles the Amtrak trains servicing Richmond. Built in 1901 as a union station servicing the Chesapeake and Ohio and the Seaboard Air Line, Main Street Station features rough-hewn stone footings, elaborate brickwork, fancy arches, loggias, and dormers, and a handsome clock tower, all built next to elevated tracks.

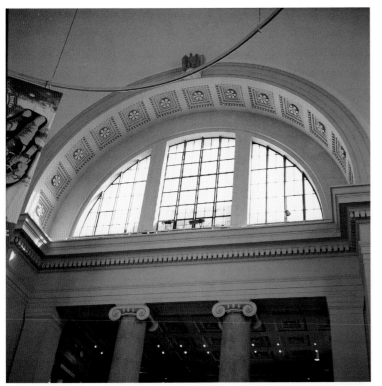

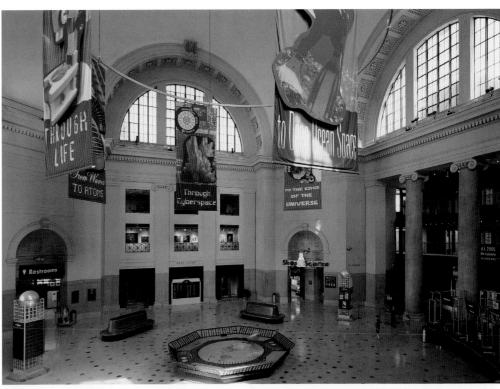

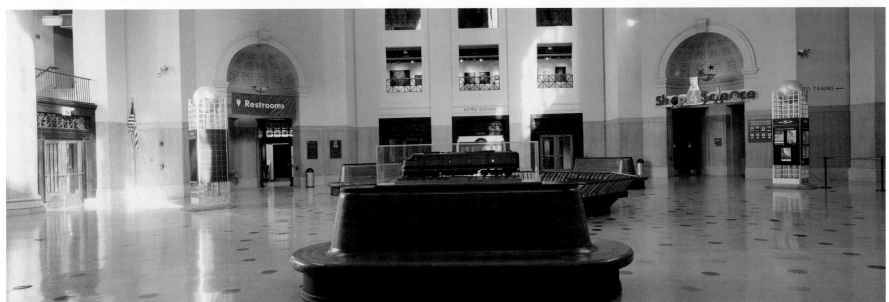

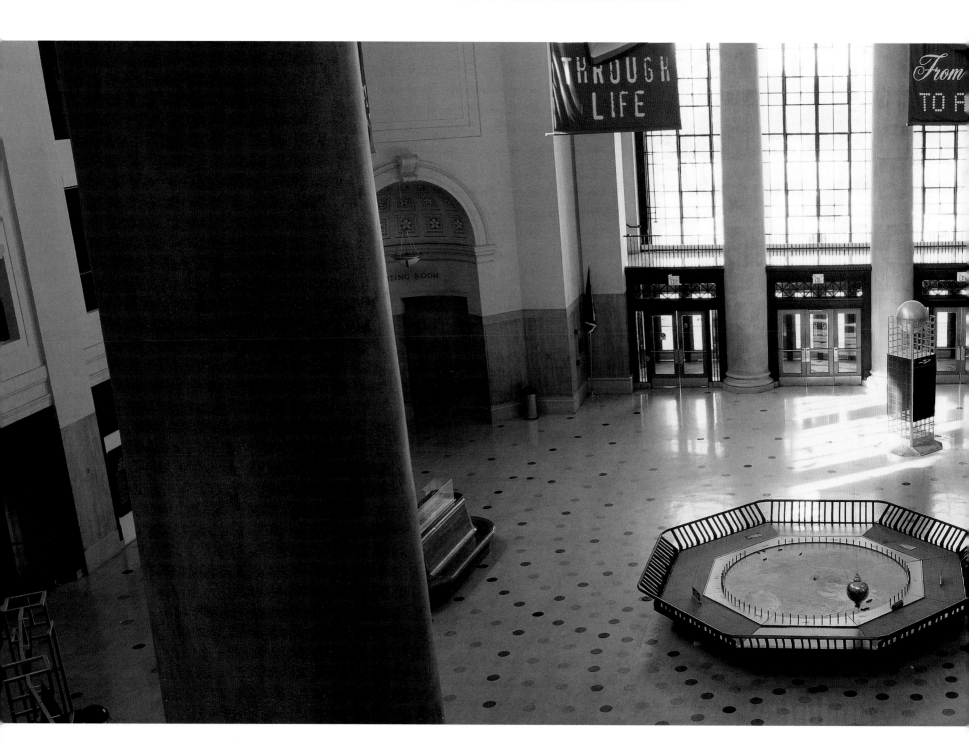

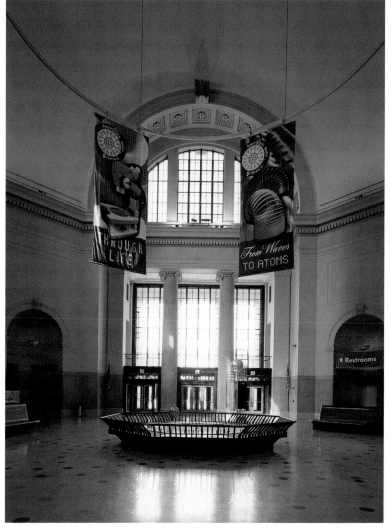

Opposite Page: An overview of the front entrance to the lobby showing its large, columned portal and the hanging golden stylus in the center of the lobby that tracks the rotation of the earth.

Above and Left: Two views of the front entrance from the far side of the lobby underscoring the serene balance of the archway windows and the Ionic columns. Above the frieze, the light sky blue paint ascends to the supporting walls of the rotunda.

WILLIAMSBURG STATION

Williamsburg Station, built in 1935, is a perfect example of a neocolonial southern rail depot for a small town. Like almost everything in Williamsburg, it is lovingly maintained and manicured to a T to ensure the tourist trade the town depends on. This quality imparts to the station an almost doll's house delicacy that is at odds with the hustle and bustle one associates with train travel in its prime. These days only

a handful of passenger trains stop here—two trains in either direction between Norfolk and Boston twice a day every day, except Friday, when there are three.

The original 1881 wooden Victorian station, the first railroad station in Williamsburg, was built the year the Chesapeake and Ohio extended its line from the coalfields of West Virginia to the port city of Newport News. The second Williamsburg station, the 1907 neocolonial version, was built to help celebrate the three hundredth anniversary of the settling of Jamestown. Some bricks from that building have been recycled into the current, larger neocolonial station. Never forget: the Jamestown settlement preceded the landing at Plymouth Rock and the establishment of the Massachusetts Bay Colony by thirteen long years.

THIS SIMPLE YET tasteful neocolonial station, one story tall, has a small pedimented portico supported by four fluted Ionic columns anchoring its front facade. The facade itself consists of handsome brickwork bonded in the Flemish style, with trimwork in trapezoidal patterns accenting the lintels above the windows. These decorative brickwork trapezoids are accessorized deftly with limestone keystones. A frieze—plain, small but prominent, with simple fretwork above it—underpins the pediment. This white-painted frieze continues on the central section of the building to form a cornice beneath the eaves. The roof, quite high, is steeply pitched and utilizes slate shingles, flawlessly arranged. Tall wide chimneys brace either end of the central section of the roofline. The charcoal gray of the roof's shingles contrasts nicely with the red bricks

Opposite Page: A lengthwise view of the station showing the lovingly maintained garden at the western end.

Right: The front facade of Williamsburg Station subtly highlighting its unostentatious neocolonial beauty and balance.

Below: An Amtrak train making a stop at the back of the station. Be sure to see the rear facade: it has understated charm.

and the egg white trim of the portico, the pediment, the cornice, the doorjambs, and the window frames.

On either side of the station's central section are recessed wings, punctuated skillfully with windows and a door. The wing on the left, the one with the door, today holds the bus station waiting room, its ticket office, a car rental office, and other services. The wing on the right houses the stationmaster's office and the train ticket offices. In between the wings is the larger waiting room for the train passengers, accessed directly through the main doorway under the portico.

The interior is unfailingly tasteful. The floor consists of beige quarry tiles, the walls are made of glazed umber bricks, and the woodwork in the wainscoting, doorjambs, and window frames is a stained and highly polished walnut. Historic pictures adorn the walls and document interesting moments in the history of the current station and its two predecessors.

There are welcome and classy touches everywhere, from the comfortable wrought-iron furniture to the patterned rugs to the occasional planters adding a spray of greenery and the plain white lighting fixtures hanging from the ceiling. The entire interior is homey without being hokey about it.

THE BACK OF this station merits a close look. Access it by walking out the front doors and turning right. This way you will pass the west side of the station. Note on this side of the building that there is a covered walkway supported by short white columns in front of a brick extension built onto the original wing. This brick extension inside the building houses part of the bus station and car rental facility that spills over from the original wing; also, built onto this western side is a wooden extension that warehouses freight and handles other storage and shipping requirements of the station. At the end of the extension you pass a vigilantly maintained garden effulgent with flowers, plants, and richly fragrant and colorful ornamental trees that in late summer sport snowy white blossoms.

After you walk around the garden, a platform at the back fronts the two sets of rails. One-story-high cast-iron Doric columns, painted green, support the platform's umbrella canopies, painted a light beige. There is also a large matching light beige canopy stretching from the double back doors out to the platform canopies, so passengers are never exposed to the elements while they wait. The platform itself is paved with red bricks, and for passenger safety there is an attractive white wrought-iron railing that runs the length of the platform except for a small gateway for the use of boarding and departing passengers.

While being very careful as you do so, cross the tracks and take in the back view of the station. The rear facade has the symmetry and the striking lines of the front, but there is as well the standard bay window one almost always finds in the trackside facade of a small-town railroad station. Situated in the stationmaster's office, it affords a view of approaching and departing trains in either direction. One more attractive little accent is worth noting: a magical little accoutrement in the form of a recessed dormer tucked asymmetrically into the eastern side of the main roof. It's quirky, it's quaint, and it adds character.

From overexposure in suburban housing developments and in ersatz college architecture for the last eight decades, the neocolonial style in architecture has suffered both degradation and, in the housing-bubble horrors of the McMansion era, desecration. Despite this, a building as brilliantly conceived and executed as Williamsburg Station summarizes and illustrates this resilient style's manifold strengths and almost inexhaustible capacity to please.

Below: The lobby features walls of glazed umber brick, handsome dark walnut woodwork, floors of beige quarry tiles, wrought iron furniture, patterned rugs, and historical photographs.

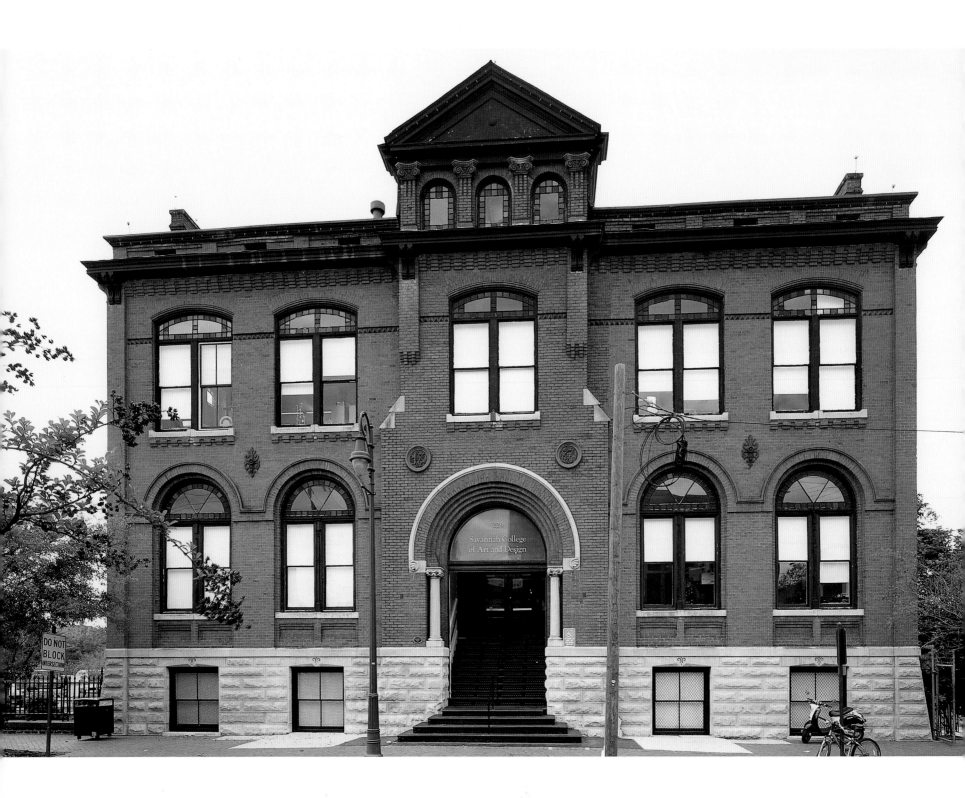

SAVANNAH CENTRAL OF GEORGIA STATION

Savannah would be at or near the top of any list of the most beautiful cities in North America, and for railroad fans it has a station that is thrilling both architecturally and historically. And to top off a visit, there is a roundhouse museum that will entertain railroad buffs of all ages. When cotton was king, Savannah and New Orleans formed the two chief ports of the realm. During the nineteenth century, railroads brought

bale upon endless bale of cotton to this beautifully planned and lushly planted tropical city with ready access to the Atlantic Ocean and, via clipper ships, the humming mills of the British Midlands. America grew the cotton; England turned it into linens and clothing.

Prosperity benefited this city, and its ingeniously laid-out squares hosted antebellum mansions whose beauty even today is undiminished. Because of this cotton bonanza, Savannah outgrew its station facilities in 1850, so Central of Georgia Railroad superintendent William M. Wadley planned a brand-new, greatly expanded station complex that could handle the influx of passengers and freight, and even service and repair the locomotives and rolling stock. Today much of that complex is still standing and being refurbished

and repurposed as a museum and, in the case of two handsome buildings, as dorms and office space for the Savannah College of Art and Design (SCAD). For this latter foresight the college has been lauded by the Historic Savannah Foundation and the Georgia Trust for Historic Preservation.

Superintendent Wadley started building the new station complex before the Civil War, but it wasn't completed until a quarter century later, the interruption of the war accounting for a good deal of the delay. The four main components of the complex are the federalist headhouse, the factors building, also in the federalist style, a Greek revival office building, and, out back and off to the side, a large roundhouse and repair installation. Both the factors building and the Greek revival office building are now part of SCAD.

Opposite Page: The plain but symphonically harmonious late federalist facade of Savannah's Central of Georgia Railroad's factors building. Note the crowning touch of the tri-windowed and pedimented dormer.

Right: Behind the headhouse stretches the large train shed with its wide and canopied doors to allow ingress and egress of bulky freight. The truss structure in the roof of the train shed inside must not be missed.

Far Right: The late federalist style facade, serene and subtle, of Savannah's Central of Georgia Station's headhouse.

Opposite Page: Side view of the factors building showing the lengthy office and warehouse space stretching out behind it. Today this building is part of SCAD, the prestigious Savannah College of Art and Design.

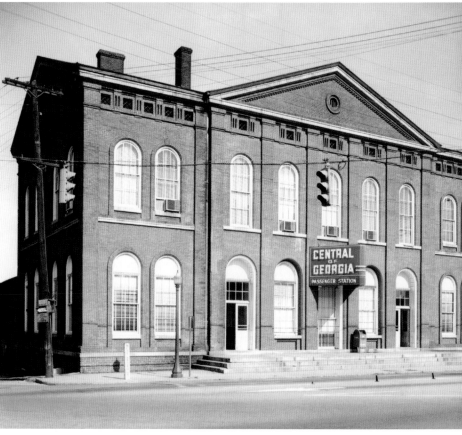

THE PRINCIPAL FEATURES of the headhouse and the factors building are the classic federalist touches, such as raised brickwork, the unadulterated symmetry of windows and doors, the use of stained glass, the limestone footings and massive main entrances with their substantial stairways, and the decorative flourishes of cupolas and cornices. When you look at these two buildings, it's easy to understand why the federalist style is often also called early Victorian; it is clearly the bridge between the early neocolonial and Georgian styles of the eighteenth century and the full Victorian style of the latter part of the nineteenth century.

The Greek revival office building—in another style popular with the Victorians—has a stately portico supported by six Doric columns supporting a handsome, unadorned pediment. The roundhouse and its repair shops are classic Victorian industrial buildings, stolid and utilitarian to the core. For railroad aficionados and children, they are well worth a visit, since they showcase installations such as an extensive black-smithing shop and a large machine shop; in addition they have on display interesting rolling stock, both freight and passenger, restored to its original condition, including the luxurious "rolling office" carriage used by the president of the Central of

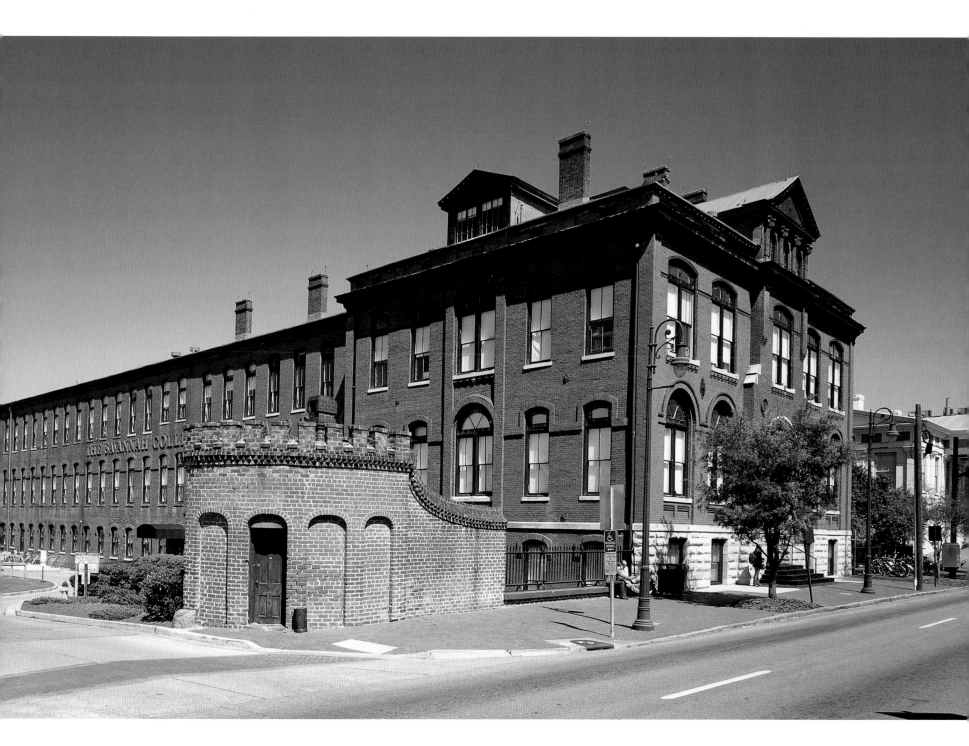

Right: Straight-on view of the Greek revival facade of the office building originally built by Central of Georgia to supplement its station's original federalist buildings. This building too is now part of the SCAD campus.

Below Left: The restoration of the roof is underway on one of the repair shops and foundries in Central of Georgia's wonderful rail yard museum adjacent to the station proper

Below Right: The working turntable with a switcher sitting on it and the corner of the roundhouse visible at the right. Between the switcher and the roundhouse in the far background is the train shed.

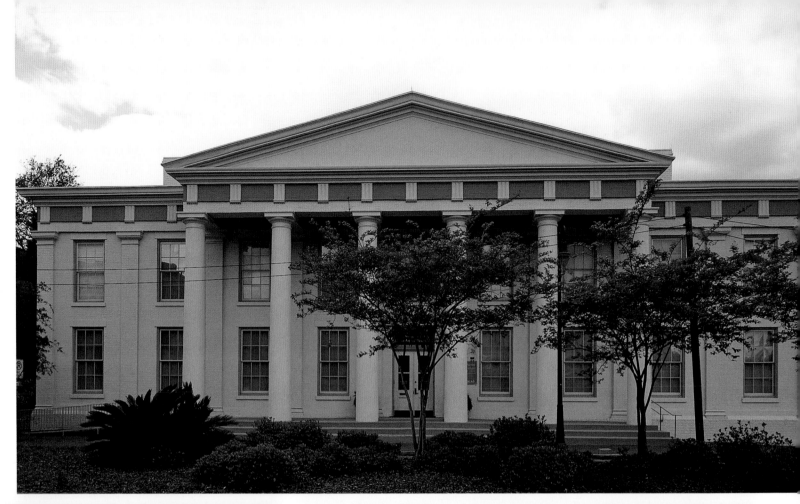

Georgia Railroad. The roundhouse also has a functioning turntable, and on weekends rides are available.

The headhouse has an impressive train shed built behind it. Between it and the roundhouse across the road sits the site of the decisive Revolutionary War battle in which the great Polish patriot General Casimir Pulaski lost his life in the cause of American liberty. As for the Civil War, the town, like the station, is steeped in its history, and the Green-Meldrim House, one of the finest examples of gothic revival architecture in the South, where General Sherman made his headquarters after his famous March to the Sea, is still on display downtown on Madison Square, next to St. John's Episcopal Church, in which the general and his staff attended Christmas services in 1864.

Left: A very early model of a small and primitive steam engine on display in the museum.

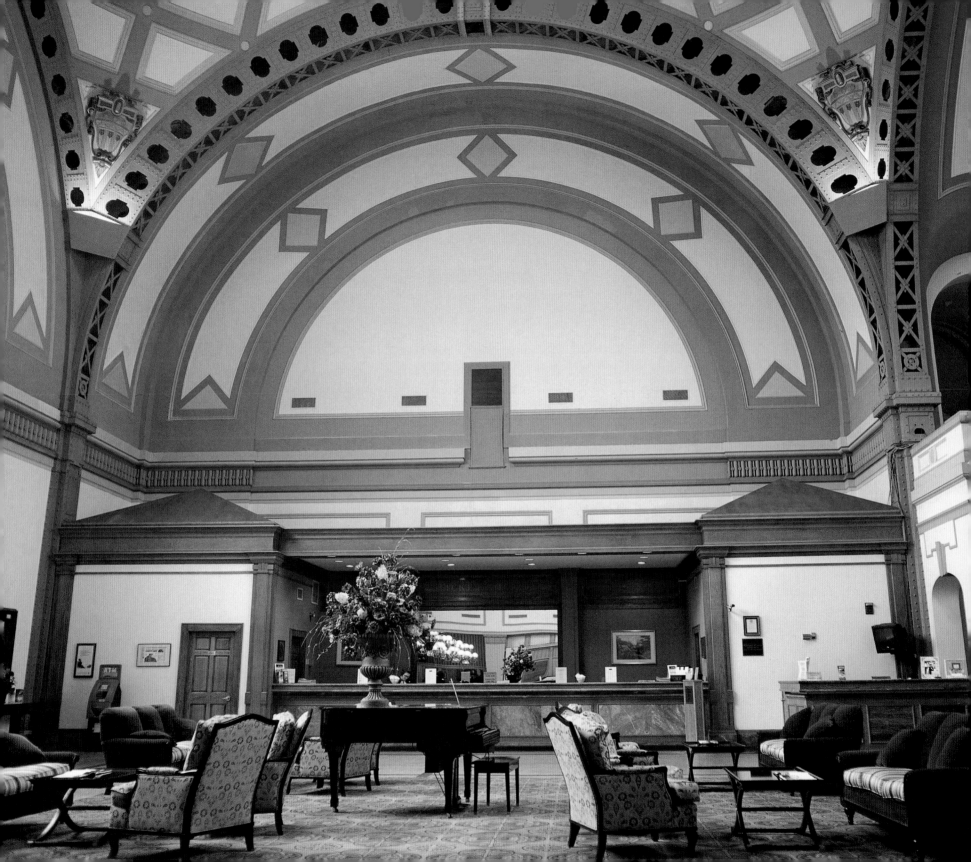

19

CHATTANOOGA TERMINAL STATION

Chattanooga Terminal Station is highly distinct. Two overwhelmingly effective features render it so. First, its massive single arch in the front facade is like none other; for years it was the world's largest arch, until the construction of the soaring arches of the architecturally groundbreaking and justifiably lauded Sydney Opera House. Second, its stunning lobby, an organic extension of the single massive exterior arch, showcases

as its centerpiece an exquisite rotunda crowned by a large circular skylight. These two features were bold strokes in 1909 when the station first opened. Although both features fit neatly within the classic parameters of the Beaux Arts tradition, they nevertheless brazenly anticipate much to come in modern architecture, especially in their shunning of all but minimum ornamentation. Both also emphatically come down on the side of plain mass, clean lines, strong planes, and uncluttered space. Focus on these two features when you visit the station. Time spent admiring them is time well spent. Other features of the station are not worth but a few moments spent on them, since the station's conversion to a hotel and entertainment complex has obliterated their original appeal.

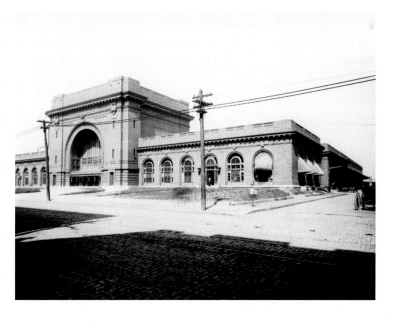

Opposite Page: A view of the extravagantly grand lobby facing the east sidewall that holds the reception desk.

Left: Chattanooga Terminal Station as it looked when it opened in 1909.

THE SALIENT IMPRESSION the station makes as you approach is one of forceful solidity. There is the dominant central section with its foursquare substantiality and its single massive arch: it amounts to a giant cube with the formidable presence of a castle keep. Six stories high, it looms over the two recessed wings, each only three stories high. Six arched windows, themselves two stories high, stand like devoted rooks at either side of the kingly central arch and reflect and extend its power, radiating from it in two regal files. That these smaller arched windows replicate the central arch's shape precisely enhances their ability to multiply its spatial aura and intensify its looming beauty. Ornamentation is minimal.

This sparseness reinforces the facade's fearful symmetry and geometric perfection. That the building consists almost entirely of handsome red bricks shows as convincingly as did Henry Hobson Richardson's New London station that this ordinary building material can yield magic when deployed to emphasize mass, plane, and line in complete compositional balance and in total spatial harmony.

THE LOBBY IS magnificent. Shaped like a cube, it has three dominant arches on each wall echoing the central arch of the facade, which faces west. The east wall has, like the

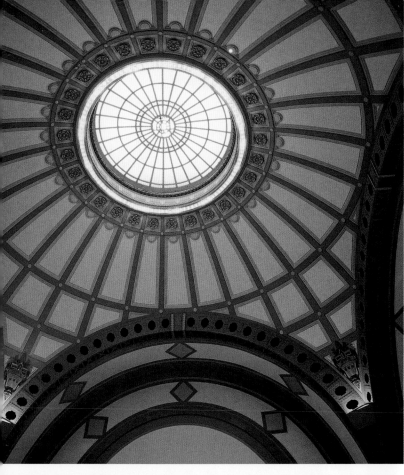

front facade, three stories of arched windows, in five panels, filling its arch. The two sidewall arches, on the north and south sides, are walled in. Within these arches the walls are recessed for symmetry with the windowed front and rear arches.

The four identical arches of the lobby underpin the supporting walls and the pendentives of the rotunda that soars above them until it climaxes at its summit in the dramatic white ocular skylight with its delicately etched and patterned glasswork. A raised plaster circle bordering the skylight holds a ring of green rosettes interspersed with lightbulbs.

The flooring of the lobby is tan terrazzo that perfectly complements the room's dominant color scheme of deep brown and light green.

HAVE NO DOUBT about this: Chattanooga Terminal Station embodies great architecture. Its back story is remarkable. New York architect Don Barber was still a student at the École des Beaux-Arts when he presented the plans for this station and won a contest for best designed railroad station for a large city. He later showed these architectural plans to the executives of the Southern Railroad. Immediately recognizing the merits of Barber's design, they chose it for the new station in Chattanooga but asked Barber to change his plans for the interior to replicate the configuration of the National Park Bank in Manhattan. He did. Thus the great lobby with its exquisite rotunda and skylight.

And it's a commendable station that, while acknowledging its Beaux Arts classicism, amalgamates that style's lyricism with the substantiality of the Richardsonian Romanesque to foreshadow the stripped-down strengths of modernism.

Top Left: A bird's-eye view of the stained-glass skylight in the ocular at the crest of the rotunda that crowns the lush lobby below it.

Bottom Left: A four-tiered fountain plashes water in a small plot of grass adjacent to the train tracks and platforms behind the station.

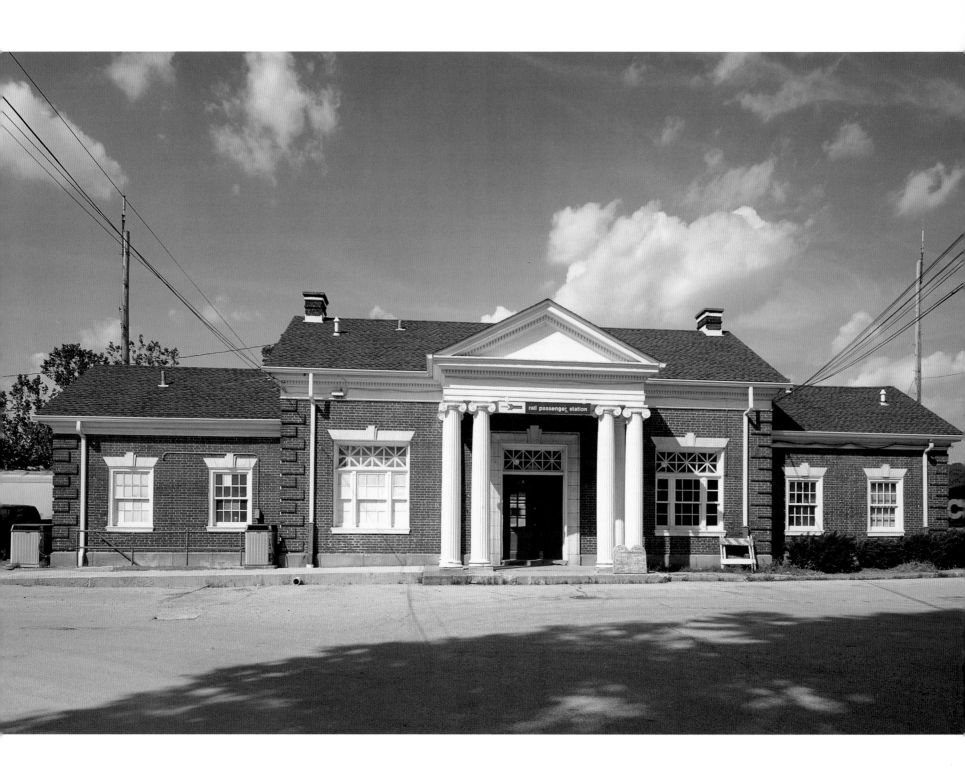

MAYSVILLE OLD CHESAPEAKE AND OHIO STATION

Your first thought as you drive down Rosemary Clooney Street and spot the Old Chesapeake and Ohio Station in Maysville, Kentucky, framed by the floodwall, is how beautifully this manmade structure crops and highlights the building's small portico and colonnade. This perfectly proportioned station is a classic example of the colonial revival style at its best. Colonial revival, of course, is based on the unbeatable balance and taste

of the eighteenth-century Georgian style that always evokes images of the prevailing architecture in use at the time of America's beginnings as an independent nation. As you gaze at this typically southern small-town station, your patriotism spikes.

The setting doesn't hurt. The station sits on a dramatic bend in the Ohio River as it heads its western way to join the emblematic Mississippi and flow the length of the South until it debouches into the Gulf of Mexico. From the station's forecourt two handsome bridges are within easy sightlines, one east, one west. The river winds its way through beautifully forested hills in summer; though the Ohio is only a tributary to the Mississippi, on a clear June day you'll think you're viewing an artist's cover illustration

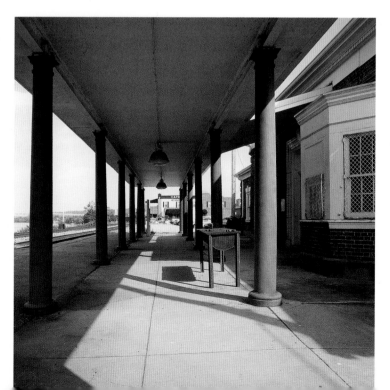

Opposite Page: A comprehensive view of the elegantly understated neocolonial facade of the Maysville, Kentucky, Old Chesapeake and Ohio Station. Note the similarities to Williamsburg Station.

Left: This trackside view shows the bay window in the rear facade with its three-directional windows. The Ohio River peeks through in the left background.

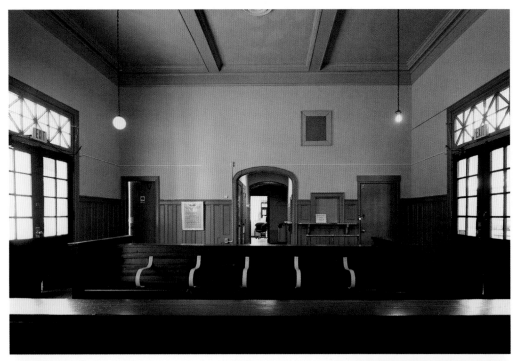

for a handsome new edition of Mark Twain's classic *Life on the Mississippi*. When you learn that the *Delta Queen* came here until the spring of 2009, you'll understand how sound your insight was.

AROUND BACK A smartly placed bay window, small but effective, breaks up what would be an otherwise too dull facade. Behind the bay window sits the old stationmaster's office and ticket window, no longer serving their original functions. Today the ticket window is permanently closed and the office is used as an administrative outpost by CSX, the giant railroad shipping concern. The three sets of tracks out back mainly serve the CSX freight trains that use the station frequently, now that Amtrak runs only four passenger trains a week through here: *The Cardinal*, twice a week in both directions, Chicago to Washington, D.C., and vice versa. You can no longer even buy an Amtrak ticket here; you have to do it online or at another Amtrak office.

THE INSTANT YOU enter the interior you sense its neglect. It needs to be restored, but funds are not likely to be made available for this purpose, given the station's scant use these days as a passenger terminal. The smart move is to get back outside and ogle the fabulous riverscape one last time.

Maysville, as you gathered no doubt from the presence of Rosemary Clooney Street, was the hometown of Rosemary Clooney, the legendary chanteuse and aunt of actor and filmmaker George Clooney.

Opposite Page Top: The small and modest waiting room awaits a refurbishing and restoration effort but is nevertheless winningly demure.

Opposite Page Bottom: The trackside view looking eastward at the big bend in the Ohio River behind an approaching freight train..

Left: The recessed and fretted pediment atop the small portico supported by Ionic columns adds infinite élan to the station's masterfully restrained facade. Note the Ten Commandment tablets.

115

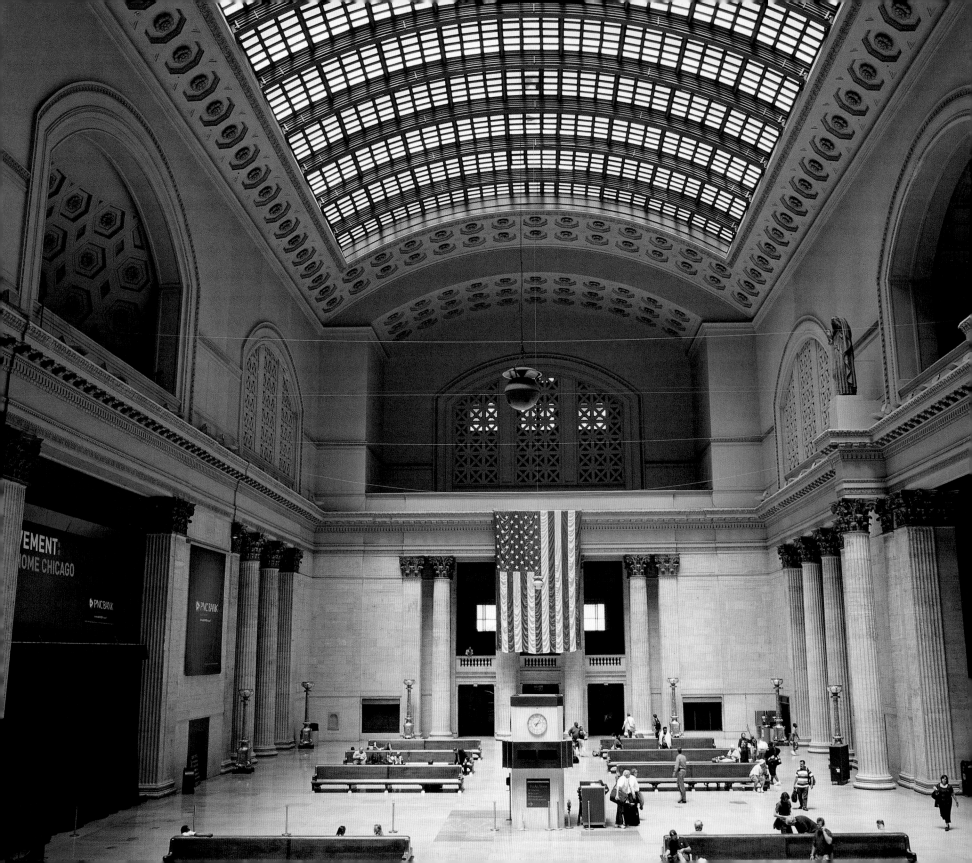

THE MIDWEST

In the Midwest lurk three examples of intermediate second-generation stations executed in the solid late-Victorian American style: Durand, Kalamazoo, and Niles, an enviable trinity well worth a side trip. In St. Louis, there is also a large and significant hybrid station designed and built with second-generation Victorian staples—a vaulting clock tower, stained-glass windows, and gothic dormers and gables—yet, despite being solidly grounded in the Victorian style, this transitional masterpiece simultaneously embodies the retrospective mass of the Richardsonian Romanesque and foreshadows the Beaux Arts penchant for classical forms and decorative elements. By combining these three styles, this station offers a Rosetta stone of American styles, each distinct and characteristic of a different era. It's an architectural treasure trove repurposed today as a restaurant, hotel, museum, and food court.

In this region the Beaux Arts style finds itself superbly executed in the Burnham-inspired classicism of Chicago's Union Station and in the geometrical and rectilinear variations on classicism, ever so subtle, blended and balanced with plain mass and harmonious symmetry by architect and City Beautiful proponent Jarvis Hunt in his magnificent Kansas City Union Station, an underrated architectural achievement if ever there was one.

The Midwest holds another architectural structure worthy of note: despite its drawbacks, which render Cincinnati Union Station something of a curiosity, it is the boldest, most unadulterated, and most relentlessly sustained homage to the glories of the American art deco style ever executed in a train station. Regrettably, however, the station's components never integrate themselves fully, handicapped as they are by overstated massiveness; as a result, the intended magic never materializes.

Previous Pages: The grand hall of Chicago's Union Station. Note the 100-yard-long, 115-foot-high skylight, the gold-leafed capitals of the Corinthian columns, the coffered ceiling in the distant alcove, the marble floor, and the allegorical statues above the archway entrance from the east lobby.

Right: The facade of St. Louis Union Station's head house showing the main entrance with its stone staircase, the twin piers with their pointed turrets, the columned loggia, and the rustic footing, all of them constructed from solid Indiana Bedford limestone.

Opposite Page: The beautifully rounded apsidal end of the Niles Depot constructed of Ohio brown sandstone.

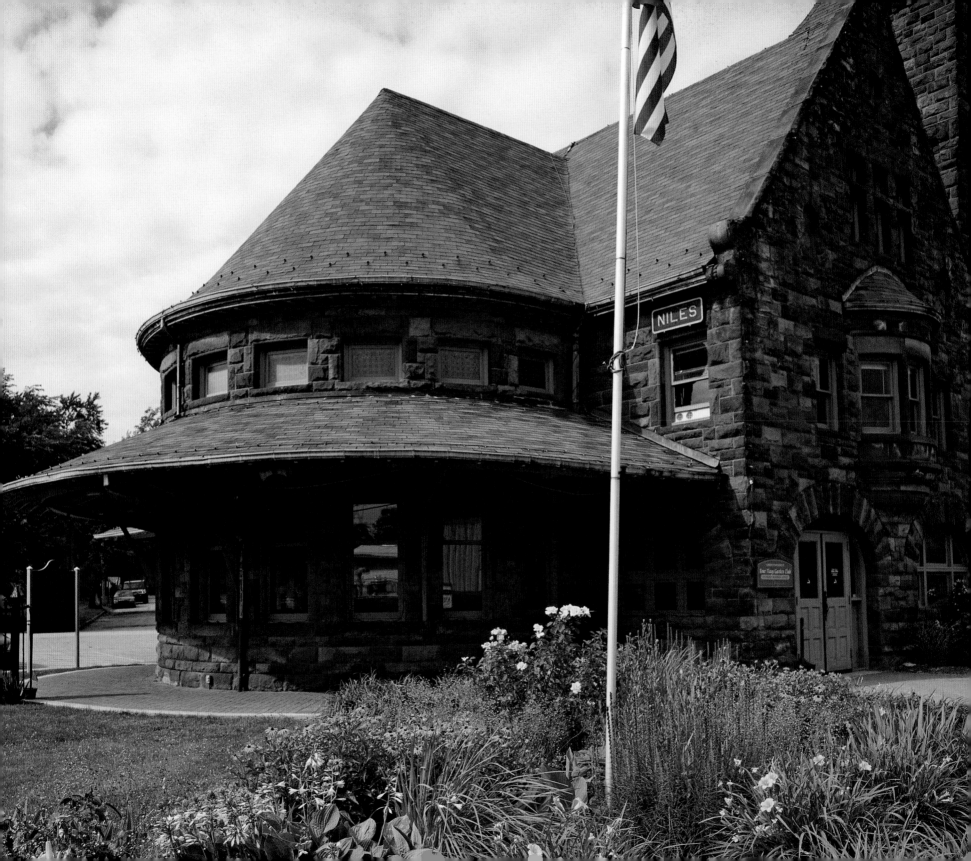

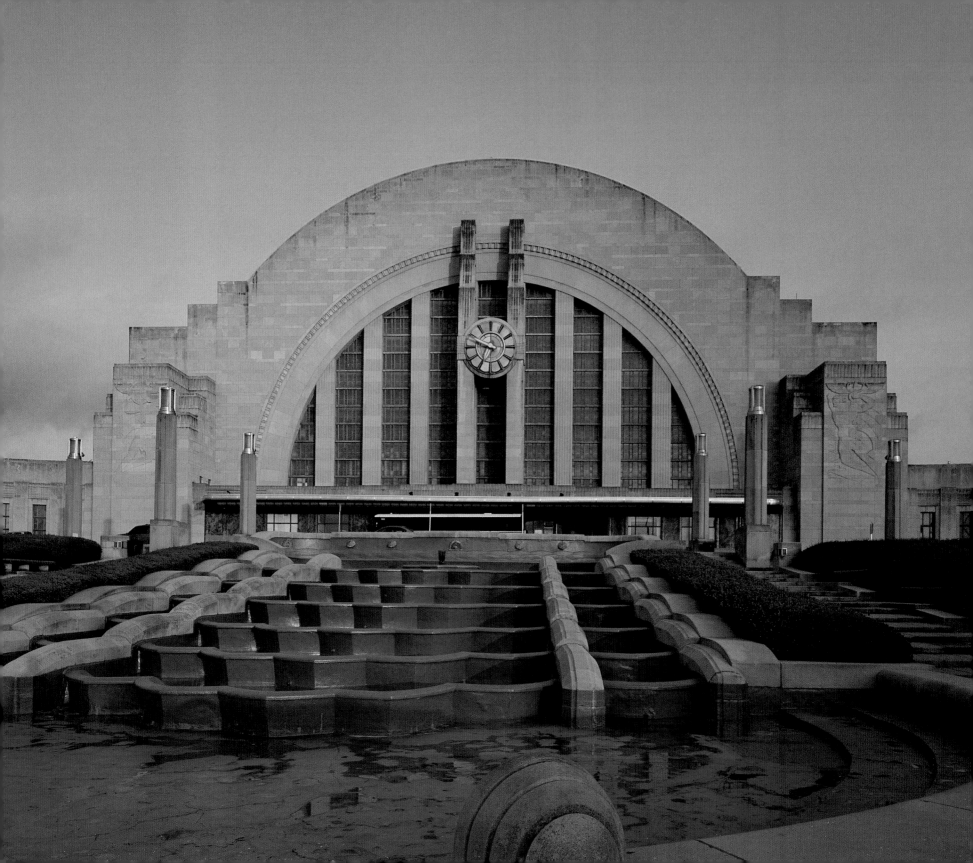

CINCINNATI UNION TERMINAL

Seen in the distance, Cincinnati Union Terminal looks like the world's largest tabletop art deco radio. As you draw nearer you half expect the heavens to open and the unmistakable voice of FDR to thunder forth megaphonically in an uncharacteristically angry voice for a fireside chat, and accuse you, individually and solely, since you're the only one who can hear him, of having single-handedly caused the Great Depression. This

is so because, despite the building's obvious grandiose longings, there is something funereal about it. As a railroad station its fate bears more than a passing resemblance to Howard Hughes's eight-engined doozy of an amphibious airliner, the ill-fated *Spruce Goose*.

The great people of Cincinnati managed to salvage their potential white elephant and today it houses a congeries of cultural institutions under the umbrella designation Cincinnati Museum Center: the Cincinnati History Museum, Museum of Natural History and Science, Duke Energy Children's Museum, the Robert D. Lindner Family OMNIMAX Theater, and the Cincinnati Historical Society Library. As a railroad station it was late to the party; as a cultural epicenter it has been reborn as the life of the party. That it was DOA in 1972, when Amtrak pulled out, and is today A-OK shows

civic resourcefulness and cultural imagination. In 2007 the American Institute of Architects designated it the forty-fifth most popular building in the United States, and many critics consider it an art deco masterpiece in the same league as Rockefeller Center's Radio City Music Hall.

UNION TERMINAL REPRESENTS a tremendous civic effort. In the days when railroads were the dominant form of transportation for people and freight, Cincinnati was the busiest rail nexus between the coasts and between the North and South, outstripping even Chicago in this regard. It played host to seven different railroad companies using five different stations spread across the city, which was inconvenient for making connections. For three decades the civic leaders tried to

Opposite Page: Frontal view of Cincinnati Union Terminal showing the tiered pools of the waterworks in the foreground and the looming facade with its gigantic clock in the background.

Right: The front entrance and lobby under the polychromatic half rotunda with the polished steel peristyle of the information desk in the center.

Below: The aquamarine half ocular at the top of the half rotunda, with the brightly colored rings of paint descending in ever widening rings from it.

Opposite Page: Striking murals by artist Winold Reiss decorate the lobby. Beneath them note the art deco splendors of the short marble columns topped with simple white lights resembling hatboxes. Above the murals the half rotunda ascends in rings of color.

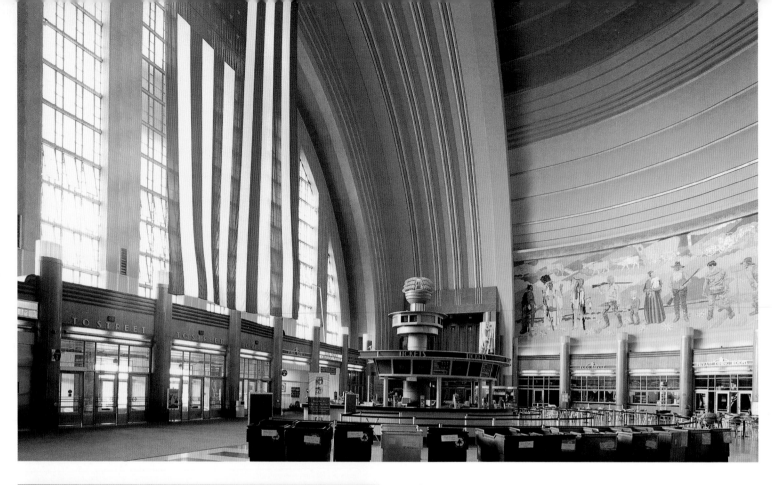

reach an agreement to build one large station uniting all the city's rail services. Unfortunately, by the time an agreement was reached among the seven railroad stations, rail travel had already peaked and was soon to rapidly decline, eroded for the usual reasons: the rise of travel by car and bus and the emerging option of air travel. This decline in the importance of railroads to the nation's transportation needs meant that the new Union Terminal in Cincinnati served its anticipated purpose only from its opening in 1933 until shortly after the end of WWII, a little over a dozen years. During the war, as at most American stations, usage peaked. But the station's size and capacity had been premised on significantly increased, rather than significantly reduced, rail traffic. When the station closed on October 28, 1972, after only thirty-nine

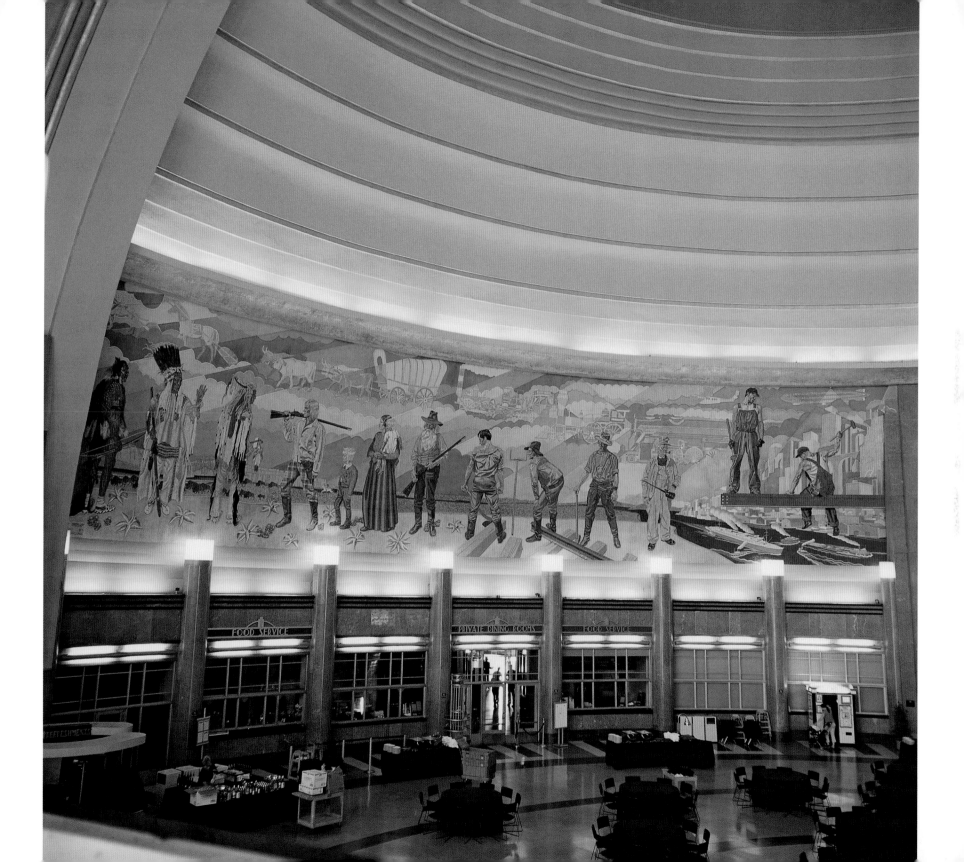

years in operation serving its original purpose, Amtrak was running just two passenger trains through it a day, *The Cardinal,* connecting Chicago and Washington, D.C., one train in either direction.

A few years after the station closed, it was briefly reincarnated as a shopping mall, but that, unfortunately, did not last more than a few years, from 1980 to 1984. Then there was talk of abandoning the station until the citizens of the city decided instead to float a bond issue to underwrite conversion of the building to its present use as the Museum Center. The conversion construction took three years, from 1987 through 1989. Today it is the seventeenth most frequently visited museum in the country. This would make George Dent

Crabbs proud. He was the original civic hero who worked for a solid four years, from 1923 to 1927, to induce the railroad companies to come together and issue construction bonds to build Union Terminal. A thousand people congregated a year later, in 1928, to celebrate at a dinner. The event was such a big deal that *Time* magazine covered it.

THE ORIGINAL PLANS for Union Terminal were drawn by Fellheimer and Wagner, a New York architectural firm that designed the beautifully conceived and flawlessly executed Utica Union Station and Buffalo Central Station, both built for the New York Central. They had designed more than one

hundred railroad stations, but were considered too conservative in their Beaux Arts approach for Union Terminal. So French-born Philadelphia architect Paul Philippe Cret came into the picture to liven things up. For years a professor at the University of Pennsylvania's prestigious school of architecture, he would later be the principal architect on the striking University of Texas campus at Austin. Hungarian-born engineer Roland Anthony Wank, who went on to become the chief architect for the Tennessee Valley Authority, was enlisted to help Cret rework Fellheimer and Wagner's plans.

In ordering rewrites on screenplays, Hollywood brings in additional writers for what it calls "body and fender work"; often this move backfires because the collaborators aren't compatible in their visions of what the end product should be. Then the old chestnut about the camel being designed by a committee comes into play. The chief engineer on Union Terminal, Colonel Henry Matson Waite, the MIT-educated grandson of a former chief justice of the

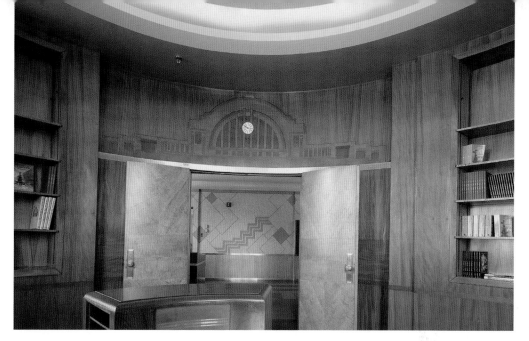

Supreme Court, recruited both Cret and Wank. Waite himself would go on to become deputy administrator of public works for the Department of the Interior in FDR's administration. The net result was a creative committee of three architects and two engineers.

Even though Fellheimer and Wagner would gravitate away from the neoclassical of Beaux Arts toward the thirties industrial streamlined design heavily influenced by art deco, it's safe to say that either Cret or Wank, or both, were responsible for the overarching industrial applications that obliterate the aesthetic aspirations of this building. Many boosters of Union Terminal rank it among the great architectural achievements of the thirties, along with the Golden Gate Bridge, Hoover Dam, and Rockefeller Center. But in that class it would clearly be fighting above its weight. It's highly ironic that in its brief stint as a shopping center it was christened the "Oz Mall"—perhaps Waite, Fellheimer, Wagner, Cret, and Wank should have joined Dorothy and company on the Yellow Brick Road and asked the Wizard to grant this building a soul.

Above: The entrance to the president's office from the reverse angle, showing the receptionist's office beyond. Note the facade of the station recreated in varied-colored woods in the lintel.

Left: The deco fireplace in the president's office with a map of the United States crafted above the mantel in various-colored woods. This suite of art deco offices is unrivaled in our experience.

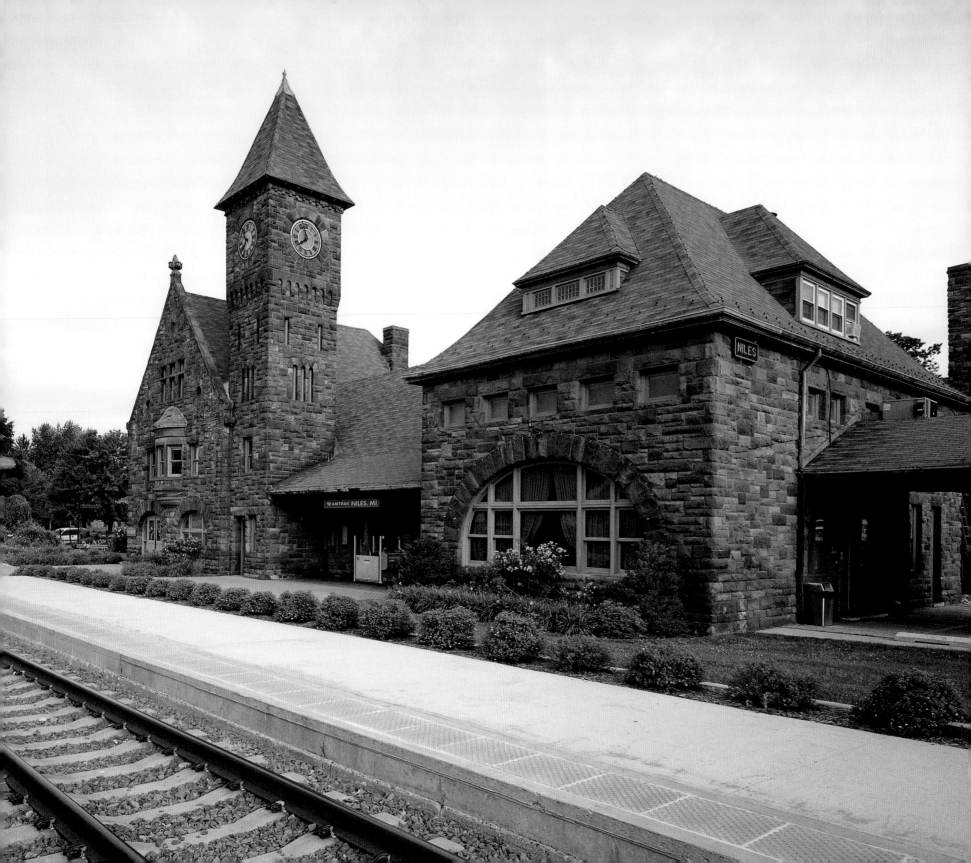

NILES DEPOT

The Niles Depot is a sterling example of a small but substantial late-Victorian Midwestern station in the Richardsonian Romanesque style. Built by the Michigan Central Railroad in 1892, the building was designed by architects Frederick Spier and William C. Rohns and constructed using Ohio brown sandstone. The last major stop before Chicago when approaching from the east, Niles took enormous pride in its station and

commissioned landscape architect John Gipner to furnish it with outstanding gardens, including a small floating garden, a trout pond, and a gazebo. The station was famous for trains stopping there long enough for the passengers to disembark and enjoy a short respite in the gardens before resuming their journey to Chicago, often, the year after the station opened, to visit Daniel Burnham's iconic Columbian Exposition of 1893. Gipner himself initiated the tradition of bestowing an individual flower on all female passengers. The Michigan Central also used the gardens and nearby greenhouses to garnish the station's restaurant and its trains with fresh flowers, especially the dining cars.

The station has three sections. Off to the extreme east sits a single-storied baggage and freight building, connected to the main building by a walkway covered with a hipped roof;

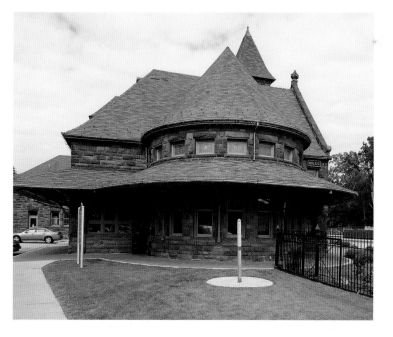

Opposite Page: Rear facade of the Niles Depot showcasing the Ohio brown sandstone in pleasing contrast to the gray shingles of the hipped roof. The clock tower and arched windows add major accents to this Victorian masterpiece.

Left: A view of the building from the opposite western end, showing the apsidal extension that houses the handsome waiting room within.

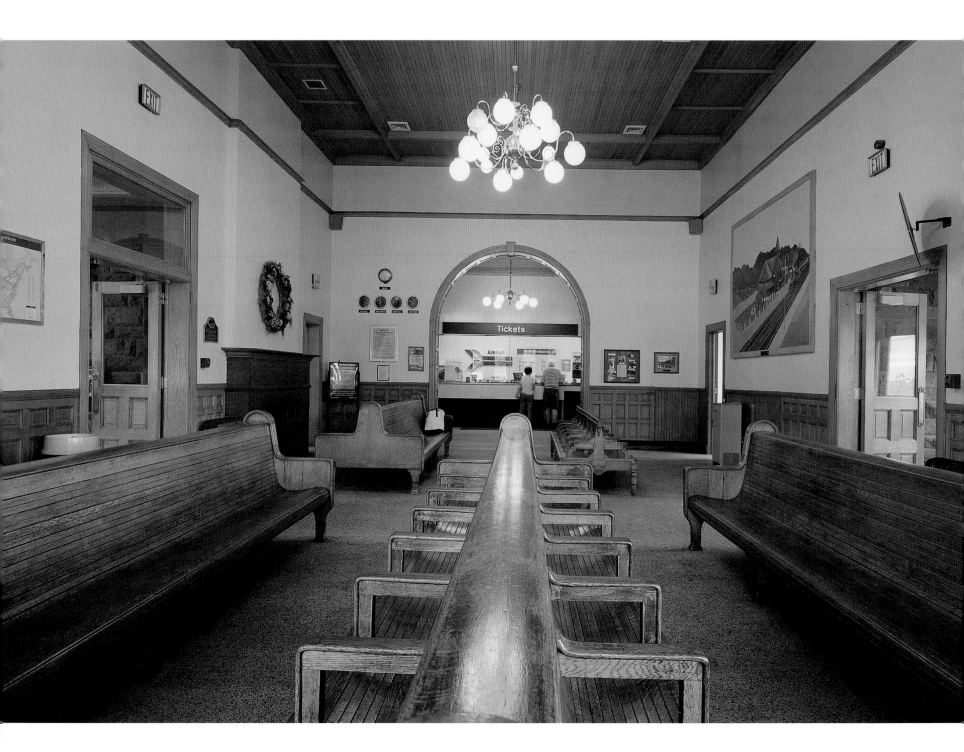

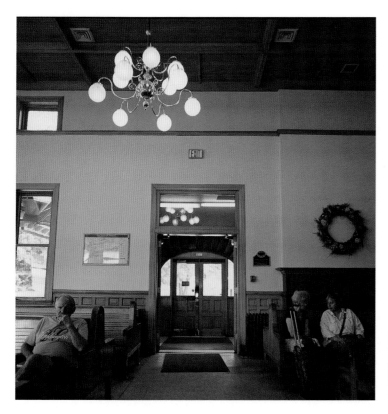

In its solidity this station bears a strong resemblance to Richardson's masterpiece in New London, albeit with more ecclesiastical touches, like the campanile and the apse. Amtrak now owns the station, and renovated it in 1988. The Niles Garden Club keeps the gardens in beautiful trim. Amtrak runs seven trains through this depot daily.

There is something all-American about the Niles Depot, perhaps explaining its use in three movies not all that long ago: *Continental Divide, Midnight Run,* and *Only the Lonely.* Or maybe it's that Niles was the hometown of John and Horace Dodge, who founded the Dodge Brothers automobile company. Then again, Ring Lardner grew up here and gave the world that most American of short stories, "The Haircut."

Opposite Page: The large center section of the station houses the ticket office and the main waiting room.

Left: The main section of the station houses the ticket office and the main waiting room. The doorway next to the fireplace affords access to the apsidal waiting room.

Below: The cozy apsidal waiting room at the western end of the station.

the main building itself is also topped with an attractive hipped and gabled roof. Its easternmost section used to house a restaurant above which, on the second floor, were the chef's living quarters. Moving toward the apsidal western end of the main building, one encounters the lobby and then the handsome circular waiting room in the apse itself, which used to house a large fireplace, a signature component of many stations and libraries built back east by Henry Hobson Richardson. The trackside facade holds an arched main doorway beneath a well-placed bay window. To their side a stone tower rises sixty feet skyward and holds a three-faced, five-foot-diameter clock made by the E. Howard Watch and Clock Company of Boston.

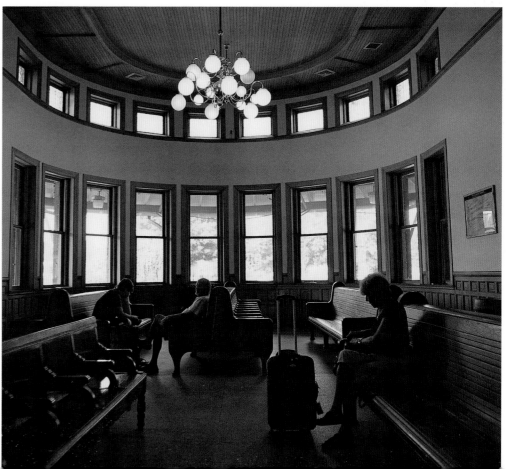

KALAMAZOO STATION

Today's *beautifully restored and refurbished Amtrak station in Kalamazoo began life in 1887 when architect Cyrus Eidlitz designed it for the Michigan Central Railroad. Executed in red brick and sandstone and topped with a hipped, turreted, and dormered red tile roof, it is an outstanding example of the Richardsonian Romanesque style transplanted deftly to the Midwest in the boom years for railroads following*

the Civil War. Originally the station consisted of three separate buildings connected by covered walkways, but today the two outbuildings—which once housed the baggage storage area in one and the telegraphic equipment in the other—have been integrated and are connected by enclosed corridors, thus preserving the original look and configuration of the structure but incorporating modern conveniences.

The station has won several civic and architectural awards since being purchased by the city in the early 1970s from the Penn Central Railroad. With the help of grants over the years from the Michigan Department of Transportation and from

Opposite Page and Right: The rear, trackside face of Kalamazoo Station boasts a rounded bay window at its center, affording the stationmaster a full view in three directions from his office. Note the sandstone and brick medley and the hipped and dormered roof, also boasting a small cupola. The front facade showcases its sandstone porte cochere, its hipped roof with an eyebrow dormer, and its lovely arched window.

Right: The solid brick and sandstone bus slips out front harmonize well with the main building of this foursquare Victorian gem.

Opposite Page Top: View of the bus slips with the station in the background and a stone planter in the foreground. That the bus slips are weatherproofed with a roof adds a welcome touch.

Opposite Page Bottom Left: The main waiting room with its handsome woodwork, period wooden coffered ceiling, oak benches, and attractive ground-level arched windows.

Opposite Page Bottom Right: A handsome wooden combination ticket booth and stationmaster's office occupies a corner of the main waiting room. Notice the stained glass, fancy grillework, and wrought iron ticket window wickets

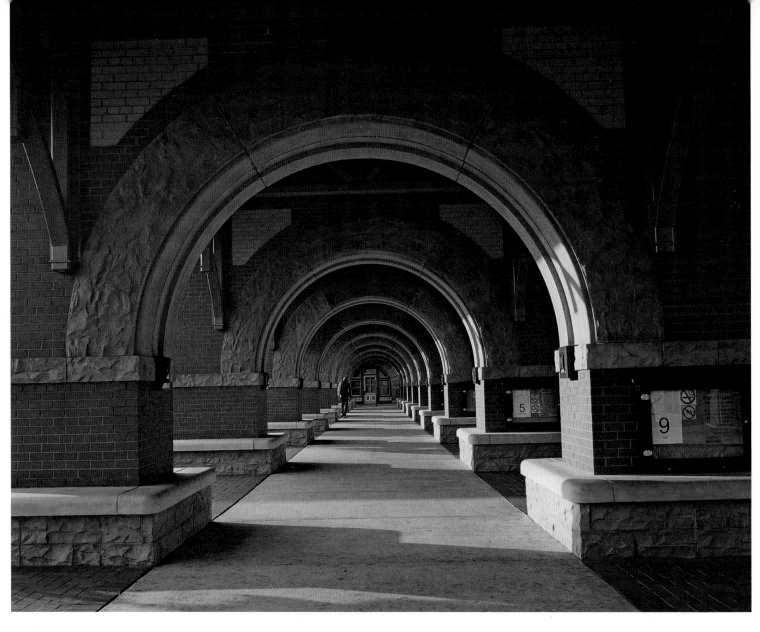

the Federal Transit Administration, the citizens of Kalamazoo undertook an arduous and comprehensive makeover of the station, which was finally completed in 2004. They not only restored and refurbished this landmark station, they repurposed it as an intermodal transportation hub as well. Amtrak currently runs eight daily trains through Kalamazoo, including the *Blue Water Service,* and on a small plaza in front of the station there are twenty new bus slips for local and long-distance buses.

In preserving the station's Victorian grandeur, the city restored such original Richardsonian touches as the large fireplaces, the boldly arched ground-floor windows, the handsome pedimented and eyebrowed dormers, and the striking and substantial porte cochere. In redoing the large

lobby and waiting room, the refurbishers even replicated the four remaining 1920s art deco benches. These combine with the high coffered wooden ceilings and the repaired terrazzo floors to complement and accent the original oaken woodwork used throughout. Though the station has been updated with such conveniences as radiant floor heating and modern lighting, it still retains the aura and feel of its original nineteenth-century splendor, now well over a century old.

Placed on the National Register of Historic Places in 1975, Kalamazoo Station befits this great Midwestern manufacturing and college town, home of Western Michigan University and the former home of Checker Motors, Gibson Guitars, and Upjohn Pharmaceuticals.

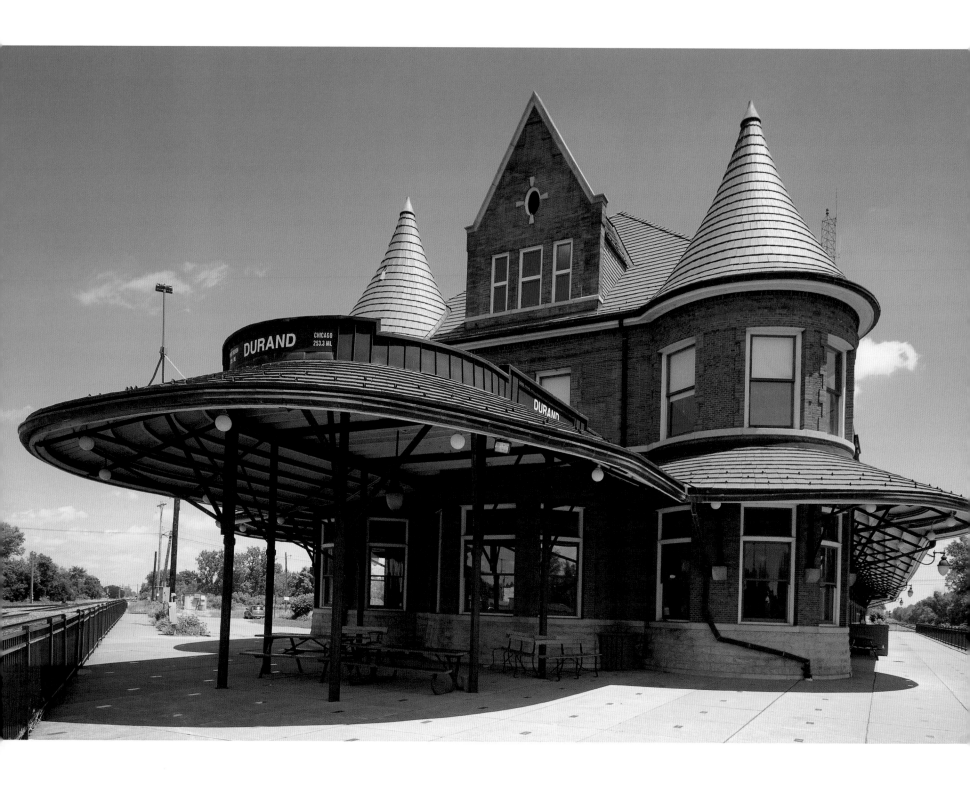

DURAND UNION STATION

*I**n the early days of the twentieth century, Durand, Michigan, was a key Midwestern railroad town where half the population of three thousand worked for the Grand Trunk Western Railroad, which in 1903 built and opened a marvelous midsized station there in the chateau revival style so popular in America at that time. The same architectural team of Frederick Spier and William C. Rohns that designed the Niles Depot a decade*

earlier designed the new station in Durand, which featured Missouri granite brick and Bedford-cut stone under a pitched slate roof. Unfortunately, two years after its grand opening, the new station burned to the ground. Yet Durand was such an important junction, accommodating six railroads all told, that Grand Trunk Western rebuilt the station quickly and reopened it in 1905. For the next sixty-five years it thrived, only to suffer hard times again in the early 1970s, when train service ceased completely and the wrecker's ball nearly razed the entire structure.

Luckily, the townspeople bought the station in 1979 for a single dollar and have since, with the help of government grants and individual contributions, restored it largely to its original condition, except for the slate roof. As with so many downtown stations, the rehabilitation of Durand

Opposite Page: The main entrance of Durand Union Station showing its chateau revival style twin turrets, its centered, pedimented and gabled dormer, and its elongated wrought iron canopy that, abbreviated, wraps around the building.

Left: The original combination ticket kiosk and stationmaster's office with its marble footing and beautifully carpentered wooden superstructure occupies the rear of the main lobby and waiting room.

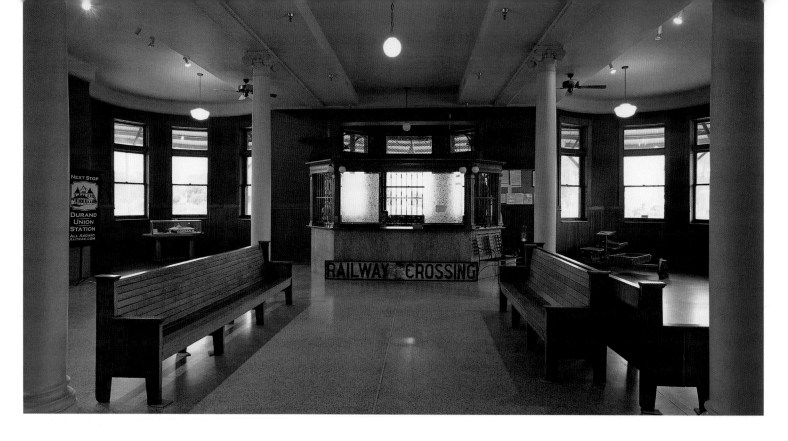

Union Station spurred a resurgence of the town's core, which was further enhanced by the creation within the station of a railroad museum underwritten by the state of Michigan. The town is proud that its heritage has been saved and enshrined.

TODAY THERE ARE only two daily Amtrak trains using the station, the *Blue Water Service,* one in each direction, east and west. Yet in its better days Durand was a key junction for two trunk lines and one branch line, and served another three lines as well; back then, it was not unusual for the station to service 150 passenger trains a day, one every ten minutes. In that era three thousand passengers typically changed trains in Durand daily, the equivalent of the town's entire population. The two principal railroads then using the station were the Grand Trunk Western and the Ann Arbor. The Grand Trunk Western connected the Canadian Maritime provinces, Quebec, and Ontario with the American Midwest, its trains terminating in Chicago after traversing New England; today, the Grand Trunk Western has been absorbed into the Canadian National Railway.

The exterior of the station features beautiful dormers and turrets, and the interior boasts luxurious accessories such as marble wainscoting, terrazzo floors, and elaborate oak woodwork. In the museum there is a model restoration of what the station was like at its zenith, including a re-creation of its 360-degree all-brick roundhouse, which was, unfortunately, torn down in the 1960s.

Nevertheless, the restored Durand Union Station is a perfect period piece and well deserves its 1971 placement on the National Register of Historic Places.

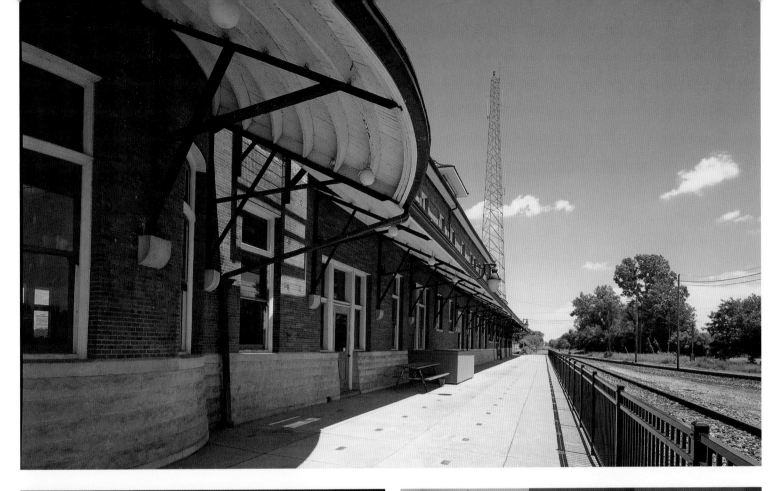

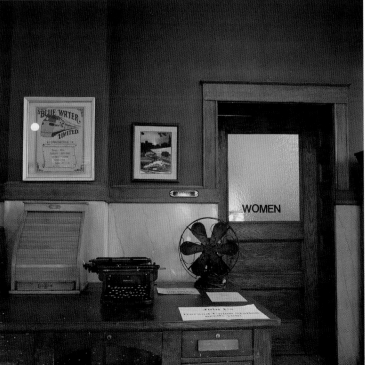

Above: A photo of the track side of the station showing its protective wrought iron fence and its wraparound canopy to weatherproof waiting passengers.

Far Left: A vintage typewriter rests upon the old wooden desk holding the roll-top organizer and an antique fan. Note the period lettering on the pebbled glass of the women's room door.

Left: Memorabilia in the lobby includes an antique safe, a roll-top desk organizer, an engine's headlamp and its numbered identification plate.

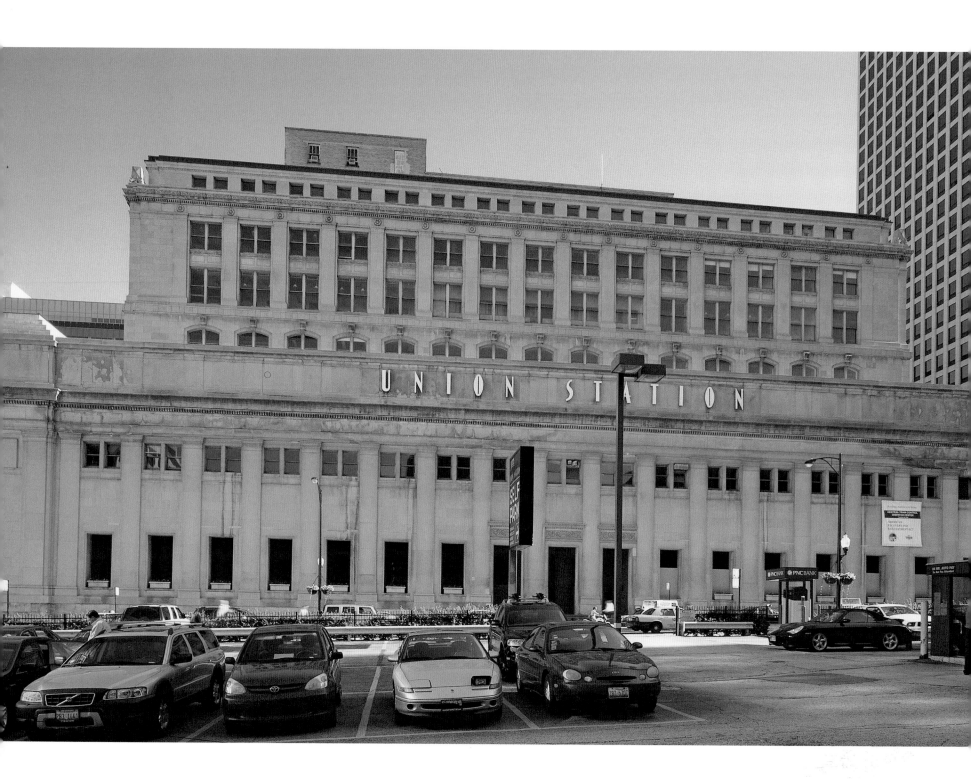

CHICAGO UNION STATION

Although Daniel Burnham died a year before construction began on Chicago Union Station, it has the imprint of his genius all over it. In his hometown he was determined to leave a lasting monument; he succeeded magnificently, although the twelve-year-long execution and completion of his original concept had to be carried out by his successor firm, Graham, Anderson, Probst, and White. Shortly after Chicago Union

Station opened in 1925, the firm designed Philadelphia's splendid 30th Street Station, another neoclassical triumph, albeit on a smaller scale. Along with Burnham's masterpiece—Union Station in Washington, D.C.—and his earliest major railroad station—Pittsburgh's Pennsylvania Station—Chicago Union Station completes his triumvirate of monumental stations created in his capacity as chief architect of the mighty Pennsylvania Railroad, the largest and most powerful railroad America ever produced.

To fund the construction of Chicago's new station, the Pennsy combined financial muscle with four other railroads: the Chicago, Burlington, and Quincy Railroad; Michigan Central Railroad; Chicago and Alton Railroad; and the Chicago, Milwaukee, and St. Paul Railway, all five of which have

a stained-glass window dedicated to them and featuring their corporate insignia in the station's east lobby.

Burnham conceived of the new station to reflect Chicago's dominant importance as a commercial, manufacturing, and transportation dynamo. From 1870 to 1900, Chicago surged in population from 300,000 to nearly 1.7 million, the fastest-growing city in history up until then. Allowing for every convenience to the traveler, Burnham eliminated the problem in Chicago of through passengers having to buy additional tickets and shuttle themselves and their baggage (sometimes lost) between multiple stations—as many as six were in service before consolidation in the new station—in order to make their connections.

The result was the only "double stub" station in the United

Opposite Page: The classic facade of Chicago Union Station with its name announced on the parapet in stainless steel art deco lettering.

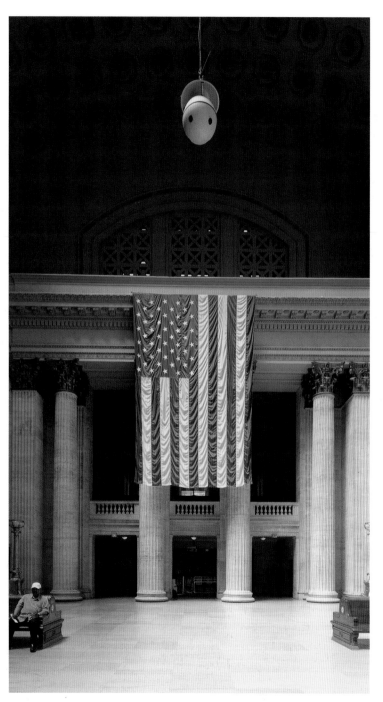

States, with twenty-four tracks approaching from each direction, east and west, befitting Chicago's role at that time as the world's largest rail hub.

Today six Class 1 railroads still converge here—the only city in North America where that is true—and one-third of all freight trains pass through here: Chicago is, even today, clearly America's greatest rail nexus.

BURNHAM CENTRALIZED EVERYTHING in two glorious buildings, one on either side of Canal Street. The building to the west, the headhouse, still stands; the one to the east, the concourse, beautifully designed to replicate a classical temple, was shamefully razed in 1969 to make room for two office buildings. Thank the gods of architecture that the headhouse—at the late date of May 1, 2002—was finally designated a Chicago landmark, placing it safely beyond the arc of the wrecker's ball.

The two buildings, for the convenience of transferring passengers, were connected by a wide and vaulted subterranean concourse beneath Canal Street that is still in use today—only, regrettably, the great temple that loomed above, along with its brilliantly skylit ground-floor concourse, is long gone. In a tribute to Stanford White, Burnham had based the concourse building on New York City's tragically destroyed and spectacularly beautiful Penn Station. In the event, both buildings were desecrated and destroyed in the benighted sixties.

In the headhouse and in the concourse Burnham used Bedford limestone quarried in nearby Indiana, imparting a native Midwestern element to both. The Tuscan columns of the headhouse, arrayed so symmetrically along the length of the facade and dominating it so gracefully, also pay homage

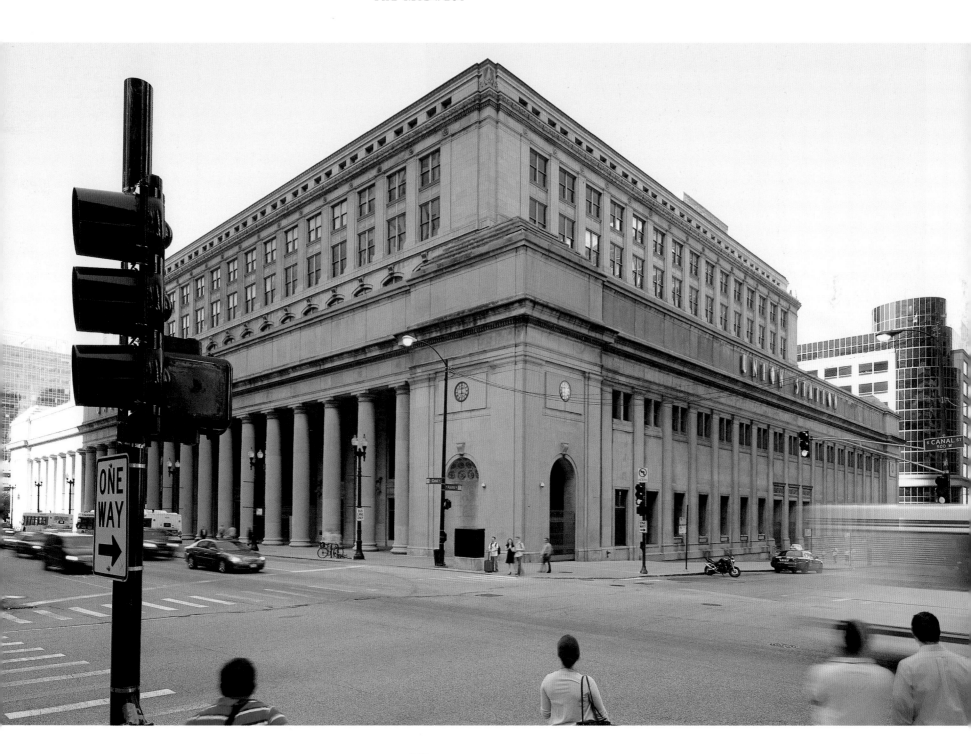

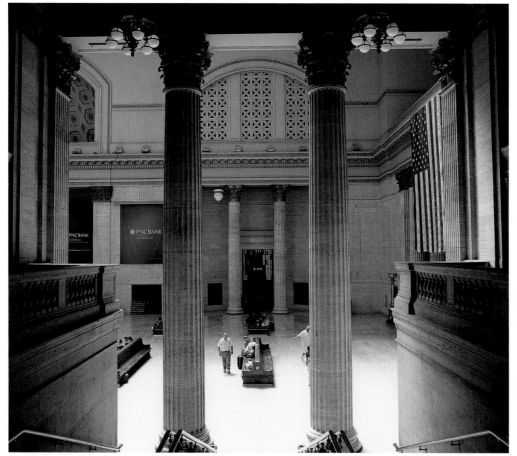

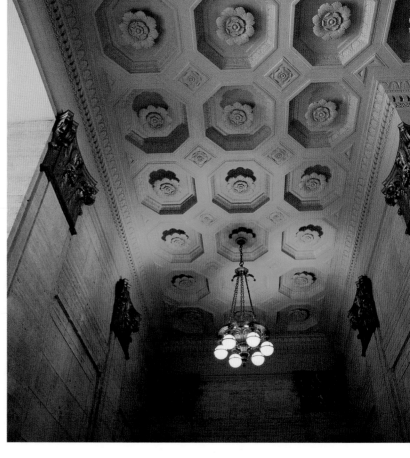

Above: A view of the grand hall from the marble staircase of an alcove leading down to it.

Above Right: The beautiful coffered ceilings of the alcoves just off the grand hall with an exquisite stone rosette at the center of each coffer.

to Stanford White's Penn Station, whose columns were equally majestic and every bit as dominant. The exterior of Chicago Union Station is pleasingly and classically plain, eschewing the excesses of Beaux Arts decoration and its typical inclusion of too much allegorical statuary.

The outstanding feature of the headhouse interior is surely its great hall. This soaring space occupies the majority of the interior of the building, which itself takes up a full city block. The crowning achievement of the great hall is a barrel-vaulted skylight a hundred yards long and soaring 115 feet above the

marble floor. The room's drama and grandeur are heightened further by numerous other accents: a bifurcated marble staircase, towering Corinthian columns whose capitals are trimmed in gold leaf, spare but striking use of two allegorical statues sculpted by Henry Hering and placed on pediments above the entrance from the east lobby, large and lovingly crafted oaken benches, and gold-and-white coffered ceilings in the columned alcoves feeding into the central space, one of which dramatically houses and frames the grand staircase. Hering's figurative statues hold, respectively, a rooster, representing day, and an

owl, representing night; together they pay tribute to the round-the-clock nature of train travel. The classical gravitas of the great hall is truly matched in America only by the lobby of Washington Union Station and by the concourse of New York's Grand Central Terminal.

CHICAGO UNION STATION is a joy to behold. What is also heartening about it is the vision Amtrak and the city of Chicago have for its future. It is not a question of repurposing but of readapting, not a question of demolition but of rededication. Although the station no longer has three hundred daily arrivals and departures of long-distance passenger trains, transporting a total of a hundred thousand people a day, as it did during World War II, it still has a total yearly ridership, combining Amtrak's service and the suburban Metra light-rail service, of 31.6 million passengers. This ridership is projected to increase nearly 50 percent by the year 2025, to 47.3 million. The station is being improved and adapted to handle that expanded ridership.

Also, the station was originally to have twenty-six floors of office space rising above the lobby, but only eight floors were actually built. Plans in the works include a possible expansion of office space skyward, an intelligent option and one far preferable to the destruction of the concourse building in order to exploit its air rights. And take heart in this: Amtrak still runs fifty-eight daily trains through this monumental station, from which America has spiraled outward in all directions so magnificently for the last eighty-six years.

Right: A lengthwise view looking down the loggia enclosed behind the tall Tuscan columns lining the exterior of this extraordinary building.

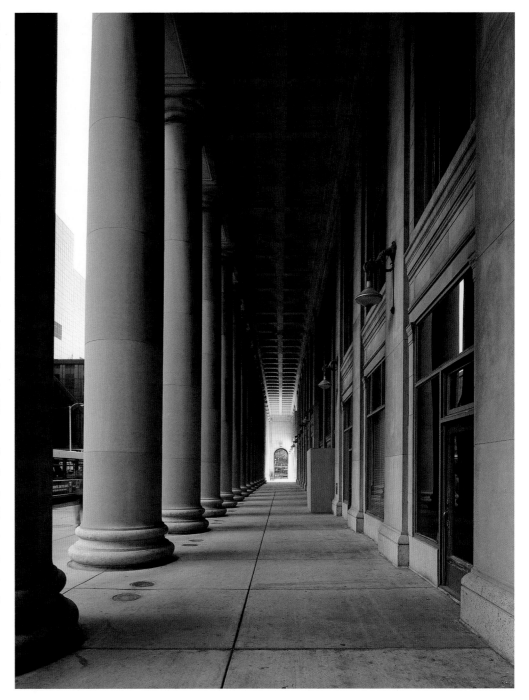

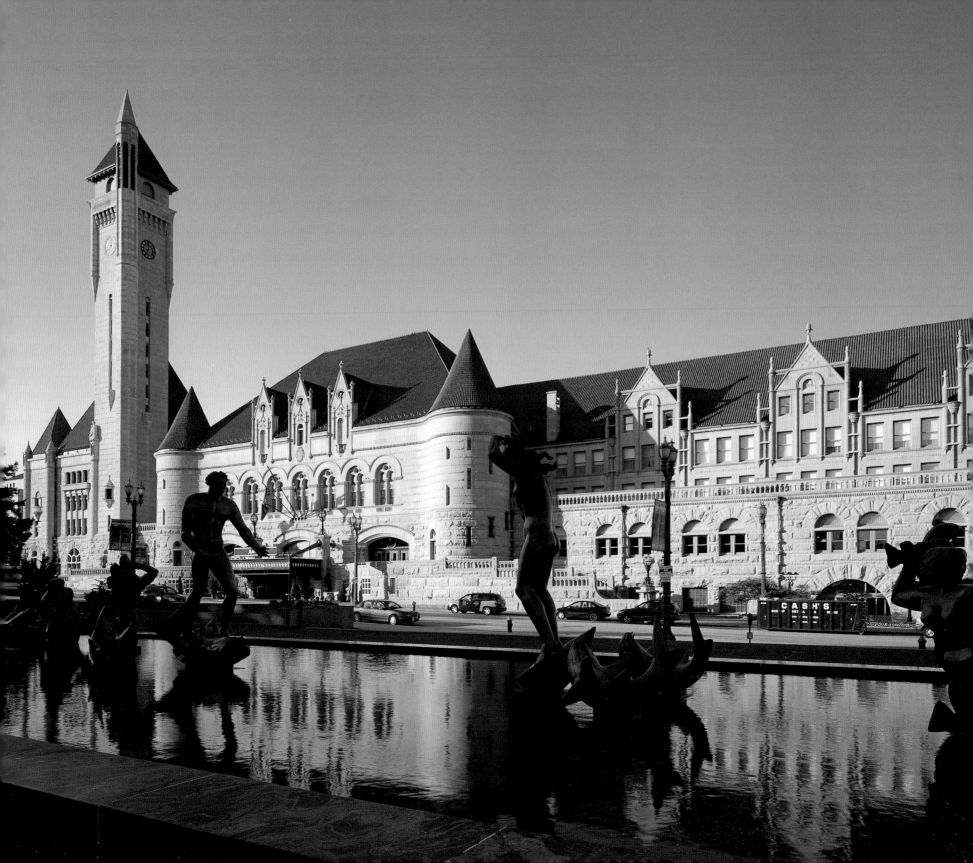

ST. LOUIS UNION STATION

St. Louis Union Station was the Ellis Island of the West. It did for the western half of the continental United States what Ellis Island did for the eastern half, the dividing line being the mighty Mississippi. Millions of immigrants passed through this massive station, many with notes pinned to their chest spelling out in English their destination, for most of them spoke not one word of their new country's language. They traveled

west to settle the plains states, the mountain states, and the states of the Southwest, the Northwest, and the Far West. If the station's walls could talk, they would tell several million stories, all of them piquant, most of them moving.

A beautiful building in and of itself, the station is nevertheless overshadowed aesthetically by its heroic service to humanity for over a century. The people of St. Louis, ever perspicacious, realize this and have turned the station into a monument, to themselves and to their forebears, that still goes on breathing and serving the community today as a hotel and meeting center, as a museum, and as a vibrant shopping mall and food court smack in the heart of town. A visit here is at once aesthetically rewarding and historically informative.

Built during 1893 and 1894, and opened in late 1894, St. Louis Union Station is a vital link between the Victorian style

Opposite Page: The grand facade of St. Louis Union Station reflected in the pool of sculptor Carl Milles' *Meeting of the Waters* fountain in the foreground

Left: The spectacular atrium lobby just inside the front entrance of the old Terminal Hotel adjoining the main station's headhouse.

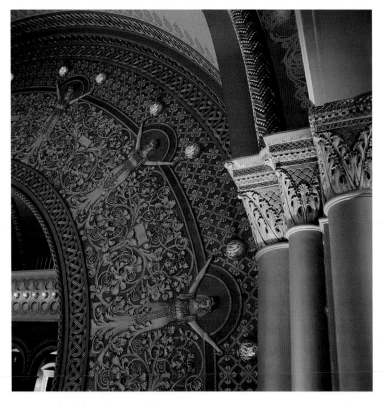

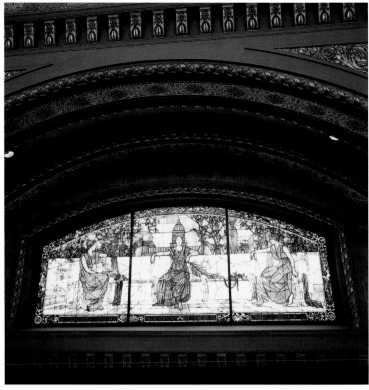

Right: The detailed arabesque plasterwork interspersed with angels in the massive stone arches at either end of the grand hall. In the foreground are the floral capitals of the small columns in the arcaded second floor gallery.

Far Right: The allegorical stained-glass window in the transom above the doors of the station's main entrance depicts three female figures in a walled garden. It has a lilting Pre-Raphaelite aura.

Opposite Page: The various columns and their decorative capitals are visible in this photo of the upper stories of the three-floor-tall atrium above the old Terminal Hotel lobby pictured back on page 145.

dominant in the latter part of the nineteenth century and the Beaux Arts style that became dominant in the early years of the twentieth century. St. Louis Union Station used no steel in its construction but is clad in Bedford limestone from Indiana, instead of in plain wood or brick, as were earlier versions of large Victorian stations. The station also makes liberal use of marble in its lush interior, thus anticipating the grandeur that marked the Beaux Arts masterpieces built two decades later, such as Grand Central Terminal in New York City and Union Station in Kansas City.

Architect Theodore Link modeled the station on the walled city of Carcassonne in southern France. His architectural aim was to have the station serve as a modern interpretation of a medieval gateway, in keeping with St. Louis's role after 1890 as "The Gateway to the West." This same architectural leitmotif will receive extended play in the interior. It is worth noting that Link's eloquent use of the gateway arch as a symbol of St. Louis would be echoed many years later by Eero Saarinen in his majestic Gateway Arch hovering above the Mississippi a few blocks east of the station.

THE MOST PROMINENT Victorian element adorning the station's exterior is the tower soaring at the east end nearly three hundred feet in the air, with clocks showing on all four of its

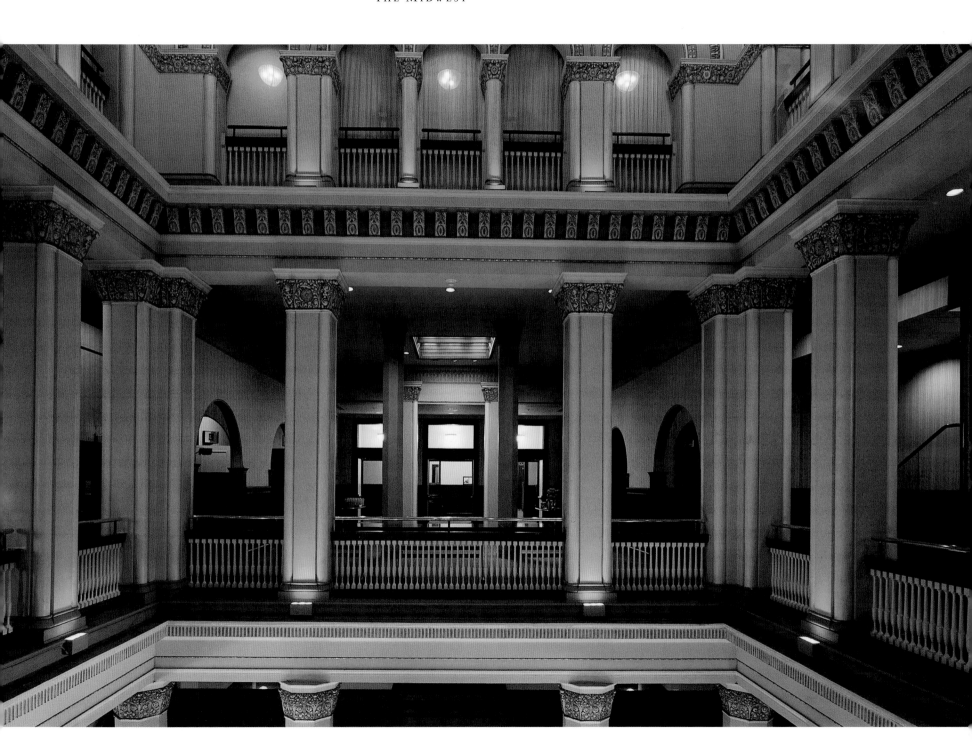

faces. On the station's facade there are also gothic elements in the finials accenting the dormer windows and in the columns separating the arched windows on the second story directly below them. The turreted roof is composed of red tiles, and attractive arcaded balconies are interspersed in the eastern pier that anchors and supports the tower. In overall effect the building more than slightly hints at the style of a Loire Valley chateau, thereby paying tribute to the founding of St. Louis by the French in 1760.

The three massive elliptical archways constituting the station's main entrance are echoed immediately inside when one ascends the main staircase and enters the grand hall. Either end of this impressive room boasts massive arches even larger than those encountered in Europe's celebrated gothic cathedrals. A barrel-vaulted ceiling rises sixty-five feet above the lobby's marble floor and features a skylight at its center whose brilliant sunlight is augmented by that streaming in from arched clerestory windows rising from the third-floor gallery and running the length of the room on either side. Architect Link made early decorative use of lightbulbs, just then coming into use, and created dramatic lighting effects by placing them strategically around the great room, especially in the ceiling and in the walls. The liberal use of different kinds and shades of marble and of mosaic tiles, and the installation of stunning stained-glass windows and well-placed statuary, render this room a study in Victorian splendor worthy of inclusion in London's Victoria and Albert Museum.

Besides the grand hall, the station featured an enormous

Left: The eastern end of the headhouse in early summer evening sunlight underscoring the contrast between the Bedford limestone and the red-tiled roof with the soaring tower looming over all.

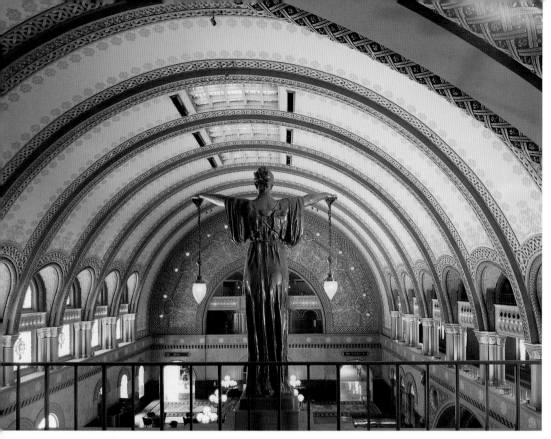

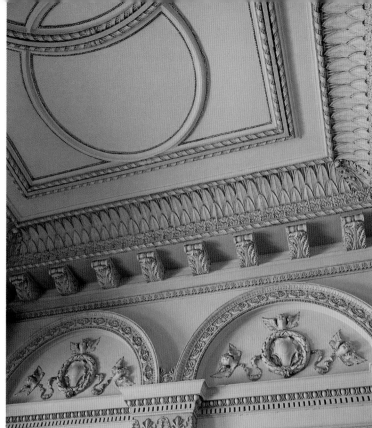

midway and, when it was built out back, the world's largest train shed. Today they have been converted, respectively, to a museum and a shopping mall that houses a large food court. Both are worth seeing. The museum will enchant any visitor, especially the collection of letters containing memories of the station from natives of St. Louis and of Missouri in general who used it in its heyday; most touching of all are the letters from World War II, enhanced by great period photos. The photos of movie stars and sports heroes and U.S. presidents passing through are entertaining as well. Simply reading the gloriously poetic names of the famous trains that passed through this station will quicken one's pulse: *Knickerbocker, Green Diamond, Meteor, Nighthawk, Bluebonnet, Jeffersonian.* Only thoroughbred racehorses are still named so poetically.

IF NOTHING ELSE, this station offers irrefutable proof of the central role played by the train station in the social life of towns and cities before the advent of air and auto travel. World War II was part of this station's heyday, and it was not uncommon then for as many as three hundred trains to pass through the station daily. Bear in mind: this was a stub station with thirty-two tracks servicing twenty-two railroads at one time. Out back in the rail yards there were three control towers; tower 1 alone controlled 1,827 possible routes. The switching options here were so extensive and variegated that social historian Lucius Beebe commented on them in his splendid book, written with co-author Charles Clegg and titled *The Trains We Rode.*

With fine justification St. Louis Union Station has been a National Historic Landmark for over forty years.

Above Left: A lengthwise view of the grand hall from the third floor balcony at the east end showing the massive arch, the curvilinear ceiling and its three skylights, the columned and arcaded gallery on the right side of the second floor and the clerestory windows on the left side. In the foreground is the female statue holding in each hand a hanging light fixture.

Above Right: The highly detailed and elaborate plasterwork in the old private dining room off the grand hall where such dignitaries as Winston Churchill dined.

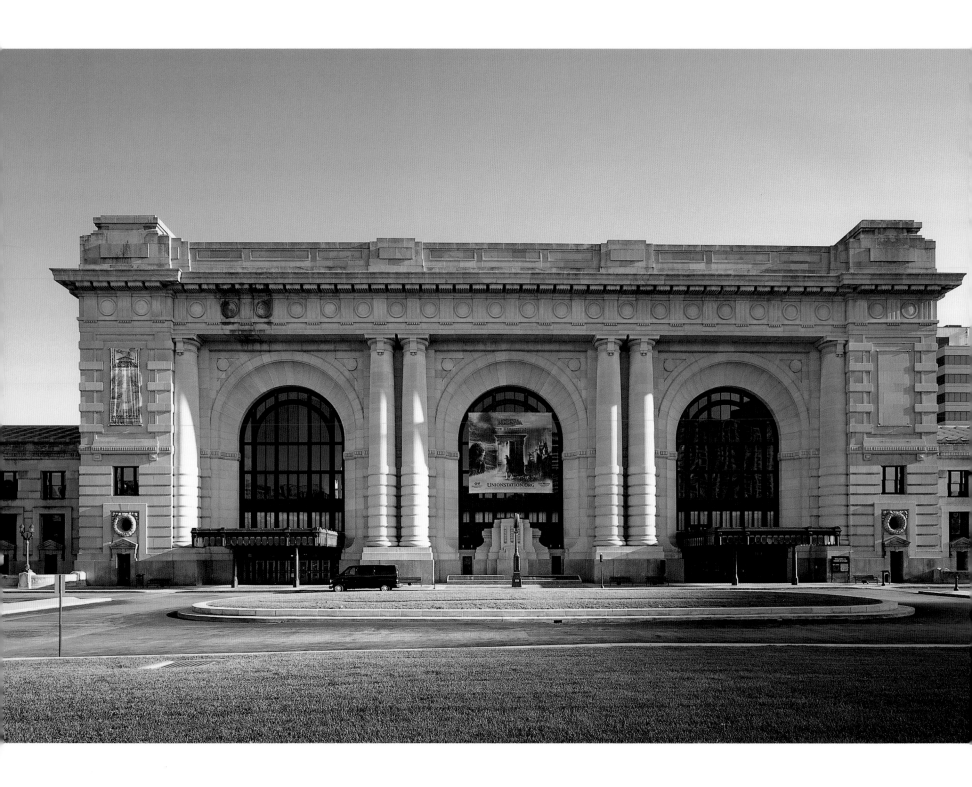

KANSAS CITY UNION STATION

When you arrive at Union Station, the exterior will stun you with its perfect symmetry, beautiful balance, and cleanliness of line and plane. On October 30, 1914, at the opening-day dedication ceremony for this triumphant station, President Wilson declared it "the Gateway to the West." Once you experience it, you won't wonder why.

The president's speech sparked a daylong celebration in Kansas City, Missouri, known the world over for its ability to cut loose—after all, this is the once notorious cattle town that as late as the 1920s still had nude waitresses serving not just dinner but lunch. That dedicatory October evening in 1914, it dawns on you, marked the beginning of Mischief Night. That could not have been more fitting, for nothing is as certain as architect Jarvis Hunt having worked artistic mischief in conceiving and designing this superb station.

TWELVE RAILROAD LINES combined to build Union Station, so busy was Kansas City as a railroad hub. In 1917 rail traffic peaked with 79,368 trains passing through; in a single day that year Union Station accommodated 271 trains. Now each day there are only three passenger trains in, three out.

Architect Hunt's original estimate called for $3.5 million. By the time the station was completed, after more than three years of construction, the cost ranged from $5.7 million to $6.36 million, and that only covered the station itself. Estimates for the infrastructure and additional tracks laid around Kansas City placed the cost to the twelve railroads backing the enterprise at between $40 million and $50 million.

The history of this station is inextricably bound to the history of World War I, and across the esplanade from the station sits the world's most comprehensive museum dedicated to American participation in that war. Built on a

Opposite Page: The serene, harmonious, and symmetrical facade of Kansas City Union Station in fading early summer sunlight.

Right: An overview of the grand hall (the lobby) looking through the archway into the north waiting room (the passenger concourse). Kansas Citians used to meet "under the clock" in this archway.

Below: The polychromatic paneled and coffered ceiling in all its restored glory and flaunting its superlative Old World plasterwork.

Opposite Page: A view framing one of the old track gates in the passenger concourse and underscoring its placid symmetry. Note the balance and elegance of the polychromatic ceiling panel reflected in the multicolored pattern of the marble floor beneath it.

knoll, the museum offers a stunning view of the station looking back across the esplanade, which features a large and impressive stone fountain shooting jets of water skyward.

THE FLAWLESS PALLADIAN balance and perspective achieved in the exterior is the hallmark of the interior as well, which consists of the grand hall (the lobby) and the north waiting room (the passenger concourse). They are two of the most impressive rooms in a train station you will be privileged to see. Airy and spacious, they feature coffered ceilings intricately painted and decorated with plasterwork fit for a European castle, marbled wainscoting and door frames, tricolored marble floors, handsome oak woodwork, massive and beautiful windows, and brilliant natural lighting. In each room, every feature is coordinated and integrated with every other feature. What's more, these rooms harmonize with the magnificently balanced and symmetrical facade. In the days when arriving

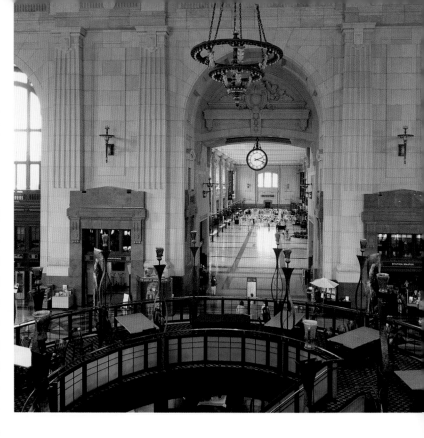

passengers would get their first glimpse of Union Station by stepping into the north waiting room, it would set the tone for the entire building as surely as would the facade and the grand hall for those arriving through the front entrance: unfailing good taste in the service of understated elegance.

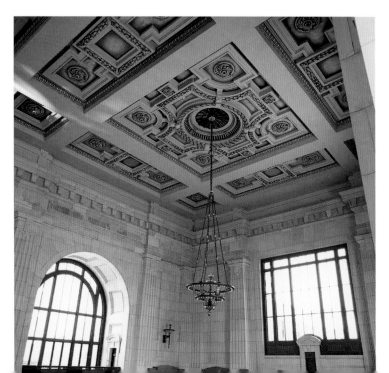

THERE ARE TWO flaws in the magnificent facade, but only a close inspection will reveal them. They are bullet holes. Remnants of a gun battle between bank robbers and law enforcement personnel, they are constant reminders of Kansas City's raucous past. On June 17, 1933, what became known as the Kansas City Massacre erupted at Union Station right outside the eastern entrance. Early that Saturday morning police officers were transporting Frank "Jelly" Nash, an escaped prisoner with underworld connections, back to Leavenworth.

Two FBI agents were waiting at Union Station while two other FBI agents brought the prisoner in on the 7:15 train from Fort Smith, Arkansas, where he had been captured. The police chief of McAlester, Oklahoma, was assisting the two agents bringing Nash in by train.

All five law enforcement officers and the handcuffed Nash walked unnoticed across the sun-shot lobby and emerged on the sidewalk outside the eastern entrance. There they packed themselves into a 1932 Chevy. But before they could pull out, a man stepped from behind a lamppost and raked them with fire from a submachine gun. Simultaneously two accomplices stepped from behind parked cars and opened up with their submachine guns. In seconds five men lay dead, including Nash. Two others, both FBI agents, were wounded. Among the dead were one of the FBI agents, the police chief, and two Kansas City detectives who had come to lend a hand with what was supposed to have been a routine prisoner transfer.

J. Edgar Hoover initially charged three hoods with the fatal shooting: Vern Miller, a local hit man; Charles "Pretty Boy" Floyd; and Adam Richetti, like Floyd another wanted criminal. All were known to be in Kansas City that day. Later investigations determined that Floyd and Richetti were likely not involved in the massacre. All three miscreants came to bad ends anyway. Miller was rubbed out in an underworld execution. FBI agents gunned down Pretty Boy. Richetti perished in the Missouri gas chamber on October 8, 1938.

What really happened that fatal day at Union Station may never be fully known. But the public was so outraged by this barbaric crime syndicate slaughter that Hoover was able to induce Congress to strengthen the powers of the fledgling FBI, including its ability to arm its agents to properly counter armed-to-the-teeth criminals.

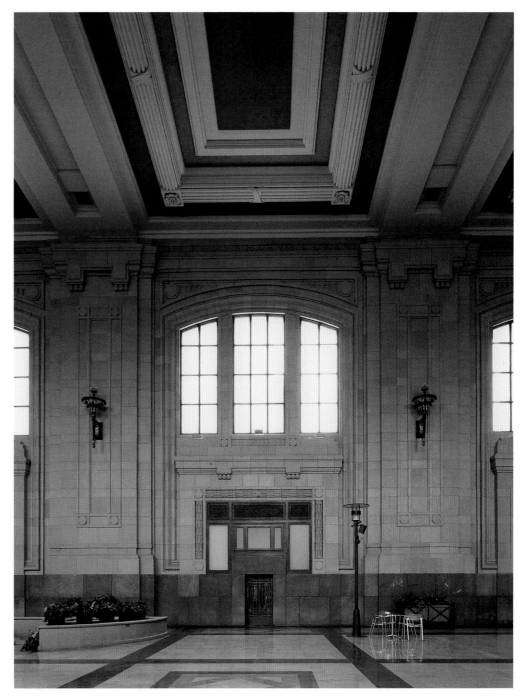

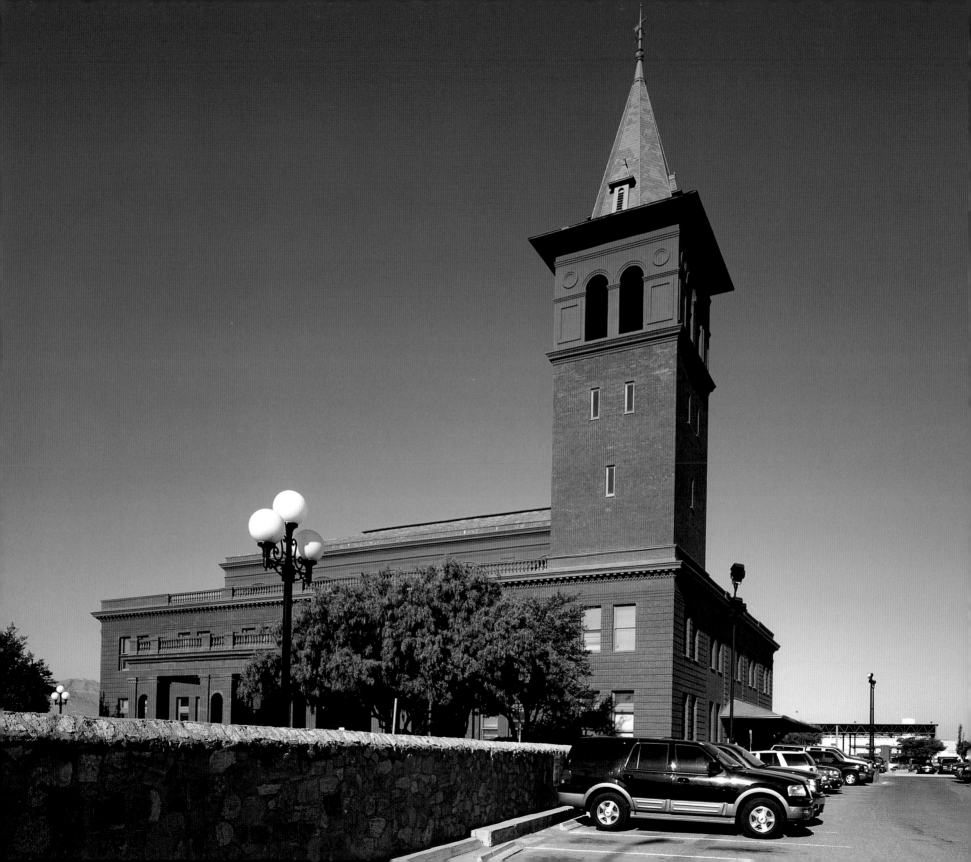

TEXAS

Texas is Texas. Always and only it is uniquely Texas, everlastingly distinct and incorrigibly sui generis: neither southern nor western, neither Midwestern nor High Plains, neither faux Mexican nor purely American—it is simply Texas. Its train stations personify this nothing-like-it-anywhere-else-in-the-world quality. The seven stations featured here are Lone Star beauties, each superlative in its own highly articulated way.

In bustling Fort Worth are two very different but attractive buildings: Santa Fe Station and Texas and Pacific Station. The 1902 Santa Fe combines in its three stories early neoclassical elements with a plain, foursquare Texas solidity spiked with decorative flair. The nearby Texas and Pacific, completed thirty years later, reflects the oil and natural gas boom times of the 1930s and is a rich example of art deco enhanced by Southwestern and Native American decorative flourishes adorning an imposing thirteen-story skyscraper.

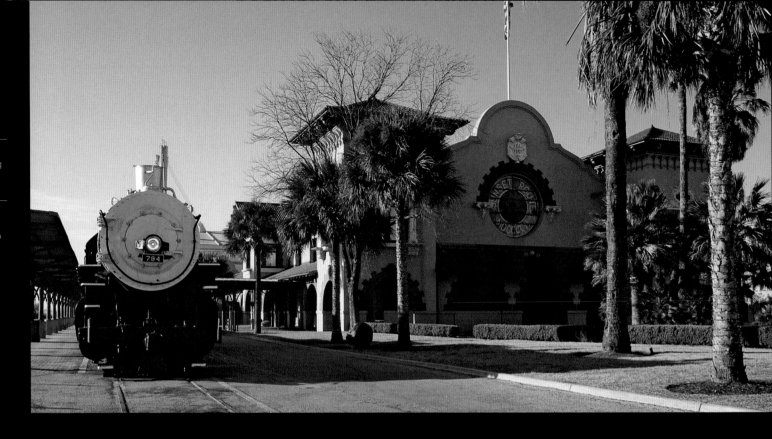

In Dallas sits another stunning Jarvis Hunt
Beaux Arts creation, much like his masterful
station in Kansas City: Dallas Union Station
radiates classicism anchored by a dollop of Texas
plainness and solidity.

In the timber country of East Texas a small
station in Mineola has been lovingly restored to its
1906 American Arts and Crafts luster. A perfect
small gem, it is self-contained and flawless.

On the border in El Paso there is a neoclassical
station designed by Daniel Burnham, four years
after his imposing Pennsylvania Station opened in
Pittsburgh. The 1906 redbrick El Paso Union
Station retains second-generation Victorian
elements, such as its impressive clock tower and

porte cochere, while projecting the classical balance
and symmetry that would soon evolve into the more
decorative Beaux Arts style.

San Antonio hosts two highly distinct and
visually arresting stations executed in the mission
revival style that reflects the dual heritages of this
former capital of the Mexican province of Texas,
before Texas became the only state in the United
States to have been an independent country prior
to its incorporation into the Union. Sunset Station
and Mopac Station each reward half a day's visit
and inspection. Happily, Mopac Station, currently
owned by a credit union, has been graciously resold
to the city's transportation department for
restoration as a transportation multiplex.

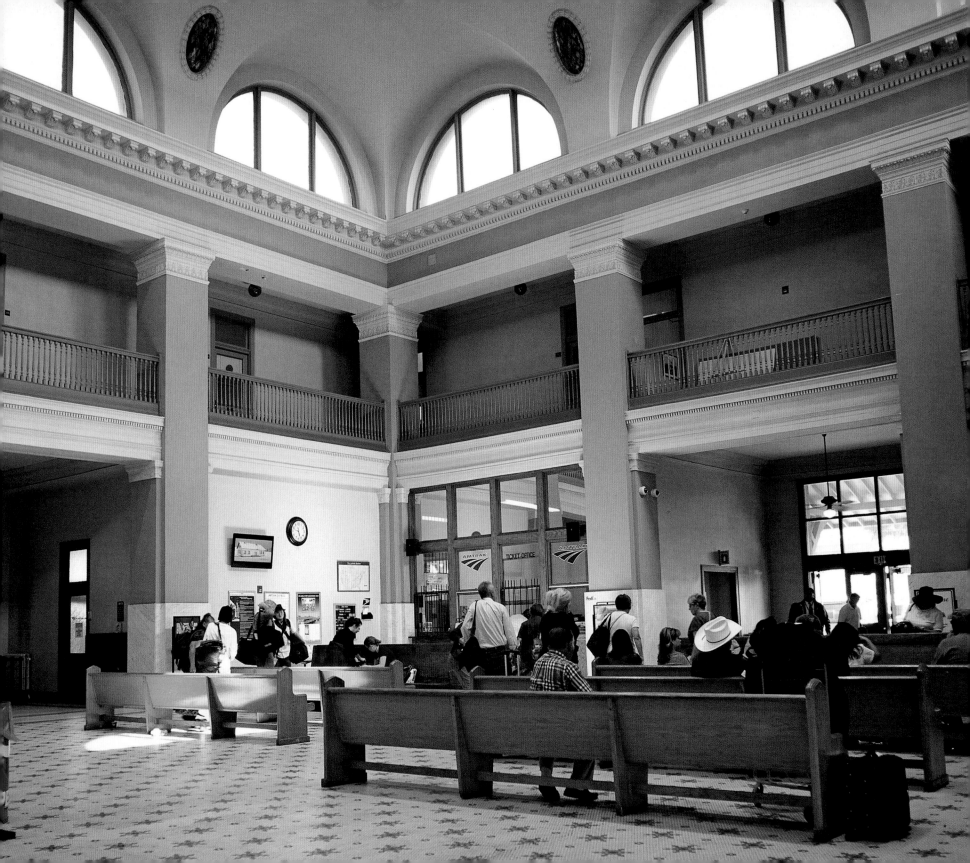

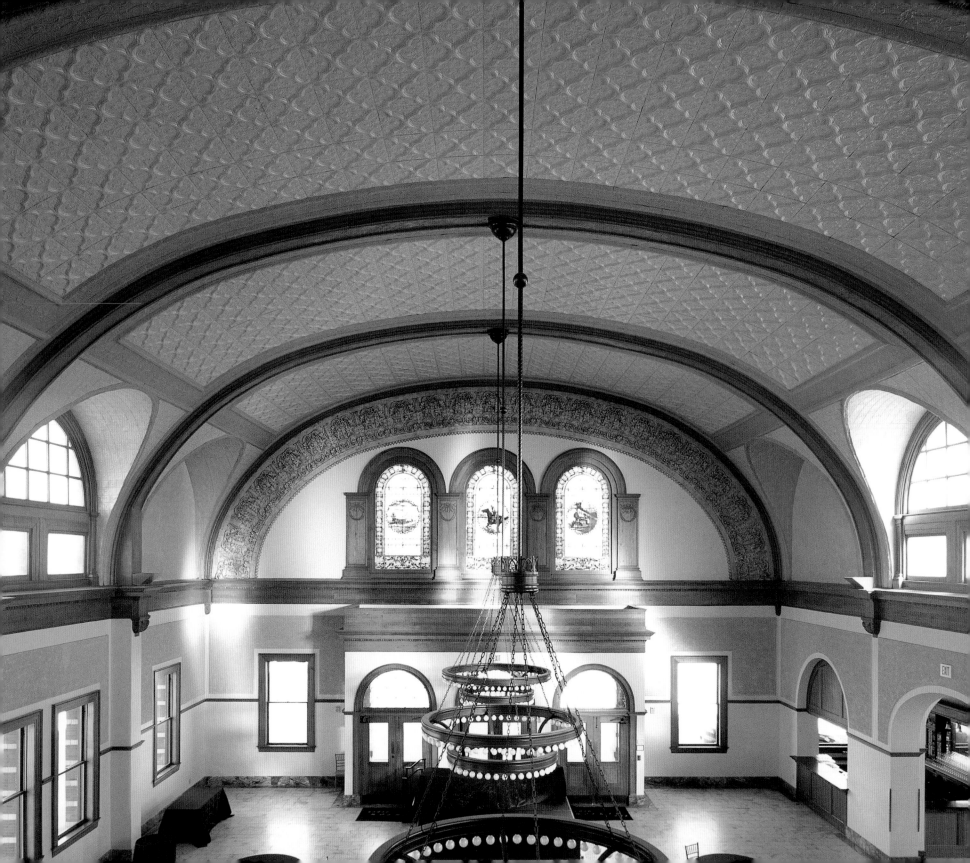

FORT WORTH SANTA FE STATION

Unpretentious yet gracious, Fort Worth bristles with enterprise and hosts two outstanding railroad stations, the first and oldest of which is the Santa Fe, opened in 1899, at the height of the cattle boom. Like the nearby Texas and Pacific, it is not an active railroad station, but both stations have been repurposed brilliantly. They are situated on the outer edge of the downtown business district and reinforce its admirable patina of historical integrity.

Santa Fe Station is a late-Victorian neoclassical jewel encrusted with Southwestern motifs. Three stories high, self-contained, and self-possessed, the building on first sight charms more than overwhelms the viewer. Its apt proportions and warm earthiness invite you to linger and explore its exterior before rushing inside. To have been a traveler rushing through this building to catch a train would have amounted to being a wayfarer missing an architectural treat, both outside and within.

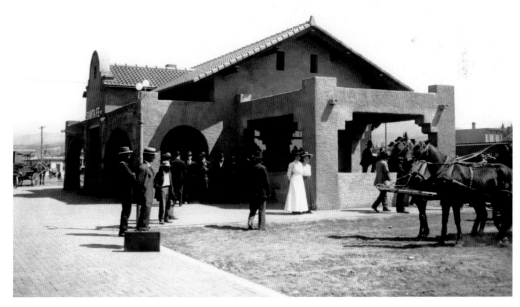

Opposite Page: The barrel-vaulted lobby and main waiting room of Fort Worth Santa Fe Station showing the three stained-glass windows above the vestibule, depicting three modes of transportation, left to right: a covered wagon, the pony express, and a vintage steam engine locomotive.

Right: Forth Worth Santa Fe Station in 1899, the year it opened.

Right: A vintage electric passenger rail carriage on display like the ones that used to shuttle between Fort Worth and Dallas.

Far Right: An exterior view of the three stained-glass windows above the main entrance depicting three modes of transportation: covered wagon, pony express, and an early steam engine locomotive.

Below: The simple but elegant woodwork of the old lobby ticket windows.

THIS BUILDING IS a model of intelligent repurposing. To its credit, it has been placed on the National Register of Historic Places and, in 1970, was designated a Recorded Texas Historic Landmark. In 1999, four years after Amtrak ceased passenger train service, Shirlee and Taylor Gandy purchased the station and restored it to its former grandeur; they restored the barrel-vaulted ceilings, refurbished the marble floors, and replicated the original stained-glass windows, going to great pains to get the colors exactly right. Rechristened Ashton Depot, the station serves today as a meeting and banquet facility for the nearby Ashton Hotel, a vintage Victorian boutique hotel in the heart of the historic downtown district also owned, restored, and refurbished by the foresighted Gandys.

The repurposing of the old station included the installation of a walled patio with a handsome fountain out back where the passengers and freight used to wait beneath a covered

platform for the trains to arrive and depart. The tracks just beyond this patio once served six railroads in the boom days of train travel, when the Santa Fe had the most rail lines in Texas, at 5,102 miles of trackage. Today these tracks still host trains from Amtrak, from the Trinity Railway Express (TRE), connecting Dallas and Fort Worth, and from various freight lines. That's because the new Amtrak station in Fort Worth lies a few blocks north, on Jones Street, and is part of the Fort Worth Intermodal Transportation Center (ITC), an intelligently designed complex providing taxi and local and intercity bus service as well as the Amtrak and TRE train services.

Visible on the southwestern horizon from the Ashton Depot and from the ITC, and somewhat dominating the skyline, is Fort Worth's second outstanding train station, the Texas and Pacific Tower.

AS YOU STAND admiring the gorgeous main entrance of the north facade of the station, turn around and note the Santa Fe symbol deftly integrated into the brickwork on the pediment of the facing facade of the matching warehouse across the small courtyard.

Duck into the ITC Amtrak facility and take in the vintage photos of the Santa Fe Station in its prime, replete with Victorian potted ferns and double-sided settees accenting its 3,500-square-foot lobby.

Don't miss the fully restored passenger rail carriage out behind the ITC Amtrak facility. Self-propelled electric carriages like this one used to shuttle between Dallas and Fort Worth in the early years of the twentieth century, long before today's TRE intercity rail service connected these two dynamic metropolises.

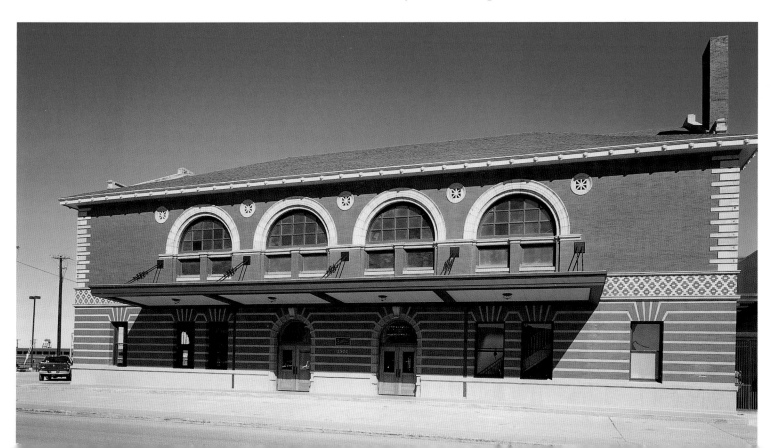

Left: A view of the western facade showing the two auxiliary entrances and highlighting the neoclassical elements evolving toward Beaux Arts decorativeness.

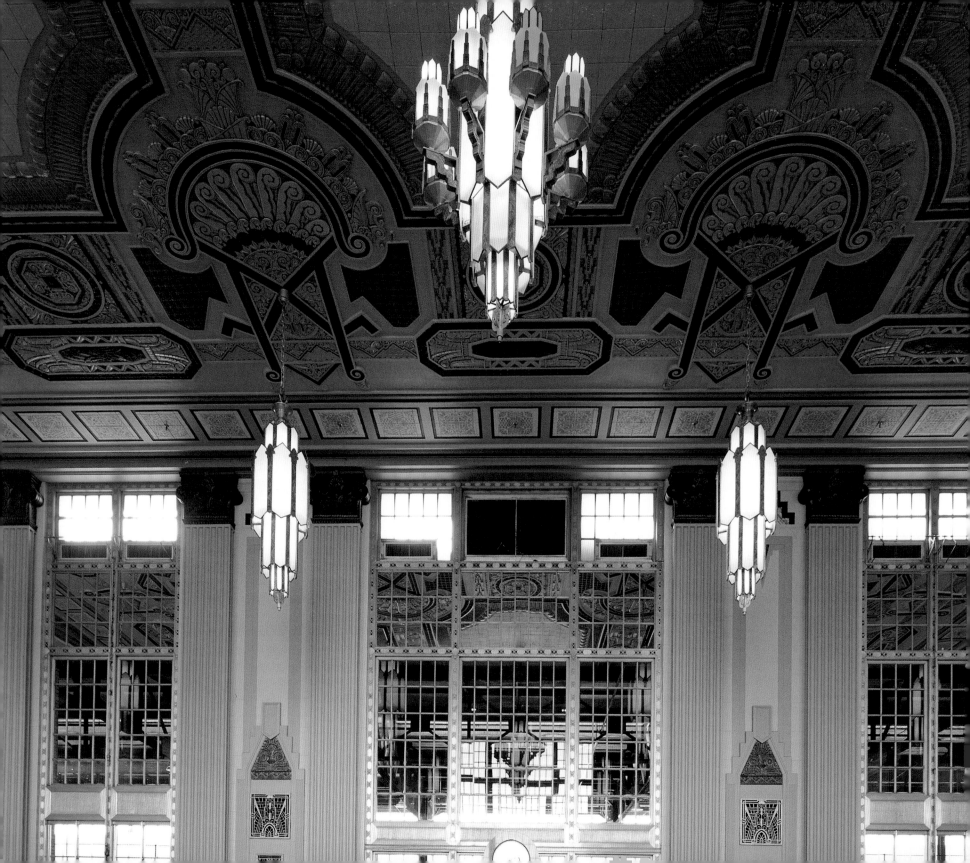

FORT WORTH TEXAS AND PACIFIC STATION

The Texas and Pacific Station looks like a midtown Manhattan art deco tower transplanted to the Lone Star State and invested with a piquant Southwestern flavor. Even from a distance the exterior of the building hints at influences from Native American artwork typical of Southwestern tribes like the Navajo and the Apache. You sense the decorative élan distinguishing this building even before you experience the lush,

colorful interior. This sense of visual anticipation was all the more pronounced because at the time of our visit the building was undergoing serious restoration and refurbishment to convert it to fancy condominium lofts, including with a rehabbed Texas and Pacific tavern in what used to be the station's restaurant, just off the main lobby on the ground floor. Seeing this handsome building under construction, you realize how magnificent it will be when the overhaul is finished, so stunning is the work already completed.

At thirteen stories high, the T&P, as the locals call the building, towers over its neighbors. Its elaborate zigzag-style exterior sports such accents as nickel-plated and polished-steel windows and doors, a long nickel-plated canopy over the three main oak doors, and a three-story-high limestone facing perched on a three-foot-high maroon marble footing. There is also an intricately carved frieze banding the facade between the third and fourth floors, and another frieze banding the facade between the eleventh and twelfth floors. Above the third floor the facade features beige brickwork braced on each corner by piers. The piers are topped by turrets and distinguished by highly patterned stone carvings, especially on the two uppermost stories and the rooftop parapet. At the center of this parapet is a dramatically carved spread-winged eagle that might well have topped a totem pole, adding significantly to the Southwestern flair of this grand building.

Opposite Page: The breathtaking lobby of the Fort Worth Texas and Pacific Station in all its art deco glory with southwestern overtones.

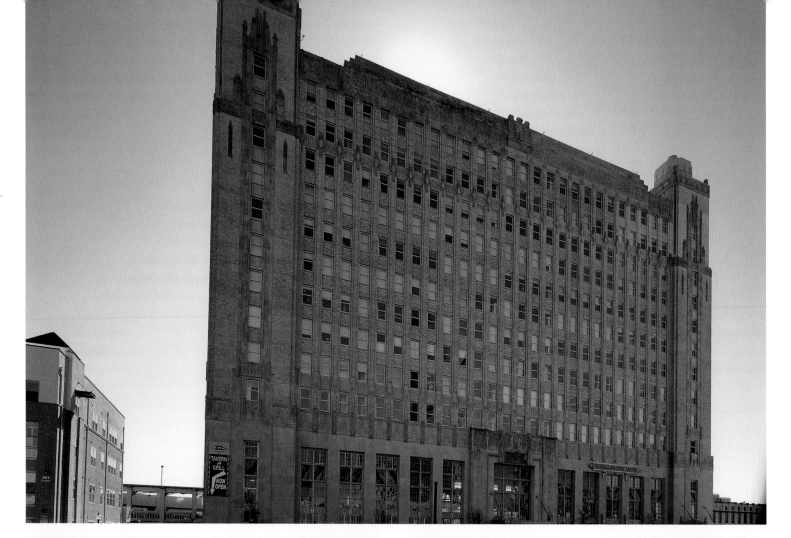

Right: The towering front facade of the station featuring the fancy stone carvings in the limestone piers and on the parapet with the spread-winged eagle at its center.

Below Left and Right: The art deco ceiling of the main lobby displaying the influence of Southwestern Native American sand painting in its elaborate patterns.

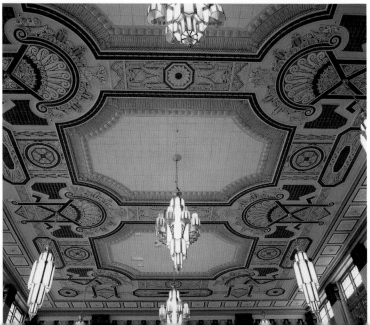

THE INTERIOR IS a revelation, the ceiling as boldly decorative as that of a baroque chapel in Rome. Multicolored geometric designs combine to form a dazzling matrix of interlocking color and form in patterns that arrest and hold the viewer's attention, evoking as they do the intricate designs of Native American sand art. About fifty feet high, the lobby ceiling achieves its mesmerizing effects through the use of raised and colored plasterwork augmented by delicately crafted sugarcane tiles, tan or gold. In executing the restoration, the developers replicated and repaired this stunning sugarcane tile work. Ringing the room at its base is maroon and pink marble wainscoting nine feet high. Above the wainscoting on the north and south facades the nickel-plated and polished-steel windows add a contrasting touch and flood the room with light. Framing these four-story-tall windows are silver pilasters crowned with Corinthian half capitals in gold. Gold in the anodized steel interior doors of the lobby's twin vestibules also contrasts sharply with their brushed-steel frames.

Adding to the lobby's flamboyant beauty are several sturdy accoutrements: Like the eleven chandeliers that punctuate the ceiling, three elaborately decorative ones running in a line down the center of the room, flanked on either side by four plainer but still complementary smaller ones. Like the brass heating grills and vents inset in the walls. Like the brushed-steel wall sconces that accent either end of the lobby. Like the big tambour clock with a gold face that sits atop the brushed-steel frame of the vestibule on the south side above the three doors leading out back to the train platforms; the clock is encased in maroon marble. Like the waist-high maroon marble ticket counter in front of the west wall that has built-in oak cabinetry below it. Like the

matching hand-crafted oak cabinets behind the ticket counter that form a long credenza. Like the attractive frieze that highlights the tops of the east and west sidewalls. All of these accessories render the lobby an art deco masterpiece worth a trip all by itself.

FROM THIS STATION the triumphant Kimbell Art Museum is a mere ten-minute car ride away. Another five-minute ride from there will land you in the heart of the old stockyards. Here you'll get a feel for this bustling town in the days before oil and gas were discovered, when Fort Worth anchored the Chisholm Trail and hosted the biggest stockyards west of Chicago. The old Armour and Swift slaughterhouses are still there, though no longer in use. A full complement of good restaurants and a casino, however, are in use.

Left: The art deco pattern in the ceiling of the smaller waiting room off the main lobby.

DALLAS UNION STATION

Dallas Union Station is one of four stations in Texas designed by Jarvis Hunt, the genius behind the supremely beautiful station in Kansas City. Based in Chicago, Hunt ranged in his station design well into the West and the South. At first blush the serene and stately Dallas Union Station is clearly a cousin to the masterpiece in Kansas City. It too is deftly balanced and proportioned and shows the Beaux Arts style at its

height in the American idiom, with plainness standing in for gratuitous ornamentation and rendering the overall effect more classical and less baroque than excessive European examples like the Paris Opéra. The station stands facing Ferris Plaza as self-assuredly as the White House faces Lafayette Park in Washington, D.C. In its quiet charm and subdued elegance the station exudes come-hither charisma as effortlessly as a southern belle perched on a veranda swing. When the station opened on October 14, 1916, the citizens of Dallas must have been bursting with pride. Designed to handle fifty thousand passengers a day, and serving seven railroads and accommodating eighty trains daily, Dallas Union Station proved that everything was up-to-date in Dallas as well as in Kansas City, whose station had opened two years earlier.

LIKE JARVIS HUNT'S Kansas City station, his Dallas station has a protruding central section flanked by two slightly recessed wings. A colonnade occupies the center of the central section and vaults two stories high, spanning the second and third floors. Behind the colonnade a large balcony stretches nearly the width of the central section. The six carved limestone columns of the colonnade are fluted and crowned with Corinthian capitals. Above the colonnade runs a parapet the width of the central section, anchored at either end by the piers that define the recessed wings. As in Kansas City, architect Hunt installed three large arched windows behind the central colonnade; in the lobby's original configuration it was three stories high and the back facade held three matching arched windows. Through the addition of a floor separating

Opposite Page: The front facade of Dallas Union Station as seen from behind the fountain across the street in Ferris Plaza.

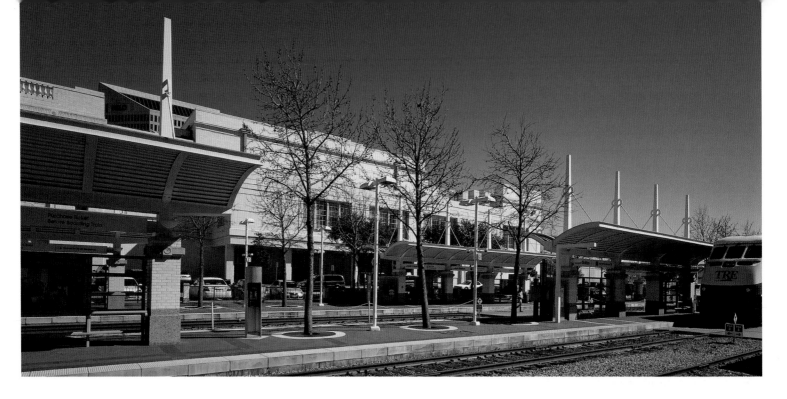

the first and second stories, the structure has been repurposed into a rail station occupying the first floor only. The original lobby from the second floor up is now a grand ballroom-sized special-events room for functions catered by Wolfgang Puck. The famous chef also has a restaurant atop the Hyatt Regency hotel, reached from the station via a climate-controlled underground tunnel that, along its length, also affords access to the still used train tracks.

The new events room, or grand hall, features four brass chandeliers and the dramatic arched windows front and back. On the front side these windows have been converted to French doors affording access to the balcony behind the facade's central colonnade; the balcony overlooks Ferris Plaza. In the plaza, as in Kansas City, Hunt placed a fountain perfectly in the foreground. From across the street in the plaza, as you look back, a gracious white marble fountain beautifully accents the vista of the station framed by the foliage of the plaza's lush trees. The ceiling of the grand

hall is barrel vaulted, and each sidewall holds at its center a two-story arched window matching the three in the front and back facades. The grand hall is ablaze with natural light, adding a dramatic touch to its elegant décor. Along the walls of the room, pilasters of white brick add a sharp touch and display the added virtue of being topped by Corinthian half capitals.

THROUGH TWO SERIOUS renovations, one in the seventies and one just completed, Dallas has repurposed its outstanding station as a hotel and restaurant center while preserving its role as a railroad station, these days for Amtrak. The tracks and platforms behind the station were overhauled and modernized. In addition, the station added service for the Dallas Area Rapid Transit intracity light-rail line and installed the Dallas terminus for the Trinity Railway Express commuter trains to Fort Worth.

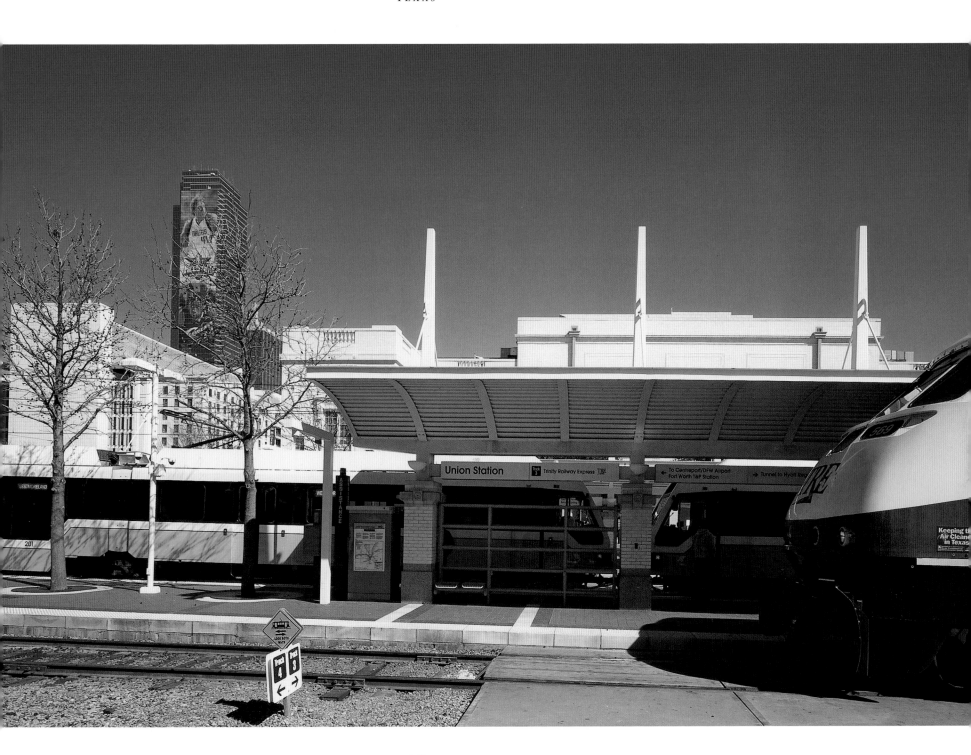

MINEOLA STATION

The small but quaint station in Mineola, Texas, is worth a detour. Because it was a switching station for train crews for the better part of a century, Mineola is a town of five thousand inhabitants steeped in railroad lore. The painstakingly restored station, opened on June 10, 2006, is an exact replica of the vintage 1906 station that served the community until 1951, when an ugly, utilitarian concrete pillbox with a

flat roof replaced it. Nearly fifty-five years later, the town, with the help of government grants, undertook a renovation that restored the station to its fetching 1906 condition. Today the restored bricks are painted beige and the canopy, doors, and windows are trimmed in green. Big wrought-iron brackets, painted black, support the canopy. A pitched roof shingled in light green holds two yellow-brick chimneys, one at either end. There is a black wrought-iron bench under the canopy for passengers who wish to wait outside in warm weather, and in front of the station a smartly landscaped small circular garden holds three flagpoles. On the Front Street side of the station there is a tall black wrought-iron stand holding a large clock. Every detail is tasteful. At night the station is brilliantly floodlit

Opposite Page: A full frontal view of the meticulously restored Mineola Station.

Left: An old-fashioned baggage wagon on display loaded with vintage suitcases inside the station in the museum half of the old waiting room.

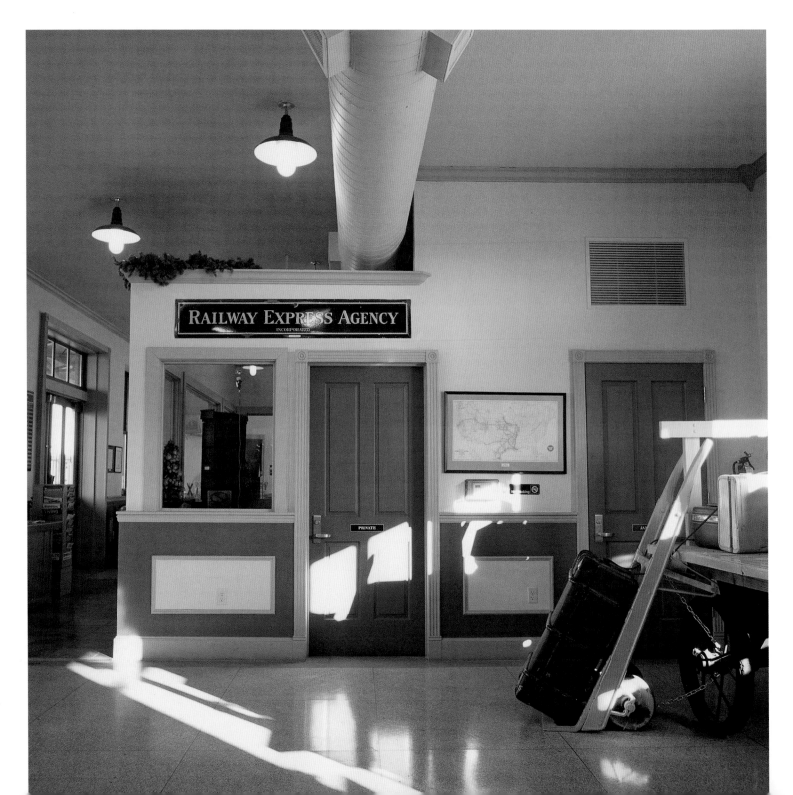

Right: The former stationmaster's office and ticket kiosk divides the waiting room in two.

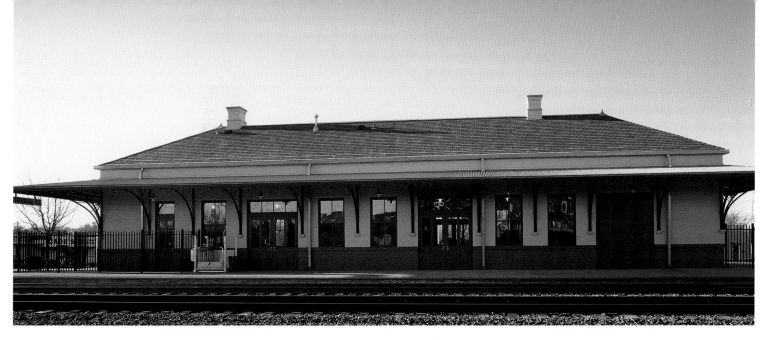

and it sparkles. At the other end of the day, a visiting photographer working at first light marveled at how beautiful the station was as its palette of colors came to life.

INSIDE ALL IS tasteful as well, and authentic. The old stationmaster's office and ticket counter divide the room in two. On one side is a piquant museum with informative posters on the walls detailing the station's and the town's histories. In addition there are displays of an authentic baggage wagon, freight scale, and—uniquely—a large wooden cabinet holding the original "Crew Board," listing the work schedules for the switching crews on the various trains. Glass cases hold artifacts of the railroad era, such as a conductor's uniform, an engineer's cap, conductors' manuals, lanterns, oilcans, coffee mugs, ashtrays, and glassware used on the different railroads servicing the station, and even antique nails. There is one other museum attraction, this one outside behind the station and across the tracks: on a siding sits a Missouri Pacific Lines caboose, open for inspection.

Back inside, the other half of the station holds a small waiting room with oak benches and double-sided settees. As you pass between the two sides of the room, make sure to take in the restored stationmaster's office and note especially the primitive time clock for Texas and Pacific Railroad workers to punch in. It must be one of the earliest models ever designed.

AS YOU WOULD expect of any town originally called Hell's Half Acre or Sodom, Mineola has a vivid history. Situated in the heart of the East Texas timber country, it was crucial to the completion, a few years after the Civil War, of the southern transcontinental line of the Texas and Pacific Railroad that connected Marshall, Texas, and San Diego, California. In its glory days as a "crew change" center, the town provided lodging for layover crews at two railroad hotels, the Beckham and the Carleton Bay. Today Mineola is home to many bed and breakfasts as well as a passel of antique shops. The town also hosts many festivals; for railroad buffs there is the annual Railroad Heritage Festival in October.

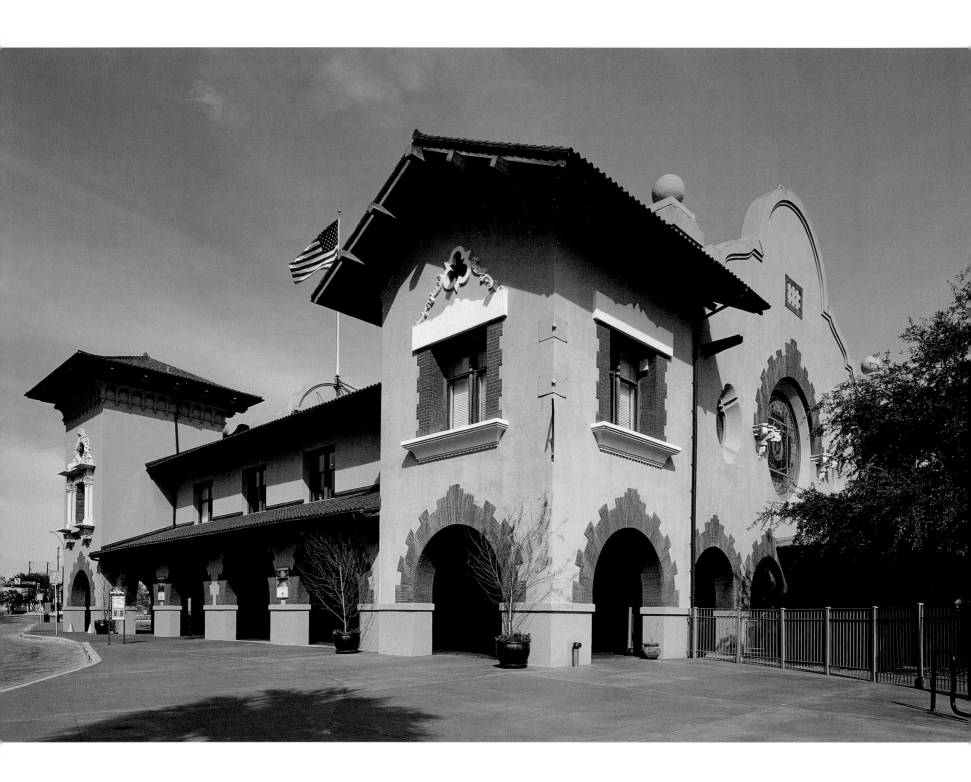

SAN ANTONIO SUNSET STATION

A festive town steeped in cultural history, both Anglo and Spanish, San Antonio, the former capital of Texas when it was a Mexican province, is also home to two of the most beautiful railroad stations in the South. As a railroad crossroads in all four cardinal directions, San Antonio at the height of rail travel hosted trains from the Southern Pacific, the Missouri Pacific (Mopac), the Texas and Pacific, and the Missouri-Kansas-Texas Railroad,

as well as trains from smaller local lines. As a result, three major stations sprouted in the city, of which only the Sunset and the Mopac remain. The magnificent Katy Station, built by the Missouri-Kansas-Texas Railroad, a mission style triumph with Moorish Southwestern-patterned tiles lining its interior walls, was razed years ago to make room for a modern hotel. That's a shame, but the two repurposed stations that remain will dazzle any visitor. They sit on opposite sides of town, the Sunset anchoring the east and the Mopac the west; fortunately, traffic permitting, they are only a twenty-minute car ride apart.

THE OLDER AND more ornate of the two stations, the Sunset was built in Spanish mission revival style in 1902 by the Southern Pacific Railroad and named for its signature train,

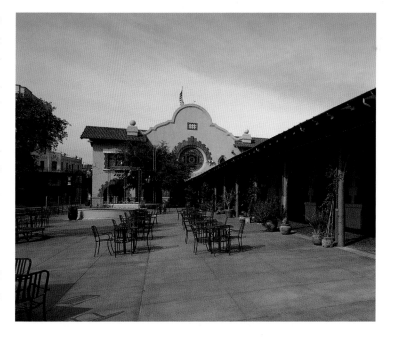

Opposite Page: A view of the Spanish mission revival style front facade of San Antonio Sunset Station.

Left: Chairs and tables arranged in the courtyard for the Al Daco restaurant housed in the station's old freight and baggage sheds on the right.

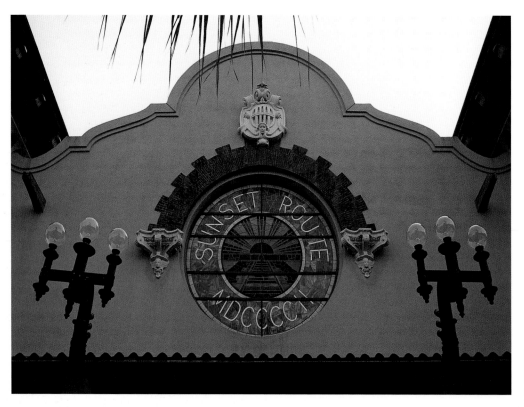

This room will knock your eyes out. Upon entering it, your first thought is that you've been transported to a medium-sized Spanish town and invited into a small but ornately decorated cathedral. Outside, you will have been struck while looking at the front and rear facades by their beautiful rose windows. Inside, these windows are even more impressive, their brilliant colors shot through with light. At either end of the room the twin rose windows frame and illuminate the space dramatically, helped by five large skylights that run lengthwise down the center of the barrel-vaulted ceiling. The rose window on the front facade

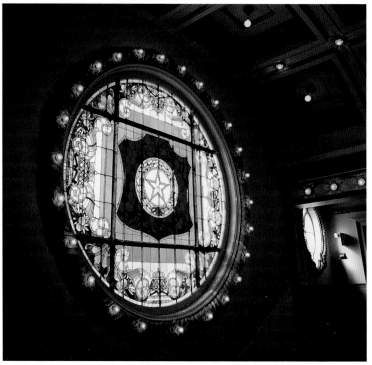

Above: Exterior view of the famous sunset rose window depicting the rays of a setting sun above receding rail lines.

Right: In the old main waiting room and lobby a view of the lone star rose window depicting the symbol on the state flag of Texas evoking its days as an independent nation.

Opposite Page: The lone star rose window above the grand oak staircase and framed by the flanking galleries and the coffered ceiling of the old waiting room and lobby.

the famous *Sunset Limited,* which connected New Orleans to Los Angeles. This train is still operating today on the same route under Amtrak, which keeps a small station a few steps away from the Sunset for this purpose. The Sunset itself has been smartly repurposed as an events complex that also features a Tex-Mex restaurant, the Aldaco, housed in what used to be the station's large freight and baggage storage room. Situated within walking distance of the Alamodome and the San Antonio convention center, the Sunset does a brisk business in event planning, and the restaurant is popular and full year-round. With a cluster of smart hotels surrounding it, as well as remnants of an old San Antonio church and market-place, the Sunset is a community focal point and an example

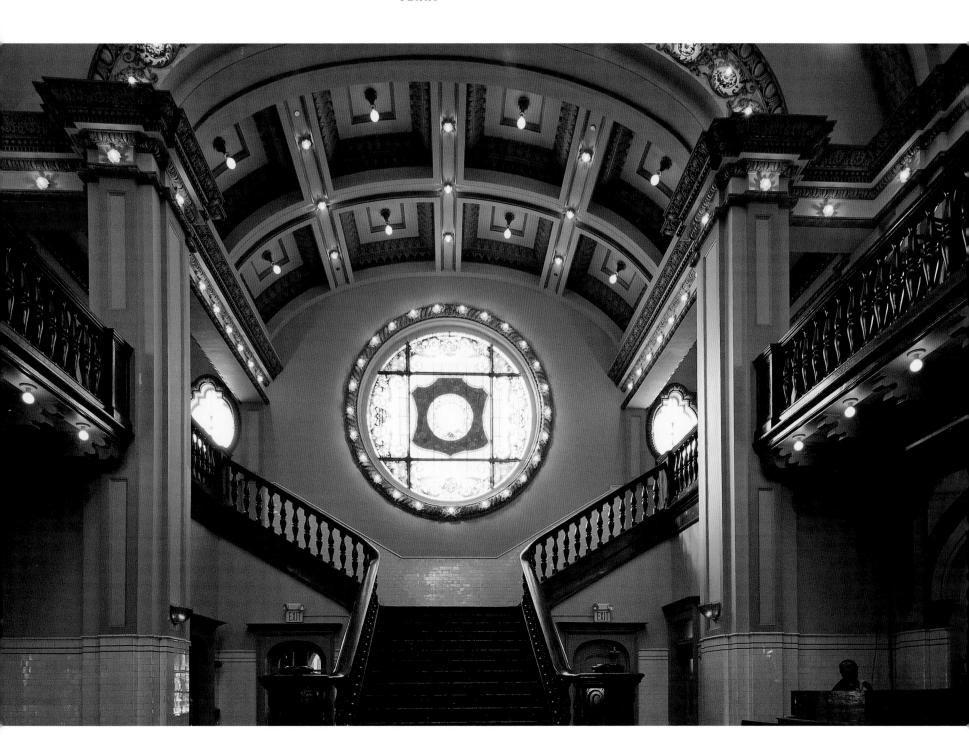

Right: Lengthwise view of the old waiting room and lobby highlighting the skylights, the coffered wooden ceiling, and the sunset rose window.

features a section of track in bold yellow receding into the distance beneath a golden sunset, its rays radiating in three directions; the window's lower border bears the legend "Sunset Route, MDCCCCII," the Roman numerals for 1902. The rose window at the room's opposite end has the Lone Star symbol of Texas at its center in vivid blues, reds, golds, and greens. Beneath this window is the grand oak staircase that affords access to the galleries running along the other three walls.

If you should miss seeing Sunset Station in bright daylight, don't despair. At night it is marvelously illuminated. Lighting was key to the station's identity, as was true of almost all stations built in the era shortly after Edison's transformative invention attained wide use. In fact it was nicknamed the "Building of a Thousand Lights" or the "Crown Jewel" because it featured so many electric lights installed during its construction. Night or day, this station is a Texas beauty, which accounts for its being placed on the National Register of Historic Places in 1975, with the description "a depot as handsome as can be found in the South."

Above: Sunset Station as seen from the east shortly after sunrise. The sunset rose window is obscured behind the palm fronds.

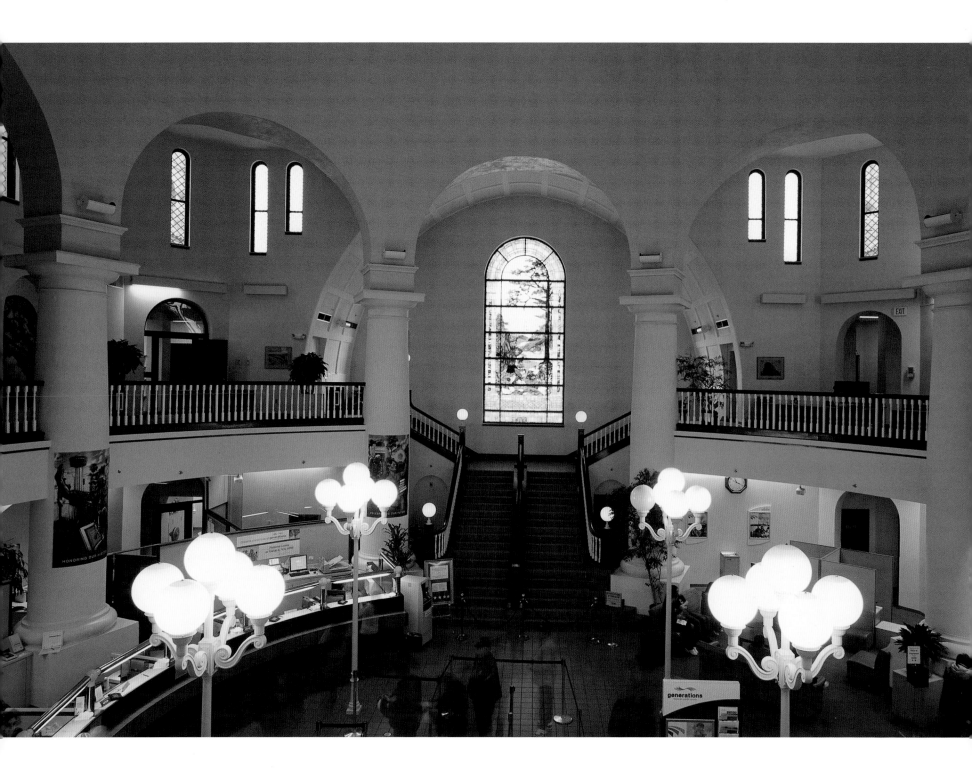

SAN ANTONIO MOPAC STATION

*B*uilt in 1907 at a cost of $142,000 by the International and Great Northern Railroad, Mopac Station is a great homage to that most prominent of San Antonio's cultural attractions, its classic string of Spanish missions built between 1680 and 1790. The most famous of these, of course, is the Alamo, but the Alamo's use as a fort resulted in damage to its beauty. If you take a mission tour in San Antonio, you will see the

better-preserved missions and you will experience firsthand the famous rose window of the beautiful Mission San José.

This window was the inspiration for the stained-glass windows of Mopac Station with the I&GN logo at their center.

The former station lobby is a big rotunda with eight Doric columns supporting the dome. A cupola holding a wall of small arched windows lets in plenty of natural light. A gallery rings the upper story; a grand wooden staircase leads to it on one side, above which looms a vibrant stained-glass window depicting the convergence of Native Americans with early settlers of San Antonio. The stained-glass windows in the lobby are this building's outstanding aspect, along with the copper dome that rises eighty-eight feet and is crowned with a bronze statue of an Indian shooting an arrow in the direction of St. Louis, which happened to be the home of

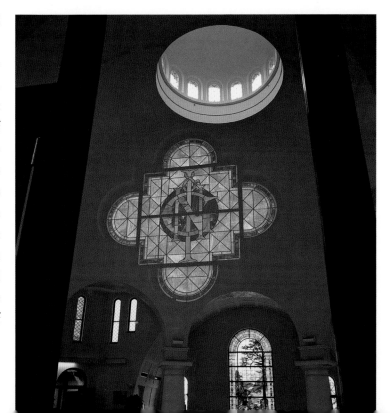

Opposite Page: Overview of the classically serene circular lobby beneath the dome.

Left: The Spanish mission revival style stained-glass window holding the corporate logo of the Great Northern Railroad in its center.

architect Harry L. Page's mistress. (This dalliance on Page's part had resulted in his divorce from a member of the Webster family of dictionary makers.) The sculptor who did the Indian statue also designed the stained-glass windows. Because the statue of the Indian was originally completely nude and anatomically intact, a scandal resulted with the local women's groups that resulted in a bronze loincloth being expediently produced and attached.

The restoration, preservation, and repurposing of this building represents a laudable civic effort. The stained-glass windows were re-created and color-matched from shards by

a firm in Pittsburgh, and the bronze statue of the Indian was miraculously recovered. Today the building is the home of Generations Federal Credit Union, and the people there will gladly regale you with stories of the station's lively history, back when it was known as the gateway to Mexico and served as a principal stop on the luxurious *Texas Eagle*, which ran from St. Louis clear to the Mexican border at Laredo. Happily, Generations Federal Credit Union recently sold the building to the city of San Antonio for restoration as a rail station and multi-purpose transportation hub.

Experiencing this building will make it immediately clear why architect Page called it his Taj Mahal.

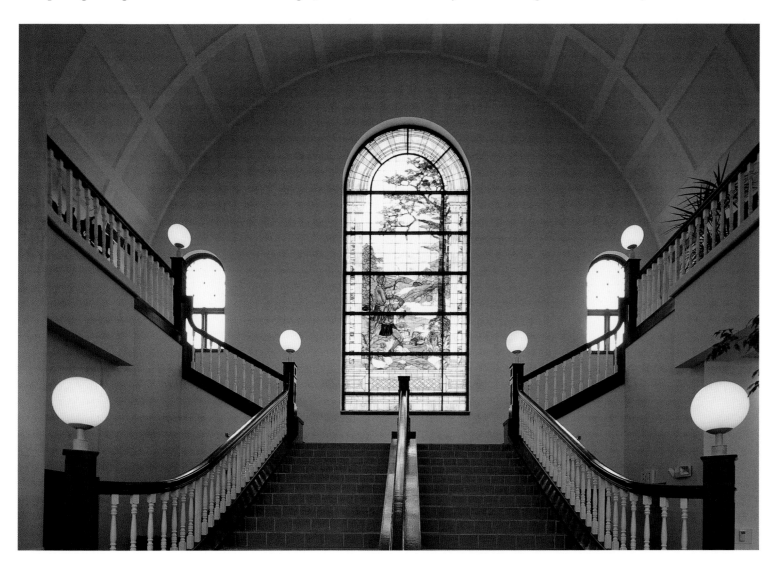

Left: The stately grand staircase ascends from the lobby under the stained-glass window on the landing depicting the convergence of early settlers with the Native Americans.

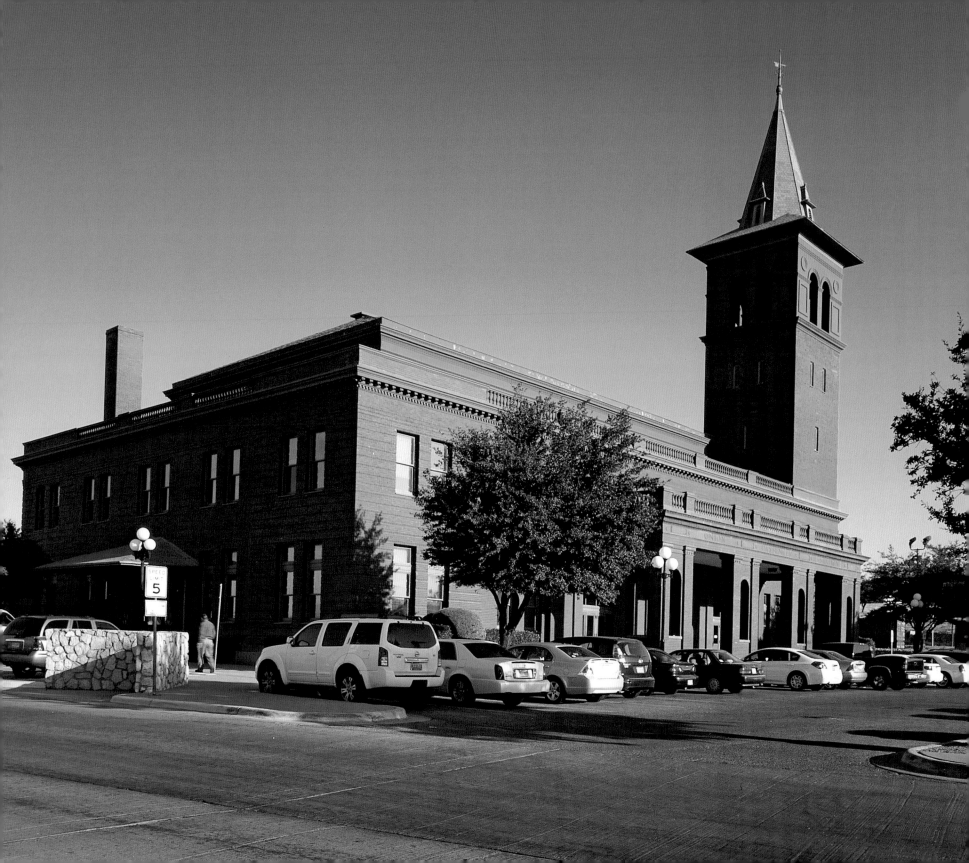

EL PASO UNION STATION

A quarter century after El Paso became a thriving rail center in the 1880s, the city built a showcase neo-classical station designed by Daniel Burnham, the renowned Chicago architect and city planner. It is one of Burnham's midsized masterpieces. When the station officially opened in 1906, so proud were the citizens of El Paso that ten thousand of them showed up to celebrate. In order to build the station, six American

railroad companies and the National Railway of Mexico pooled their resources, thus making El Paso the first international station in the United States, with service to and from Mexico, on whose border El Paso sits.

Constructed of red brick, the station boasts a distinctive bell tower six stories high, a throwback to earlier Victorian stations. It also features a three-story lobby forty-five feet high whose third floor is entirely composed of a large raised atrium with arched clerestory windows lining its walls. These windows flood the interior with brilliant Southwestern light and offset the patterned marble floor, the white marble wainscoting, and the white and gray walls of the ground floor and the second-floor gallery. To arriving passengers the lobby extends a grand welcome.

Outside, Burnham situated the front entrance under a large three-arched portico and, on the interior, topped the entrance's handsome oak doors with two tiers of attractive stained-glass windows.

Union Station was remodeled and truly desecrated in a 1941 makeover that remade it in Spanish mission revival style, with stucco walls covering the red brick, the spire of the bell tower lopped off, the roof recovered in red tiles, and an adobe wall replacing the iron fence that defined its perimeter. For decades the station had been the centerpiece of downtown, yet after the mid-fifties it fell into decline and was shuttered and nearly demolished in 1974.

Happily, a year later it was spared when the National Register of Historic Places added it to its list. After securing

Opposite Page: El Paso Union Station showing the portico in front of the main entrance and the looming tower in the background.

Right: A frontal view of the station dramatizing its neoclassical elements evolving toward the Beaux Arts style. Note above the main roof the clerestory windows in the sidewalls of the raised penthouse above the lobby's central atrium.

Below: A closer view of the auxiliary entrance alcove showing the oak doors and woodwork, the stained-glass transom, and the stylishly patterned two-toned marble floor.

Opposite Page: An overview of the tastefully restored lobby emphasizing the building's decorative Beaux Arts elements: the marble floor and wainscoting, the bowed clerestory windows, the columned galleries, and the fretwork frieze.

a federal grant, the city soon bought it for just under a million dollars and restored it to its original 1906 glory, removing the stucco from the redbrick exterior, rebuilding the spire of the bell tower, and refurbishing the lobby with marble imported from Italy.

Local lore has it that in 1916 Mexican Revolutionary War general Pancho Villa used the station's tower as a lookout point while conducting a siege of Ciudad Juárez, the Mexican city that sits opposite El Paso across the Rio Grande. At the time American general "Black Jack" Pershing was trying to hunt Villa down and capture him.

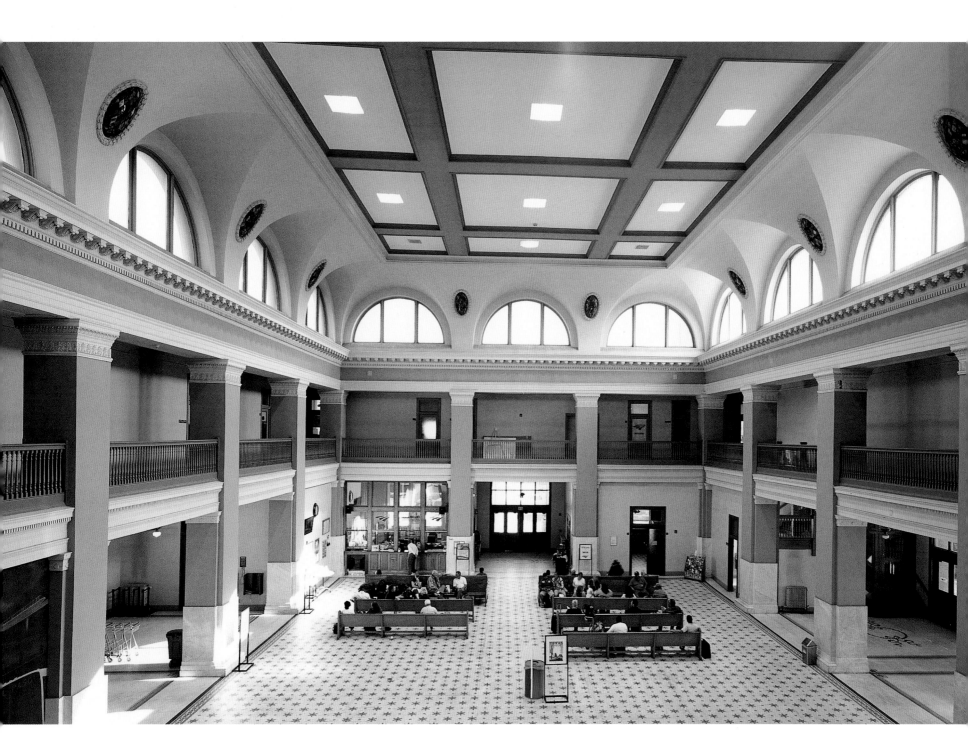

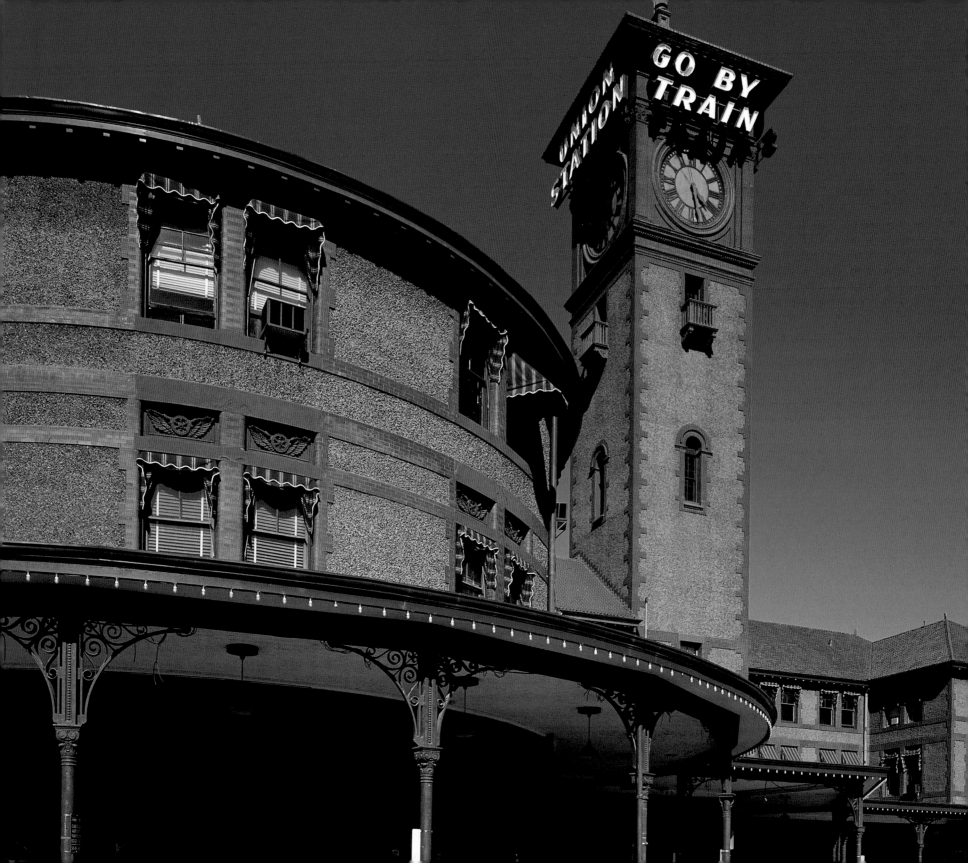

THE WEST

Seattle and Portland offer excellent examples of second-generation stations built on a large scale. Both stations opened shortly before the Beaux Arts style superseded the Victorian. Each is quite large, Victorian in composition, spare in decoration, and highlighted by that most distinctive feature of second-generation Victorian stations built on a large scale: a lofty and striking clock tower. Each also boasts a stunning interior.

Tucson's Spanish revival station was designed by Southern Pacific architect Daniel J. Patterson. He is the talented artist who also designed the splendid Sunset Station in San Antonio as well as Seattle's Union Station that so enhances the beauty of its central Pioneer Square. In Tucson, Patterson again displayed his mastery of the Spanish revival style, with its large debt to the great Spanish missions of the seventeenth and eighteenth centuries. Southern Pacific, however, remodeled this station in 1941 in the art moderne style, downplaying most of the Spanish revival elements, though remnants remain, mostly in the station's overall configuration.

Previous Pages: Portland Union Station with its distinctive tower front and center.

Right: Tucson Southern Pacific Station today reflects its art moderne makeover while retaining remnants of classic Spanish colonial architecture.

Opposite Page: The gardens and patio behind Tucson Southern Pacific Station display a Sonoran Desert theme.

The four California stations offer two examples of small stations: the picturesque Spanish revival gem in Davis and the practical yet pleasant stalwart in Dunsmuir. Each would seem possible in no other state of the Union; indeed, both seem as indigenous to California as bottlebrush plants and avocados.

The two large Californian stations also celebrate and commemorate their heritage. Sacramento, a town key to the history of railroading in America—the western terminus of the transcontinental railroad—has a 1926 Beaux Arts station befitting its status, and one that, especially in its lush interior, reflects a distinctly Californian aura that hints at what is to come a decade and a half later in the last great train station built in America: Los Angeles's unique, voluptuous, variegated, and sensual masterpiece, the Los Angeles Union Passenger Terminal, or LAUPT. LAUPT combines elements of the Spanish revival and art deco styles in a pleasing medley unlike anything else anywhere in the world.

Bracketed by its partner in the East, New York's incomparable Grand Central Terminal, Los Angeles Union Passenger Terminal bookends America's peerless collection of great train stations.

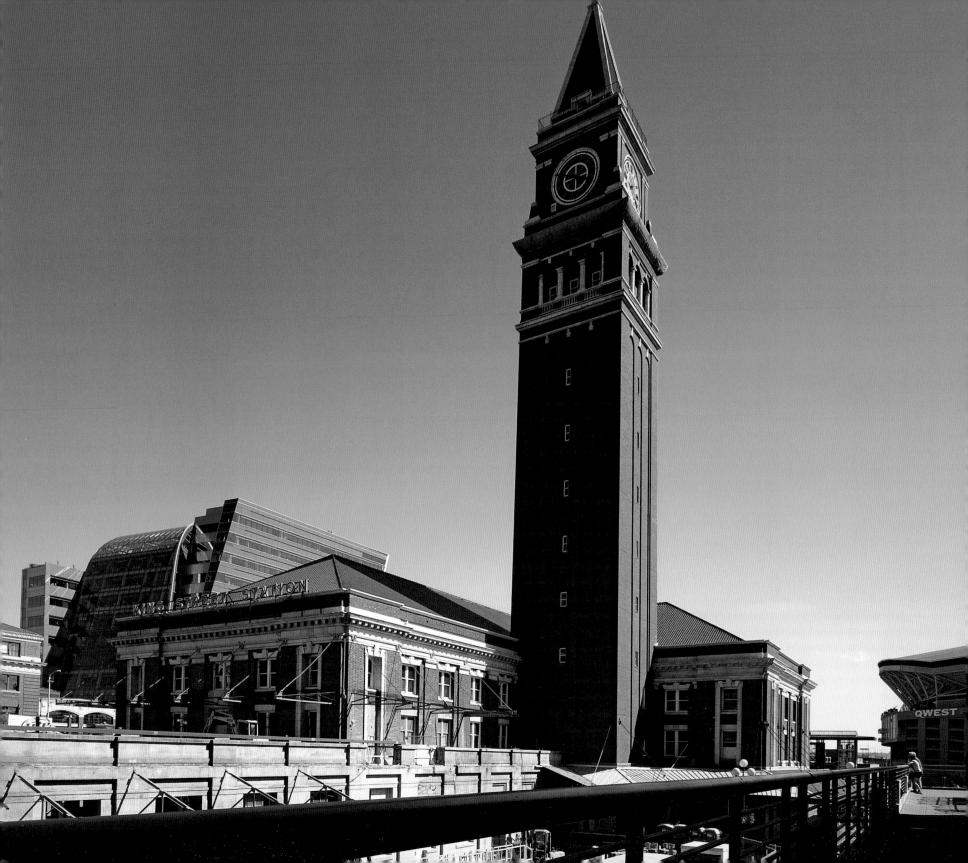

SEATTLE KING STREET STATION

Your first thought upon seeing King Street Station in Seattle is that there must be singing gondoliers nearby. The station's dominant feature is its 242-foot-high tower modeled on the campanile that towers above Venice's celebrated Piazza San Marco, with the great Byzantine cathedral, the gothic arcades, and the famous blue lagoon for backdrop, filled as it is with shiny black gondolas punted by those colorful and vocal

gondoliers. King Street Station is also hard by a waterfront and has Seattle's excellent harbor for backdrop, filled as it always is with freighters, commercial fishing boats, and recreational craft of every size and description.

Built from 1904 to 1906, King Street Station replaced, in the same waterfront area, smaller stations rendered outmoded by the growth of rail traffic. In the 1890s Seattle had two principal railroads serving it: the Northern Pacific and the Great Northern. Their presidents bickered for years and involved the city council in the fray until, in 1901, Great Northern president James J. Hill managed to acquire Northern Pacific. He then made plans to build King Street Station to serve all the trains of his newly expanded railroad, initially hiring the St. Paul architectural firm of Reed and Stem to design it. These are the same two architects who played

Opposite Page: Seattle King Street Station flaunts its magnificent campanile.

Left: The lobby boasts patterned marble floors, marble wainscoting, and outstanding plasterwork, such as that garnishing the clerestory windows.

ON THE TRACK side the station has three stories; on the street side, only two. The subterranean first story on the track side originally allowed carriages and hackneys to deposit passengers under its canopy, thereby avoiding exposure in unpleasant weather. The station's exterior consists of handsome granite and red bricks over a steel frame, and also displays terra-cotta trimming and cast-stone ornamentation. Sitting at the conjunction of Jackson and King Streets, the tower looms above the station's main entrance, which opens onto Pioneer Square.

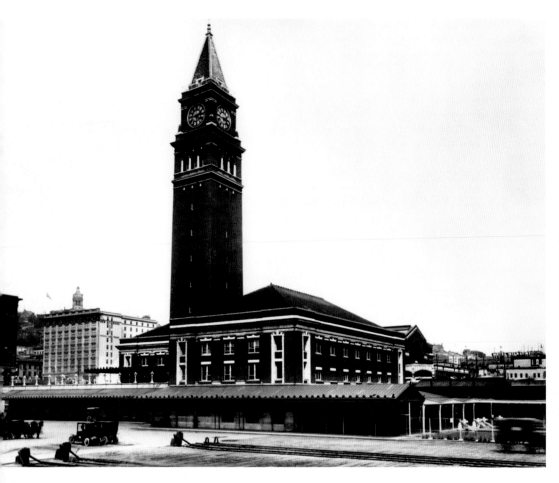

Above: The station in the early years of the twentieth century, not long after it opened in 1896.

Right: The station undergoing renovation to preserve its original grandeur and stateliness.

Opposite Page: The compass room showing its magnificent compass of inlaid marble.

leading roles in the overall design of New York's magnificent Grand Central Terminal, until Whitney Warren, of the collaborating firm Warren and Wetmore, stepped in to install the Beaux Arts elements and ornamentation.

In the case of King Street Station, however, the tightfisted James J. Hill saw no reason to spend excessively on a "fancy depot." The resulting station, nevertheless, has many exquisite features, a great deal of ornamentation by modern standards, and is quite imposing overall, all the more so since it has been under restoration since 2003.

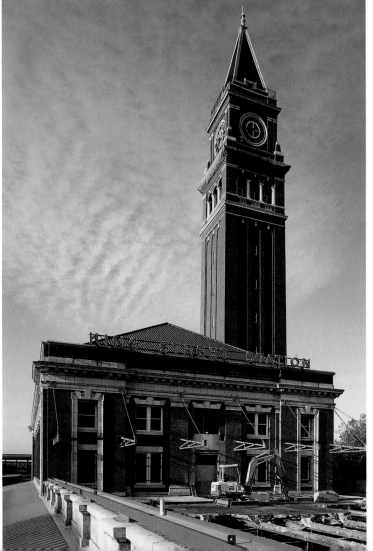

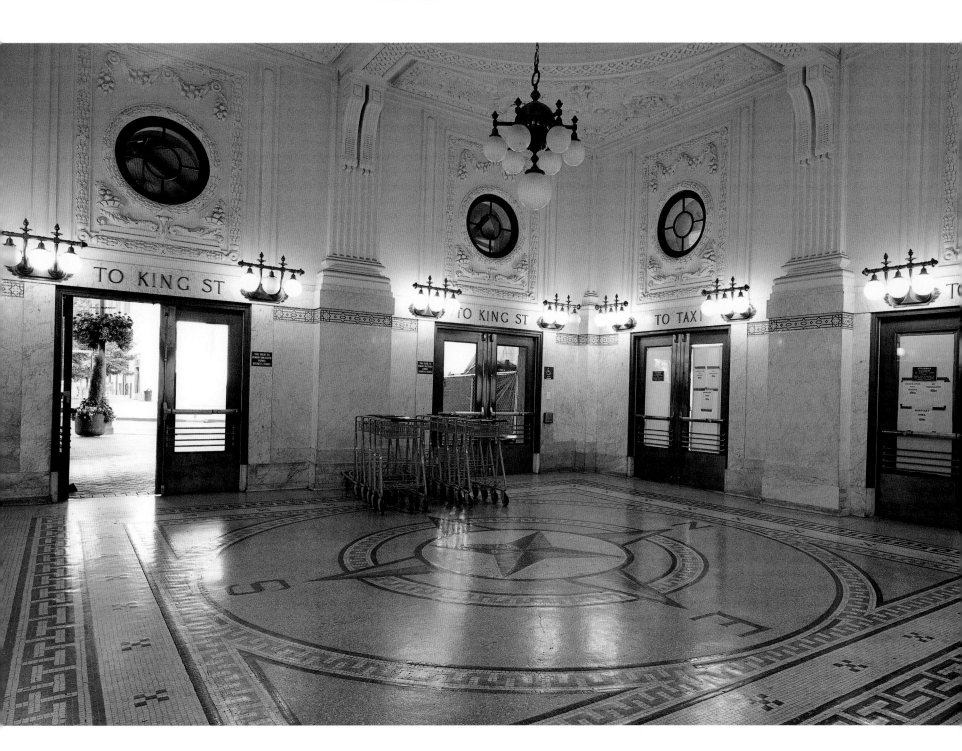

On the interior, the tower rises above the compass room, so named for the elaborate navigational compass inlaid in hand-cut marble tiles in the center of the floor; the compass, in turn, is framed by pleasing two-toned marble fretwork. A single white-globed chandelier, aided by white-globed wall sconces, supplies the room's artificial illumination. Above the wall sconces, circular clerestory windows encased in raised plasterwork furnish additional natural light. This sunny and welcoming room also boasts marble wainscoting and elaborate raised plasterwork in the ceiling, including a rosette that anchors the chandelier. Beyond the compass room is the spacious and elegant waiting room, with its stunning coffered ceiling, its two-tiered sets of windows, and its commodious benches.

The station has twenty-one daily departures on weekdays, eight on weekends. Amtrak runs eight trains on its *Cascades, Coast Starlight,* and *Empire Builder* lines daily; on weekdays only, the Sounder commuter rail service runs nine trains south to Tacoma and four north to Everett.

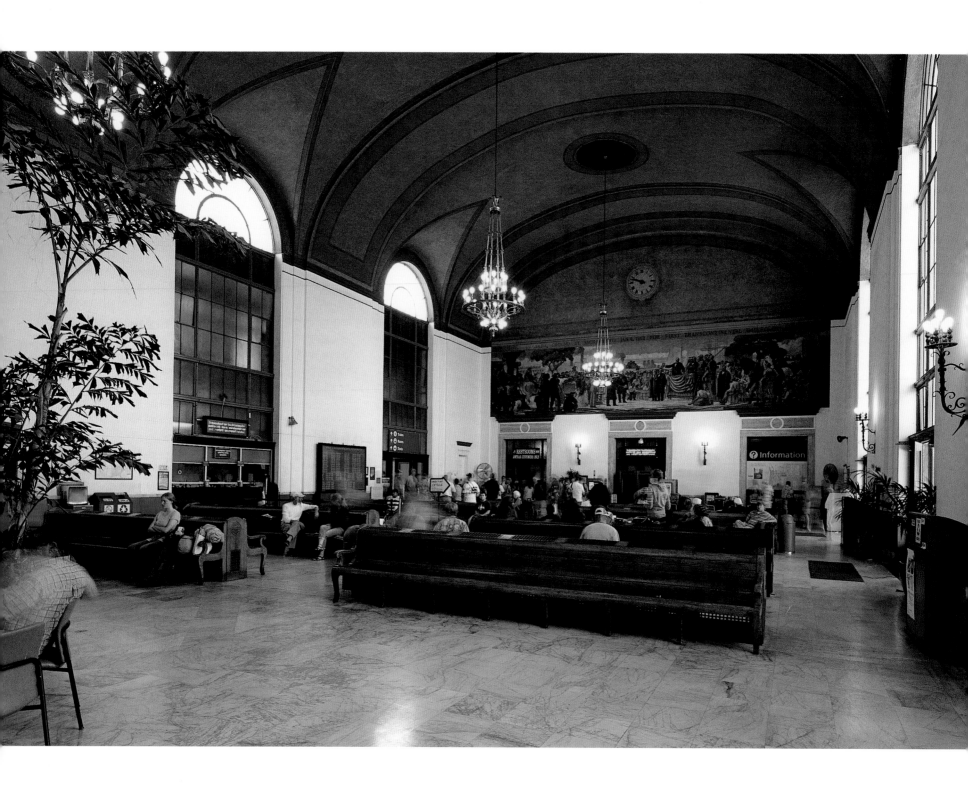

SACRAMENTO STATION

acramento played a monumental role in the history of railroading in the United States. In 1863 the Central Pacific, which eventually merged into the Southern Pacific, started building its first depot in Sacramento in preparation for its eastern push to hook up at Promontory Point in Utah in 1869 with the Union Pacific. When Leland Stanford drove the golden spike on May 10, 1869, the deed was done, and one of the

greatest engineering feats of the nineteenth century was a fait accompli: the country was connected Atlantic to Pacific by rail on what was called the overland route. It initially took eight days and cost sixty-nine dollars to cross the country by rail.

As a result of the completion of the transcontinental hookup, Sacramento became synonymous with the railroad. It constituted the key terminus on the West Coast, with extensive rail yards and repair and storage facilities, which are still in evidence today and which are celebrated in the California State Railroad Museum, also in Sacramento and much visited and extolled by American railroad buffs of every age, stripe, and kind.

Before the current Sacramento Station was built and opened, to much fanfare, in 1926, two lesser stations preceded it, both rapidly outgrown by booming rail traffic in the late-Victorian era right up to the mid-twentieth century.

Opposite Page: The lobby and main waiting room of Sacramento Station.

Left: An overview of the platforms and tracks out back as seen through the parapet's balustrade.

Right: The station's Renaissance revival facade is balanced, serene, and impressive without being overwhelming.

Fortunately Sacramento Station was left to deteriorate and was not desecrated in any way by clumsy attempts at "modernization." This sensible restraint has made the current efforts by the city of Sacramento to restore the station to its original glorious condition all the easier. That rehabilitation is well under way at present.

THE SAN FRANCISCO architectural firm of Bliss and Fairweather, whose founding partners met while working as fledgling architects in New York for McKim, Mead, and White, designed this pleasing Renaissance revival station. The three-story building has a steel framework faced with Italian brick of a light russet color, offset by the darker russet of the roof tiles. The entire exterior is trimmed with terra-cotta. The station has a large central section that protrudes slightly from two symmetrical wings. This central section features five magnificent thirty-five-foot-high arched windows; the two wings each have five slightly smaller rectangular windows, with keystones in their lintels rather than arches. The exterior's seemingly effortless harmony is subtle and flawless.

Inside, the central waiting room has a barrel-vaulted ceiling sixty feet high, and its spacious accommodations are flooded with sunlight from the soaring arched windows.

Because these windows are glazed with amber-colored cathedral glass, they impart a soft tone to the entire interior ambiance. The floors consist of California marble trimmed with travertine, and the woodwork is made of Lamao mahogany imported from the Philippines. On the east wall a large mural by celebrated San Francisco artist John A. MacQuarrie allegorically re-creates the crucial role played by Sacramento in linking America by rail from sea to shining sea. Large chandeliers and unobtrusive wall sconces provide the nighttime lighting and complete the room's aura of understated opulence. The total cost of the station's construction was $2,317,000 in 1926 dollars, and the result was one of the grandest and most imposing stations in the West, befitting a city whose role in American railroading history cannot be overstated.

Amtrak's fabled *California Zephyr, Capitol Corridor,* and *Coast Starlight* trains still serve the station, and there is a quick connection, via a short bus trip to Stockton, for passengers wishing to pick up Amtrak's southbound San Joaquin line. In addition, when completely renovated, Sacramento Station is planned to function as an intermodal transportation hub, encompassing intercity and intracity bus and taxi service as well.

Below Left: The facade features five tall arched windows that flood the lobby with light.

Below Right: The allegorical mural by artist John A. MacQuarrie dominates the east wall of the lobby.

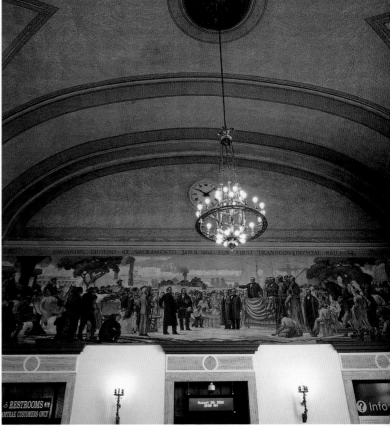

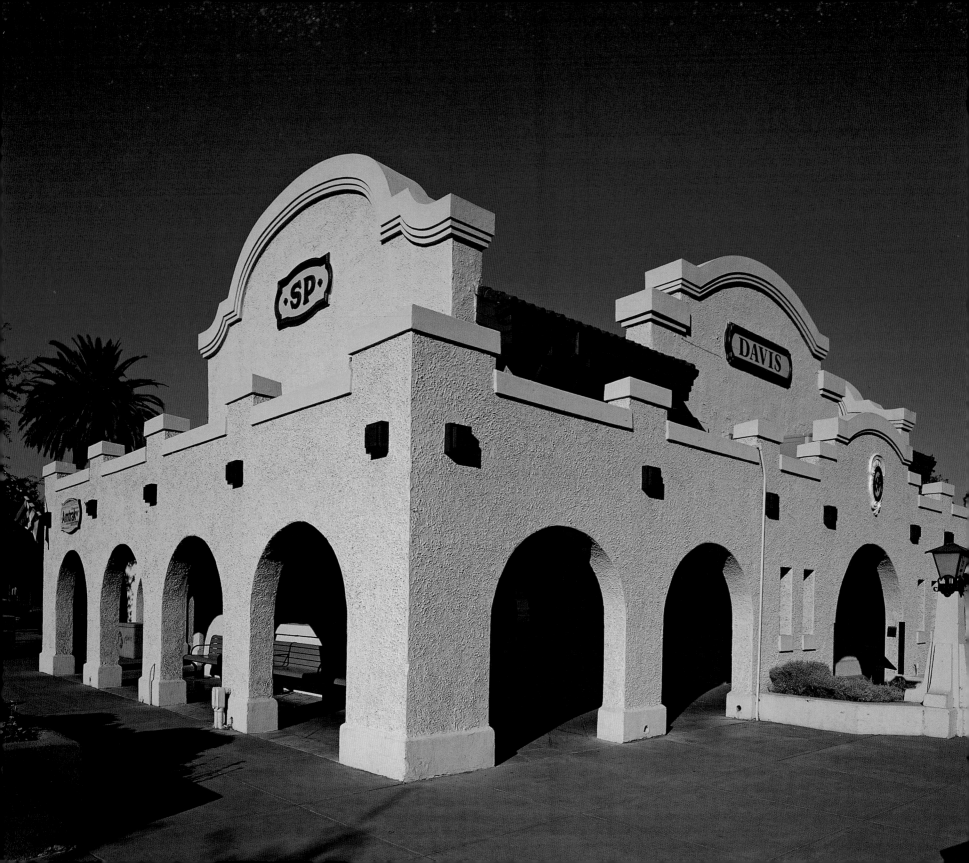

DAVIS RAILROAD DEPOT

Built by the Central Pacific Railroad in 1914, Davis Railroad Depot is an excellent example of an early twentieth-century midsized station in the mission revival style totally indigenous to California. The station manages simultaneously to evoke at a glance the Golden State's colonial history and its futuristic modernism. The homage to California's heritage as a Spanish colony is boldly stated in the station's overall

design and configuration, yet the clean lines and subdued decorative accents speak to its modernism and its futuristic plainness. From its red tile roof to its pink stucco arches, from its tropical plantings to its gently scrolled pediments, this station could fit so well in no other state. Ridgeline to foundation, Davis Depot is vintage Californian.

The current station was constructed after a fire destroyed the original small station built at this location in 1868, one year before the transcontinental railroad completed its hookup at Promontory Point. In 1986 the residents of Davis completely refurbished and restored the station to reflect its opening-day condition of 1914. Today the station, with its tasteful waiting room and stationmaster's office, plays host to Amtrak's three legendary Californian trains: the *California Zephyr,* the *Capitol Corridor,* and the *Coast Starlight.*

Not surprisingly for such a perfectly realized and preserved instance of mission revival architecture, the Davis Railroad Depot was placed on the National Register of Historic Places in 1976.

Opposite Page: The facade of Davis Railroad Depot is a quintessential tribute to Spanish mission revival style.

Left: The interior of the lobby is subdued and plain and reflects early twentieth century taste and good sense in its handsome woodwork and substantial hardwood floors.

Right: Like the lobby, the waiting room is all restraint and good taste and boasts beautifully crafted period benches.

Below Left and Right and Opposite Page: The photos below of the back and side of the station showcase its mission style staples like the attractive stucco arcades and the scrolled pediments. The photo of the station's front entrance on the following page emphasizes these same features.

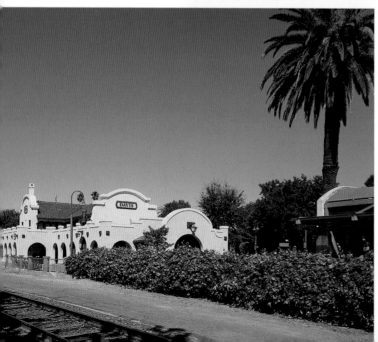

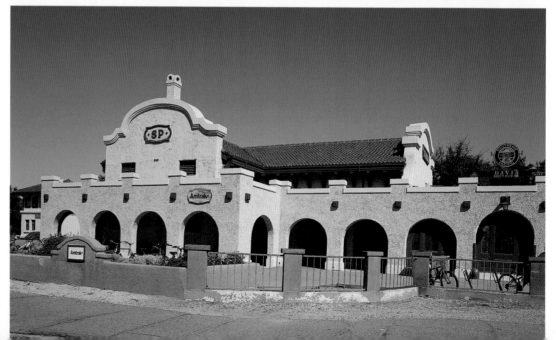

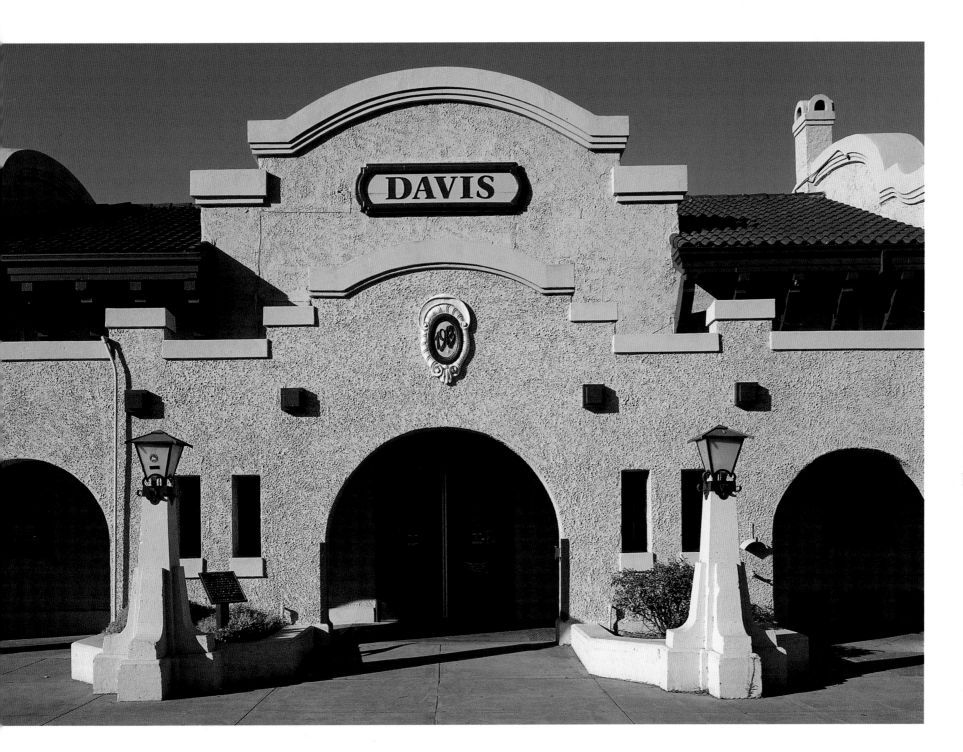

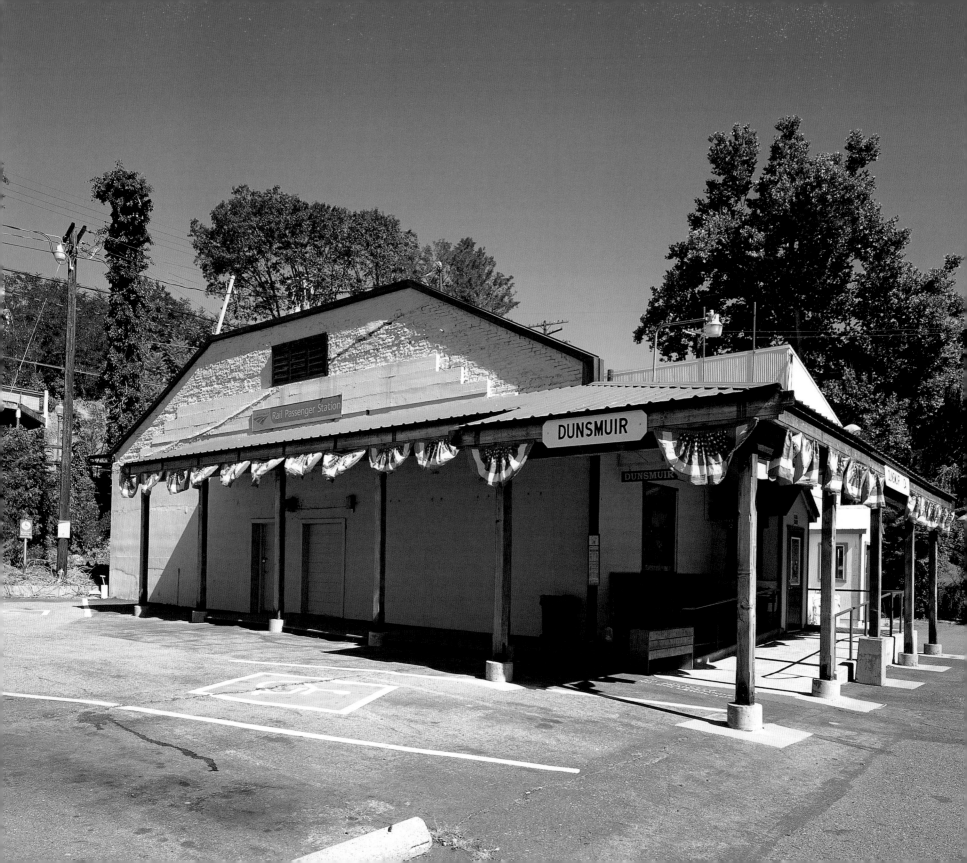

DUNSMUIR STATION

The story behind the preservation and revival of this charming little train depot by the townspeople of Dunsmuir, California, is as authentically American and inspiring as reading Mark Twain's great, and greatly amusing, tall tale "The Celebrated Jumping Frog of Calaveras County." The townspeople obtained grants from the James Irvine Foundation to lease from Union Pacific Railroad what had been the ramshackle

ruin of a once small but tasteful train depot serving a small town redolent with local history and nestled in a spectacular valley on the upper Sacramento River, with the stunning vista of Mount Shasta and the Trinity Alps as backdrop. In short order the residents of the town restored the station, a portion of which had served previously as Union Pacific crew quarters, to its original foursquare sturdiness, so that today the town still enjoys Amtrak service on its *Coast Starlight* route.

Dunsmuir's first European settlers were trappers for the Hudson Bay Company who arrived in the 1820s; three decades later they were succeeded by hordes of miners panning for gold

Opposite Page: Dunsmuir Station is a hardy small-town workhouse set in a bucolic mountain valley in central California.

Right: This trackside view shows how vigilantly maintained the station has been since its restoration.

Above: A working diesel idles behind the station, attesting to the frequency of freight traffic passing through, though only the *Coastal Starlight* now services passengers.

in the midcentury California gold rush. The first railroad arrived when the Central Pacific installed its line along the Siskiyou Trail in 1886, initiating train service in that part of the Sacramento Canyon. The original 1886 depot was housed in a boxcar. In the 1920s and '30s Dunsmuir flourished as a resort, and much of that era's charm is still prominent today.

The refurbished train station adds significantly to this enchanting historical aura, especially since the depot has been furnished with a handsome display room, dedicated by the Dunsmuir Railroad Depot Historical Society, that showcases the town's pivotal role in the settlement and early railroad history of the region.

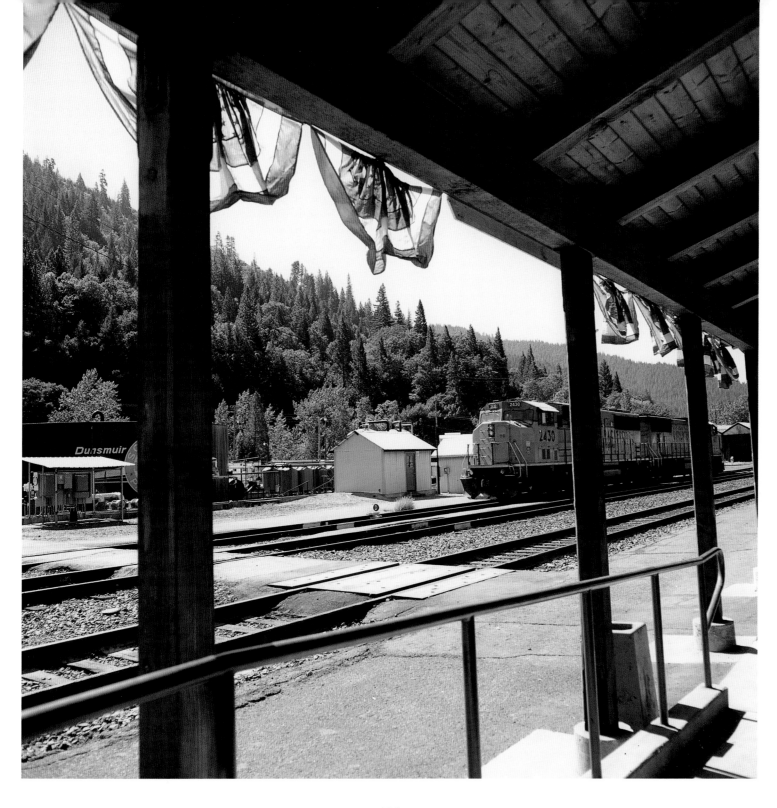

Left: The station nestles in a stunningly beautiful alpine setting that attracted early trappers and then prospectors and miners before becoming a resort.

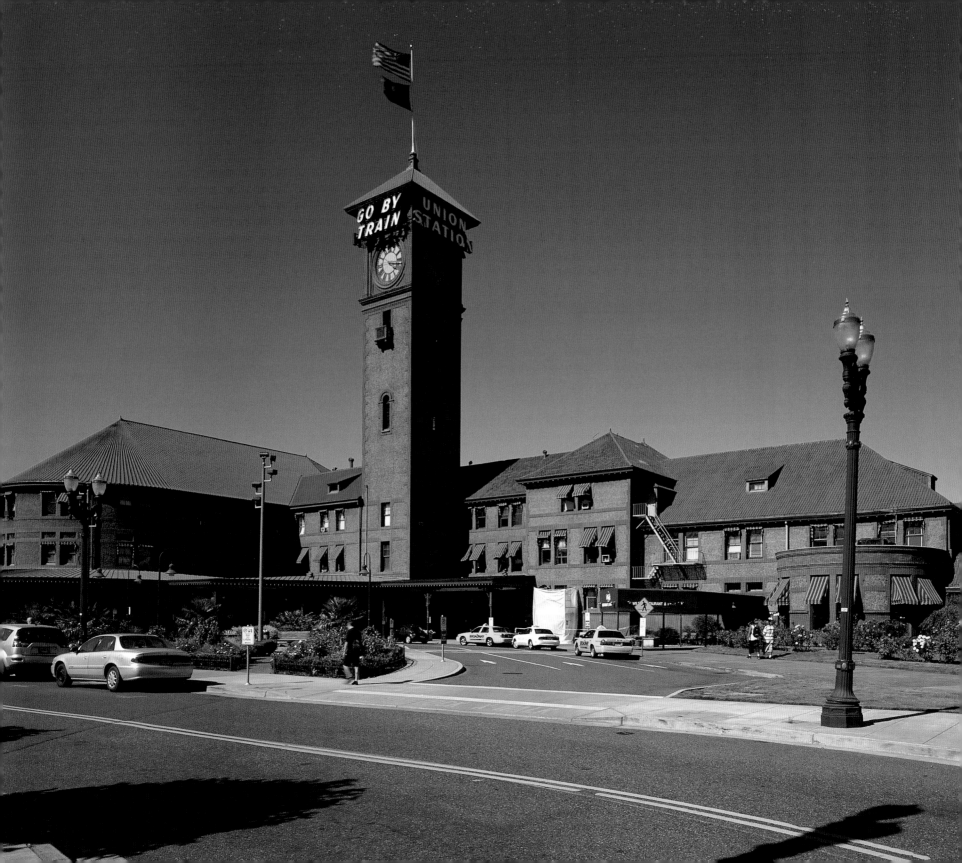

PORTLAND UNION STATION

*I*n *the 1880s and '90s Portland was a boomtown, expanding rapidly like many western towns then coming into their own as commercial centers, thanks largely to proliferating rail service in the far West, the transcontinental railroad having been completed a scant eleven years earlier. Naturally the city's old wooden railroad station was suddenly antiquated and in need of replacement with an updated facility. Originally,*

railroad baron Henry Villard planned to fulfill this need, and he hired no less prestigious a firm than McKim, Mead, and White of New York to execute a design for the new station. They duly did, and the station they planned would have been the largest in the world at that time, had it only been built; unfortunately, this never happened because Villard fell on hard financial times.

Eventually the Northern Pacific Terminal Company stepped up in 1885 and commissioned a less grand plan for a new station from the architectural firm of Van Brunt and Howe. Construction began in 1890. Six years later the station opened, appropriately enough, on Valentine's Day: that's form and function in harmony, since the resulting station is a sweetheart combination of the Queen Anne and the Romanesque styles. Though quite grand, Portland Union Station,

Opposite Page: A sweeping view of Portland Union Station's facade showing its large forecourt and driveway.

Left: The walls and floor of the interior are clad in marble and there is a pleasing rectilinear quality to this station's interior.

Right: The station's facade about 1920 showing the tower absent its now famous "Go By Train" sign.

Opposite Page: The main waiting room has an attractive wooden coffered ceiling to complement the marble clad walls and patterned marble floor. Note the beautiful vintage oak settees.

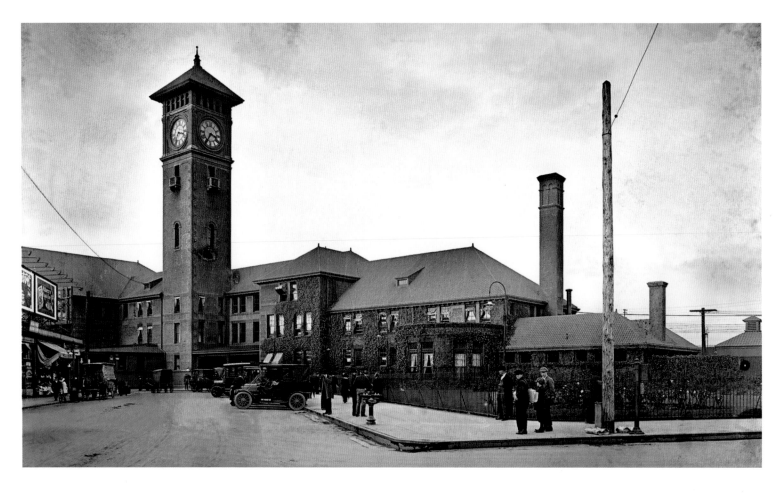

like everything in the always pleasant Rose City, is cozy, welcoming, and built on a livable scale.

Today the station is also a centrally situated main hub in the much admired and widely imitated transportation system that integrates all modes of transportation within and without the city, combining long-distance, light-rail, and commuter trains, as well as local and long-distance bus facilities, in addition to local taxi service. Both in the United States and across the world the Portland transportation system has served as a prototype of enlightened, environmentally friendly urban

engineering. All this has been accomplished while preserving the period charm and glory of the original station.

Built of red brick and stucco, with sandstone banding, and capped by a tin roof in red tiles, the station is distinguished from afar by its 150-foot-high clock tower, featuring on all four sides an original Seth Thomas clock that is still hand-cranked by station workers to rewind it for each week's service. The renovation undertaken in the 1990s saw the station's entire interior restored to the elegance installed when Portland designer Petro Blush directed a major remodeling between

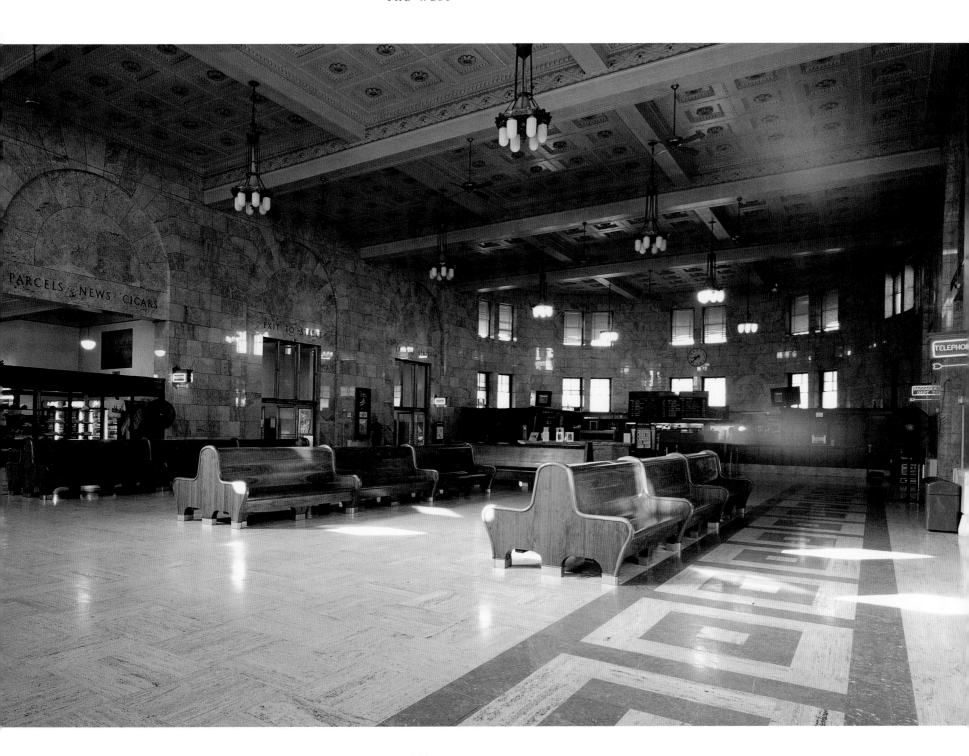

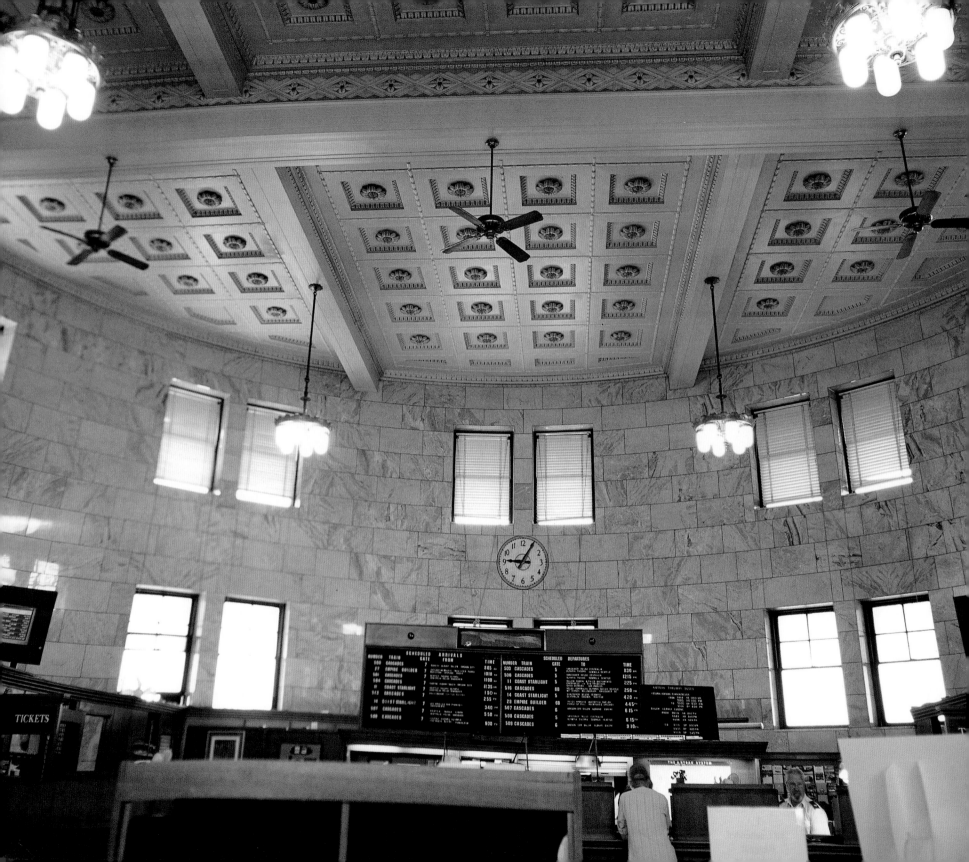

1927 and 1930: He chose marble cladding to cover the walls and floors, dressed arches in travertine, inserted a stark art deco clock above the doorway leading to the train platforms, and commissioned handsome built-in wooden phone booths to complement the highly polished oaken benches, the art deco chandeliers, and the wood-beamed coffered ceilings.

In addition to serving two very active MAX local light-rail lines, Portland Union Station is a main terminal on Amtrak's *Cascades, Coast Starlight,* and *Empire Builder* lines. The station is also projected to be a main hub on the high-speed line Amtrak hopes to operate up and down the Pacific coast someday soon.

Opposite Page: The apsidal end of the waiting room contains the ticket counter with its bold arrival and departure boards.

Above: A view of the main waiting room showing the exits to the train platforms out back

Far Left: Wooden phone booths, anachronistic now, impart a pleasant period feel to the interior.

Left: The refurbished beauty of this corner of the waiting room and the arched corridor leading away from it attest to the effectiveness of the station's 1990 restoration.

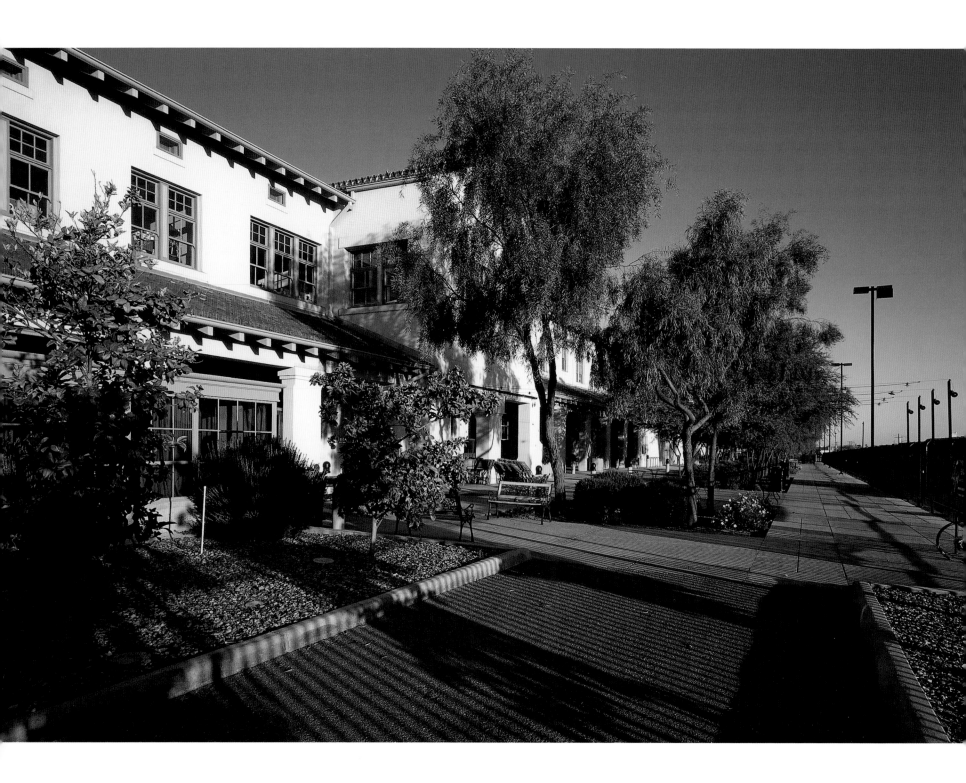

TUCSON SOUTHERN PACIFIC STATION

Tucson Southern Pacific Station today is a simplified version of the Spanish revival building designed by Southern Pacific's staff architect Daniel J. Patterson and opened in 1907, five years after the opening of his Sunset Station in San Antonio. Significantly, Tucson was a stop on the two legendary trains that ran west along the southern tier of the country, the Sunset Limited *and the* Texas Eagle. *The building had originally*

displayed the baroque excesses of the Spanish Churrigueresque style named for Spanish architect José Benito Churriguera (1665–1725) and popular in Spain and in its Latin American colonies in the late seventeenth and early eighteenth centuries.

Southern Pacific modernized the station in 1941, giving it an art moderne face-lift, eliminating the rococo decorative curlicues and replacing them with the plain walls, doors, and windows that retain only a hint of the Spanish flavor of the Southwest in the big shaded arcades, the rounded arches above some windows and doors, and the hipped red tile roof. The building still has a striking central section flanked by two attractive wings. Out back the area leading to the train platforms is pleasantly landscaped to form a small garden with a Sonoran Desert theme.

Opposite Page: The station today is a pleasant amalgam of its 1907 Spanish revival roots and its 1941 art moderne makeover.

Left: Southern Pacific Steam Locomotive #1673 sits proudly on a siding behind the station's transportation museum. It played a prominent part in the movie *Oklahoma*.

The present makeover reflects the money the city of Tucson poured into the building upon purchasing it from Southern Pacific Railroad in 1998 and funding a complete restoration to its 1941 art moderne incarnation. The rehabilitated station now features retail, office, and restaurant facilities in addition to servicing Amtrak's passenger trains on their triweekly schedules.

The Southern Arizona Transportation Museum occupies the station's former records vault and recaps the city's history as a rail center. On a siding behind the museum sits Southern Pacific Steam Locomotive #1673, which played a major role in the 1954 film adaptation of Rodgers and Hammerstein's smash Broadway musical *Oklahoma!*

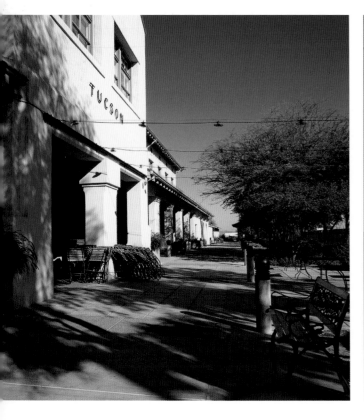

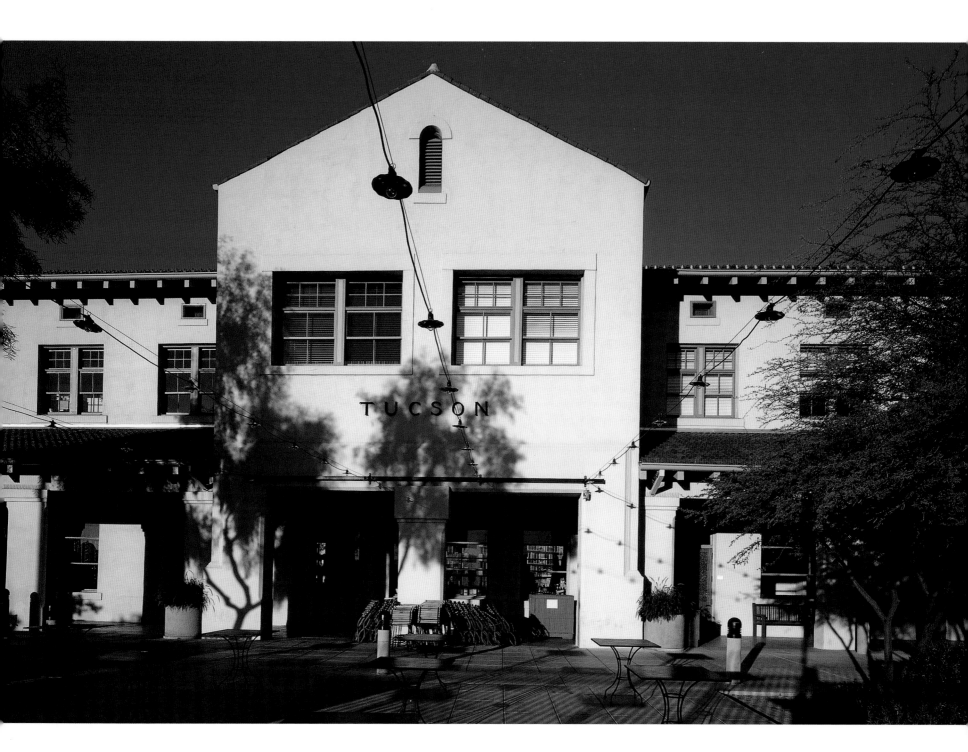

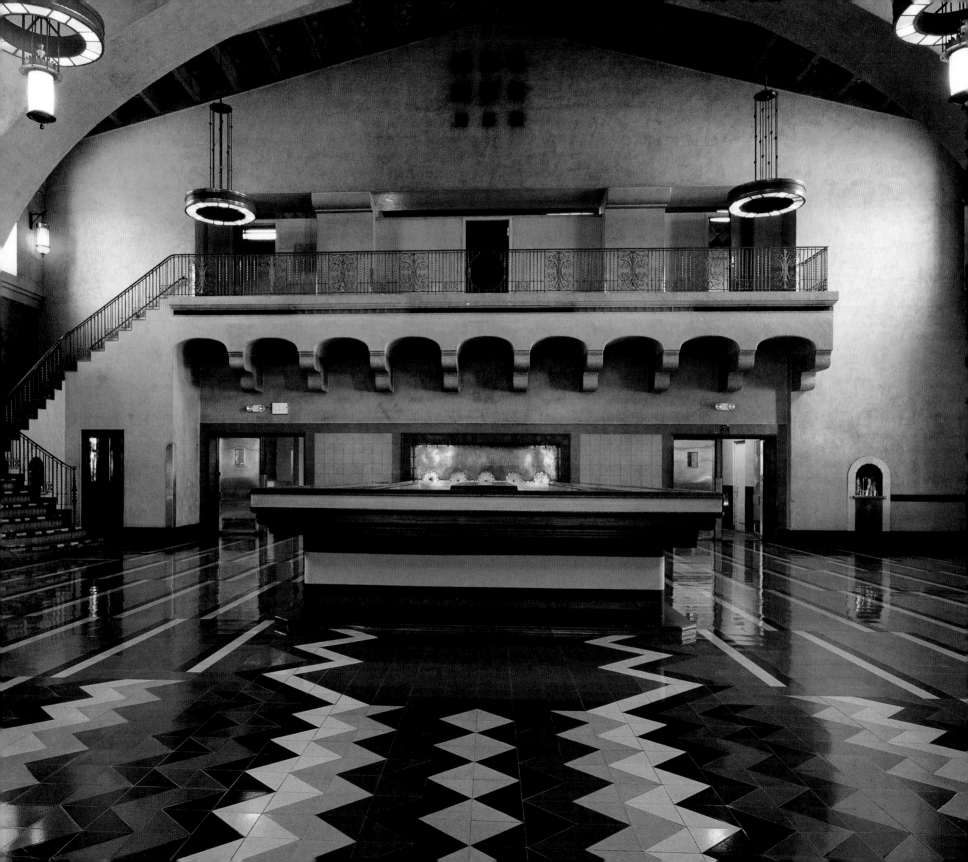

LOS ANGELES UNION STATION

Long before Los Angeles had such instant cultural magnets as the Getty Museum and Frank Gehry's Disney Center, it had a cultural monument in its midst to complement all the cinematic masterpieces produced by its legendary movie studios: the magnificent Union Station, opened in 1939. Considered the last of the great railroad stations built in the United States and officially known as Los Angeles Union Passenger

Terminal (LAUPT), the station is still resplendent today. No first-time visitor to the City of Angels will have seen this glorious metropolis at its best if a tour of Union Station is skipped or slighted.

Though Los Angeles Union Station bears glancing similarities to other monumental stations such as Grand Central in New York, Union Station in Washington, D.C., or Union Station in Chicago, the similarities are restricted to function and scale only: they all serve train passengers and they are all monumental, but the similarities end there because Los Angeles Union is one of a kind. A unique blend of Spanish colonial, mission revival, and art deco architectural styles, LAUPT is nevertheless an integrated—no, a *harmonious*—work of art. Like Los Angeles itself, the station melds the best of two cultural heritages, Spanish and Anglo, and then overlays them

with a quintessential American veneer that is timeless and timely, historical and modern—and, ultimately, futuristic. You will see no station like this anywhere else in the world.

LOS ANGELES UNION Passenger Terminal, like Hollywood's classic films, has a fascinating backstory. The three railroads that combined resources to build it—the Southern Pacific, the Union Pacific, and the Santa Fe—ended up battling the city in court for years over the station's location, cost, and configuration. The city wanted the station built adjacent to the original Spanish Plaza site on which it ultimately went up, a site situated in the heart of downtown in the area known as Chinatown. The railroads did not want it there. They wanted instead to expand and modernize the Southern Pacific's existing

Opposite Page: The balcony overlooking the main dining room of the old Fred Harvey restaurant, the last one built by this famous restaurant chain that catered to railroad stations. The art deco bar dominates the foreground. Note the blend of art deco and Native American patterns.

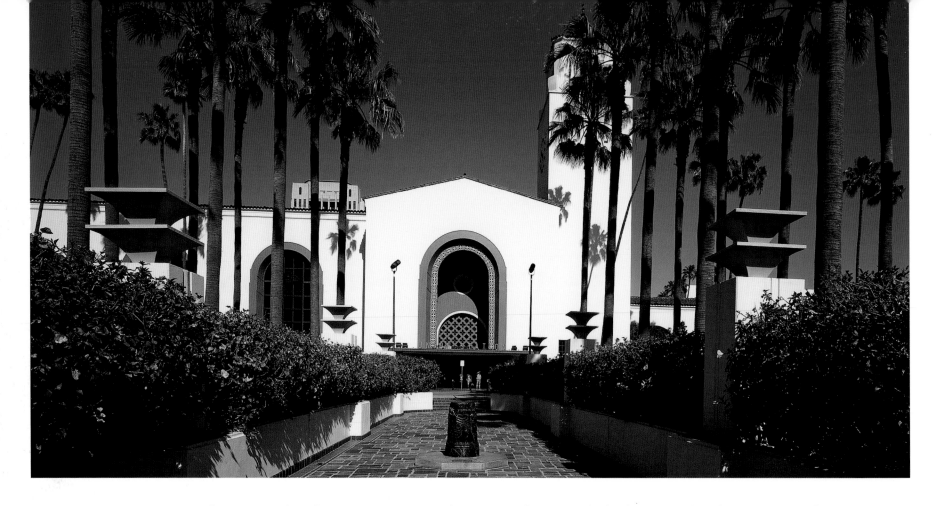

Central Station and make it a union terminal servicing all three railroads. To eliminate the noisome and dangerous grade crossings on the city streets, the railroads proposed that a series of elevated tracks be built, a much cheaper option for them than underwriting a whole new depot. The debate raged on for years and ended up first in the California Supreme Court and then, on appeal, in the U.S. Supreme Court. With the help of *Los Angeles Times* magnate Harry Chandler, after the drama of a voter referendum, and, finally, with the decision of the U.S. Supreme Court, the city won, but not before winning voter assent to a gasoline tax that produced a million dollars toward defraying the expense to the railroads of building this spectacular station.

With the decision to build Union Station finally arrived at after two decades of wrangling, the city appointed as consulting architects John and Donald Parkinson, who oversaw and coordinated the efforts of the chief architects of all three railroads: H. L. Gilman, J. H. Christie, and R. J. Wirth. From the clearing of the building site in the fall of 1933 to the grand opening of the Los Angeles Union Passenger Terminal in May of 1939, construction of the station took just under six years. For three days, from Wednesday, May 3, to Friday, May 5, 1939, the city staged an extravaganza to mark the station's opening, including parties and a parade replete with floats and ten brass bands. Half a million people attended. As you would expect in the movie capital of the world, there was

even a show that included a film called *Romance of the Rails* that played in a special amphitheater constructed alongside the tracks. The film illustrated the history of transportation in California and highlighted its railroading heritage as the terminus of the transcontinental quest.

AS BREEZY AND bright as its host city, Los Angeles Union Station features a white exterior clad in reinforced concrete, a main entrance topped by an arch fifty feet high rimmed with mosaic tiles encircling a smaller interior arch of ornamental concrete, and colored and patterned glass. Next to the main entrance a clock tower soars another sixty feet into the air. The marquee over the main entrance is topped with slender stainless-steel deco lettering that boldly spells out the station's name.

Inside there are classy modern touches like leather and carved-wood settees in the main waiting room and brass chandeliers hung from coffered wooden ceilings reminiscent of an ancient Spanish mission. The walls and floors are dressed in tile mosaics and travertine and marble. There are towering interior arches and tall windows that cast brilliant sunlight everywhere. The station was the first to install acoustic tiles in the walls and ceilings to cut down on the train announcement echoes and the noisy blowback from train engines.

Notably, the main waiting room is flanked by open-air patios and gardens for the comfort of departing passengers as well as friends and family waiting to greet arriving passengers. With their tiled fountains and native plantings, these patios and gardens are truly enchanting, and must have soothed many a troubled passenger over the seven decades of the station's operation. Other original amenities included the last Fred Harvey restaurant ever opened, a luncheonette, a

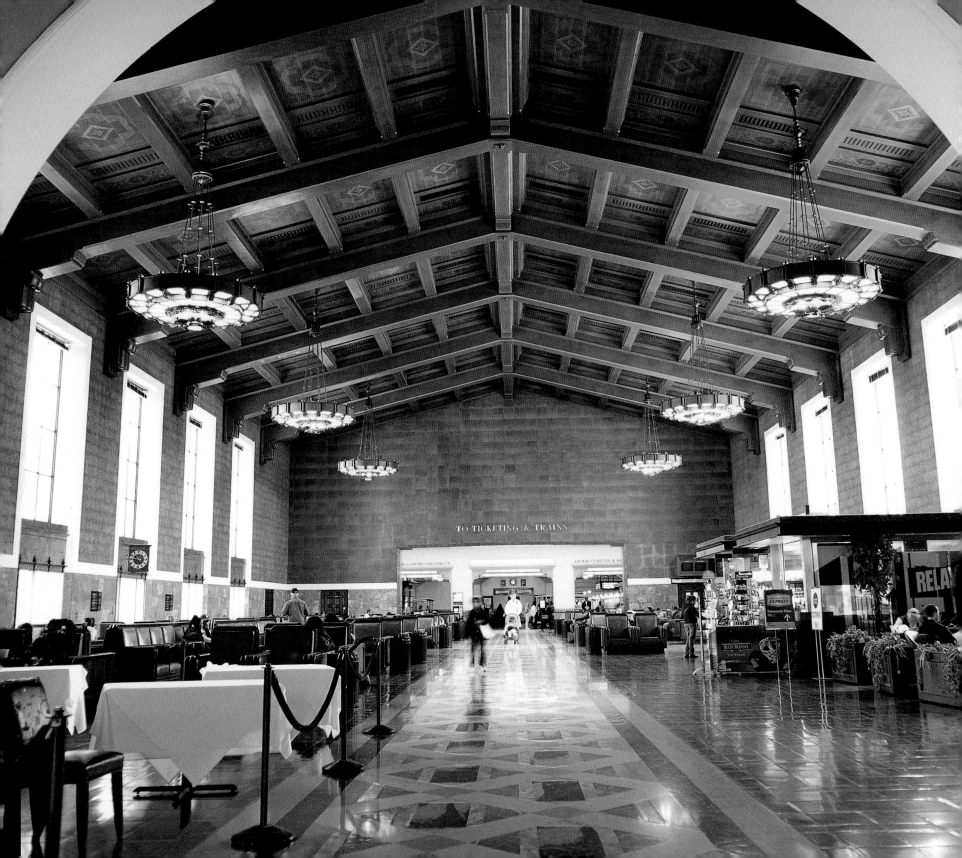

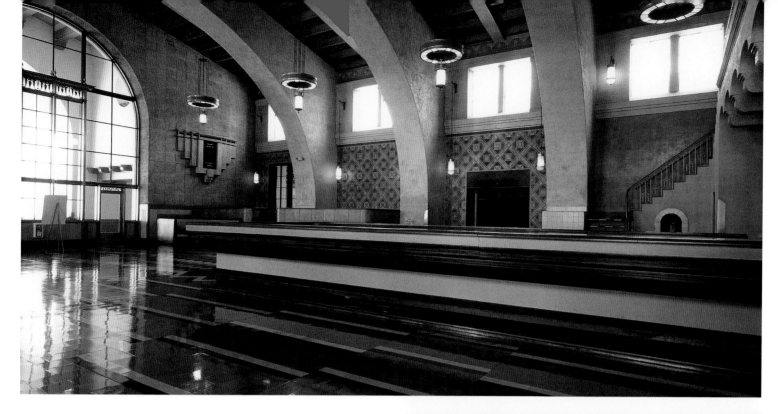

newsstand, an information booth, a travelers' aid station, a soda fountain, a barbershop, a tobacconist, and other retail shops, all laid out and decorated by celebrated designer Mary Colter. No expense was spared.

IT IS FITTING that Los Angeles would construct a dream palace of a railroad station, even though that station would have a foreshortened heyday of under two decades, a shorter period than the donnybrook between civic planners and corporate executives that preceded its construction. As visionary as ever, Los Angeles had provided ample parking space at Union Station; in the same vein, shortly after the station's opening the city would vigorously pursue the expansion of the small windsock aerodrome called Mines Field out in far Inglewood into what is today LAX, one of the biggest and busiest airports in the world. Those twin nemeses of the

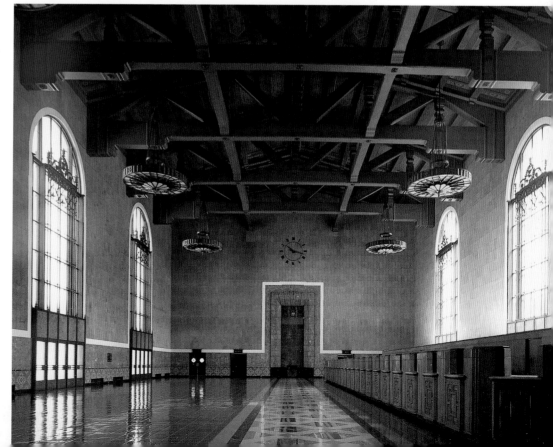

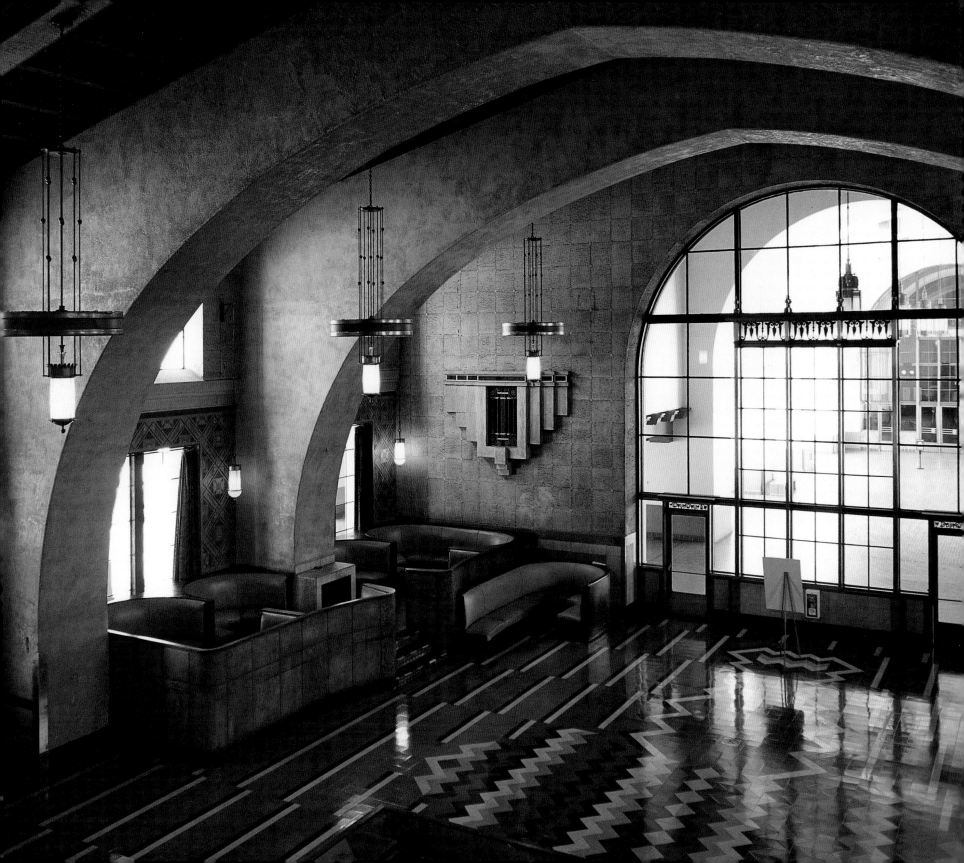

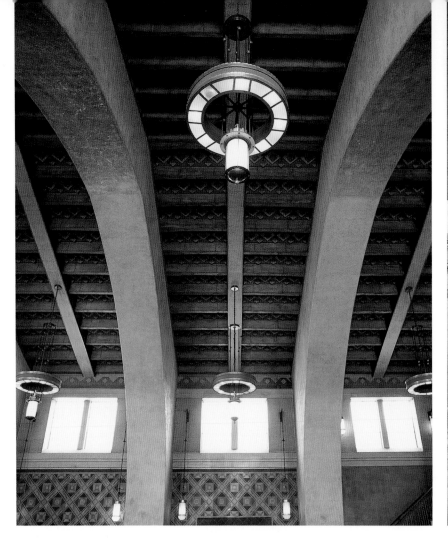

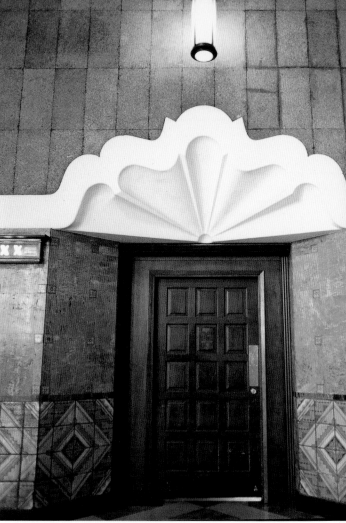

Previous Pages: Both the Fred Harvey cocktail lounge and the main dining room reflect the design genius of Mary Colter.

Right: The ceiling, walls, windows, and chandeliers of the Fred Harvey dining room play a Spanish revival and art deco fugue in wood, glass, stucco, and brushed steel.

Far Right: A Spanish revival wooden door encased in art deco marble and tile and topped by a scalloped seashell for a lintel distinguished the entrance to the Fred Harvey cocktail lounge.

Opposite Page: The giant exhaust vents loom like haunted sentinels over the old Fred Harvey kitchen.

railroad empire, the automobile and the airplane, would soon after the war combine to end the days when railroads were the kings of the road and the last word in rapid, convenient, and comfortable travel.

To its credit, Los Angeles has kept Union Station in good trim throughout its existence, even in the lean years of the late fifties, sixties, and early seventies. Even now the city is refurbishing and adapting the station to accommodate its continued use by Amtrak, its newer light-rail service, its expanded commuter train service, and its function as a principal station on the city's new subway system, as well as to facilitate stepped-up intercity and intracity bus services based there. Yet when you enter the station you instantly feel the aura of its legendary long-haul trains, like the luxurious and speedy *Super Chief* and *El Capitan* making their lightning-fast runs to Chicago, the famous intercity *Lark* and *Daylight*, shuttling speedily to and from San Francisco, and the fabled *Sunset Limited*, streaking back and forth to New Orleans. It's a great comfort to know that Amtrak still runs trains on several of these renowned old routes.

ACKNOWLEDGMENTS

We thank our agent, Alex Hoyt, and our editor, Studio Books vice president and editorial director Megan Newman, for their outstanding efforts in making this book happen. At Studio Books we also thank Megan's talented team: Amy Hill, design director, and Miriam Rich, assistant editor, as well as Renato Stanisic, interior and cover designer, and copyeditor Nicholas LoVecchio. Bill Shinker, president and publisher of Gotham, Avery, and Studio Books, deserves a salute for ensuring that everything ran smoothly.

Marc Magliari, media relations manager for Amtrak Government Affairs and Corporate Communications, Chicago, Illinois, was extremely helpful, as was his colleague Vernae Graham, at Amtrak Media Relations, Oakland, California.

Special thanks to Peter Laskowich and Gabby Gabarino for guided tours of, respectively, Grand Central Terminal and Fort Worth's stations.

We salute the Heermance Memorial Library of Coxsackie, New York, Linda Doubert and her peerless staff.

Many people helped us at the various stations: Mohamed Abaye, Laroe Adams, Joseph Alves, Lucille Austin, Linda J. Bailey, Sid Ball, Dawn Banket, Crystal Bernard, Dan Brooks, Steve Buchanan, James Kent Butcher, Velma Chambers, Hinda Chandler, Daryl Close, Ben Cober, Jeff Cooper, Jim Corbett, Karen Crowder, Julie Dodson, Daniel Dombak, Jeannie Dolmolin, Janene Edgerton, Shirley Gandy, Rita Green, Tim F. Haegelin, Ashley Harris, Sheryl Haynes, Brian Henry, Larry Jackson, Margot Janack, Paula Jenkins, Paul Kerr, Terry Koller, Harold and William Mangini, Chad Mertz, Elaine Metzger, Dave Morgan, Jerome Morris, Beverly Morrow-Jones, Donald Muscat, Margaret S. Neilly, *Matt Nestor, Gloria North, Todd O'Donnell, Frances J. Percich, Terry Prather, Don Riegle, David Rist, Ruby Rogers, Dan Samp, Betsy Sexton, Jenna Snyder, Valerie A. Sousa, James M. Staniewicz, Heather L. Stiver, Joanne Swaner, Doug Totter, Amy VerBeek, Tod Virgil, Joe Ward, Bud Warran, Nathan Weber, and Wayne Wiggins.

Linda Jo Calloway's suggestions and comments on the text were most helpful. We are especially grateful to Wendy Wolf for her indispensable help in the early stages of this book. Ed carpenter, Larry Groebel and Dan McNeilly drew our attention to vital information that enhanced the book.

PHOTO CREDITS

Grateful acknowledgment is made to the following individuals and organizations for permission to reprint the historic photos in this book:

For his invaluable advice in finding sources for the photos, to Dan Liedte of the National Air Museum.

Sofie Gogic, Special Collections Division, University of Washington Libraries, for the photo of King Street Station, Seattle.

Diane Hassan, Danbury Historical Society, for the photo of Union Station, Danbury.

Kenneth Johnson, Library of Congress, for the photo of Central of Georgia Station, Savannah.

Kansas City Public Library, Special Collections, for the photo of Union Station, Kansas City.

Library of Virginia, for the photo of Broad Street Station, Richmond.

Oneida County Historical Society, for the photo of Utica Union Station, Utica.

Katherine Reeve, Arizona Historical Society, for the photo of Southern Pacific Station, Tucson.

Scott Rook, Oregon Historical Society, for the photo of Union Station, Portland.

Cathy Spitzenberger, Special Collections, University of Texas Arlington Library, for the photo of Forth Worth Union Station.

Pittsburgh History and Landmarks Foundation, for the photo of Pittsburgh Pennsylvania Station.

Images from the Past, Bennington, VT, for the photo of North Bennington Station.

Society for the Preservation of New England Antiquities for the photo of Worcester Union Station.

Library of Congress for the photo of Chattanooga Terminal Station.

BIBLIOGRAPHY

Beebe, Lucius and Charles Clegg. *The Trains We Rode, Volume I*. Berkeley, California: Howell-North Books, 1965.

Bradley, Bill. *The Last of the Great Stations: 40 Years of the Los Angeles Union Passenger Terminal*. Glendale, California: Interurbans Publications, 1979.

Diehl, Lorraine B. *The Late, Great Pennsylvania Station*. New York: American Heritage Press, 1985.

Fussell, Paul. *Abroad: British Literary Traveling Between the Wars*. New York: Oxford University Press, 1980.

Greene, Bob. *Once Upon a Town: The Miracle of the North Platte Canteen*. New York: William Morrow, 2002.

Highsmith, Carol M. and Ted Landphair. *Union Station: A Decorative History of Washington's Grand Terminal*. Washington, D.C.: Chelsea Publishing, 1988.

Jonnes, Jill. *Conquering Gotham: The Construction of Penn Station and Its Tunnels*. New York: Viking, 2007.

Low, William. *Old Penn Station*. New York: Henry Holt, 2007.

Marx, Leo. *The Machine in the Garden: Technology and the Pastoral Ideal in America*. New York: Oxford University Press, 1964.

Middleton, William D. *Manhattan Gateway: New York's Pennsylvania Station*. Waukesha, Wisconsin: Kalmbach Publishing, 1996.

Potter, Janet Greenstein. *Great American Railroad Stations*. New York: John Wiley and Sons, 1996.

Richards, Jeffrey and John M. MacKenzie. *The Railway Station: A Social History*. New York: Oxford University Press, 1986.

Schlichting, Kurt C. *Grand Central Terminal: Railroads, Engineering, and Architecture in New York City*. Baltimore: Johns Hopkins University Press, 2001.

Smith, Henry Nash. *Virgin Land: The American West as Symbol and Myth*. Cambridge: Harvard University Press, 1950.

Solomon, Brian with Mike Schafer. *New York Central Railroad*. St. Paul, Minnesota: MBI Publishing, 2007.

INDEX